MW01037377

THE ART OF CONFESSION

PERFORMANCE AND AMERICAN CULTURES

General Editors: Stephanie Batiste, Robin Bernstein, and Brian Herrera

The Art of Confession: The Performance of Self from Robert Lowell to Reality TV
Christopher Grobe

The Art of Confession

The Performance of Self from Robert Lowell to Reality TV

Christopher Grobe

NEW YORK UNIVERSITY PRESS

New York

NEW YORK UNIVERSITY PRESS
New York
www.nyupress.org

References to Internet websites (URLs) were accurate at the time of writing. Neither the author nor New York University Press is responsible for URLs that may have expired or changed since the manuscript was prepared.

ISBN: 978-1-4798-2917-0 (hardback)
ISBN: 978-1-4798-8208-3 (paperback)

For Library of Congress Cataloging-in-Publication data, please contact the Library of Congress.

New York University Press books are printed on acid-free paper, and their binding materials are chosen for strength and durability. We strive to use environmentally responsible suppliers and materials to the greatest extent possible in publishing our books.

Manufactured in the United States of America

10 9 8 7 6 5 4 3 2 1

Also available as an ebook

CONTENTS

PREFACE

In September 1959, M. L. Rosenthal declared, "The use of poetry for the most naked kind of confession grows apace in our day."[1] By the 1960s, you could say the same of standup comedy; by the '70s, performance art; by the '80s, theater; by the '90s, television; and by the 2000s, all sorts of media platforms online. Everywhere, lone individuals turn, look us square in the eyes, and tell us their stories. *The Art of Confession* tells the history of such intimate acts—from the midcentury poetry reading to reality TV's "confession booth." In the process, it uncovers a network of influence among artists who have little else in common. They work in different media; their cultural status ranges from popular to elite, but taken together, their work forms a coherent tradition. What unites them, in spite of their difference, is a shared belief: that private selves can be captured through public performance—and that capturing them this way *matters*.

This doesn't mean that they find the task easy, nor do they present it to us that way. Instead, they dramatize access to themselves, each confession marking a hard-won "breakthrough back into life."[2] In the early years, when such confessions felt extraordinary, an affront to norms of privacy and restraint, each "breakthrough" came colored by uneasy feelings like shame and embarrassment. At the same time, each confession was also an act of defiance—a breakthrough past Cold War America's "containment culture."[3] If embarrassment was the cost of proud rebellion, these artists were willing to pay the price. Even today, with confession itself now the norm, this old drama of containment and breakthrough remains. We demand not authenticity, but the spectacle of crumbling artifice; not direct access to the personal, but a sidelong view of the persona falling away; not straight-ahead fact and sincerity, but the roundabout truths of an ironic approach. We want the truth, of course, but we want it hard—because the strain authenticates.

This drama of breakthrough proves that to "be yourself" is never simple. It requires a complex apparatus, which shapes not just art, but also

life itself. Art, after all, isn't walled off in "windowless art house[s]"[4]—least of all confessional art, which, by its nature, opens a door to the world. With a cross-breeze blowing, confessional art circulates things. It takes in worldly stuff, puts it to artful use, and then sends it out the back door, transformed. So, for instance, a woman in the 1970s might learn to confess from a second-wave feminist consciousness-raising group. But say she then started to make performance art in a confessional mode: Wouldn't that change her experience of feminist politics? Wouldn't it make her self-conscious about consciousness raising? So, too, across the arts: when artists put real-world intimacies in play, they help us hear the unspoken rules of confession—help us see the hidden architecture of the self. They reveal the art in our most "artless" acts.

In such moments, confession is revealed as a *performance*—at least in a specialist's sense of the word. For a scholar of performance studies like me, this word describes all the stylized *doings* in our lives—whether a performance in a gallery or a protest on the street, whether balletic technique or the bodily regimen known as gender. But this stands in sharp contrast to standard American usage, where "performance" and other theatrical terms imply bad faith, exaggeration, or outright fakery. *Oh, she just likes drama. That's nothing but political theater. In the end, it's all one big show!* The truth, we imply whenever we speak this way, never need be performed. It simply *is*. Confession, though, is the recognized exception to this rule. Its truths can't just *be*; they must *happen*, and once they do, they have the power to shape our world. Whether or not we make them up, confessions make *us* up—they make us *real*.

<p style="text-align:center">* * *</p>

The Art of Confession is structured around four case studies—moments when "confession" first invaded a particular art form, transformed its practice, and altered its future. Chapter 1 insists that confessional poetry, shaped by a craze for poetry readings, was, from the start, a performance genre. Chapter 2 presents women's performance art of the 1970s not only as the heir apparent to confessional poetry, but also as an artful response to second-wave feminism, a movement defined by its confessional rites of passage. Chapter 3 shows how theatermakers, inspired by both poets and performance artists, invented a new kind of confession in the 1980s, only to find that their "talk" was all tangled with writing,

their "immediacy" shot through with mediation. Finally, Chapter 4 argues that this long tradition of confessional performance culminates in the 1990s with the rise of reality TV. Defined by its reliance on the "confession booth" monologue, reality TV promotes a vision of life long familiar to confessional artists: a life defined by its conversion into narrative, by its constant acts of self-mediation.

When studying pivotal moments like these, it's tempting to take a deep but narrow view—studying a thick cross section of the work created at these key moments. But that wouldn't accord with the way audiences experience this art. We receive confessional works—even the very first ones by a given artist—as part of an ongoing practice or life, as nothing but "fragments of a great confession."[5] So, as critics, we must soften our gaze, focusing on something larger than the work and something vaguer than its moment of production. The proper unit of analysis is not the work but the career, not the instant but the longue durée. So each chapter, after setting the scene for one art form's confessional turn, dwells at length on a few early adopters: poets Robert Lowell and Anne Sexton, performance artists Linda Montano and Eleanor Antin, monologuist Spalding Gray and his circle, and the creators of MTV's *The Real World*. To sink deeply into the lives and careers of such artists is well worth it. Not only does this force us to take the same stance their publics took, peering beyond the work to the oeuvre or the life; it also permits fresh kinds of critical insight. Only when an artist's practice is taken whole, for instance, is it obvious that "non-confessional" works can, in fact, be integral to a confessional career. The persona and the personal aren't always (or even usually) at odds—a fact we miss if we fail to zoom out.

Together, these artists belong to a growing movement in American art we might call "confessionalism." Like other such movements—realism, Romanticism, the Gothic—confessionalism was, at first, strongly tied to one medium and genre: in this case, lyric poetry. But just as "Gothic" first described a style of medieval architecture, which then gave rise to modern, neo-Gothic buildings, which then provided the fictional settings for novels known as "Gothic," which, in turn, inspired paintings, plays, toys, and films in this mode, which now affect how we see Gothic buildings and read Gothic novels, confessionalism, too, is awfully hard to pin down.[6] Aesthetic movements like these are always on the

move. If we want to understand them, we must follow them around and around until—like blood in a centrifuge—their elements sort out and their essence goes clear. These clarified tactics, textures, and affects constitute what I call the movement's *style*, which can reach across media, across history, and across the blurry border between art and culture.

Since confessionalism was born into a postmodern media culture, it's even harder to pin down. The Gothic movement may have been on the move, but at least its component works tended to stand in one place, neatly confined to their medium of choice. Confessional works, by contrast, are themselves on the move—always sparking from one medium to the next. Confessional poems, for instance, were defined not only by their text, but also by their performance, recorded or live (see Chapter 1). Early confessional monologuists, conversely, fretted openly over their performances' relation to print (see Chapter 3). More than that, theatrical monologuists took from performance artists (like those I study in Chapter 2) an obsession with documenting their performances and with putting documentary media of all sorts onstage.

Such media instability is a defining feature of postmodern culture, but it's particularly significant to confessional artists, who tend to doubt that any one medium has the power to capture the truth of themselves. But, doubts be damned, they keep going, driven forward by the belief that, in fact, there's something real (if not solid) to *get right*: a *self*, which might leave traces in various media while eluding capture by any of them. And so confessionalists play with and across media, convinced that only a flickering succession of mediations will do justice to the subject of their confessions. Text-centered critics (especially those reading under the influence of poststructural theory) might experience these flickerings as proof that the self is fragmentary and incoherent. They might find themselves chasing the letter "I" as it endlessly falls through the chasm between representation and reference. Confessional artists, though, aim for coherence and, strange as it may seem, they tend to believe they're making progress.

Defining confessionalism as a styled media ecology, I'm not alone among performance studies scholars. In fact, landmark books in the field might also be seen as explorations of a cross-media style. For instance, in *Disidentifications: Queers of Color and the Performance of Politics* (1999), José Esteban Muñoz finds a set of consistent "communal

structures of feeling" in queer photography, film, performance art, and television performance.[7] These structures, he says, define a particular "minoritarian" experience of the self.

> The fiction of identity is one that is accessed with relative ease by most majoritarian subjects. Minoritarian subjects need to interface with different subcultural fields to activate their own sense of self.[8]

Muñoz's own thinking in this book mirrors what his subjects are doing: he "interface[s]" multiple art forms in order to "activate" our sense of the subcultural style he's discussing. His work compels belief insofar as this network of interfaced artworks resonates, giving rise—in overtones—to a style of art and self that we might call "disidentity." So, too, with the work of Peggy Phelan in *Unmarked: The Politics of Performance* (1993). Though she claims to be describing performance-as-such, it's a style *within* performance she has actually captured: the politicized performance of "disappearance," which enacts a sense of subjectivity as something "unmarked." This idea of the "unmarked" then helps her "interface" various art forms—the photographs of Robert Mapplethorpe and Cindy Sherman, the films of Yvonne Rainer, the drag performances filmed by Jennie Livingston, and the theater of Tom Stoppard—until, together, they reveal a shared approach to subjectivity and the self.

Like Muñoz's concept of "disidentification" or Phelan's idea of the "unmarked," the "confessional" is also a cross-media style of art *and identity*. As such, *The Art of Confession* doesn't just tell the story of how confession came to invade and transform American art; it also grounds this analysis in a new account of postwar American conceptions of the self. In my introduction, I ask how midcentury Americans understood "confession" and "performance"—and why they came to demand *both* from public figures. While telling this story and making this argument, I mostly resist the urge to generalize across cultures or centuries. Most authors—whether of book-length studies or of offhand remarks on confessional art—have tended to ornament their writing with appeals to the deep history of confession in the West. I ground my analysis in a purposefully shallower cultural history. Catholicism, with its sacrament of confession; psychoanalysis, with its talking cure; and the Western legal regime, with its troubling reliance on self-incrimination—none of these

were new. But when they all went mainstream together in midcentury America, they gave rise to a new assumption: that all of these realms (and many more) were, in fact, intricately connected—that they were all part of a broader phenomenon we'll call confession.

This new vision of confession soon gave rise a class of demi-celebrities, including the artists I feature in this book. These artists (and their audiences) began to understand confession not as a rare and climactic event, but as part of an ongoing practice that just happens to include the confessional artwork at hand. These new confessionalists used art to "discover and invent" themselves.[9] They made a life's work out of life-work. And, more than that, they seemed "to take pleasure in the act of mediation."[10] Now, in the age of Facebook, don't we all?

ACKNOWLEDGMENTS

In the theater, it's always tempting to credit the actors onstage with the achievements of those behind the scenes: the playwright's eloquence, the designer's vision, the director's discretion, and the stage manager's steady hand will somehow accrue to them. Academic books play a similar trick on their audience. The title page lists one name, but many are responsible. I'd like to thank a few such people here.

Only communities can foster the kind of energy that drives a book project forward all the way from beginning to end. My first scholarly community was at Yale, where this book began its life. There, I was nurtured by several communities' worth of fellow students, especially the members of the Twentieth-Century Colloquium in English, the cross-disciplinary Theory and Media Studies Group, and (most of all) the Performance Studies Working Group. My co-conveners of that last group—Julia Fawcett, Madison Moore, Lynda Paul, and Katie Vida— shaped my mind and this project from the start. Other members of that group—especially John Muse and Nathalie Wolfram—were, like my co-conveners, good friends and essential partners in thought.

While I was there at Yale, many teachers had a hand in shaping me and this project—most of all, my three closest advisors: Joe Roach, Amy Hungerford, and Jessica Pressman. One of the best things about Joe Roach is that he can't say "no" to any tempting possibility. More times than I can count (or than I surely deserved) he single-handedly drove me forward with his cries of "Yes, and . . . !" Amy Hungerford, for her part, was unstinting of her energy and wit. She took the gnarliest knots of my thinking and, through some sleight of hand, gave me back straight rope every time. And Jessica Pressman, thank goodness, steadied my hand as I steered into unfamiliar waters. Thinking back on my work with these three—especially Joe Roach, who was teaching me Sophocles and Soyinka when I was seventeen—I think I understand William Empson's homage to T. S. Eliot: "I do not know for certain how much of my

own mind he has [or, they have] invented." This phrase might also describe my teachers Marc Robinson and Langdon Hammer, who, along with Anthony Reed, were such generous and perceptive readers of my finished dissertation. I turned often to their advice as I set about revising and redescribing this book.

Since arriving at Amherst College, I've gained new communities, colleagues, and friends who have likewise left their mark on me and on this book. My thanks go first to my colleagues in the English Department, especially my dedicated mentor Rhonda Cobham-Sander. Outside this department, my most essential supports have been the members of the 5Perform faculty seminar. I give thanks to them all, with special thanks to the two who passed me the baton of leadership (and took it back before too long): Jenny Spencer and Daniel Sack.

Away from home, I owe a special debt to all the archivists and librarians who supported my research. I'll always remember fondly the hot summer month I spent in cold rooms with Richard Warren and Nicole Rodriguez of Yale's Historical Sound Recordings archive. And I still think often with great fondness of the staff (top to bottom) of the Harry Ransom Center, paradise of archives. Finally, a short, harried stint at the Getty Research Institute would have never been possible without the staff who made me feel right at home.

As I've turned this manuscript into a book, it's been a pleasure and an honor to work with NYU Press. Eric Zinner has been a tireless champion of my work. Brian Herrera, Robin Bernstein, and Stephanie Batiste embody the field, performance studies, in its ideal form, and I've been lucky to learn the ropes from them. Lisha Nadkarni, Dorothea Halliday, and many others at NYU Press deserve thanks for their part in easing this book into the world. Last but not least, two anonymous reviewers gave vital feedback and warm encouragement that made this a better book.

Parts of Chapter 1, I should note, appeared elsewhere before they fell into the hands of NYU Press. An article with a similar title, and a good deal of the same material, appeared in the March 2012 issue of *PMLA*, and a few paragraphs on Sexton and the theater also appeared in my contribution to *This Business of Words*, published by the University Press of Florida. I have Steph Burt and an anonymous reader to thank for their advice on those portions that appeared in *PMLA*—and I owe

thanks to Amanda Golden, who agreed to include my essay on Sexton in her book and in the flattering company she assembled.

Finally, I want to thank my family—given and chosen. My brothers and I (the professor, the minister, and the Swiss businessman) may sound like the lead-in to a joke, but our love for each other is no laughing matter. Dave Gorin and Jason Fitzgerald were anchors to me from the earliest days of my work on this project, and Jeanne-Marie Jackson, believe it or not, kept me sane. Meanwhile, my parents proved once again just how strong their stomachs were. I'll never fathom how they felt when I traded one bone-chiller ("I want to be an actor!") for that much-underestimated heart-stopper ("I want to be an academic!"). Quite seriously, their faith, support, and love could get me through much, much more than this. Finally, I dedicate this book to my partner, Michaela Bronstein. It's impossible to thank her well or deeply enough. My best friend and best editor, she knows which question (or which cocktail) is needed at every juncture. This book wouldn't exist without her.

Introduction

Say you're walking down the street one day, and then suddenly there *I* am. Let's assume you don't know me—but when our eyes meet, mine light up with recognition. Now your mind is really racing: *do I know him? should I know him? where do I know him from?* After a moment, I speak: "You don't remember me, do you? That's alright. I find your absent-mindedness charming." (And, you know, I always have. . . .)

That first paragraph was full of *you*'s and *your*'s, but notice how different each one felt. The *you* who walked down the street was, at first, a mere cipher. (*Instructions: please solve for* u.) But then I came along and by some transitive law *you* grew more solid in response. Before long *you* and *I* were entangled, though it's still hard to tell in what kind of relationship. Confrontational or tender? Filled with love or condescension? Either way *your* trajectory is clear. At first you're an anonymous figure—more knowing than known—then my insistence slowly unmasks you.

Of course, this happens in any story: characters slowly take shape, and as they do their relationships ramify. But isn't it odd, in this case, that the "character" in question is you? What's changing, then, isn't your knowledge, but your acknowledgment that I might mean you (yes, *you*) when I say it—even here at my keyboard, behind this mute page; even ensconced in this silly little thought experiment; even, believe it or not, in the preamble to a scholarly book. This is how pronouns work: they don't refer, they attach. One moment they're notional; the next, you feel them stick.

This book tells the story of a new way of saying *I* (and meaning it) in postwar America. Ever since the rise of mass-produced text, we've taken a pretty limpid *you* for granted and a pretty watery *I*. But at the middle of the twentieth century, America's *I*'s focused more sharply than they ever had before. By dint of their newfound solidity, these *I*'s grounded new identities, fueled new therapies, and inspired fresh

kinds of political action. They also offered—still offer—an inexhaustible quarry for artists, those modern masters of the art of confession.

The Breakthrough into Confession

Ah, the American Fifties: where it all began!

Well, not exactly. Because way back in 1886, Sigmund Freud saw a patient undergo what she called "the talking cure." Placed in a hypnotic trance, this woman poured out her thoughts while her doctor mostly sat by in silence. This method (minus the hypnosis, of course) would become synonymous with psychoanalysis—and thus a pillar of confession in the West.

Mm, Freud: founder of discourse, father of confession!

If you must. But what really got the ball rolling back in 1782 was the release of Rousseau's posthumous Confessions. *This book offered no story of spiritual growth. It just chronicled a life in all its grimy detail—utterly worldly, unredeemed. If Jean-Jacques ever aspired to anything higher, it could only be this: the grace of exceptional candor.*

Aha, Rousseau: modern man! Freudian subject *avant la lettre, extraordinaire—sans précédent!*

Mais, au contraire! *Because way back in 1215, the Catholic clergy made Rousseaux of us all by requiring a new sacrament. From that time forward, on pain of eternal damnation, all Catholics would confess to a priest once yearly. This had been the custom in some places for centuries, but now it was the law across all Christendom. The world's first (and, to date, its most interminable) analysis had begun.*

Right, the Fourth Lateran Council, the moment everything—!

—and a millennium and a half before Rousseau's were printed, St. Augustine composed his own Confessions, *telling of his youth as a sinner and of his conversion to Christianity. Augustine confessed his sins (a shameful story on the page) but also "confessed" (professed) his faith, a holy act before God.*

Oh, so it was Aug—!

—and Augustine himself merely belonged to a longstanding tradition of studied self-reflection. Many centuries before he was born, someone had carved a simple maxim into a temple at Delphi: γνῶθι σεαυτόν, "know thyself." It didn't yet say ". . . by confessing to someone else," but it now feels inevitable that it should.

Uh, wait—

—and even he, you see, this simple carver, was more the last than the first of his species. For, back in the depths of time, in some fateful cave—ugg ugg! aroo aroo!—and humankind would never be the same!

* * *

Studies of confession—even offhand remarks on the subject—must, by custom, begin with a few sweeping claims about CONFESSION IN THE WEST. No essay on personal poetry, no think-piece on memoir feels complete until someone has lit a candle at the shrine of St. Augustine. Having witnessed a few such acts of historical hand-waving, you could be forgiven for thinking that a council of thirteenth-century bishops—or was it an eighteenth-century philosopher?—made the debut of *The Real World* in 1992 a historical inevitability.

There is, however, a serious point to be made on this millennial scale. Our current culture of self-awareness, self-expression, and self-care rests on foundations laid long ago. We've risen to penthouse levels—millions of life stories high—so it's only natural if we've lost sight of the ground. If we could just get our heads out of the clouds, maybe we'd see that other foundations were poured—or were possible. As it is, we have trouble "imagin[ing a] self absent the imperative to scrutinize and . . . articulate it."[1] In the famous words of Michel Foucault: "Western man has become a confessing animal."[2]

Stories on this scale (*Western man!*) can take your breath away. They can also suck the air out of the room. They're not harmful in themselves, but they turn deadly when we use them not to explain new phenomena, but to explain them away. *There's nothing new under the sun. Just read your Augustine and Rousseau—your Wordsworth, your Sade, your Freud!* But here's the thing: midcentury Americans *had* read them—well, all right, maybe not Sade—and still they felt that they were witnessing something new. I want to start by taking this sense of newness seriously.

* * *

Consider American poetry, which took a "confessional" turn around 1959—in April of that year, to be precise.

APRIL 1ST, NEWTON LOWER FALLS, MA—Anne Sexton, a little-known
 poet, declares herself "the most about to be published poet around."[3] Boy,

she's not kidding! Before ten weeks more can pass, she'll have poems out in *Harper's*, the *Hudson Review*, the *New Yorker*—the list goes on. She will write about her brushes with madness, about suicide attempts, about sex in (and beyond) the marriage bed. Pretty soon, she'll be known as the confessional poet *par excellence*.

APRIL 13TH, NEW YORK, NY—Knopf publishes W. D. Snodgrass's *Heart's Needle*, in which the poet deals frankly with his recent divorce and subsequent estrangement from his daughter. The book would gain national attention and go on to win the Pulitzer Prize in poetry.

APRIL 28TH, NEW YORK, NY—Farrar, Straus & Cudahy releases Robert Lowell's tell-all book *Life Studies*. In a series of memoirs—some in prose, some in verse—Lowell exposes his troubled youth and confesses to an ongoing struggle with mental illness. *Life Studies* flies off bookstore shelves and drugstore racks. It would go on to win the National Book Award.

This sudden swell of confession, rising and breaking as one, quickly pulled in other people, too. Emerging poets were caught in the undertow (see: Sylvia Plath), while established figures (Ginsberg, Berryman, Roethke, Rich, etc.) suddenly found that they were riding a wave. It turns out they'd been writing "confessional" poems for years already. Reviewing *Life Studies* for the *Nation*, M. L. Rosenthal dubbed this book "confessional," and the name stuck like tar. Many—though not Rosenthal—meant it as an insult, but the public didn't care. Pretty soon, confessional poetry was America's most popular genre of verse.

Telling this story of confession's sudden ascent, poets and critics reach for the same word again and again. This was a *breakthrough*—past formalism, past repression, past social restraint—into emotion, into experience, into the world. "A breakthrough back into life," Lowell famously called it.[4] A "breakthrough into . . . very personal, emotional experience," Sylvia Plath chimed in.[5] So overworked was this word that, pretty soon, a critic could roll her eyes and refer to that "famous 'breakthrough' that it is the custom to talk about."[6] This supercilious tone about "confessional poetry" and its "breakthrough" has been available to critics ever

since. Take Laurence Lerner, for example, author of the 1987 essay "What Is Confessional Poetry?": "Everyone knows who the confessional poets are," Lerner begins, "Robert Lowell, Anne Sexton and Sylvia Plath, plus a few other candidates."[7] *Everyone knows*, he says, but what he means is, *Everyone but me*. By the end of the essay, he has concluded that we grievously "overstate [the] newness" of this genre.[8] Elizabeth Barrett Browning, the Romantic poets, William Shakespeare—heck, even "Sappho and Catullus . . . look like confessional poets" to him.[9] "Confessional poetry," in other words, is as old—or is practically the same thing—as poetry itself.

Other critics have rushed to the genre's defense, but they find only the narrowest position defensible. Confessional poetry *was* new, Diane Middlebrook retorts in an essay pointedly titled, "What *Was* Confessional Poetry?"—but properly speaking, only a tiny group of poets belong to the genre. "This was thoroughly middle-class postwar art—produced by [a small number of] WASP writers"—by her reckoning, only Lowell, Sexton, Snodgrass, and Plath.[10] Narrower still, only "certain poems" by these writers truly count as confessional, and all were published "between 1959–1966."[11] Middlebrook's careful historicism might seem totally opposed to Lerner's wide-eyed genre essentialism, but these critics do agree on one thing: midcentury responses to the genre were overheated and uncritical, and therefore should not guide our thinking. Well, I disagree.

* * *

By way of analogy, compare the genre "reality TV." Any scholar of that genre could pull a Lerner and tell you that *Cops* (1989–present), *An American Family* (1973), or *Candid Camera* (1948–present) did "reality TV" first. After a few drinks, you might even get them to say that TV *is* reality TV. Or else they could do the Middlebrook and argue that *The Real World* certainly counts as "reality TV," but only the first four seasons—and later shows called "reality" belong, in fact, to another genre, which we really ought to name. But to a cultural historian, distinctions like these seem beside the point. If all of sudden a certain phrase is on everyone's lips (*reality television, confessional poetry*), this alone is a fact worthy of our attention. If, in the process, these genres

slosh out of the containers we critics have built for them, then so be it. Genres, after all, aren't just categories-ideal in some theorist's or critic's taxonomy; they're also cultural events we undergo together. As surely as "reality TV" *happened* in the 1990s, "confessional poetry" belongs to the turn of the 1960s. And just as "reality TV" was defined backward—its features deduced from the shows of the 1990s and 2000s that popularized the term—so "confessional poetry" was a backformation from the personal poetry of Lowell & Co.

Such reverse definitions—no one's creation and everyone's property—might feel out of place in the scholarly realm, but they exist in the world whether we like it or not, and they exert their force on the things scholars study. Loose and baggy though they may be, they tightly shape how art is produced and received—across platforms and media, across continents and centuries. In this sense, Lerner's claim that Sappho and Catullus "look confessional" to him is an *example*—not a refutation—of that postwar formation called "confessional poetry." And the sudden insistence on a deep, unified history of confession in the West—this, too, is a product of the postwar culture of confessionalism. We see this happening right now with "reality TV"—not only in our growing desire to look backward at shows like *An American Family* or *Candid Camera*, but also in the way reality TV's formal features and ways of being are spilling over into film, scripted TV, politics, and everyday life.

"Confessional poetry" had precisely this kind of outsized impact. This genre soon became "the whipping boy of half of a dozen newer schools"—an effigy of what Gillian White calls "lyric shame."[12] When subsequent poets were caught *identifying* with their speakers, or when critics smelled too ripe a mode of *expression* in their poems, the poet had to kneel in repentance, or else stand in defiance—but always, now, one of the two. This wasn't the first time that poets had mixed art with life, but somehow the chemistry had changed. Art and life were now potassium and water: they never met but sparks went flying. If you want to understand the culture of confession this created, you can't afford to be a wet blanket. You must be ready to catch fire.

Rosenthal was ready. Reviewing *Life Studies*, he knew that personal poems had been published many, many times before—many of them dealing, as these did, with subjects that were, in their time, beyond the

pale—but he insisted that these latest poems were different somehow. They certainly *felt* different in the wake of modernist poetry, whose practitioners often preferred to keep their poems "impersonal." And, in the heyday of New Criticism, with its principled insistence that poems should be autonomous from their authors, it surely must have *felt* bold to see such personal poems for what they were. But beyond *feeling* different, they also *were* different from the poems critics named as precedents. While it is true, Rosenthal concedes, that the Romantics "spoke directly of their emotions" in their poems, they also transformed these emotions posthaste into "cosmic equations and symbols" for something else. They hoped to lose their sorrows and their selves as quickly as possible "in the music of universal forlornness."[13] Midcentury poets, for their part, resisted such transformations—they protected themselves against such loss. Rebelling with equal force against the Romantic legacy and the modernist tradition, these poets chose *personality* as their second medium, alongside (or even, at times, above) the written word.[14] The *I* they uttered would be an obdurate thing, gumming the works of transcendence, slowing the enrichment of life into literature.

Whether readers (then or now) approve of the genre, whether they even believe it exists, a generation of them could take the idea of "confessional poetry" for granted—and this alone is an important fact. But most readers weren't simply *aware* of confessionalism; they were *thirsty* for what it had to offer. They didn't wait around to see which poems the critics would deem properly "confessional." Instead, they looked for confession everywhere. Restless and suspicious, these new readers could spot the least hint of fact, could sense the faintest whiff of abjection. Whether poets liked it or not, the rules had changed. Poetry had once been abstract until proven confessional; now it was the other way around.

* * *

Meanwhile, at the lower end of America's cultural hierarchy, a similar change was afoot among comedians. Just like poets, they'd been saying *I* for ages already, but at midcentury they suddenly seemed to *mean* it. More than that, they seemed to mean it so intensely, they gave the lie to all those *I*'s that came before. No more vaudevillian acts done with

Figure I.1. Mort Sahl performs, newspaper nearby and magazine in hand. Photograph by Robert Vose. LOOK Magazine Photograph Collection, Library of Congress.

polished detachment—no more black-tie dress code or pat one-liners. They now performed in a loose, amateurish way, as if all they ever meant to do was just stand up and talk. ("Standup comedy" someone decided to call it circa 1954.)[15] Rambling, mumbling, and jamming—they could improvise for hours around a few core "bits" of humor. That is, they

Figure I.2. Lenny Bruce performs from the transcript of his latest obscenity trial. Village Theater, New York, 1964. Photograph by Kai Shuman. Michael Ochs Collection, Getty Images.

would repeat set stories (I mean, who doesn't?) while also reacting to the audience—to the *world* as they found it. To prove their point, some carried newspapers (Mort Sahl) or live telephones (Lenny Bruce) onstage, but whatever the tool, they were up to the same thing: busting out of that spotlight and into the world, breaking out of persona and into a personal mode.

It was hardly inevitable that this change in style should lead to a preference for confessional content, but it quickly did.[16] What better way, after all, to generate lots of new material—and material that you could deliver with an air of spontaneity—than to draw on your life? Before long, comedy, too, just like poetry, had become confessional until proven otherwise. "I was walking down the street the other day . . . ," says the comedian; "I wandered lonely as a cloud . . . ," the

poet muses—except we believe them now. We want to know which street. ("Hardly passionate Marlborough Street," perhaps?)[17] We wonder where the clown was wandering last and how he got so sad and lonely. (Drugs, divorce, obscenity trials?) We want—okay, maybe not the *whole* truth—but enough to make us feel that, in a pinch, we could figure it out for ourselves.

These new expectations changed art from both ends: production and reception. On the supply side, artists now instinctively reached for life matter. "Imagine a blind poet of today *not* writing on the subject of his dutiful sighted daughters reverentially scribbling so many thousands of pentameters," Billy Collins recently quipped.[18] This is not unimaginable; we have simply (as poets, as readers) been slower to imagine it. The poet's life is just *there* now—so available, so ready to be reshaped (or read) into art. But even back when this wasn't yet the case, when "confessionalism" was still a minor subgenre of poetry, it had already become a major mode for *receiving* all kinds of American art. *I'm not confessing!*, comics might cry in the fifties, but by the seventies they could only sigh, then meet their public halfway. "Audiences nowadays want to *know* their comedians," Joan Rivers observed in 1971. "Can you please tell me one thing about Bob Hope? I mean, if you only listened to his material, would you *know* the man, could you tell for one second what he is all about? His comedy is another America, an America that is not coming back."[19] She was right: what had changed, more than art, was the audience's desire. They wanted to *know*—not just their comedians—but their poets and politicians, their actors and news anchors, too.

And what they wanted, the mass media gamely supplied, creating in the process a newly *knowing* public. Even Laurence Lerner, in a rare moment of historical specificity, acknowledges the impact of this sudden shift. Shakespeare and Lowell may be equally "confessional" in Lerner's eyes, but, of the two, only Lowell had a public ready to *receive* him that way. The readers of Shakespeare could only "guess at the esoteric facts" to which his sonnet might allude, Lerner concedes—not so, the readers of Lowell's *Life Studies*. "In the 1590s, you would have to ask someone who knew someone who knew the poet. Today the higher journalism does this for you, and anyone can join the coterie."[20] The age of confes-

sionalism, then—it's no coincidence—is also the heyday of broad-based cultural journalism. It is the age (in other words) of the mass coterie.

* * *

Other critics who noticed this shift gave it different names. Christopher Lasch, writing in 1979, warned Americans that they were assenting to a "culture of narcissism." Driven by their "salacious" desire to *know* each other, they had settled for "mere self-disclosure" instead of demanding greater "insight into . . . historical forces."[21] (Yes, you've encountered Lasch's spiritual heirs bemoaning performance art, talks shows, Facebook, etc.) Lionel Trilling, lecturing at Harvard in 1969, took a milder view of this cultural shift, though he agreed on its scale and significance. What we were witnessing, he declared, was nothing short of "the moral life in process of revising itself."[22] European and American lives had once been governed by an ethic of "sincerity": *To thine own self be true!* Now they were subject to a "more strenuous moral" standard, "authenticity." To be authentic, in Trilling's sense, meant to accept "a more exigent conception of the self and of what being true to it" entails. It meant committing yourself to an epic quest inward, a "downward movement through all cultural superstructures to some place where all movement ends, and begins."[23] This "downward movement" to a "more exigent self"—this was precisely the work that confession performed.

At its worst, this project of authenticity was deluded and destructive. As Trilling wryly observes, the "judgment may be passed upon our sincerity that it is not authentic," but of course authenticity itself would suffer the same fate.[24] This "downward movement" can become a race to the bottom as you discard first one truth, then another, then another in an endless search for the *really* real. Meanwhile, you tighten your belt so the race can be run, starving anything that dares to extend beyond the confines of your own lonely brainpan. Maybe Christopher Lasch is right! If true value lies within, and if "cultural superstructures" can only threaten it, then where will this "downward movement" lead us if not toward narcissism and away from politics—away, indeed, from any form of communal life?

And yet: consider two signature acts of excavation that *fueled* politics and *created* community. In the late 1960s, "coming out" was the

gateway to gay politics; a few years later, "consciousness raising" fueled second-wave feminism. In each case, individuals were encouraged to tell their stories—but, in so doing, they joined a community and began to take action. When you put it this way, it sounds like a clever ploy: a quietist means to an activist end. But these confessional rituals didn't just play on people's narcissism in order to recruit new troops into old campaigns. Instead, these rituals pointed the way to new social theories and new ideas of what activism might entail.

Just as poets had grown wary of the rush away from life and toward "universal" resonance, so these activists found they wanted to postpone the moment when individuals were swallowed up in grand theories of progress and oppression. The goal of consciousness raising, said Vivian Gornick at the time, was "to theorize as well as to confess"—with these two actions caught in an endless feedback loop.[25] *The personal is political*, that was the cry—and social theories would have to change accordingly. Gay and feminist activists wanted a chorus of *I*, not some guy with a megaphone leading the crowd in chants of *We!* If these movements fell short—and they did, one by one—it was because some kinds of *I*'s (usually the ones coming from middle-class mouths on white faces) amplified each other and drowned out the rest. But even as these movements began to sputter or splinter, this ideal of a personal politics remained the gold standard. *The personal is political— . . . is the personal, is the political . . .*—both today and for the foreseeable future.

This path I've just beaten from art to politics is, of course, well-worn by the feet of others, but I swear I haven't drifted this way by habit or from some sense of scholarly duty. When the topic is confession, a deep rut runs this way. It grabs your tires and yanks the wheel from your hands. That's because confession is both a work and an act—an artistic form and a social function. So, it's impossible to know just where art leaves off and real-world action begins. Return to Rosenthal's review of *Life Studies* with this in mind, and you'll notice just how *active* he found Lowell's poems to be. *Life Studies*, he says, was clearly serving as "therapy" for Lowell, but the poet was also "denigrat[ing]" himself in these poems, doing "violence to himself" with their well-sharpened edge—and, along the way, he was using these poems to "discredit" his poor, dead father. But despite all the harm these poems were causing, they also managed to win "moment-by-moment victories over hysteria and self-concealment."[26] Archibald Mac-

Leish, in his poem "Ars Poetica," had concluded that "A poem should not mean / But be." Under the sign of confession, poets had changed their minds: a poem must not mean, not be, but *do*.

What Was Confession?

It's easy to imagine why, confronted by poems like these, the word "confessional" sprang to Rosenthal's mind—and why the term would ring true for a generation of readers. Lowell came from blue-blood Protestant stock, but was known as a sometime Catholic convert. He was also notorious for having served time in jail as a conscientious objector to World War II. And, at least among the literary set, his struggles with mental illness were also common knowledge. (Even as *Life Studies* was first being "read and reviewed," the news of "Lowell's latest crash was hissing around the poetry world," Peter Davison recalls.)[27] In short, Lowell's life was the theme of a thousand confessions—sacramental, legal, and therapeutic. To call his poetry "confessional" was to invoke all three facts at once—not separately or sequentially, but together. Lowell himself yoked the three together in a passage from *Life Studies* that Rosenthal quotes in his review:

> I was a fire-breathing Catholic C.O.,
> and made my manic statement,
> telling off the state and president.[28]

Entangling his Catholicism, his mania, and his felonious dissent—each shocking, no doubt, to the Lowells of Boston—Lowell (like Rosenthal) makes them the theme of a single confession. When the term "confessional" did stick to other poets, it was usually because they shared at least two of these three things with Lowell: a flirtation with the Catholic faith, an outlaw air (if not a felony record), and a prolonged, public struggle with mental illness. The term was diffuse, in other words, but also overdetermined, drawing together with one gesture all the tributaries to *Life Studies'* torrent of scandal.

Rosenthal hardly invented this ambiguity in "confession"; he just revealed it and put it to use. In English, "confession" has long done the work of three words: describing a sacred profession of sin, a legal admission

of guilt, and an intimate revelation of shame. The German language, Rita Felski reminds us, has three distinct words for these acts (*Beichte, Geständnis,* and *Bekenntnis*), but despite these linguistic resources, it was a German-speaking Austrian, Theodor Reik, who wrote the signature book on the unity of all confession.[29] Reik's *The Compulsion to Confess*—published in English the same year as *Life Studies*—gathers a dizzying array of religious, psychoanalytic, legal, artistic, and everyday behaviors under the rubric of confession. More than that, Reik suggests that all these acts of self-betrayal spring from the same psychic mechanism. Though ancient and buried deep, this drive is always surfacing in unexpected ways: *Geständniszwang,* the compulsion to confess. The ambiguity Rosenthal found in "confession," then, lies not in the word, but in the act itself—and in the buried impulse that spurs it on.

Confession, in this view, is no single behavior, nor even a set of related behaviors; it is a shape-shifting metaphor for a whole way of being in the world. After all, no sooner has Reik proposed the term, than he renders it a cipher, observing that confession proper (i.e., *Geständnis*) is "from an evolutionary point of view, the youngest function of this tendency."[30] Subtracting the *Geständnis* from *Geständniszwang,* Reik renders compulsion itself (plain *-zwang*) the naked placeholder for this urge. So expansive does this theory become that, according to Reik, every psychoanalytic "symptom" can be traced to this compulsion-formerly-known-as-confession—from the neurotic's "acting-out" to the "compulsory self-betrayal [of] blushing."

In his preface to the American edition of *The Compulsion to Confess,* publisher John Farrar offers the book to a "public interested in psychological literature"—and interested they were.[31] This English edition of Reik's work joined the burgeoning ranks of what I'll call the American psycho-pop canon. Public interest was rising not only in psychoanalysis, but also in existentialism, in faux-confessional literature, and in the outlaw life-writing of the Beats. Bookstore ads from the period suggest the range of this canon, as well as Reik's place of honor within it. An ad for the Marboro Book Club from late March 1959—i.e., on the eve of confessional poetry's *mensis mirabilis*—invites the reader to "choose from a TREASURE OF ART MASTERPIECES—LOLITA—THE COMPULSION TO CONFESS—MASS CULTURE—and twelve other important books." Among the other suggested books, you'll find Sartre's *Being and*

Nothingness, an anthology of *The Beat Generation and the Angry Young Men*, and a second Reik book (*Of Love and Lust*). A second ad, this one touting the psychology offerings at Brentano's Paperback Emporium circa 1966, features eight of Reik's works (including his autobiography, *Fragments of a Great Confession*) and gives him pride of place among such figures as Wilhelm Reich, Erich Fromm, Erik Erikson—even Jung and Freud.[32] It is these works Farrar was probably imagining when he introduced *The Compulsion to Confess* as the perfect book for a "public interested in psychological literature," but it is tempting to imagine that he was thinking of another book published under his imprint that year, "psychological literature" of a more literary bent: Lowell's *Life Studies*.

Lolita is a particularly apt companion for *Life Studies* and *The Compulsion to Confess*, and an excellent emblem of the psycho-pop canon generally. It begins, "'Lolita, or the Confession of a White Widowed Male,' such were the two titles under which the writer of the present note received the strange pages it preambulates." "The writer of the present note" (the fictional John Ray, Jr., PhD) then describes the book we are about to read as a "remarkable memoir," as the quasi-legal "confession" of a man awaiting trial, as a "confession [that] does not absolve [its author] from sins," and as a "case history" bound to become "a classic in psychiatric circles."[33] *Lolita*, in other words, proudly embodies midcentury America's heady conflation of all kinds of confession. Welcome to confessional America: your exit visa will not be approved.

* * *

Their bookshelves filled with such words, their heads filled with such thoughts, the American public was primed for yet another national spectacle of confession: legal wars waged in American courts (including the court of public opinion) over the admissibility of confessions at trial. Having mostly done away with the rope and the rubber hose, judges were turning their attention to "subtler devices" of coercion.[34] After a decade of case-by-case appeals, the US Supreme Court decided to bring the issue to a head. "Once again," Justice Felix Frankfurter sighs in the opening sentence of the majority opinion in *Culombe v. Connecticut* (1961),

> the Court is confronted with the painful duty of sitting in judgment on a State's conviction . . . in order to determine whether the defendant's

confessions, decisive for the conviction, were admitted into evidence in accordance with the standards for admissibility demanded by the Due Process Clause of the Fourteenth Amendment.[35]

Anxious to bring this barrage of appeals to an end, Frankfurter relied not primarily on the circumstances of this case—which were easily damning enough—but instead on a broader, philosophical argument about the nature of free will. *Voluntariness*, he argues, is an "amphibian."[36] Neither a subject for psychology alone nor a mere question of legal procedure, it inhabits the shoreline between each person and the law. Shouldn't this change how we decide whether a confession is voluntary? Chief Justice Warren began his concurring opinion in a tone of wry disapproval: "It has not been the custom of the Court . . . to write lengthy and abstract dissertations upon questions which are [not] presented by the record. . . ."[37] Five years later, though, Warren himself would pen one of the twentieth century's most controversial "dissertations" on confession, the majority opinion in *Miranda v. Arizona*. In it, he argues that "the process of in-custody interrogation . . . contains inherently compelling pressures which work to undermine the individual's will to resist and to compel him to speak."[38] To depressurize this process, he proposed a warning ("You have the right to remain silent," etc.), which was meant to be more practical than Frankfurter's musings, though its implications were just as sweeping.

For all their differences, Warren and Frankfurter do agree on one thing: that a confession is not a mere document—not that bit of textual ephemera admitted into evidence at trial and available to higher courts via the record on appeal—but rather a performance that takes place in a home, on the street, in a squad car, or inside an interrogation room. Both justices, accordingly, replace the confession itself with a little drama of its production. Frankfurter constructs his along the lines of a well-made play, with rising action and a sudden climax. ("It is clear that this man's will was broken Wednesday afternoon.")[39] Warren, meanwhile, works in a more Pinteresque mode: it is the "atmosphere" that interests him—the "nature and setting of this in-custody interrogation."[40] But the effect is the same: the lonely voice of a written confession gives way to a cacophony of voices; confessional authorship

gives way to confessional performance, filled (as all performances are) with rival acts of authorship and authorization. Here, for instance, is Frankfurter's account of how Culombe's confession arrived at its final form:

> At about 8 p.m., [Officers] Rome, Paige, O'Brien and County Detective Matus brought Culombe to the interrogation room to reduce his several confessions to writing. Culombe made a number of statements. The manner of taking them (no doubt complicated by Culombe's . . . tendency to give rambling and non-consecutive answers) was as follows: Rome questioned Culombe; Culombe answered; Rome transposed the answer into narrative form; Culombe agreed to it; Rome dictated the phrase or sentence to O'Brien. Each completed statement was read to and signed by Culombe.[41]

The telling phrase here is: "to *reduce* his several confessions to writing." Just like Frankfurter, Warren wanted to reject *reductive* notions of confession and confessional authorship. To that end, from among 150 relevant appeals on his desk, he handpicked four filled with pre-confessions, written and oral.[42] The result was the omnibus case known as *Miranda v. Arizona*, designed to probe the boundary between performance and writing—and to ask the insistent question, *Whose writing?* Confession, for these justices, was itself an "amphibian," shared between confessant and confessor, flitting from text to performance and back.

* * *

You can tell a lot about people from their choice of enemies: Chief Justice Warren found his nemesis in Fred Inbau, a midcentury expert in criminology and the author of best-selling interrogation manuals. "To obtain a confession," Warren writes, quoting Inbau, "the interrogator must 'patiently maneuver himself or his quarry into a position from which the desired objective may be attained.'"[43] But it wasn't just Inbau's predatory language that drew Warren to him. Inbau also made no bones about his desire to turn the subjective act of confession into an objective form of evidence. A leading proponent of the polygraph

machine (the so-called *lie detector*) Inbau had little patience for free will, "amphibious" or otherwise. In one particularly dystopian passage from his manual *Lie Detection and Criminal Interrogation*, Inbau dreams of a future where,

> Since the physiological reactions obtained by the [polygraph], and even the "yes" and "no" answers are not used testimonially—that is, as "statements of fact to show their truth"—it well may be argued that there should be no legal obstacle to a compulsory examination of this nature. The situation in all essential respects may be considered analogous to that involved in cases in which an accused person is compelled . . . to give impressions of his fingerprints. . . .[44]

Monitoring the bodily reflexes of criminal suspects—taking their pulse, tracking their breathing, and measuring their sweat—the polygraph promised to convert this messy business of confession into a simpler form of authorship: three quivering arms with inked needles that wrote the body's guilt out in longhand.

Treating the signs of a suspect's anxiety as a legible form of "writing," the polygraph collapsed the distance between matter and mind, body and text, object and subject. No wonder, then, that early accounts of this machine are so filled with metaphors of vivisection:

> Nothing could have been more dramatic, more dispassionately heartless than the manner in which science dissected [the suspect], felt his heart beats, his pulse, examined his breathing, looked beneath the flesh for indications.[45]

This unsettling imagery, echoed also in early descriptions of confessional poetry, captures the polygraph's uncanny power.[46] Like vivisection, lie detection sounds the depths that confessional poetry and psychoanalysis probe only metaphorically. And, sounding these depths, the polygraph finds nothing but meat—throbbing, heaving, secreting—all the way through: a depth made entirely of surfaces. Like some inversion of the torture device in Franz Kafka's "In the Penal Colony," the polygraph works not on the assumption that our guilt must be carved into our flesh from without, but that it's already written there from within.

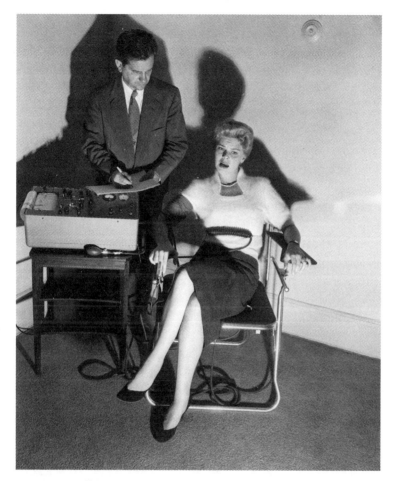

Figure I.3. Fred Inbau performs a polygraph exam on film actress Betsy Palmer. Bettmann Archive, Getty Images.

In his dissent to *Miranda*, Justice Harlan seems baffled by Warren's impassioned attack on police interrogation, and he scoffs at the Chief Justice's hair-trigger sense of the accused's confessional urges.

> It has never been suggested, until today, that such questioning was so coercive and accused persons so lacking in hardihood that the very first response to the very first question . . . must be conclusively presumed to be the product of an overborne will.[47]

What Harlan didn't realize was that Warren was reading these confessions as if they were polygraph printouts. As a prosecutor in California's Alameda County in the 1920s and '30s, Warren had a front-row seat to the polygraph's debut as a bit of policing hardware, and he watched closely as the Berkeley police created software to match: that is, formal interrogation techniques.[48] This was—not figuratively, but quite literally—the same software Inbau was peddling in the 1950s and '60s in his interrogation manuals.[49] The "right to remain silent," in short, was invented by a man who feared we might be incapable of exercising it.

Midcentury Americans agreed with Warren on this point—or, at least, they were fascinated by this horrible idea. Not only were members of the psycho-pop canon like Theodor Reik insisting that our confessions could erupt anywhere (and in any form), but this same anxious vision of our psychic fragility was central to America's Cold War mythos. Just think of all the overblown nightmares of communist brainwashing or mind control that filled American popular discourse, crystallized by Richard Condon in his 1959 best-seller *The Manchurian Candidate*. Stories like these made sense, in their exaggerated way, because Soviets, the Chinese, and other communists were thought to possess a psychic steeliness that Americans, nurtured in the warm embrace of capitalist democracy, could never attain.

So, in ways that both exhilarated and terrified Americans, "confession" described a breakdown in psychic boundaries: between voluntary and involuntary acts, between subjective and objective states, between private experience and public life. When Rosenthal reads the final poem in *Life Studies* as Lowell's "assertion that he cannot breathe without these confessions, however rank they may be," he is spotting a new mode of confession in the offing: not just one that tries to purge us of whatever chokes our psyches or stifles our breath, but also one that, whether we like it or not, comes as naturally—and as continuously—as breathing in and out.[50] On the cusp of the epochal 1960s, Americans panted and gasped—now with confession on their breath.

Committing to Print, Promising Performance

What if we approached all life-work in this spirit? What if we tried to read confession after the manner of *Miranda*? Autobiography studies,

it turns out, is already full of legal metaphor, from the contract law of Philippe Lejeune's "autobiographical pact" to the widespread idea that a "law of genre" (as theorized by Jacques Derrida) is enforced with particular severity against life-writing.[51] According to Paul de Man, the reader of autobiography "becomes the judge, the policing power in charge of verifying the *authenticity* of the signature and the consistency of the signer's behavior"; readers "become detectives," Leigh Gilmore adds.[52] Neither de Man nor Gilmore quite approves of this stance, but they attribute it to the silent majority of readers. Casting the bad reader of autobiography as a policeman or trial judge, theorists of life-writing appoint themselves to the court of appeals. From that high bench, they assess our procedures—for granting authority, affirming authenticity, and inferring agency. What if we thought more explicitly of appellate judges as our peers, especially when they confront legal questions that border so nearly on our own—when, for instance, they consider our integrity before the law and the law's power to shape us?

<p style="text-align:center">* * *</p>

Like the literary scholar, the appellate judge is conventionally limited to the textual record on appeal. But in deciding *Miranda*, Chief Justice Warren never settled for this hidebound position. Instead, he strained at the limits placed upon him—first, by the norms of appellate law and then by the secrecy of police procedures. The "privacy" of what Warren darkly calls "incommunicado" interrogation "results in . . . a gap in our knowledge as to what in fact goes on."[53] His solution was to wield text against text—e.g., interrogation manuals against confessions—sifting this expanded archive for traces of the confessional repertoire. Warren was, in this sense, a performance theorist of confession; scholars of autobiography should follow his lead.

Literary historians and theorists often ask us to imagine the moment when a panting confession gives way to an autobiography; when a narrative act, in other words, is finally committed—to print. Sometimes, they treat this moment as the turning point in some grand evolutionary narrative, as when James Olney describes "autobiography as a literary mode . . . emerging out of autobiography as a confessional act."[54] More often, though, critics aren't thinking of a particular moment. Instead, they're trying to account for a vague feeling readers get: that autobiography's

content rests uneasily in its form; or, in the words of Jeremy Tambling, that autobiography is simply "confession's repressed form."[55]

This, we say, feeling the weight of a book in our hands or the flimsiness of a thin dossier, *is not a person, not a life*—and many theorists of life-writing positively revel in the feeling. They love the hyphen, that measurable gap between life and writing, and they wish life-writers would join them. Rita Felski, for instance, counsels confessional writers to avoid "the illusion of face-to-face intimacy," and to embrace instead writing's "play, ritual, and distance" from life.[56] Paul de Man likewise imagines autobiography as a "de-facement" that leaves the subject "eternally . . . condemned to muteness."[57] But can't we acknowledge that writing dislocates us from life without casting all life-work into the mute, faceless distance?

Diana Taylor, author of *The Archive and the Repertoire*, offers an alternative—the same one, it turns out, that Warren had discovered. "Instead of focusing on patterns of cultural expression in terms of texts or narratives," Taylor writes, "we might think about them as scenarios that do not reduce . . . embodied practices to narrative description."[58] These "scenarios" are much broader than any action or document to which they might, from time to time, give rise. They are vast "meaning-making paradigms that structure social environments, behaviors and potential outcomes."[59] Just as Justice Frankfurter distrusted the interrogator's habit of "reduc[ing]" a suspect's "several confessions to writing," so Taylor wants new approaches that "do not reduce" a performance to a text—nor to any archivable medium.

Following Taylor—but also Frankfurter and Warren—I suggest that we treat confession not merely as autobiography's repressed content (and certainly not as its evolutionary precursor), but rather as the scenario that "structure[s the] social environments, behaviors and potential outcomes" of American life-work, including acts of life-writing. Felski and de Man, as well as other theorists working in the wake of critical theory, would surely agree: the displacement of writing from life is never simple. But it is also, I would add, never finished—and always able to be undone. Even after a self is committed to the page, the scenario of confession persists, ensnaring the texts of life-writing in a tangle of non-textual media and non-literary practices. "Confession," then, is a much broader term than "autobiography" will ever be. The latter word—just

look at its suffix—begs the question of writing's centrality to life-work. Confession, meanwhile, may pass through writing, but it inherits past practice and promises future performance.

* * *

These performances, when they arrive—in the form of poetry readings, performance art, "confession booth" monologues, etc.—may look like some of the simplest performances we have: one person, typically placed in an everyday space or against a neutral background, speaks directly to the audience. But, studied closely, these performances are not immediate; in fact, they betray an obsession with their own mediation. Confessional performers don't just chronicle the events of their lives; they also dramatize the tension between their inchoate selves and the media they use to try to capture them. Confessionalism, then, amounts to a living critique of autobiography, which confessionalists understand as something stagnant and one-dimensional.

Scholars of autobiography, especially in the twenty-first century, should take this critique to heart. Even life-*writing* now circulates in ways that should boggle the simply "graphical" mind. This is especially true in the case of the serial confessant, a sort of celebrity who makes a living by performing act after act of life-work. Consider an extreme instance of the type: Cheryl Strayed, whose Oprah-anointed memoir *Wild* has been visible in every subway car and airport since it was first published in 2012. Long before she wrote *Wild*, Strayed had already produced a semi-autobiographical novel, several personal essays, and an unusually self-revealing advice column for *The Rumpus* called "Dear Sugar." (This last, to complicate matters further, was later collected into a book, and has now been revived as a WBUR podcast.) And in the wake of *Wild*, Strayed did what any memoirist must now do: she kept confessing on talk shows, at readings, in webchats—wherever an audience was willing and waiting.[60] Faced with someone like Strayed, why would we fixate on the moment when this flow of confession coagulated into a book called *Wild*?[61] For her—and, more and more, for all life-writers—committing your story to print means, quite literally, promising performance.

If Marshall McLuhan is right and Western cultures have become "post-typographic" in this age of mass media, this has not led—all

hand-wringing aside—to the death of text or print. (The memoir boom is evidence enough to the contrary.) Instead, media hierarchies are flattening—or, at least, the caste-lines have eroded—and we've grown savvier to what McLuhan once called the "interplay and ratio" of different media interacting.[62] At midcentury, this kind of "interplay and ratio" among media was already many artists' primary concern, and they tended to give this interplay the same name: performance. The poet Charles Olson, arguably the first person to say "postmodern" and mean not a fall from modernist grace but the birth of a new aesthetic, defined it by its habit of embracing "the active intellectual states, metaphor and performance."[63] In typical whirlwind fashion, Olson barrels past this assertion, leaving "performance" a mere cipher, but we can see what he meant by simply looking at the art that inspired this line of thinking. In 1952 at Black Mountain College, Olson participated in what some call the very first "happening," a collaboration with, among others, John Cage (bête noir of midcentury music), Robert Rauschenberg (in his White Paintings phase), and Merce Cunningham (refugee from the high modernist dance of Martha Graham).[64] Gathering in a theatrical venue, these artists set their work side by side with as little (and yet as much) integration as the two terms in any metaphor. Such collisions and flows among media—*this* is what performance was coming to mean.

What, after all, *is* the medium of performance? Phrased this way, it almost feels like a trick question. We might as well ask, *What color is plaid?* Performance can only be what several media do—together and to each other—in a live and tensile display. Why else has this word, over the past half-century, come to serve—not as a stand-alone noun, but as the first half of many compound phrases: performance art, performance poetry, "performance theater," and so on?[65] In each case, "performance" unsettles its neighbor—sets it in motion. (In this sense, we might describe Cheryl Strayed and Earl Warren as two masters of "performance print.") This isn't exactly new: the theater has long been a meeting-ground for other arts—a "hypermedium," as Chiel Kattenbelt calls it, "a medium that can contain all media."[66] But at midcentury, this kind of hypermedial "performance" escaped the theater, and it soon pervaded American culture.

It shouldn't surprise us that confessionalism emerged during this heyday of hypermedial "performance." The confessional self, after all, is a complex thing—better conjured than represented, more triangu-

lated than found. The very "concept of mediation," writes John Guillory, "expresses an evolving understanding of the world (or human society) as too complex to be grasped or perceived whole (that is immediately), even if such a totality is theoretically conceivable."[67] For confessionalists, the self is exactly this sort of thing: sublimely elusive, but "theoretically conceivable"—and thus something to pursue through countless acts of mediation. *Here it is*, says the confessionalist, producing one poem, performing one bit, *but also here—and always elsewhere*. This pursuit may remind you of what Derrida calls *différance*, the endless deferral of full reference or meaning, but confessionalists never shared Derrida's irony toward the task. Instead, as media theorists Jay Bolter and Richard Grusin observe in their discussion of "digital hypermedia," confessionalists sought "the real by multiplying mediation so as to create a feeling of fullness, a satiety of experience which can be taken as reality."[68] Call it magical thinking, if you will, or sleight of hand, but confessionalists always aspired to foster such feelings. They promised their public a *self*, and they never set out to make promises they couldn't keep.

<p style="text-align:center">* * *</p>

But in a mediated age, maybe the truth itself is nothing but a tissue of broken promises. Guillory again:

> It would be difficult to imagine speaking without being able to revise one's speech, to try to put one's thoughts into more accurate or better language. The difference between what one means and what one says defines the mediation of words and sustains the enabling fiction that ideas exist. Or, to put this another way, the statement "no, that is not what I meant" is the necessary warrant for credibility in communication. . . .[69]

Confessional selfhood, likewise an "enabling fiction," is sustained not by identity, but by difference—the inevitable difference between what you are and what you confess. This difference does not mark confession as a failure; on the contrary, it is "the necessary warrant for [its] credibility." *No, that is not what I meant*, the confessionalist says, and so the act of confession goes on. This makes the confessionalist quite different from Jean-Jacques Rousseau who, in the preface to his *Confessions*, plays out a peculiar fantasy:

> Whenever the last trumpet shall sound, I will present myself before the
> sovereign judge with this book in my hand, and loudly proclaim, thus
> have I acted; these were my thoughts; such was I.[70]

Monumental certainty, each book a perfect double for its author: this is
something to which a confessionalist never aspires.

Perhaps this is why confessional poets produced, not autobiographi-
cal narratives exactly, but collections of life-vignettes. No other genre
of American poetry is more strongly associated with the poem-cycle:
John Berryman's *Dream Songs*; W. D. Snodgrass's *Heart's Needle*; Lowell's
Life Studies, Notebook, For Lizzie and Harriet, and *The Dolphin*; Anne
Sexton's long, segmented poem "The Double Image" and her books *All
My Pretty Ones* and *Live or Die*. Confessional poetry came to the public
not as a work, but as a network. The significance of any poem lay not in
itself, but in its connections. It always deferred to a grander order—be
it the poem-by-poem form of the cycle or the day-by-day progress of a
poet's life. So, quite against the critical norms of its day, the confessional
poem lacked all pretense to autonomy. Even these poets' resistance to
formal metrics was just part of this general rejection of the poem's au-
tonomy: "regularity [of form]," Lowell notes, "just seemed to ruin the
honesty of sentiment, and became rhetorical; it said, 'I'm a poem.'"[71]
What he needed was a poem that would stop announcing its poesy to
every stranger it met—maybe even one that stubbornly failed to become
a poem in the first place, or else refused to remain one for long.

If this was the aspiration, then it oddly resembled the caricature
drawn by some of confessional poetry's harshest critics. I'm thinking not
only of the immediate outcry that this poetry was "anti-poetic," but also
of the bizarre and enduring notion that a poem's poetics and its confes-
sionalism are related not in the way that any other form-and-content
pairing are, but as a kind of trade off, in inverse proportion to one an-
other.[72] Laurence Lerner offers a particularly cutting version of this cri-
tique in his essay "What Is Confessional Poetry?" when he excoriates
one deservedly obscure Lowell poem as "an instance where confessional
poetry becomes, quite simply, confession."[73] Indeed, the poem digs up
some details from Lowell's childhood and, with a barely stifled yawn,
puts them on the public record. It feels less like a poem than like some-

one's attempt to file for a patent on his life. But I'm not really interested in either trashing or defending this poem. What interests me is this: that Lerner's notion of the poem as "quite simply, confession" reveals that he and Lowell *share* an understanding of confession—or, at least, of its odd relationship to poetry. They both see a spectrum stretching from poetry on the one side to confession on the other, with confessional poetry perched (boldly or foolishly) in the middle. Wanting neither to submit to the strictures of poetic craft nor to revert to "mere confession" (a cliché on both sides of this debate), confessional poetry dwells in a no-man's-land.[74] It may mount forays "back into" one side or the other, as Lowell claims his "breakthrough" poems had done, but the confessional poem's ambivalent status and shifting position are key. Confessionalism is the endless rehearsal for a breakthrough.

The Art of the Breakthrough

A breakthrough back into life. I had tossed the phrase around for years—studied it, cited it, parsed it, and generally made much of it—but one day, for no particular reason, I heard it as if for the very first time. It carried a whiff of the outlaw—*a break-in to life?*—which might account for my sudden fascination, but on reflection I couldn't be sure I was right in hearing so much *violence* in this phrase. So, I did what any lover of language would do: I consulted the corpora.

The data told the tale. From utter obscurity, the word "breakthrough" sprang into public discourse in English over the course of 1939. It spiked in 1945, rose steadily through the 1950s, and has been ascendant ever since. Today, we speak nonstop about breakthroughs—technological, scientific, therapeutic, emotional, spiritual, or organizational—but, as you may have already guessed from the years listed above, it was, at first, a military term. It actually originated in the trench warfare of World War I, where it described the hard-won breach of an enemy line, but it entered the popular lexicon of English speakers only after World War II. Once a flurry of breakthroughs had ended that war (see the mid-1940s spike on the Ngram in Figure I.4), American soldiers brought "breakthrough" home alongside novelties like kamikaze, blockbuster, and flak.

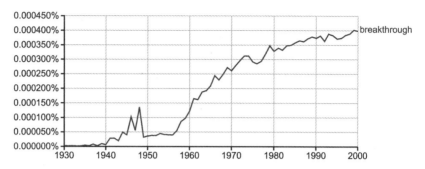

Figure I.4. American print usage of the word "breakthrough." Google Books Ngram Viewer.

If these words slid into metaphor over the ensuing years—shedding some or all of their wartime significance—they were helped along by the Cold War, which tended to render war itself a metaphor. To track the word "breakthrough" through any magazine or newspaper of the time is to witness, in slow motion, how the Cold War normalized an intangible, pervasive concept of war.[75] In *Time* magazine, for instance, you'll first see "breakthroughs" on the abstract fronts of a war without battlefields: as in "a strategic breakthrough in the cold war" or "a major research breakthrough" or "metallurgical breakthrough" in its arms race.[76] Then come the self-consciously elaborate conceits of war—e.g., "the biggest breakthrough in the long stalemated war against polio" or "the most promising breakthrough yet on the antibody front."[77] Finally, knowing puns creep in, as in the 1957 article about possible vaccines for the common cold called—yes, of course—"Cold War Breakthrough."[78] Only one or two years before Lowell's famous usage does the metaphor begin to go dead. And even then it still shows signs of life, since people mostly used it to describe advances in industry—the domestic front in the global war on communism.

Breakthrough was clearly, in this moment, a master metaphor, the perfect counterpart to another keyword of that era, "containment." This was the name famously given by George F. Kennan to America's Cold War strategy for stemming the spread of communism; it was also, according to Alan Nadel, a cultural logic of far-reaching consequence. American Cold War culture, Nadel argues, "equated containment of communism with containment of atomic secrets, of sexual license, of

gender roles, of nuclear energy, and of artistic expression."[79] It was, in short, a metaphor that Cold Warriors lived by. "Breakthrough," I suggest, is containment's natural complement—a world-shaping metaphor of equal and opposite force. The enemy must be contained; the white-hats, always breaking through! But Lowell and his ilk weren't exactly the white-hats. "I am kind of a secret beatnik hiding in the suburbs," Anne Sexton confessed in 1959.[80] And no matter how ideologically bland they may seem to us now, confessionalists saw themselves this way: as the enemy within, lurking in the suburban middle class, plotting a breakthrough past the forces of cultural containment.

This may seem like the long way around to interpreting a few words tossed off by a poet giving an interview—but if we restore to the word "breakthrough" its midcentury connotations of violent rupture from containment, then we can start to understand why people thrilled at (and recoiled from) confessionalism the way they did. Without accepting a boosterish view of such art or of its service on the cultural front of the Cold War, we can at least say this: confessionalists stuck their fingers in the wound of containment, reenacted the trauma of being contained and the triumph of breaking through.

* * *

This art of breakthrough drew energy from another postwar trend: the rise of what Daniel Belgrad calls a "culture of spontaneity":

> . . . the impulse to valorize spontaneous improvisation runs like a long thread through the cultural fabric of the period, appearing also in bebop jazz music, in modern dance and performance art, in ceramic sculpture, and in philosophical, psychological, and critical writings.[81]

Working in "media that responded quickly or easily to the impulse of the moment," many postwar artists and thinkers entered "into improvisational 'dialogue' with [their] materials."[82] Breakthrough artists were also involved in such dialogue, though usually with less responsive kinds of media. Printed text did not respond "quickly or easily" (or at all) "to the impulse of the moment." So, instead, confessionalists had to dramatize—either within these texts, or in their manner of performing them—a struggle against fixity and stagnation. Robert Lowell did

this by "mak[ing] little changes just impromptu as [he] read" his earliest confessional poems in public.[83] And by 1976, when Caedmon Records captured one of his readings live, these encrustations threatened to overwhelm his poems altogether. If this feels like a radical attack on the autonomy of these poems, well, that's because it is. *Of course, these poems aren't autonomous,* Lowell seems to be saying, *They emerged from my life, and they are emerging still.*

Donald Hall, expressing his distaste for Lowell's way of reading, reaches for a telling comparison: "I have heard Robert Lowell play his audience with the skill and vulgarity of Ed McMahon."[84] David Wojahn, in an essay dismissing poetry readings as "a kind of vaudeville," clarifies the reasons for such a complaint. While he praises one poet for a rambling lead-in to a poem whose "timing and phrasing are worthy of a stand-up comic's," he insists that such standup-style talk "should offer a counterpoint to the more special diction of the writer's poems." In other words, the glib spontaneity of standup comedy is fine, so long as it doesn't seep into the poems. These, Wojahn says, should stay "clear and precise," performed in a "neutral but not emotionless" manner.[85]

These queasy feelings of attraction and repulsion were mutual: poetry and comedy circled each other at midcentury, exchanging anxious glances. Comedy, for its part, went back and forth between wanting to claim the protections of kinship and wanting to disavow poetry as hopelessly square. Lenny Bruce, for example, did both. When he was first brought up on obscenity charges, it was in front of the same judge who, five years earlier, had handed down the famous ruling in favor of Ginsberg's *Howl*—and Bruce's lawyer, Al Bendich (who also argued the *Howl* case), called in experts to defend Bruce's act as a kind of poetry. One Berkeley professor, Don Geiger, even went so far as to read a John Berryman "dream song" into the record.[86] As Bruce, a self-taught expert in obscenity law, would know, this analogy was part of a sound legal strategy. Obscenity law, at the time, required that the local particulars of art—by themselves, perhaps, obscene—be justified by appeals to an aesthetic "totality" to which these details were essential. At the height of New Critical power, nothing epitomized this sort of "totality" better than a poem.

But these ideas of a stable, integrated "totality" couldn't be further from the truth of Bruce's practice. No matter how much he might rely on

(and repeat verbatim) a handful of well-crafted "bits," he identified most with those moments when his act went spontaneous. *Unlike comedy,* he would have scoffed, *poetry cannot achieve true spontaneity.* This, any-way, is the gist of one bit on his 1959 debut album, in which he skewers two of poetry's recent bids for spontaneous expression: confessional po-etry and "poetry and jazz." While a jazz combo plays in the background, Bruce recites (in doggerel verse) a mock confession to bestiality:

> Psychopathia sexualis:
> I'm in love with a horse that comes from Dallas.
> Poor neurotic-a me.[87]

It's easy to see why the performance genre of "poetry and jazz" earned Bruce's scorn. A bunch of squares were suddenly haunting the same jazz clubs he played, trying to mooch an air of hip spontaneity. One Bruce biographer, Albert Goldman, perhaps thinking of this bit, goes on his own rant against poetry and jazz, and he reveals the hidden stakes of this argument. "Jazz was one thing," Goldman observes, "Poetry another. Comedy was something in between."[88] In order to carve out this intermediate space, Bruce exaggerated the elasticity of jazz and the woodenness of poetry performance.

* * *

In mocking poetry's out-of-touch rigidity, Bruce was in fact acting out one of his own deepest nightmares: that he might be reduced to an unchanging text. This anxiety suffuses Bruce's most elaborate bit, the famous twenty-minute "Palladium" sketch. In it, a mediocre standup comedian named Frank Dell, feeling restless in his slow-growing Ameri-can career, strong-arms his manager into booking him into the variety lineup at London's famous Palladium Theatre. Although Dell clearly isn't the sort of guy with whom Bruce would *like* to identify, he does—in spite of himself. Not only that: Bruce goes out of his way to make Dell resemble him, plucking him from the same small-time world in which Bruce first honed his craft, giving Dell his own age and drug addiction, and generally encouraging the comparison. Don't get me wrong: it's not an image of who Bruce was, but it's a terrifying image of who he might have become.

Dell's act bombs during his debut at the Palladium, to the point where he must beg the theater's booking agent to give him a second chance. The next night, though, things only get worse: the act just before Dell's ends on a "moment of silence" for "the poor boys who went to Dunkirk and never came back." Amid a general rapture of tears, Dell begins—and repeats to his puffy-eyed audience the same corny opening line:

> Folks, a funny thing: I just got back from a delightful, crazy little town, a crazy, crazy place called *Lost Wages*. You know, folks, a funny thing about working *Lost Wages*, Nevada. . . .[89]

Not only are the words identical, but the tone is precisely the same two nights running: the polished smarm of a hopelessly fixed act. When Dell does force himself to try something new—shouting "SCREW THE IRISH!" in a last-ditch effort to get a response—he incites not laughter, but an all-out riot. He flees backstage where he's confronted by the theater's booker:

> Now look, son, I don't mind these boys—they come out, and they start with the same word every night, they finish with the same word, perhaps they're not too creative or funny, maybe—but goddamn, son, . . . there's a difference between not getting laughs and changing the architecture of the theater![90]

It's a perfect Freudian dream of discipline: deriding Dell for sticking to the script, but then damning him the second he dares to depart from it. John Limon, author of *Stand-Up Comedy in Theory*, would surely see this as an example of how Bruce stages "abjection," which Limon defines (via Julia Kristeva) as "a psychic worrying of those aspects of oneself that one cannot be rid of, that seem, but are not quite alienable."[91] It's not just that Bruce fears he can't rid himself of the small-time Dell within; it's also that his words, once fixed—whether by habit or transcription—feel like a horrific containment of the self.

<p style="text-align:center">* * *</p>

This nightmare would soon play out for Bruce in the criminal courts. In every city he played, district attorneys started sending police officers

to record or transcribe his act in hopes of substantiating a charge of obscenity against him. Nothing can fix a performance quite like the gaze of the law, which, besides preferring text to any other medium, always demands a stable object of complaint and defense. As Bruce put it in one of his final nightclub appearances,

> I do my act—perhaps, uh, eleven o'clock at night. Little do I know that eleven a.m. the next morning, before the grand jury somewhere, there's another guy [i.e., a police officer] doing my act, who's introduced as Lenny Bruce, in substance. *Here he is, Lenny Bruce!* (In substance.) . . . The grand jury watches him work, and they go, "That stinks!" But I get busted. And the irony is, I have to go to court and defend *his* act.[92]

Almost the entire ensuing performance (filmed and released as *The Lenny Bruce Performance Film*) is spent reading and commenting on the transcripts from one of these trials. It's a playful idea: the prosecutor's case, which naturally leaps from one salacious bit to the next, enables Bruce to do the same. (After all, surely the district attorney wasn't being obscene!) Meanwhile, Bruce gets to laugh along with the audience at the police and prosecutors, who, like a bunch of Frank Dells, crib his act and then butcher it before a stone-faced audience of judges. Not too far beneath the surface of this irony, though, is something darker and more sincere. As Bruce alternates between voicing the state's powerful words and rambling through his own powerless commentary on them, it almost feels as if he's trapped behind that sheaf of papers—not just in the literal sense, like a poet burying his face in a manuscript—but also in a more abject, figurative sense. When Bruce finally stopped appealing his convictions for obscenity, he gave this reason: "I don't want to win the right to do another comedian's act."[93] But here he was doing exactly that. The Lenny Bruce before our eyes can't quite seem to upstage that other guy: Lenny Bruce, in substance. Once a liberated and liberatory comedian, Bruce had allowed himself to be chained to this other Lenny—the one who seems, but never is quite alienable.

But ponder this: what if this dynamic isn't unique to a comedian's run-in with the law? After all, one lesson of "The Palladium" seems to be that these dangers inhere in performance itself. What Bruce is doing with that trial transcript is just an obvious (and dour) version of what

made his best performances whir—namely, the tension between the pleasures of repetition and the thrills of spontaneous digression. Spontaneity, after all, is valued not for itself, but for its departure from fixed conventions or forms.

This thrill, invoking a script only in order to break it, is captured perfectly by Albert Goldman in his breathless reconstruction of a typical Bruce performance. "Everybody knows this piece from the record," Goldman says of an unnamed "classic" sketch, but there's a kind of pleasure in hearing it repeated. "People are like children," Goldman muses, "They want to hear the same story in the same words over and over again."[94] However, the choicest pleasure—in comedy, if not in bedtime stories—lies in waiting for that moment of expansion or variation. This departure will feel like a moment of contact, of access to the comedian himself. Describing another well-known bit later in the performance, Goldman exclaims, "Suddenly the needle skitters off the record. Everybody knows this bit . . . [but] tonight there's more."[95] You go to a Bruce show, in other words, neither to hear spontaneous Bruce nor to hear him reproduce himself, but to witness as the copy gives way to the original. As Bruce's work went confessional, this play of freedom and constraint came to dramatize our access to Bruce's own, true self. Here he was—more than text, beyond the album—off the record, off script. Lenny Bruce was live and breaking through!

* * *

Comedians weren't alone in feeling that the texts they produced pinned them down like dried-out moths. Poets, too, in the age of the reading, could feel this same uncanny sense of entrapment. In fact, though much has been written about the shock of immediacy and liveness that readings introduced into poetry, it's as easy to say that readings introduced poets to feelings of mediation and deadness. Most poets now had a poem they simply dreaded repeating—one that went dead for them long ago, but that their audience continued to demand. In fact, every poem threatened to grow a bit of this deadness inside—so poets *had* to find a way to break through.

In 1965, Anne Sexton reached for a telling analogy when, on the eve of a ten-day reading tour, she wrote a letter of complaint to Elizabeth Bishop: "in the end," she wrote, "the 'reading' is a gastly [*sic*] sort of

show—an act such as a comedian has."[96] Just like Bruce, Sexton felt herself turning into Dell, reducing her poems into deathly things. Fortunately, like Bruce, she turned this pitfall into a source of creative energy and confessional spectacle.

It was that same year when Sexton unearthed an old poem, one she had considered including in her debut book, but which wound up at the bottom of a drawer. Back then, it was called "I Live in a Dollhouse," but as she polished it up for inclusion in her third book, she renamed it "Self in 1958." The poem would become a mainstay of her readings, and it's easy to see why. To perform this piece was to reflect on confessional art, which always must fathom the distance between past and present selves, dead texts and live performance. Her very presence, each time she performed this poem, would attest to the difference between a text and a self—between all textual selves and the self performed. *I may be in this text*, she's saying, *but I'm also beside and beyond it.* Like Lenny Bruce's transcript bit, Sexton's "Self in 1958" is the act of a breakthrough artist.

Once more, that sentence of M. L. Rosenthal's comes to mind—only now with a different emphasis: "The *use* of poetry for the most naked kind of confession grows apace in our day."[97] Understood as the art of breaking through, confessionalism is an ongoing experiment in the *use* of autobiography, whatever medium it may happen to inhabit at the moment. Here, in the cases of Bruce and Sexton, it's an unbound stack of typescript pages, but the same would hold true for any medium. The confessional performer is "the player of different media" and "acts in the empty spaces between [these] media."[98] Masters of media, they are inhabitants of none. They dwell in a no-man's-land, plotting a breakthrough back into life.

<p style="text-align:center">* * *</p>

This book's twin keywords, confession and performance, both permit—no, depend upon—such play across media. This sort of play has real consequences: outsourcing their irony to the "interpolated distance" of mediation itself, confessional performers free themselves for a certain tonal and philosophical sincerity.[99] We are often unprepared to hear just how sincere they are trying to be. The resulting blend of sincerity and irony is arguably the defining affect of American culture

since modernism. No one has given a better account of this affect than Shoshana Felman, who calls the people who experience it "Don Juans."

> Modern Don Juans, they know that *truth is only an act*. That is why they subvert the truth and do not promise it, but *promise themselves to it*.[100]

Acknowledging the importance of performance in a postmodern world, we need not succumb to the old antitheatrical notion that a world performed is a false, fallen one. After all, even the truth must be performed. So, why not commit ourselves to confession? Why not promise performance?

Interlude

The Unbearable Whiteness of Being Confessional

And here I must confess (and I imagine most of our contemporaries would confess the same thing) that I am green with envy of your kind of assurance. I feel that I could write in as much detail about my Uncle Artie, say—but what would be the significance? Nothing at all. . . . Whereas all you have to do is put down the names! And the fact that it seems significant, illustrative, American, etc., gives you, I think, the confidence you display. . . .

—Elizabeth Bishop to Robert Lowell, December 14, 1957[1]

. . . there is all the difference in the world, I'm afraid, between her [Anne Sexton's] kind of simplicity and that of *Life Studies*, her egocentricity that is simply that, and yours that has been—what would be the reverse of *sub*limated, I wonder— anyway, made intensely *interesting*, and painfully applicable to every reader.

—Elizabeth Bishop to Robert Lowell, May 19, 1960[2]

Whether she knew it or not, Elizabeth Bishop had stumbled onto some foundational questions about confessional art. Who can work with "confidence" in a confessional mode? Who, once they have done so, will be received by the public *as* confessional? More than that, who will be *celebrated* for confessing? Only Lowell, Bishop seems to believe. He has the "confidence" to write confessionally because his family is, of course, "significant" and his own life clearly "illustrative." Never would he stoop to an "egocentricity that is simply that"—instead, his confessions are "intensely *interesting*," and yet somehow "applicable to every

reader." Bishop expresses all this with an air of wonder, as if she couldn't quite fathom what natural law could explain such mysterious effects. It's no mystery to us now—and on the far side of civil rights, second-wave feminism, and identity politics of every sort, few would agree that there's anything natural about it. It's privilege in its purest form—straight, white, cis male, blue-blood Protestant privilege. This privilege was the source of Lowell's "assurance"—and of his audience's faith that his life would be "illustrative, American, etc." Lowell's privilege allowed him to strike a delicate balance—to seem both private and public, both personal and social, both unique and representative.

If you want to know how precarious a balance this was, try changing just one variable—say, the poet's gender. A woman was always at risk of losing her balance—of having her poems deemed *merely* private, *merely* personal, *merely* unique. This happened often to Anne Sexton, and perhaps this explains one of her persistent writerly habits. Sexton belongs, Bishop quipped, to "the 'our beautiful old silver' school of female writing"—women who "make quite sure that the reader is not going to mis-place them socially." A certain "nervousness" mars the writing of such women, Bishop observes, and "interferes constantly with what they think they'd like to say."[3] This "nervousness," precisely the opposite of Lowell's "assurance," is in Sexton's case a sign of how difficult it is for her to confess. As Lowell puts it, Bishop was one of "only three American writers of our generation who don't have to work."[4] (Lowell was another, and the third was Randall Jarrell.) Sexton was hardly so lucky. Haunted by *merely*, she clung tightly to what privilege she had as a member of the suburban middle class.

Subtract another variable from Sexton or Lowell, their whiteness, and it's suddenly unclear whether they ever would've been deemed "confessional" at all. A black Sexton or Lowell may never have wanted—or had the "assurance"—to write confessionally, but even if they had, the public may have ignored this intention completely. As Michael Nieto Garcia has argued,

> Not only do readers read a black author's autobiography as racially representative, racial relations and the representational expectations imposed on black subjects are also so much a part of personal experience that they become integral to one's story.[5]

Black life-writers, then, faced the opposite of Sexton's dilemma: whereas white women risked seeming merely private, merely personal, and merely unique, writers of color were in danger of coming across as merely public, merely social, and merely representative. Henry Louis Gates, Jr. has said of black literary traditions that they "posit both the individual 'I' of the Black author as well as the collective 'I' of the race."[6] In the 1950s and '60s, it was the privilege of white authors to focus on confession's "individual 'I.'" For black authors of that era, a "collective 'I'"—the "I" of witness and testimony—felt far more urgent. You can hear this first-person (singular only by grammar) in the public rhetoric of James Baldwin during those years. Giving a speech at the Cambridge Union in 1965, Baldwin, often a master of deeply personal expression, opted instead for the "collective 'I.'" "*I*—picked the cotton, and *I*—carried to market, and *I*—built the railroads under someone else's whip—for nothing. For nothing."[7] Each *I* rings out in that silent hall, carrying with it the echoes of an ancient oppression. Why, at that moment in history, would Baldwin have settled for anything less?

So, maybe we can add another question to Bishop's list: who, in the first place, would *want* to work confessionally? At midcentury—and in the early phases of each art form's confessional turn—the answer was pretty simple: white people. Deborah Nelson, writing about the relationship between privacy law and confessional poetry, has a theory about why this might be:

> Certainly, confessional poetry was nearly exclusively a white, middle-class, and even predominantly heterosexual genre, perhaps because white middle-class heterosexuals enjoyed the greatest expectation of privacy, and were therefore the most likely to experience its violation.[8]

Let me offer another theory, though: confessional poetry was essentially a genre of identity crisis and, as James Baldwin argues, these kinds of crises could startle only "white men, who believe the world is theirs and who, albeit unconsciously, expect the world to help them in the achievement of their identity."

> But the world does not do this—for anyone; the world is not interested in anyone's identity. And, therefore, the anguish which can overtake a

white man comes in the middle of his life, when he must make the almost inconceivable effort to divest himself of everything he has ever expected, or believed, when he must take himself apart and put himself together again, walking out of the world, into limbo, or into what certainly looks like limbo.[9]

At every stage of the process, then, confessionalism selects for privilege: for the people who are motivated to write this way, who feel confident in doing so, and who are then received and celebrated for it by the public. This is not to say that there were no confessionalists of color—or, at least, that there wouldn't be soon. It's just that they had a lot of trouble surmounting this genre's many barriers to entry.

The first confessionalists in each art form, then, tended to be white— but they also rebelled against limiting notions of whiteness. According to Deborah Nelson, when Robert Lowell wrote *Life Studies*, he was subverting not privacy *tout court*, but one form of it: what he calls in his most famous confessional poem "the hierarchic privacy / of Queen Victoria's century."[10] This culture of privacy, Nelson points out, was ethnically and socially distinct, motivated by "the WASP regard for personal privacy" and sustained (while it was) by "the allegiances of class."[11] This privacy belonged only to upper-class whites. Just like Lowell, Sexton and Plath attacked not privacy, per se, but a particular culture of privacy: the anxious culture of the white-flight suburbs. Compare two poems of theirs in which neighbors come to call, Sexton's "Self in 1958" and Sylvia Plath's "The Tour." A housewife, Sexton sighs in "Self in 1958," "should spring the door open in a wholesome disorder / and have no evidence of ruin or fears."[12] And, at first, this is precisely what Plath's speaker does, welcoming a "maiden aunt" into her home and revealing herself in a wholesome state of disorder. ("And I in slippers and housedress with no lipstick!" My word!)[13] Soon, though, the charm is broken, and we, in fact, see nothing else but her "ruin" and "fears." "It's a bit burnt-out," the woman says of her home, and she means it literally. Her furnace, she reports, "simply exploded one night, / It went up in smoke. / And that's why I have no hair, auntie, that's why I choke."[14] But although this speaker suffers, it isn't on her maiden aunt's account. She shoots right back at her guest—and at the (WASP, suburban) culture she represents. With all the relish of a host at a haunted house, she cackles, "Toddle on home to tea

now in your flat hat. / It'll be lemon tea for me, / Lemon tea and earwig biscuits—creepy-creepy."[15] Now, shoo—and you know what to do with your visions of "wholesome disorder" in the suburbs!

But such attacks on restrictive norms of whiteness grow hard to stomach when they seem to come at others' expense. As Marsha Bryant points out, the major confessional poets all "invoke dark figures to articulate the vexed enterprise of making a new kind of poetry"[16]—and, as Hilene Flanzbaum observes, they all claim for themselves a "metaphorical Jewishness," too.[17] In other words, finding their whiteness unbearable, these poets escape into the voices of racial and ethnic others. Lowell, in fact, goes even further in *Life Studies*, claiming queer and female voices, too. In his review of *Life Studies*, M. L. Rosenthal describes this book's four sections as "four intensifying waves of movement that smash at the reader's feelings and break repeatedly over his mind."[18] At the crash of each wave, Lowell gives voice to one of these others: "A Mad Negro Soldier Confined at Munich," a queer poet ("Words for Hart Crane"), and the battered wife of a drunkard ("To Speak of Woe That Is in Marriage"). These poems, written in the voices of others, speak in tones that Lowell never quite allows himself to use: they pulse with sexuality, sarcasm, and despair. Such feelings may feel absent from his other, more confessional poems, which seem delivered with a stiff upper lip, but in fact they reappear—as the repressed always seems to do. For instance, the first section ends with "A Mad Negro Soldier . . . ," a poem Bryant justly calls "Lowell's black-face run at baring his own mental illness."[19] He then begins the second section, the long prose memoir "91 Revere Street," with a long digression on the one non-WASP he knows of in his lineage. Major Mordecai Myers was, according to Lowell, "a dark man," "full-lipped," with an "almond eye"; indeed, he looked like "one of those Moorish-looking dons painted by his contemporary, [Francisco] Goya."[20] In similar fashion, the third section ends with a dramatic monologue, where Hart Crane speaks of his habit of "stalking sailors" and of the general "role / of homosexual" that he always plays.[21] In the fourth section, Lowell duly confesses to some crypto-homosexual feelings of his own, though he confines them to early childhood. "In the mornings I cuddled like a paramour / in my Grandfather's bed," he says in this section's second poem—then, in the third, "Grandpa! Have me, hold me, cherish me!"[22] Alternating between plausibly deniable persona

poems and undeniable eruptions of personal feeling, Lowell reveals the emotional charge that lurks within even his flattest poems. Don't you see? He can barely keep it in.

From today's political and theoretical vantage, we instantly see how destructive such identifications can be. Privileged poets identify with marginalized others only in order to credential their own feelings of angst and alienation, feelings they harbor in spite of (or, all the more, because of) their extraordinary privilege. This phenomenon persists throughout the history of white confessionalism, from Plath's confession, "I think I may well be a Jew," to Jewish performance artist Eleanor Antin's insistence that "my blackness [!] is the existential center of my work," to theater critics' insistence (and his own) that monologuist Spalding Gray was, in some elusive sense, basically "Jewish."[23] These artists may have had one good intention—to undermine toxic notions of whiteness—but they purchased this broader self-image at others' expense. After all, just an inch below the surface, these "confessional others" are nothing but damaging stereotypes: the suffering Jew, the crazy Negro, the hypersexualized homosexual, the dominated woman, etc.[24] This book, because it focuses on early confessional experiments in each art form, presents a lily-white view of confession. This image is real, if unsettling. The early history of confessionalism in each art form was full of straight, white artists—many of them filled with feelings of "margin envy," as they attacked their own straightness and whiteness through acts of "self-othering."[25]

This does not mean, however, that the structures and styles of confessionalism are themselves somehow inevitably "white." Proof to the contrary: Lowell's mix of personae and the personal in *Life Studies* resembles tactics used by the iconic black standup comedian Richard Pryor. Pryor's comedy wasn't always confessional. During the heyday of confessional poetry in the 1960s, he was already famous as a "winsome comedian in the mold of Bill Cosby"—inoffensive and impersonal.[26] In the late 1960s, though, he put this career on hold and reinvented himself as confessional. Says one Pryor biographer Scott Saul, "For him, the worm was turning: those parts of himself that had been buried, by shame or censorship, were now his creative fuel."[27] His comedy grew "intimate and conversational," dealt with the "facts of *his* life," and "radiated" "vulnerability and menace"—he had become, in a word, "confessional."[28] This

transformation took place in front of a new kind of audience—racially mixed, sometimes entirely black—but he soon brought this act back to majority-white audiences. And when he did, by some quirk of fate, a camera was there to catch it. A young director filmed the gig—nothing special, just a little something for his "sample reel"—and fourteen years later, at the height of Richard Pryor's celebrity, he rediscovered and released it under the title *Richard Pryor: Live and Smokin'*.[29] It's a stunning performance—and one that, like Lowell's *Life Studies*, carefully separates confessional affect from confession itself.

Pryor begins with a rapid-fire series of childhood stories, most of them telling how he came to understand the truth of racial and economic injustice. Cigarette in hand, he tells these stories with a deadpan demeanor, breaking the mask only a few times to chuckle nervously along with his crowd. In scattered moments, though, he seems to suddenly access a voice more desperate or more enraged than his own—at least as he's established it tonight.

> I remember tricks used to come through our neighborhood. That's where I first met white people. They'd come down through our neighborhood to help the economy. Nice white dudes, though—cuz I coulda been a bigot, you know what I mean? *I coulda been prejudiced!*
>
> I—I coulda been prejudiced. (*A single chuckle.*) I coulda been, man, but I met nice white men, just coming up, "Hello, little boy. Your mother home? I'd like a blowjob."[30]

This bit opens and closes in Pryor's established tone, but for an instant, it's as if he's trying on another voice. During the pause that I've transcribed as a paragraph break, he slowly scans the audience, seeming to take them in one at a time. Is he threatening them? Sizing up their reaction to his newfound voice? He repeats himself faintly, but no sooner has he finished this second effort than, with a nervous chuckle, he launches straight into his punch line. This happens repeatedly: more passionate voices get their moment, but always in a mood of experimentation.

Just when you think you've gotten the hang of this rhythm, though, Pryor launches into two full-blown characters, old standbys of his act by this point in his career: the Wino Preacher and Willie the Junkie. This night, he plays them without a trace of irony (and with almost no

deliberate laugh lines) for the last third of his forty-minute set. It's what anthropologist Dell Hymes calls a "breakthrough into performance"—sudden access to a fully theatrical, boldly stylized mode of behavior—but Pryor is only setting the stage, it turns out, for a breakthrough back into life.[31] As the Wino Preacher fades from view and the junkie's abject monologue goes on, getting less and less laughable as it does, something happens: the same affect that Pryor had been testing over the course of this performance pours out of him all at once. He reaches a depth of emotion—especially grief—that he hadn't allowed himself yet *in propria persona*. Or else, he collects in this abject soliloquy all the disavowed feeling from the rest of his act, setting confessional feelings safely to one side of his actual confessions. After forty minutes of push and pull between sincerity and self-consciousness, Pryor achieves the breakthrough he's been rehearsing. And like Lowell, he breaks through when he dares to let loose in the voice of another—dares to be, in other words, *beside himself.*

Confessional poets, the subject of Chapter 1, often appeared beside themselves—and, like Pryor, they made sense of this confounding experience through the repetitive act of live performance. For Pryor,

> The stage is the place where he can set his contradictions in motion and play the full array of his many selves. If he's having a good night—if the "comedy gods" smile upon him, if he finds his form—Richard Pryor can own all these personalities as much as they own him.[32]

The same can be said of the confessional poets: the stage was a place where they could finally collect themselves. Their poetry was not just "performative"—as so many literary critics are eager to argue—it was also quite literally something *to be performed*. Their ways of entangling performance in the poem—and then breathing it back from the printed page—are the subject of Chapter 1.

1

The Breath of a Poem

Confessional Print/Performance circa 1959

What did Robert Lowell smell like? Did Sylvia Plath wear perfume? And I know they say that vodka has no odor, but imagine you were sitting in the front row at an Anne Sexton reading: do you think you could smell the booze on her breath? Questions like these seem offensive to the literary sensibility. Poets aren't supposed to have smells because, by and large, they aren't supposed to have bodies. And, aside from the occasional frisson over the smell of old books or the feel of fine paper, neither are we readers supposed to have bodies—or make much use of them if we do. That strange ritual, the formal poetry reading, seems designed to enforce such prohibitions. Why else do our literary titans, asked to perform their authority, aspire instead to escape our notice—tucking their bodies behind podiums, dressing themselves like stagehands, and flattening their voices to a comforting drone? Why, for that matter, do they defer to the printed page, reading word by word poems that, in fact, they know by heart, by breath, and by gut? The poet, it seems, is just an onionskin overleaf—the mercifully thin barrier to a poem, not its conduit.

What happens, though, when the poet's self is not just the conduit, but (suddenly) the content of the poem as well? This is precisely what happened in midcentury America, when confessional poetry emerged side by side with a craze for poetry readings. Together, these two forces—confessionalism and the reading—conspired to make public creatures of poets, yoking the old *I* of lyric more tightly than ever to its living, breathing referent. If this were a coincidence, it would be a cruel one—to write such poems is one thing; to perform them in public, quite another—but we can't rightly say that the confessional poets were ambushed by their own publicity.[1] On the contrary, confessional poetry was from the start a performance genre, infused at every stage of its creation with the breath of the poet—and with a promise to perform.

Confessional poetry thus confounds any easy distinction between performance and the printed page. Poets who write under the pressure of the reading don't just look for perfection on the page—nor do they settle for creating a winsome "performance piece." Instead, they look to create rich interactions between page and performance. Peggy Phelan has recently asked that we attend more often and more closely to this space between literature and performance, what she calls (borrowing a term from Robert Frost) poetry's "oversound":

> What we need is *and*: close readings of performances and poems, more muscular math for calculating oversound, the thing not in the words, not in the melody, not in the dance, not in the meter. . . . If we lose the intimacy of the connection between literature and performance, we diminish something vital in and between them.[2]

Plath, Sexton, and Lowell—indeed, *all* confessional poets—dwell in what Phelan calls the *in and between*. Their poems encode past performances, capturing the breath of a once-living voice, and their readings (live and recorded) channel this breath. They breathe their poems (and past selves) back from the page. According to Diane Middlebrook, the confessional poets are united by "content, not technique," but these poets *do* share a technique: a way of putting their poems in motion, a strategy for playing *in and between* print and performance—in other words, an oversound.[3]

Any present-day reader—anyone shameless enough, that is, to risk being overheard—can begin to search for this oversound by simply reading a few of these poems aloud: testing their affordances, seeking their implied parameters, trying to discover "what it means for a life to say these words."[4] But if, like me, you want to approach this problem historically, you'll need something more than a text and some gusto. You'll need proof of what pushed these poems toward performance, evidence of their journey from the page to the podium, and a rich sense of how they were actually enacted: with what style, by what strategy, amid what norms of reception. In other words, you'll need the kinds of evidence that performance scholars routinely amass.

Few poets have gotten this treatment. Two decades ago, Charles Bernstein announced his ambition "to integrate the modern history of poetry into a more general history of performance art."[5] A whole subfield

of poetry studies, sound criticism, was born to answer Bernstein's call, but it has tended to focus on a rather narrow canon. One contributor to each of this subfield's leading books names the same "wide range" of relevant poets: "Charles Olson to Allen Ginsberg," "Allen Ginsberg to Robert Creeley," that is, the Beats to the Black Mountain poets.[6] (Why not Anne Sexton to Amiri Baraka—or John Cage to Percy Dovetonsils?) Even by a more generous definition of the field—say, the poets featured on PennSound, a website Bernstein co-founded—sound criticism's canon has been limited to the avant-garde mostly, joined by a smattering of general high-brow verse. Scholars like Lesley Wheeler, Derek Furr, Tyler Hoffman, and Raphael Allison have begun to expand the canon of poetry performance, covering a broader and less homogenous range of poets. In this chapter, I build on this work by taking the confessional poets—middlebrow literary celebrities, some would say—quite seriously as performers and subjects for sound criticism.

These poets should be essential to any story we tell about poetry's midcentury turn to performance. Not only were their poems deeply shaped by (and aimed toward) performance; they also muddied the distinction between art and life, treating even the most page-bound poem as a worldly event—or, at least, as a trace of a life truly lived. Before they were through, poetry readings were presumed confessional—something "to be staged primarily as a theatrical performance of *exposure*," in the words of Kamran Javadizadeh.[7] Slipping from the page to performance and back—and leaving all sorts of traces in between—poetry went manifold, channeling newfangled powers and gaining all kinds of strange new dimensions.

The Dimensions of the Midcentury Poem

Our private senses are not closed systems but are endlessly translated into each other in that experience we call consciousness. . . . Our [media] technologies, like our private senses, now demand an interplay and ratio. . . .
—Marshall McLuhan, *The Gutenberg Galaxy*[8]

Marshall McLuhan surrendered these words to print in 1962, and at that moment few American art forms answered his call for "interplay" quite so

well as poetry. Beginning in the 1950s, and with increasing fervor through-out the 1960s, poetry lived (with promiscuous simultaneity) in print, on vinyl, and in the heat of live performance. Caedmon Records, the first mass-market label devoted entirely to literature, was founded in 1952, and other labels soon followed, each one clamoring to capture the voices of every sort of poet. At the same time, the demand for live poetry readings exploded. Once the prerogative of few poets—exceptional performers or literary stars—readings were now expected of all poets, no matter their standing in the profession, no matter their skill (or special interest) in performance. For a short time, then, performance—captured on LPs and repeated at readings—rivaled print as poetry's main mode of circulation.

This would quickly transform poetry criticism—well, at least the *New York Times* thought so in 1956:

> One thing these Caedmon records are bound to do is to alter the course of future scholarship. . . . [C]ritics of the future (Freudian, New and se-mantic) will have a high time pondering slurred words, dropped lines and changed rhythms. And the House of Caedmon will rank with the Domesday Book . . . as prime source material for doctoral theses.[9]

The future is finally here: poetry scholars, Marit MacArthur chief among them, are now using linguistics software to parse poetry recordings en masse, and if "slurred words" aren't yet on anyone's docket, well, it's only a matter of time—but this future came slowly and unevenly.[10] Only in the past few decades have poetry scholars begun to show much interest in readings, live or recorded, which is odd when you think that so many live readings have happened on college campuses—and that recorded-lit LPs were marketed primarily for classroom use. Many scholars must have listened to poetry LPs, but few left any record of what they heard. They surely attended readings, too, but somehow without attending *to* them. Thin descriptions of live readings may crop up around the edges of midcentury memoir—the way any irrelevancy might—but thick descriptions are pretty thin on the ground.

Even when scholars did take an interest in readings, they tended to treat them as purely sonic events. Just look at the titles of most arti-cles and books on the subject: to this day, most of them center around keywords like "sound," "voice," and (audio) "recordings." Embodied

performance was—and, with a few happy exceptions like Raphael Allison's *Bodies on the Line*, still *is*—beyond the pale of poetry criticism.[11] Charles Bernstein, for instance, urged scholars to focus on "*aurality* . . . the sounding of the *writing*," and not on "*orality* with its emphasis on breath, voice, and speech."[12] And even when critics began to defy this rule and consider embodied performance, they often veered into dry dissection. Lesley Wheeler, for instance, announces her intention to treat poetic voice as "a bodily phenomenon," but then quickly whips out her scalpel and saw: "In order to speak, an individual pushes air from her lungs through her vocal cords, which are muscular folds in the larynx," etc. Then, "In a listener . . . complex mechanisms in the ear and brain translate these speech sounds into perception through neural signals."[13] In other words, poetry readings are where ear/brain combines go to absorb the compressed air of lung/larynx/tongue cooperatives—or, more to the point, where poets and their audiences admit to having bodies only when it will help them enjoy the "sounding of the *writing*." Anatomical litanies like Wheeler's are, in fact, common when sound critics wish to dispatch with the body quickly. See Bernstein: "Aurality is connected to the body—what the mouth and tongue and vocal chords [*sic*] enact—not the presence of the poet."[14] There's more to a body, though, than its respiratory tract. Once we acknowledge this fact, can we believe anymore in the bright line Bernstein draws between bodies and "presence"? I would call this splitting hairs—if the scalp weren't out of bounds.

But Charles Bernstein was hardly the first one to strip the writer's voice of its body. His midcentury counterparts were doing the same thing. In *The Program Era*, Mark McGurl tells the story of the "Voice Project," a creative writing program at Stanford devised and run in the 1960s by the novelist John Hawkes. In one exercise, a student was asked to record herself speaking, then "listen to her recorded speaking voice, . . . asking herself how her text might better embody her voice."[15] Recording technology literally separated the voice from the body, making it available for study and reflection. But, to my ear, there's something off about this notion: that what a voice gains in being extracted from the body is embodiment—in a text.

For an opposing view, look no further than the folks who made their living recording writers. Lee Anderson, a poet whose many recordings

of other poets provided the basis for the Yale Series of Recorded Poets (YSRP), never wished to flatten a voice into mere "sounding of the *writing.*" Instead, he wanted his records to foster a feeling of intimacy and, yes, presence. In sales brochures for the YSRP, Anderson is portrayed as some kind of ethnographer, capturing poets in their natural state:

> A poet is not a machine which, at the touch of a button, will unerringly produce the nuances and emotional overtones of the lines he has composed. . . . For such reasons, Mr. Anderson took his recorder "into the field"—to the homes of the poets, to the living room, the garden, or some other place where leisurely conversation could create an atmosphere of relaxation. . . . In the background, at times, faint noises from the outer world provide an almost imperceptible but nevertheless enlivening undertone.[16]

He cultivated these "overtones" and "undertones" (what Phelan might call the poetry's "oversound") by treating these sessions at the mic as if they were sessions on the Freudian divan. Before agreeing to record any poet, Anderson insisted on an "acquaintance [with the poet] over a period of time." Only then, he insisted, would he be able to foster in them the "relaxed yet vulnerable attention needed to get the best reading possible."[17] Caedmon Records, a label that specialized in cleaner studio recordings, strove for this same sense of intimacy. Hoping to foster a poet's "connectedness . . . to all subsequent listeners," Caedmon's founders performed the role of audience themselves. "Highly responsive, caring," they sat right there in the studio during every take.[18] Just like Anderson, they wanted to capture on tape and etch into vinyl something more than mere textuality. They wanted to find what they called, in Caedmon's most famous slogan, "A Third Dimension for the Printed Page."

To understand poetry in the age of the reading, we must begin by believing in this third dimension. We must admit that we are interested not only in recordings, but also in the events that they record—even if that event is only a studio session. We need not reach for new kinds of evidence right away; we can start by approaching the old stuff in new ways, using performance theory as our guide. Performance theorists used to argue that performance is ephemeral and, thus, eludes the archive en-

tirely. Now the opposite argument is common: performance is ephemeral and so it fills the archive with ephemera for us to study. Performance theorist José Muñoz has defined ephemera as "anti-evidence"—"traces, glimmers, residues," a "kind of evidence of what has transpired but certainly not the thing itself."[19] Literary scholars are too used to beholding "the thing itself," an authorized text between their hands. Deny yourself that feeling for a while, and whole new horizons will open up to you. Even poems on the page will have more to offer the scholar who treats them as "traces, glimmers, residues" of an embodied event.

We must give the voice its body back—even if only in our critical imaginations. Ironically, my guiding spirits as I do this will be two of sound critics' favorite subjects: Charles Olson and Allen Ginsberg. In a famous 1950 essay called "Projective Verse," Olson led the would-be poet

> . . . down through the workings of his own throat to that place where breath comes from, where breath has its beginnings, where drama has to come from.[20]

Olson's "breath" reaches deeper and radiates further than any "aural" dissectionist would venture. Both visceral and ethereal, "breath" describes, for me, the tensile play between words and bodies, print and performance. Charles Olson openly disdained the confessional poets, and they, for their part, despised him, but that's hardly the point: if we want to grasp the full scale of poetry's performative turn at midcentury, we need to look past mere factional skirmishes like these.[21] In the case of Ginsberg, though, we don't even need to do that. Just listen and you'll hear it everywhere: the confessional poets had more friends than foes among the Beats.

Secret Beatniks

I am kind of a secret beatnik hiding in the suburbs in my
square house on a dull street.
—Anne Sexton[22]

Anne Sexton wrote these words in a letter dated April 1, 1959. In it, she calls herself "the most about to be published poet around," and, though

it may sound like hyperbole, it was probably true. Thanks to a rapid-fire volley of submissions, a whole slew of her poems were coming out—and so was she, as a "secret beatnik."[23] If she were truly a "beatnik," I can understand why she'd want to keep this identity a secret. After all, beatniks were a walking checklist of everything McCarthyite America feared the most. To find one "hiding" anywhere—let alone in the suburbs—would worry many a fine, upstanding citizen. But now the secret was about to get out. Her poetry was just "so controversial," she fretted, "NO ONE WILL LIKE IT." But what really made her anxious was the task of living up to these poems once they were published: "my writing has guts," she confided, "but I do not."[24]

Thankfully, Sexton was hardly alone in this act of cultural brinkmanship. As she explains in the same letter,

> Cal and Snodsy both have books appearing this April. Tho I haven't seen Cal's, I hear it is full of personal poetry and think that he is either copying me or that I'm copying him (tho I haven't seen his new stuff) or that we are both copying Snodsy![25]

The title poem of *Heart's Needle* by W. D. Snodgrass ("Snodsy") was notable for dealing frankly with the poet's recent divorce and subsequent estrangement from his daughter—taboo topics, all. And Sexton is right: *Heart's Needle* probably did influence Robert Lowell ("Cal"), who would have read some of these poems while teaching Snodgrass at the Iowa Writer's Workshop in 1953.[26] Now Lowell was publishing his own personal poems in a book called *Life Studies*, which would lend real stature to the genre seeing as Lowell was widely considered to be America's leading poet. Lowell had made his reputation by writing in a dense, involuted style on political and religious themes. Now, he was writing in a conversational mode (and even in prose) about the unflattering minutiae of his own life. As Lee Anderson puts it, "The parallels are not exact, but . . . if Eliot after the *Four Quartets* began to sound like Allen Ginsberg, then we have a comparative shock."[27] Confessional poetry, in other words, marked a grand coming out for all of the "secret beatniks" on the American literary scene.

Believe it or not, Lowell would have agreed with that statement: from the start, he thought of his new, confessional style as indebted to the

Beats, a moderate version of their radical poetics. In the acceptance speech he gave upon receiving the National Book Award for *Life Studies*, he claimed to "hang on a question mark" between two factions in American poetry, "a cooked and a raw."

> The cooked, marvelously expert, often seems laboriously concocted to be tasted and digested by the graduate seminar. The raw, huge blood-dripping gobbets of unseasoned experience are dished up for midnight listeners. There is a poetry that can only be studied, and a poetry that can only be declaimed, a poetry of pedantry, and a poetry of scandal.[28]

Years later, he would still declare at readings—with obvious pride, if also with a bit of a smirk on his face—that "the Beat poet Allen Ginsberg . . . seems to regard me as a Beat manqué."[29] It's easy to imagine how his audiences would titter—and Beats, guffaw—at the thought that there was even one ounce of the beatnik in this marble-mouthed scion of Boston Brahmins, but Lowell seems quite earnest in wanting to affiliate with them. While he derides the "raw" poet's skill with words, citing James Baldwin's quip that they "are as inarticulate as our statesmen," he worries more about the fate of the "cooked" poet, whose entire mode of production, he fears, is dying off: "the modern world has destroyed the intelligent poet's audience," he warns, and has "given him students" instead.[30]

Indeed, in the decade before *Life Studies* came out, poets were increasingly installed as teachers in university classrooms, a trend that steeped them in literary criticism and precipitated, Lowell believed, a crisis in poetic style. Criticism and the classroom had sapped poets of their "boldness," he said. Their poems were "forbidding," staving off any but the most intrepid readers—they were "clotted," hardening like a scab upon exposure to the world beyond the seminar table.[31] As Lowell summed things up in 1961,

> The writing seems divorced from culture. . . . [It] can't handle much experience. It's become a craft, purely a craft, and there must be some breakthrough back into life.[32]

What revealed this crisis to Lowell was the practical experience of trying to perform his poems—or, in other words, his attempt to circulate

these poems the way a "raw" poet would. (Remember, "cooked" poets have midday readers—worse: students!—while "raw" poets have hungry "midnight listeners.") Lowell again:

> I'd been doing a lot of reading aloud. I went on a trip to the West Coast and read at least once a day and sometimes twice for fourteen days, and more and more I found I was simplifying my poems. . . . I'd make little changes just impromptu as I read.[33]

Finding himself in front of West Coast audiences—people more used to Allen Ginsberg than Allen Tate—Lowell realized that if he didn't ditch his old, forbidding style, then he was "cooked." And by recycling "raw" performance edits into his overcooked poems, Lowell began to aim instead for a bloody-centered medium-rare.

Anne Sexton and Sylvia Plath, the other poets most associated with the early days of confessional poetry, also harbored deep commitments to oral performance—though theirs were, at first, more private than Lowell's. Sexton's longtime friend Maxine Kumin later recalled how, in the workshop where both of them launched their careers, students shared their poems by reading them aloud. Their friendship, begun in this workshop, continued on the telephone:

> . . . they both had special phones installed at their desks and used them through the day to check out drafts of poems. "We sometimes connected with a phone call and kept the line linked for hours at a stretch," Kumin remembered.[34]

Weeks would pass—and so would draft after draft—before a typescript poem would replace these telephonic performances.[35]

For Plath, performance was more than a stage in her writing process: it verged on a poetic religion. In the fall of 1958, she vowed to make "reading aloud an hour" a part of her daily regimen.[36] She later justified this practice as "a way to feel on my tongue what I admire," but she wanted something more from her reading than the mouth-feel of excellent verse.[37] She wanted that feeling of ritual transcendence that only oral performance could provide:

Read pound [*sic*] aloud and was rapt. A religious power given by memorizing. . . . Best to read them in the morning first thing, review over lunch and catechize at tea. . . . The irrefutable, implacable, uncounted uncontrived line.[38]

She had long subjected her own poems, as she wrote them, to this kind of catechism. When she first discovered, to her delight, that some of her poems had "an aura of mystic power," she resolved (prefiguring the language of her Poundian creed) to "Say them aloud always. Make them irrefutable."[39] Her reasons for doing so were the same as Lowell's: to resist the "cooked" norms of academic verse culture. The poems she vowed to say aloud were, she says, "Very physical in the sense that worlds are bodied forth in my words, not stated in abstractions, or denotative wit on three clear levels."[40] Years later, rejecting academic approaches to Yeats, she vowed in similar terms "to read his poems through aloud. Read only the great poets: let their voices live in my ear & not the dregs & academic twiddle & pish of the young grey-flannel suit poets."[41] These were the forces of refutation—the people against whom she made her poems "irrefutable." "Grey-flannel suit poets," the most cooked-through men imaginable, were ruling the roost, and only a full-bodied performance could scare them off.

Although such private performances were always crucial to Plath's practice, it was only with *Ariel*, her last and most confessional book, that performance surpassed print as her poetry's true medium. This may seem like an odd thing to say about a book published posthumously, but Plath herself was adamant on the point. Speaking in 1962 about the *Ariel* poems, Plath insisted, "I've got to say them, I speak them to myself, . . . whatever lucidity they may have comes from the fact that I say them myself, I say them aloud."[42] Even in the act of describing her drive toward performance, Plath falls into the old rhythms of catechism: "I've got to say them . . . I speak them . . . I say them . . . I say them." *And, as I do, I make them irrefutable.* Poetry critic A. Alvarez, a close friend and strong champion of Plath, recalls his first encounter with *Ariel*: Plath forbade him to lay hands on the typescript until she had read every poem out loud to him herself.[43] If it weren't for the money and the fame books bring, it's not clear that Plath would ever have pub-

lished at all—or, as she once put it, "mummif[ied her poems] in print."[44] Only in performance could she hope for her words to body forth worlds. Only in performance, for that matter, could Sexton and Lowell hope to body forth their lives.

Breath and the Poem

We think and speak rhythmically all the time, each phrasing,
piece of speech, metrically equivalent to what we have to say
emotionally.
—Allen Ginsberg, letter to Richard Eberhart, 1956[45]

Close reading, they showed, means knowing when to breathe.
—Joseph Roach, on his training in oral interpretation[46]

Plath's devotion to performance must have begun in childhood, with her training in the oral interpretation of literature.[47] This discipline was descended from old-style elocution, but was now professional-ized and taught in university schools of speech and communications. Sharing facilities with, say, courses in radio announcing—and pushing back against emerging drama departments—oral interpretation tried to codify a simple, untheatrical style of literary performance, which they called "neutral." Chloe Armstrong and Paul Brandes, authors of the 1963 textbook *The Oral Interpretation of Literature*, begin with an epigraph from Harold Osborne:

> There is no conceivable way in which the experience communicated by
> an artist in a work of art can be "told" by any one person to any other
> person except by pointing silently to that work of art in which the experi-
> ence is embodied.[48]

"This book," they add, extending Osborne's image, "is concerned with pointing silently to the art that is embodied in literature"—quite an odd thing to say at the beginning of a how-to book on oral performance.[49] They aspire for their students to speak in a voice that is no voice at all:

the voice of text itself. This "neutral" ideal is the baseline against which we should judge any performance of literature in midcentury America.

At the same time, though, a new wave of oral interpreters was surging, and they would soon break free of the old restrictions. Don Geiger, a professor of oral interpretation at UC Berkeley, was the most outspoken of these new barbarians. He had no patience for the idea of "neutrality":

> [O]ne of the most misleading of all oral readings is a "neutral" one. . . . Actually, by reading "neutrally" that which snarls and smiles . . . the reader probably suggests largely that all literature was written by the same listless author.[50]

Instead of teaching students a strict, minimalist style, Geiger recommends "carrying the student 'beyond' analysis" and into the full-bodied power of performance. Instead of teaching diction and posture, we must "simply hope that [the student's] slouch and garble will disappear with the text-directed seizure."[51]

To understand the sound and feel of a "text-directed seizure," it might help to look across the Bay from Geiger's classroom to the coffee shops, clubs, and galleries where Beat poets, including Ginsberg, were then performing their poems. A Ginsberg reading would lure no one into believing that these poems were written by "the same listless author" as any other. His poems "snarl and smile" (and coax, and weep) and so does Ginsberg—as his album *Howl and Other Poems* attests.[52] That album's strongest "seizure" is the "Footnote to Howl," a litany of blessings that begins with fifteen straight cries of "Holy!" before proceeding:

> The world is holy! The soul is holy! The skin is holy! The nose is holy!
> The tongue and cock and hand and asshole holy![53]

This wave of blessing engulfs nearly everything, the grand right along with the grotesque. The line's true meaning, though, enters as a sonic effect. Near-assonance (world/holy) develops into near-rhyme (soul/holy), and then is subsumed into a bass-line hum of nasals (ski*n*, *n*ose, to*n*gue, ha*n*d, a*n*d) and a rising spray of unvoiced

consonants (*skin*, *tongue*, *cock*). This tracks Ginsberg's mental move from the ethereal (the soul, vocalic breath—the two original meanings of the word *psyche*) to the visceral (flesh: humming in the nose, sinewy with the work of consonants). But just when this progression reaches its nadir, an echo rings out like a foreshock (hand and) and, all of a sudden, what might have been our crash-landing into the grotesque rises instead into an effect beyond rhyme (-hole holy!), a ululation that links the low to the high—that makes the asshole, in fact, the truest site of all that is holy. Extend this mode of reading to every line of the poem, and you'll be ready for a "neutral" reading of the poem—letting the words, as they say, speak for themselves.

And yet the words *don't* speak for themselves. In fact, this way of reading would get the poem precisely wrong. In order to see why, we must ask a further question: what does the poem *do* to (and through) the body that performs it? On the page, the "Footnote" looks like an exuberant praise-song, and nothing in our "neutral" reading would convince us otherwise, but nothing could be further from the truth embodied in Ginsberg's performance. Celebratory this "Footnote" is not, and perhaps practical considerations should have given this away. After all, fifteen cries of "Holy!" are hard to perform in tones of escalating exuberance. Ginsberg never tries. Instead, in the 1959 studio recording, he uses these fifteen cries to induce a tearful panic, taking advantage of that old actor's trick: each "H" a heaving breath, which, repeated enough times, triggers emotions, or at least their appearance. Seized by this physically induced panic attack, Ginsberg then uses the poem to talk himself back to peace. The *holies* continue, but the poetic lines (and thus the breaths) get longer and smoother until he returns at last to a state of calm. Geiger would urge each of his students to work "toward a performance involving his own organic reactions," and that is just what Ginsberg has done.[54]

Place the "Footnote" in its full ritual context, and this reading of the poem is even harder to ignore. "Howl" ends with two sections that help create the panic attack that the "Footnote" must assuage. The first decries the evils of "Moloch," a figure for capitalist-industrial power, but also for the despair it instills in its victims. The final section expresses empathy for a poor, insane friend: "fifty more shocks will never return your soul to its body again."[55] The poem has taught us whom to blame for

this friend's madness: "Moloch in whom I am consciousness without a body!"[56] We needn't hear the holy H's of the "Footnote," then, as a mere theatrical trick. They simply give Ginsberg the chance to channel the sobs that the finale of "Howl" had already drawn out of him. The poem's *holies* are born not from ecstasy, but from a feeling of desperate precarity. The cry of "holy!" is, in other words, more truly a howl than anything in the poem it concludes—a clawing attempt to carve out space for something holy, a performative call to bring the holy into being. It sounds like Ginsberg has finally succeeded when, late in the poem, he reaches this run-on line:

> Holy time in eternity holy eternity in time holy the clocks in space
> holy the fourth dimension holy the fifth International holy the
> Angel in Moloch![57]

Long and unpunctuated, the line mimics the flattened calm of Ginsberg's voice in performance, having reached a state where he can bless even Moloch. One last bout of despair will erupt, like that last fit of crying that comes just when you thought tears had passed—"Holy forgiveness! mercy! charity! faith! Holy! Ours! bodies! suffering! magnanimity!"— but a final long breath will return him to peace: "Holy the supernatural extra brilliant intelligent kindness of the soul."[58] None of this is clear unless we've considered a bit more than the poem's themes and phonemes: namely, its power to shape the breath of the poet and, through his breath, his body, its motions and emotions.[59]

<p style="text-align:center">* * *</p>

Read this way, the confessional poems of Lowell's *Life Studies* reveal a recurring breath-pattern, and thus a repeated structure of feeling. With long, slow breaths, he surveys the facts of his life, the texture of distant memory. His lines hiccup, his breath roughens around objects—the lost, loaded *things* of his past. Then, at some climactic moment—where any connoisseur of Lowell's poetry might expect a gnarl of syntax or imagery—we get instead bluntness, dullness, and above all cliché: found language or understatement. These textual failures—"I feel awful," "We are all old-timers," "My mind's not right" (and, in his next book,

simple ellipses)—emerge not only at the height of each poem, but also, he claimed, at the end of his writing process.[60] When one interviewer asked Lowell about his tendency to include "an idiom or a very common phrase . . . to bear more meaning than it's customarily asked to bear," Lowell responded, "They come later because they don't prove much in themselves, and they often replace something that's much more formal and worked up."[61] Like those off-the-cuff revisions of his poems he made while touring his act through Beat country, these measured acts of destructive revision—placing inadequacy where we expected an epiphany—open a space for more meaning to emerge in performance than is evident (at first glance, anyway) on the page.

Each of the poems about the death of Lowell's father follows this pattern, but, for the sake of argument, consider "Terminal Days at Beverly Farms." For most of the poem, Lowell has drawled through a series of reminiscences—literally drawled, a habit he got from his southern mentors (e.g., John Crowe Ransom) and that he seemed to associate with nonchalant, intellectual chat. In the last two stanzas, though, Lowell disrupts this lolling calm.

> Each morning at eight-thirty,
> Inattentive and beaming,
> Loaded with his "calc" and "trig" books,
> His clipper ship statistics,
> And his ivory slide rule,
> Father stole off with the *Chevie*
> To loaf in the Maritime Museum at Salem.
> He called the curator
> "the commander of the Swiss Navy."
>
> Father's death was abrupt and unprotesting.
> His vision was still twenty-twenty.
> After a morning of anxious, repetitive smiling,
> His last words to Mother were:
> "I feel awful."[62]

In a recording of this poem released almost simultaneously with the book *Life Studies*, Lowell's voice gains a sudden rhythmic urgency at

the start of this excerpt.[63] The volume even increases over the first four lines as if he suddenly leaned in toward the microphone. Close-mic'd, his voice betrays the ragged breathing these lines draw out of him—a breakthrough past mere porchfront chat. In fact, he speaks the first two lines with a breath more stiff and stifled than the punctuation would even seem to allow, adding each few words like a correction or an addendum, slowly crowding in more and more information. (This is Lowell's medium-rare version of Ginsberg's raw holies.) Beginning to list his father's things, Lowell's voice broadens at each new object—each line prolonging this stanza a bit further, delaying what he knows must come by poem's end.

Breathless from this catalogue, Lowell tries one more delay, repeating his father's lame joke in the tone of a man defeated—by this stanza, at least, if not entirely by life. And yet this line's proper wit restores a bit of his self-possession—not the drawling calm of earlier stanzas, but at least the stiff-upper-lip control of the Boston Brahmin. It's as if all the anger and anxiety he feels over his father's death has been crowded out of the poem's final moments and displaced onto this silly little story about the Maritime Museum. The final line, though, completes the signature Lowell performance. "I feel awful," allegedly his father's dying words, gives the poem its anticlimax. But despite the line's blandness—and despite the restraint we thought we just heard Lowell achieve—his delivery of the line turns almost mawkish. He swallows the phrase—chokes on it, nearly. M. L. Rosenthal wrote in his review of *Life Studies* that Lowell "cannot breathe without these confessions," but what's clear when you read these poems as events, or actually hear them performed by Lowell, is the fact that he can barely breathe his way through them at all—not because the poem fills him up with fresh feeling each time, but because, like Ginsberg, Lowell has written into the poem a breath-pattern that helps him conjure this kind of emotion.[64] What might, on the page, look wry or resigned becomes, in performance, a poem of barely repressed outrage—at his father's unpoetical life (and death) and at Lowell's own absurd struggle to do it justice on the page. This truth about the poem lies not in the text—and certainly not in any "neutral" voicing of the poem—but in the interplay of text, voice, and body: what I'm calling the breath of this poem.

Embarrassing Literature

[The oral interpreter's manuscript] alerts . . . the audience
that the emotions presented are not in reality those of the
person standing before them. Realizing this they can re-
spond without embarrassment.
—Charlotte Lee, *Oral Interpretation* (1965)[65]

A reading like Lowell's can embarrass its audience—not by failing to stay
"neutral," but by refusing to distinguish between the poem and the poet
standing (literally, in this case) right behind it. To be embarrassed is to
know with painful clarity precisely where you are: in a blushing body, in
the gaze of others, in an uneasy social context. This kind of clarity, says
theater theorist Nicholas Ridout, is the essential "predicament" of modern
spectators, who often find themselves caught between art's pretensions
of distance from them and their own experience of intimacy with it.
Recalling a performance where an actor locked eyes with him and
addressed him directly, Ridout confesses he felt "embarrassed because at
precisely this moment the utter foolishness of the theatrical contract . . .
overwhelm[ed] me. . . . The whole edifice of theatrical representation
collapse[d], and [it was] my fault . . . for going along with the project."[66]
Reuben Brower—not thinking of the confessional poets, who as yet did
not exist, but nonetheless describing them rather well—reached for the
same image (and emotion) as Ridout:

> The voice we hear in a lyric, however piercingly real, is not Keats's or
> Shakespeare's; or if it seems to be . . . we are embarrassed and thrown off
> as if an actor had stopped and spoken to the audience in his own person.[67]

At a confessional reading, it almost goes without saying, this is precisely
what happens. Only a paper-thin pretense would keep us from acknowl-
edging this fact. Once we do, what collapses is the guiding assumption
of the poem's autonomy—from the poet, from the audience, and most of
all from the act of performance. A poetry reading, according to polemi-
cists on the subject, should offer its audience "the poem itself," "the real
sound of words"; letting "words speak for themselves," the reading will
ensure that any "exposure" that might occur "is not of the poet but of

the poem."[68] Yet try as we might to distinguish between "the sounding of the *writing*" and "the presence of the poet," we will fail—and find this failure embarrassing.

Lowell makes quite sure this will happen. His climactic clichés are embarrassing—not in the sense that they are bad, but in precisely the way these polemicists dread. Flooding the engine with emotion, Lowell purposely stalls out his writing, leaving his audience to confront his own presence directly—within and behind his failing poem. Rather than adopt the studied ease of a platform performer—a voice that he had quite easily achieved before—Lowell chooses to make spectacularly clear how much effort (technical, emotional, and even vocal) these poems demand. More than that, by challenging the norms of both poetry and poetry readings, Lowell exposes just how much effort we had *previously* put into "going along with the project" of poetic autonomy. We must squeeze our eyes shut, refusing to see what is right in front of us: not just some "writing," but also "the presence of [a] poet."

Often, Lowell uses his confessional poems not only to reveal himself, but also to expose his audience's desperate attempt to detach themselves from him and his performance. Take the handful of poems in *For the Union Dead* about an eye injury Lowell once sustained. Stephen Yenser, from an armchair somewhere circa 1975, interprets this injury as a symbol of "the flaw in man's nature, original sin, which 'Nothing can dislodge.'"[69] But I'd love to see him try to sustain that reading when faced with a live performance of the poem "Eye and Tooth." At a poetry reading in 1976, recorded and released on vinyl by Caedmon Records, Lowell introduces the poem with a long anecdote:

> It [the poem] came from a time when I first arrived in New York and had been persuaded by my cousin . . . to wear contact lenses. . . . But they were absolute hell in New York because little bits of filth, grit would get under them. And after I did that twice I went back to glasses, decided they were much more becoming and useful anyway. But this is a period—the cornea was all red from being cut. Nothing—[no] permanent damage.[70]

Are you squirming yet? If so, good—because apparently you're meant to approach the poem in that mood. (If not, may I suggest a quick viewing of the eye-slicing scene from the film *Un Chien andalou*?) If "Eye and

Tooth" was meant to help us muse on "man's nature," then Lowell has an odd way of going about it. "My whole eye was sunset red," he begins rather abstractly, but then decides to be blunt: "the old cut cornea throbbed," and the rest of the poem proceeds in this manner.[71] Every time Lowell seems ready to appease our desire to escape into the ether of abstraction, he sabotages our efforts. Whatever the supposed topic of a stanza, Lowell always finds a path back to the throbbing pain of his eye. He often does so by using enjambment in frankly nasty ways. Consider this stanza:

> My eyes throb.
> Nothing can dislodge
> the house with my first tooth
> noosed in a knot to the doorknob.[72]

If that first line makes you squirm, then the second seems designed to double your discomfort. *Nothing can dislodge—the grit that gashed open my cornea?* But breathe easy: what Lowell is failing to "dislodge," it turns out, is only a childhood memory. But wait—in a final twist, this memory itself shows a scene of awful, anticipated pain, as Lowell waits to have a tooth dislodged (ripped, really) from his mouth. Throughout the poem—and, indeed, throughout his confessional career—Lowell won't let himself "yammer metaphysics" for too long.[73] Instead, he courts embarrassment—demands that we take an eye for an eyeball and an "I" for a vulnerable body.

But where does this leave "the poem itself"—whatever that is? One poetry editor, trying to respond to an early Sexton poem, seems flummoxed by the question: "SOME FOREIGN LETTERS troubles me. But I do not think I like it. I think I only like what it does to me, not what it is."[74] But what a confessional poem *is*, even while sitting on the page, is inseparable from what it wants to *do*—to the poet and to the public. Even the strictures of poetic form, key aspects of what a poem *is* on the page, are embraced by Lowell and Sexton primarily for what they can *do*. Despite its reputation for conversational ease, Lowell's *Life Studies* is haunted by what Deborah Nelson calls "the ghost of formality"—structures of meter and rhyme that, while no longer totally there on the page, still "[whisper] from the background" of his writing.[75] He has formed these poems carefully, and then only de-formed them halfway. They are picturesque ruins: erected in drafts, worn down by revision, and

offered to readers in a ramshackle state. In performance, though, this form *does* more than molder away. Crumbling dykes, weakened walls— these poems are designed to break down. They are primed for a "break-through back into life."

Sexton also thought of form this way—as something you use by using it up. "Once I am through with a poem," she admits, "the form has little interest to me. It's a means to an end," and this end is quite simple: the production of confessional truth.[76] Rigid forms, she once explained in a public lecture, help her explore the most wounding confessional truths:

> . . . some poems are too difficult to write without controls of some sort. An impossible syllabic count, an intricate rhyme scheme . . . I use them when I hurt the most. I make up a cage that is strong enough to hold the poem in, as in the circus, as with the wild animal. Form acts like a super-ego, permitting this angry thing to enter the arena.[77]

The strict demands of form might seem to squelch confession, but, in fact, they permit it to happen. More than that, form spurs on confession. Poetic "structure," according to Sexton, "puts up a hindrance, a bar-rier, that one then fights harder to surmount."[78] (Foucault would soon observe a similar link, historically, between sexual repression and the "discursive explosion" of confessional talk about sex. Not every barrier, it turns out, is a hindrance.)[79] There's another word for such a "hindrance" or "barrier," although we rarely use it nowadays: it's an "embarras" or an "embarrassment."[80] One word, then, describes both the dam and the flood. Repression and breakthrough, writing and performance. The confessional poem, by design, is just one big embarrassment.

Performance circa 1959

A performative will, for example, be in a peculiar way hol-low or void if said by an actor on a stage, or if introduced in a poem, or spoken in soliloquy on a stage.
—J. L. Austin, *How to Do Things with Words*[81]

The confessional poets, in short, were always *doing* things with words— both as they wrote and when they performed—and yet, according to

Austin's famous caveat, the only thing less "performative" than their poems would be their readings, "a poem . . . spoken in soliloquy on a stage." How ironic, then, that Austin's keyword now pervades scholarly writing on confessional poetry. Worse, "performative" seems to serve as a slippery synonym for words that would surely make Austin cringe—words like theatrical, dramatic, staged, and artificial. Derek Furr, for instance, refers to Lowell's "reserved performativity," by which he means Lowell's way of using his voice in performance.[82] And Ernest Smith describes the readings Sexton gave as "performative events" that empha-size her poems' "dramatic aspects."[83] Most of the time, though, scholars aren't thinking of any literal performance; they only mean, *pace* Austin, that the confessional self is "performative," "dramatic," "theatrical"—you know: a fiction. "Performance," observes Jo Gill in her book on Sexton's poetry, "is an accurate term in that it signifies the fundamental artifi-ciality of the [confessional] mode."[84] This conflation of performativity, performance, and theatricality—all unmoored from actual performance practice—is the legacy of Jacques Derrida, who famously dealt with Aus-tin's argument (especially the caveat quoted above) not by refuting it, but by turning it on its head. What language, he asked, *isn't* playful, fictive, iterable—in a word, "performative"?

But by stretching Austin's caveat until it applied to "the entire field of what philosophy would call experience," Derrida preempted another equally damning critique of Austin.[85] Simply put, Austin got poetry and theater wrong. During the same years when he was writing *How to Do Things with Words* (1955–62), poetry and theater were both trying to achieve the sort of real-world force that Austin presumes they lack by definition. Clearly, he was thinking of a certain kind of theater only: il-lusionistic realism where actors disappear into their roles, and where the stage is quarantined behind a "fourth wall." Likewise, Austin is think-ing of only one sort of poetry, the kind New Critics were championing: "impersonal" poems, utterly autonomous from their authors and from the world. But, in fact, even as Austin wrote, both regimes were under siege. From avant-garde "happenings" to middlebrow Method acting, live performance was now filled with lived experience, and from the engagé Beats to the oversharing confessionals, poets, too, were seeking to entangle their art more fully with the world.

Meanwhile, on the other side of Austin's art-life divide, social theorists were asking people to acknowledge (without anxiety or despair) that the world was itself a "performance." About a month after *Life Studies* hit bookstores, it was joined on the shelf by Erving Goffman's *The Presentation of Self in Everyday Life* in its first American edition. This best-selling book popularized the notion that social behavior should be studied as if it were happening onstage. "Life itself," Goffman observes, "is a dramatically enacted thing," but he doesn't mean that life is a fraud.[86] In anyone's social performance, he concedes, there's "a natural movement back and forth between cynicism and sincerity," but he wants us to focus on the "transitional point that can be sustained on the strength of a little self-illusion."[87] He wants, in short, to take our performances seriously. In a final flourish, Goffman abolishes theatrical metaphor altogether—and with it the last vestiges of antitheatrical cynicism. This metaphor, he explains, was only scaffolding for what he really meant to build, a vision of life as an ingenuous performance: "This report is not concerned with aspects of theater that creep into everyday life. It is concerned with the structure of social encounters."[88] In such encounters, the goal is rarely to get away with cheap tricks; instead, we try to sustain a shared social reality.

So, too, with all kinds of midcentury "performance," including the kind confessional poets were staging—on the page and at the podium. When Robert Lowell says he wants his "reader . . . to believe he [is] getting the *real* Robert Lowell," he means precisely what he says.[89] He wants to *foster belief,* and only a hopelessly professional critic would add, uninvited: *. . . in lies.* Sexton, too, hoped her poems would capture the truth, even (or especially) when she donned a persona or fudged the facts. Scholars—anxious, I suppose, not to sound too naïve—rarely hear the sincerity in Sexton's words. Instead, they obsess over her frequent admission that, in her confessional poems, she doesn't always "adhere to literal facts."[90] As she explains in 1967 radio interview, though, her poems' untruths (which, when she names them, turn out to be inconsequential) are in fact "little escape hatches"—inserted so that she will "always have an out." With these hatches in place, "I can tell *more* truth than I have to admit to," she explains, "because I can tell the truth and say, after all, 'This was a lie,'" or "'of course not all of my poems are

true.'"[91] When writing to fans, rather than speaking to critics, Sexton lets the mask drop: "I am much more honest in my poems," she confides, "than I am in person or in a letter."[92] Or, as she put it in one of her late poems, ". . . if it is not my life I depict / then someone's close enough to wear my nose."[93]

As Sexton's audiences tried to respond to her readings, you could see them grappling with ideas like these. Bound as they were to the impoverished language of an antitheatrical culture, they struggled to explain what they experienced, but whatever it was, they knew it was extraordinary. One pair of fans assured Sexton that her readings were "not entertainment (as so many 'performances' tend to be) but an experience—a poet living his poems (pardon! her poems!) to the edge of our common humanity."[94] Another, praising her "power as an actress," goes on to explain that it's not *that* sort of acting: "You live your poems when you read them in a way I have never seen."[95] Sexton herself struggled to reconcile her own antitheatrical misgivings with her sense of possibility in performance. Responding to a woman who praised her as "a splendid actress," Sexton got oddly defensive all of a sudden: "I have a certain guilt about the ham in me," she blurted out, though it might help to know that the woman in question was Dr. Martha Brunner, a former therapist of Sexton's.[96] Even when the compliments weren't coming from Freudians, though, she would sometimes react as if they were accusations. "I don't think I'm a fraud onstage," she responded— again, to a letter full of nothing but compliments, "but the theatricality does creep in, not to entertain but to emphasize."[97] In moments like these, you feel her struggling, just like her fans, to express a new vision of *performance*—something deeper and realer than the word might otherwise imply.

But Sexton, unlike her fans—and in stark contrast to J. L. Austin— was well-versed in midcentury American theater and its trends. During her formative years as a poet, she was, in fact, a bit of a theater hound on the side. From 1961, when she completed her first draft of a play, until 1964–65, when she was author-in-residence at the Charles Playhouse in Boston, Sexton "bought at least fifty plays in paperback" (many of them avant-garde titles), "subscribed to the *Tulane Drama Review* [*TDR*]" (then a leading theater journal, soon the flagship publication in the field of performances studies), and "started seeing plays everywhere

and anywhere" she could.[98] Based on all this reading and theatergoing, Sexton would surely have known that the loudest evangelists of the antitheatrical creed weren't language philosophers or poets, but, in fact, the theatermakers themselves. With ample encouragement from journals like *TDR*, they weren't just practicing the Method and orchestrating happenings, they were also studying rituals, staging "environmental theater," and engaging in all sorts of "non-matrixed" performance.[99] *No more imitation—we want action! No more fakery—we want something real to finally happen onstage!* This must have sounded awfully agreeable to Sexton, who, at the time, was also discovering the acting theories of Konstantin Stanislavsky. Where *Stanislavsky on the Art of the Stage* speaks of his hatred for the "arts of imitation" and his advocacy for an "art of direct experience," Sexton's copy is emphatically dog-eared.[100] And though her fans didn't have the language to say it, they instinctively placed her in this tradition. She wasn't a "fraud," nor did she mean to "entertain." Instead she gave them "an experience" by "living" her poems at the podium.

Sexton must have thrilled at such sensitive praise. After all, she spoke often of "the strain of being what [she] wrote" at readings, but all she wanted was for her audience to say she had succeeded.[101] "I wish sometime you'd come see me read and figure out if that's me," she begged her therapist Dr. Martin Orne—and, in this context, her reaction to Dr. Brunner (Orne's mother) should make a little bit more sense: Sexton wanted a therapist's okay, but "splendid actress" was precisely the wrong compliment.[102] After all, she thought of her work not as acting, exactly, but as performance, in that new, midcentury sense. "For me poems are verbal happenings," she once wrote—meaning that they are events, even on the page.[103] Poetry readings, in turn, were "a reliving of the experience, that is, they are happening all over again."[104] So, if what's "happening" in performance is what's "happening" in the poem—and if it's hard to tell either apart from what's happening inside of her—this, for Sexton, was a mark of her success. "I . . . become the private poet who wrote the poem," she once said, describing her favorite sort of moment at any reading—and this "poet who wrote" was, in turn, always teetering on the edge of real life and true feeling.[105] "Emotion recollected in tranquility is nonsense," she once scrawled, "I write in a frenzy of recreated experience."[106] Combine this frenzied vision of writing with the idea

that, in performance, she becomes the "poet who wrote the poem," and it's suddenly clear what her fans were trying to describe. Her readings must have been saturated with "recreated experience" in all its vitality—its volatility.

Getting Exercised

Let me remind you of our cardinal principle: Through conscious means we reach the subconscious.
—Stanislavsky, *An Actor Prepares*[107]

We work with emotions so that the actor can deliberately create them, and at the same time deliberately make use of them. . . .
—Lee Strasberg, interviewed in *TDR* (Autumn 1964)[108]

Shortly after the release of *Life Studies*, Lowell observed that he had said "something not to be said again" in those poems.[109] Nothing could be further from the truth. He would, in fact, say this "something" over and over while performing these poems for years on the reading circuit. In some cases, these poems stayed in his repertoire until the day he died. Drawn from life and perfected in performance, these poems must have felt, at first, utterly alive—but how long could this feeling last? The question never occurred to Lowell, but Sexton was positively obsessed with it. After only three years on the circuit, she began to worry: was there a deadness at the heart of live performance? In December 1962, facing the prospect of a long winter giving "reading after reading," she bemoaned her fate:

> . . . you can make your living reading (I think to myself) dead and old poetry. (course it's not dead but it's not really RECENT . . . newborn as it ought to be . . . or we all wish it were). . . .[110]

"Readings are a show," she concludes, ". . . big show . . . rather depressing." She often felt this way. Even on her best nights, readings could make Sexton feel the "strain of being what [she] wrote" in her poems,

and this strain could only worsen with each passing month and each performance of a dying poem.[111]

A few poems, though, never let Sexton down; they stayed lively despite years in heavy rotation. One of these old reliables, she explains in a 1962 essay, was her early poem "Some Foreign Letters":

> I have almost always read this poem during a "reading" and yet its impact upon me remains strong and utterly personal. I get caught up in it all over again. By the time I get to the last verse my voice begins to break and I, still the public poet, become the private poet who wrote the poem.[112]

By the time she wrote this essay, she'd been performing "Some Foreign Letters" at readings for at least three years already, and yet it could still make her voice "break" with fresh emotion every time. If it was no longer "recent," it was at least "newborn"—reborn every time she performed it. Such vocal "breaks" were Sexton's touchstone for testing her very best poems. In 1966, she would describe another of her standbys, "The Double Image," the same way: "every time I read it aloud my voice cracks and gives me away."[113] And when, in 1973, Sexton briefly swore off readings altogether, she returned to the exact same image, though now focusing on her audience's prurient desire to witness this sort of vulnerability. "Some people secretly hope your voice will tremble," she sneered, "(that gives an extra kick)."[114] But back in 1962, when she still thought she could strike a balance between poetry and the "show" poets "are asked to make of it," she found this balance in the moment when her voice broke, cracked, or trembled—when she broke down and her emotions broke through.

Imagine her relief and recognition, then, when two years later Sexton started to read *Stanislavsky on the Art of the Stage*. Here was a vaunted theater theorist who had confronted the same problem she faced: the emotional deadness of live performance. He had even, like her, had his epiphany while trying to repeat a performance over and over on tour. "During my last tour abroad," he explains, "I kept repeating mechanically those well-drilled . . . 'tricks' of my part," but these tricks—meant to help him feel emotions on cue—only betrayed the "absence of genuine feeling" onstage.[115] As his English-language translator explains (on a page Sexton marked in her own copy of the book),

> When an actor suffers in order to suffer, when he loves in order to love . . .
> when all this is done merely because it is in the play and not because the
> actor has experienced it inwardly . . . then he will find himself in a hope-
> less fix, and to act "in general" is the only solution for him.[116]

Sexton must have wondered: was she performing "in general"? Was she
feeling an emotion at readings "merely because it [was] in the [poem]"?
Poems like "Some Foreign Letters" gave her hope—but why exactly did
this poem work so well on her? Perhaps this old Russian could tell her
the answer. . . .

Stanislavsky solved the problem of emotional deadness by teach-
ing actors to strengthen what he called their "emotion memory." As his
fictive avatar Tortsov explains to a student in Stanislavsky's *An Actor
Prepares*,

> Since you are still capable of blushing or growing pale at the recollec-
> tion of an experience . . . we can conclude that you possess an emotion
> memory. But it is not sufficiently trained to carry on unaided a successful
> fight with the theatrical state. . . .[117]

Desperate to fend off this theatrical state, Stanislavsky observed the great
actors of his day, studied human psychology, and devised a new psycho-
technique for the theater. Feelings, says Tortsov, are like wild animals;
they flee before we even know they're there. Since we cannot hope to
capture them directly, we must find "the most effective kind of lure" to
draw them out.[118] "Don't think about the feeling itself," Tortsov insists,
"but set your mind to work on what makes it grow."[119] Lee Strasberg,
American disciple of Stanislavsky, made this a central pillar of what
came to be called "Method acting." In a *TDR* interview that Sexton (a
subscriber at the time) may have actually read, Strasberg explains his
own practice:

> I think of the place I was in, and what I wore, and how it felt on my body,
> and where I was hot and where I was cold, and the light in the room, and
> I try to see the light, and so on, and I hear a voice, and I try to hear that
> voice, and I see somebody and try to see that person, touch and try to
> remember the touch. . . . As I do that, the emotion is relived.[120]

In other words, he wills the memory of sensation, but the memory of emotion must happen on its own. It must, in that strange passive construction, *be relived*. As is clear from Strasberg's tortured phrasing in this passage, the kind of acting he's after blurs the line between spontaneous reflex and willed repetition. We first "hear," then "try to hear"—first "see," then "try to see." And if the emotion "is relived," it's because we have dwelt in this limbo between effort and surrender. We get exercised, in short, by going through the motions of a well-planned memory exercise.

Though it must have been comforting to know that these titans of the theater were on her side, Sexton hardly needed Stanislavsky or Strasberg to teach her any of this. Years before she encountered their theories, she had already offered one of her own in a poem called "Music Swims Back to Me." Recalling the song "they played / the night they left me / in this private institution on a hill," she marvels at its power to revive her memories of that night.[121] In fact, by the end of these three quoted lines, it has already happened: instead of writing about *that* private institution, she slips and finds herself right back in "this" one. Reflecting on this experience of being transported, she concludes:

> Music pours over the sense
> and in a funny way
> music sees more than I.
> I mean it remembers better . . .

What this music "remembers" is, at first, external details of the sort Strasberg emphasizes, but, just as he would have predicted, these details soon lure an old feeling out of hiding. In a telling slip, Sexton writes not that she hears this music, but instead: "I *feel* the tune they played." The poem itself, then, mimics an emotion-memory exercise in how it slips from sensation to emotion. When introducing this poem at her readings, Sexton went even further, explaining that this poem was itself the result of a memory exercise conducted in private. "Hearing the song" years later, she explains, "I ran out and I bought this record," then wrote the poem while "playing this record over and over."[122] This poem, then, is not just a thing in itself; it's the trace of a trick she once played on herself with an old, fraught song.

Primed with stories like these, Sexton's audience might realize something more than what Sexton reveals: that as she performs the poem she is putting herself through this exercise again. Even without the record literally playing in the background, Sexton would use it to lure out elusive feelings. On the Caedmon LP *Anne Sexton Reads Her Poetry*, recorded a full fifteen years after that day at the typewriter (and turntable), you can hear her reviving these now-ancient feelings one more time.[123] She begins in a deep, incantatory voice—cigarette-scarred, yet also supremely assured—until the ghost of this song returns, and her voice suddenly changes. "La la la, Oh . . . ," she sighs, hearing the song and audibly turning away into the depths of this memory. Then, out of nowhere, she begins to channel another voice—youthful, excitable, and noticeably higher-pitched. "Imagine it," she exclaims, as if suddenly conversing with us, "A radio playing / and everyone here was crazy." You can hear the smile spreading across her face, and her pitch slowly rising until her voice cracks on "crazy." Now she's right back in it, that mixture of mania and despair she felt one night in a mental hospital: "I liked it and danced in a circle," she cries, and though she has written these words in the past tense of memory, she performs them in a virtual present tense. "Liked," she croons, stretching the *ah* in this diphthong before giving the word "danced" the same drawn-out, joyful treatment. Stanislavsky's Tortsov relished moments like this, but also warned that they might prove ephemeral:

> Your head will swim from the excitement of the sudden and complete fusion of your life with your part. It may not last long but while it does last you will be incapable of distinguishing between yourself and the person you are portraying.[124]

Just as quickly as it appeared, this voice vanishes from Sexton's performance. Even so, for a moment it broke through, bringing Sexton's past into our shared present tense.

In "Some Foreign Letters," the poem she held up in 1962 as an especially reliable performance piece, these sorts of tactics proliferate—indeed, the whole poem is aimed toward achieving this sort of breakthrough. Like "Music Swims Back to Me," "Some Foreign Letters"

is offered as the result of an exercise conducted in private.[125] One night, she picked up a leather-bound book containing the letters that her great aunt ("Nana") wrote home from Europe in her youth. As Sexton read these letters, she remembered and mourned this woman—who was once, she says, nearly "an extension of [herself]"—and in the heat of such feelings, she wrote this poem.[126] The poem, in turn, is built not only to describe but to help her revive this experience. It puts Sexton through her paces, dramatizing her slow access to her feelings about Nana that night. In order to dramatize this gradual process, the poem is written in a roving present tense that puts us right beside Sexton as she reads: "I read how London is dull," "Tonight I read how the wind howled," "I read how you walked," etc. But within the framework of this letter-reading ritual, her own memories slowly begin to accrue. "You were the old maid aunt who lived with us," she observes; "When you were mine you wore an earphone," she recalls; and she slowly builds from factual memories like these to more emotional ones like this:

> When you were mine they wrapped you out of here
> with your best hat over your face. I cried
> because I was seventeen. I am older now.

Even here, having raised strong emotions, she tamps them down with that curt phrase, "I am older now." This is by design, because her true present-day feelings are held back until the final stanza—the one, remember, where her "voice begins to break" every time she performs. Here, finally, her own memories and feelings overwhelm Nana's letters. The poem, it turns out, was a trellis meant to help this last stanza grow. *Through conscious means we reach the subconscious.*

Whether she knew it or not, when she performed this poem, she was benefitting from another Stanislavskian tactic. In the chapter of *An Actor Prepares* on emotion memory, Stanislavsky focuses at length on how the performers' actual surroundings (sets, lighting, sound effects, props) can feed their memories and color their moods. Surely Sexton, reading a poem about reading letters, has managed to make the most of her minimal surroundings. Even as she becomes "the private poet who wrote the poem," the book in her hands becomes this book of Nana's letters.

An awkward aspect of the formal poetry reading—the poet's tendency to keep her eyes always glued to the page—becomes here, in a stroke of theatrical genius, part of her immersion in the scene that she's reliving. And this trick would only grow more effective, and its effects more poignant when, in 1963, these letters were stolen from the trunk of Sexton's car as she was touring around Europe.[127] Now, the phantom-book she conjured each time she read this poem was the only copy she had left.

Sexton returned to this trick again and again, incorporating fraught scenes of reading into many of her poems. Her next book, *All My Pretty Ones*, concerns the death of her parents, and it begins, after a short poem about their deaths, with a scene of Sexton sifting through the documents they left behind. In "Some Foreign Letters" she uses a deictic *this* to conjure each new letter into existence—"This Wednesday in Berlin," "This is Wednesday, May 9th, near Lucerne," "This is Italy"—and in this new poem, "All My Pretty Ones," she recycles the tactic: "This is the yellow scrapbook that you began / the year I was born," "These are the snapshots of marriage," "I hold the five-year diary my mother kept."[128] Like "Some Foreign Letters," this poem would, for a while, be a fixture in Sexton's reading repertoire. And Sexton didn't stop there. In her third book, *Live or Die*, she returned again and again to this *idée fixe*—even returned, in two poems, to those same "foreign letters" that had inspired the first poem of this sort.

> I have read each page of my mother's voyage
> I have read each page of her mother's voyage
> I have learned their words as they learned Dickens'.[129]

And if "learn[ing] their words" sounds like a veiled allusion to theatrical roleplay, the next poem ("Walking in Paris") lifts the veil. Thinking again about Nana's letters, Sexton writes, "I read your Paris letters of 1890, / Each night I take them to my thin bed / and learn them as an actress learns her lines."[130] Having read Stanislavsky (and possibly Strasberg) Sexton was prepared to embrace her theatrical inheritance: the memory exercise, helping her to breathe new life and fresh feeling into "dead and old poetry."

"Breathing Back" as Confessional Ritual

> I try
> to reach into your page and breathe it back . . .
> —Sexton, "Some Foreign Letters"

More than theatrical exercises, though, these poems begin to seem like religious rituals. This is most obvious in the last of these poems, "Walking in Paris," where Sexton tells not just of rereading Nana's letters, but of actually attempting to relive them. Traveling through Europe herself, literally following in Nana's footsteps, Sexton grows ecstatic whenever their experiences align: "What is so real as walking your streets!" she exclaims, "I too have the sore toe you tend with cotton." This connection between rereading and reliving had, in fact, been percolating in Sexton's mind all along. In the last poem of her first book, a rehearsal run for "All My Pretty Ones," she puts the image of herself rifling through her dead mother's things side by side with a scene of ritual reenactment: "the devout" Catholics of Boston following "the hours of The Cross."[131] In this context, Sexton's incantatory rhetoric in these poems takes on a whole new significance. "I read / . . . I read"—"I have read . . . / I have read . . ."—"This is Italy," "This is the yellow scrapbook"—these words come to resemble the deictic words of the Communion liturgy. And, just like that liturgy, these are not statements of fact. They work a strange transformation (in her, in the room) that's neither literal nor theatrical. They are, in a word, performative. *This is my body*, Sexton is saying, *This is my blood*. Who would ever suspect a priest of "problematizing" the self by saying so?

Rather than thinking of confessional poems as "performative" deconstructions of identity, we should think of them instead as performative rituals of identity-formation—as the poet's attempts to collect herself on-stage. Consider "Some Foreign Letters," which enters the present tense of so many past moments—Sexton's and Nana's alike—only in order to emerge, in the end, in the perfect presence of "tonight," the dual moment of writing this poem and performing it. The poem's many presents accrue like sediment, imbuing the poem (and Sexton's performance) with an archaeological depth. The *now* of Nana's writing and the *tonight* of Sexton's reading blur into the moment Sexton wrote this poem—and

at a reading these many *nows* are all confused with the *here and now*, the *presence* of performance itself. In the final stanza, which Sexton always performed with a sudden emotional and vocal intensity, these many *nows* merge. "Tonight I will learn to love you twice," she begins, her voice always cracking on *tonight*. "Tonight I will speak up and interrupt / your letters," she goes on, her voice trembling on the word *letters*, as the poem's many "tonights" blend together and join with the *now* of Nana's now-interruptible writing. "I tell you . . . / . . . And I tell you," Sexton insists, indulging in apostrophe—a trope that Jonathan Culler calls "embarrassing"—but if these words do "embarrass" the architecture of the poem, it is on purpose.[132] They insist that something real is happening here, an invocation, a conjuration—not of Sexton's dead Nana, but of her complex, buried feelings about this woman—I mean, this "extension of [herself]." Throughout the poem, she has teased us with access to her feelings, letting them flash by exactly as they must have done while she was leafing through those letters that night, but she has stopped merely reading now. She interrupts the letters—interrupts her own poem—by insisting on what's happening "tonight." Yes, she has spent the bulk of the poem focusing on someone else (Nana) and has rigorously repressed her own feelings whenever they arose ("I am older now"), but what she really breathes back from the page, in the end, is herself.

"The Double Image," Sexton's most performed poem, follows this same logic.[133] Like many of her poems, this one conflates three generations of women—this time: herself, her mother, and her daughter. The poem, addressed to her daughter Joyce, tells of years she spent away from home, living sometimes in a mental hospital and sometimes with her mother. Caught between her mother and her daughter—and between her twin roles as a mother to her daughter and a daughter to her mother—Sexton meanders through a confusing series of first-person voices meant to reflect the chaos of those years. "I am thirty this November," "I who chose two times / to kill myself," etc.—and, in one jumbled sequence,

> All that summer I learned life
> back into my own
> seven rooms, visited the swan boats,

the market, answered the phone
served cocktails as a wife
should, made love among my petticoats . . .

On a textual level the result is dizzying. Where does each "I" fit into the timeline (let alone the narrative—or the *truth*) of Sexton's life? How knowing is each of these I's she voices or describes? How distant is she now from any of them? Some critics, encountering such a poem, know exactly what to say: "In place of a coherent subject, faithfully mirrored, we see only fleeting, oblique glimpses of a fragmentary reflection."[134] But, in saying this, we mistake the path for the destination. Sexton wants to achieve coherence beyond crisis and unity beyond fragmentation.

This is where the performing body—or our sense that the poem on the page is shot through with performance—comes in, offering to ground this hypercharged text. In a 1964 recording of "The Double Image," Sexton introduces the poem by saying that, in it, "I keep telling her [Joyce] and telling her, and telling me" the "truth of why she did not live with me since she was a baby."[135] The insistent triplet of "telling . . . and telling . . . and telling" should recall both Plath's catechisms and Sexton's ritual incantations, but the shift from "telling her" to "telling me" is most revealing. Telling and telling, Sexton reveals her self to herself in a climactic moment of breakthrough. If, as she claimed, this kind of moment was always marked by a broken voice, the 1964 performance has one clear breakthrough. Her voice suddenly catches on these passionate lines: "Today, my small child, Joyce, / love your self's self where it lives." Audibly, involuntarily, her voice trembles on the phrase "self's self." This line, punctuated by Sexton's broken voice, is an injunction to herself, as much as it ever was to Joyce—and "where it lives," at this instant, is on the stage of the YMHA Poetry Center in New York City. The vertiginous swirl of I's is held together for a moment by the one who breathes them back behind the podium. They all exist on the same plane, one perfectly familiar to any confessional performer: the sliver-thin divide between retelling and reliving—between the "dead and old" poem and the live event. "It's wonderful," one of Sexton's fans exclaims, "she breathes her words, they are alive, she is so alive."[136] And—for a moment, anyway, onstage—it's true: she is.

The Confessional Performance Tradition

The theater, as we call theater, will soon be once more *rhabdian* [from Gr. *rhabdos*, a kind of poet-performer who preceded drama as we know it], plots gone, gab gone, all the rest of the baggage of means, stripped down. . . .
—Charles Olson, "Notes on Language and Theater"[137]

When Olson predicted a theater "once more *rhabdian*" he almost certainly wasn't thinking of performances like these, but no genre of poetry has had so clear an impact on performance as confessionalism has. Its influence on slam poetry—always performed, usually confessional—is undeniable, but its impact is most direct on the confessional monologue, which would soon pervade performance art and theater. Spalding Gray, a pioneer and popularizer of theatrical confession, avidly collected recorded literature, and cites particular LPs by Robert Lowell and Allen Ginsberg (in his more confessional vein, "Kaddish, not Howl") among his chief performance influences.[138] Scholars have made little or nothing of Gray's insistence on this poetic inheritance, but meanwhile Gray—along with the feminist performers who followed Sexton and Plath—has indelibly marked the "one-person show" (now ubiquitous) with the sound and feel of confessional poetry, with what Peggy Phelan would call this genre's oversound. This oversound spills across the borders that separate literature from performance, carrying with it an aesthetic and a creed. The aesthetic is one of breakthrough, and the creed: a faith that private selves, which print can only "mummify," might still be breathed back in public performance. An oversound is a tricky thing, but it will always appear to anyone willing to disregard the boundaries between archive and repertoire, print and performance, autobiography and confession.

Interlude

Feminist Confessions, 1959–1974

> Don't publish it in a book. You will certainly outgrow it, and become another person, and then this record will haunt and hurt you.
> —Sexton's mentor John Holmes, in a letter (February 8, 1959)[1]

> . . . when I started writing everyone said, "You can't write that way. It's too personal. You tell too much." And I think they meant tell too much about women.
> —Anne Sexton, in a letter to a fan (February 25, 1974)[2]

By 1974, the last year of Sexton's life, she had indeed "become another person." Back in 1959, she'd been a housewife first, an "about to be published poet" second. By 1974, she was a star author, a polished performer, and—by the way—a divorcée. Back in 1959, she had struggled to give voice to "the problem that has no name" before it had even *that* one. By 1974, she knew all its many names—had, in fact, bestowed a few of them on it herself. Fifteen years will work startling changes on anyone, but this decade and a half was downright tumultuous for a woman of Sexton's age, race, and class. She had "become another person"—as so many women had.

After all, April 1959 wasn't just the *mensis mirabilis* of confessional poetry; it was also, according to one famous account, the mythic origin of second-wave feminism. As Betty Friedan recalls in *The Feminine Mystique*,

> [O]n an April morning in 1959, I heard a mother of four, having coffee with four other mothers in a suburban development fifteen miles from New York, say in a tone of quiet desperation, "the problem." And the

others knew, without words, that she was not talking about a problem with her husband, or her children, or her home. Suddenly they realized they all shared the same problem, the problem that has no name. They began, hesitantly, to talk about it.[3]

Over the next decade and a half, activists would channel this urge into a new political ritual. People gave it various names (small group, rap session, bull session, etc.) before finally settling on one: consciousness raising (CR). Sitting in a circle, women would try to make sense of "the problem" by sharing the stories of their lives with one another. As story built upon story (in one session or across several) women would realize that "they all shared the same problem, the problem that has no name." Society's sexist oppression of women: *that* was its name, not "local circumstance" or "personal failings." And just like that, as in an old fairy tale, having learned its name, they would escape its power.

Truths on this scale might seem easiest to declare in the third-person plural of political proclamation, but declarative ease was hardly the point of CR. The first women to practice it were seasoned activists who found it easy—too easy—to explain their lives in ideological terms. For these women, CR's "first-person rule" was a speed-bump, slowing their rush to received New Left ideology.[4] But as CR's popularity grew, movement feminists lost patience with this process: the long, slow path out of oppression may have worked for certain radicals, but most women, it seemed to them, just needed an ideological airlift. So, in 1974, when the National Organization for Women (NOW) assembled a task force to study CR, they in fact redefined it. No longer a "free space" or a "process that probably has no end," CR was now a formal training program with a set curriculum, a handpicked leader, and (most importantly) a strict ten-week, in-and-out time frame.[5] In NOW's *Guidelines to Feminist Consciousness Raising*, authored by members of this task force, they went so far as to rewrite the movement's most famous slogan: "a basic part of the feminist CR philosophy," they observed, "is the phrase 'from the personal to the political.'"[6] But who on earth had ever said it *that* way? The implication was clear. No slowing, no stopping, no U-turns allowed—just a one-way ticket away from the personal. Not only was "the personal" now a means to an end; this end was predetermined by

NOW. Women might "begin by discussing their own experiences . . . but with the guidance of the leader they [would] recognize the common denominators" of womanhood.[7] In fact, with the help of session outlines, leaders could ensure that these "denominators" would stay the same no matter what stories women might bring to the room. And just like that, the heyday of feminist confession—of life stories that urgently mattered—was over.

But while it lasted, this culture of feminist confession fostered poetry like Sexton's and framed its public reception. For some readers, all women's poetry of that era belonged to a sort of ongoing CR session. One whimsical 1975 essay literalizes this fantasy by pretending to offer the transcript of a CR session among poets, including Anne Sexton, Adrienne Rich, and many others. As they discuss the fate of women, these poets slip in and out of verse, treating their poems as a heightened form of CR chat.[8] Seen in this light, Sexton's earliest poems begin to look like proleptic responses to CR discussion prompts. Consider, for instance, the following exercise from NOW's *Guidelines* on the topic of "Mothers/Daughters":

> Role play: Pretend your mother is in this group. (The leader should allow time for each woman to do this. . . . Set up an empty chair for her to talk to.) Tell her directly whatever you want to say to her. (The leader may want to ask after everyone's turn, "Does anyone want to say 'I love you' or 'I forgive you'?") Repeat the role playing for a significant female child— daughter, niece, etc. What do you want her to know about you?[9]

Imagine Sexton in this group. If she could resist pat conclusions (*Does anyone want to say "I love you"?*) and if she could somehow speak in verse, she might find herself spouting "The Double Image" word for word—which, come to think of it, is a perfect CR monologue, complete with an effortless rise at the end from anecdote to "aha" moment. (*Does anyone want to say, "I made you to find me"?*) Long before CR swept the nation, Sexton's poems were already received in this spirit. Just leaf through her fan mail and you'll see that, in classic CR fashion, each of her confessions triggered waves of counter-confession. Upon reading her poems, women sent her raw letters and revealing poems, each

one trumpeting the "common denominators" between their lives and Sexton's. CR didn't just happen in the flesh, then. It happened also on paper, in the exchange of written words.

But Sexton never really embraced CR's triumphalist view of feminist confession and its power to transform us. According to Esther Newton and Shirley Walton, two anthropologists who conducted the earliest study of feminist CR, this ritual incited "something equivalent to religious conversion," which they define (via William James) as "the process . . . by which a self hitherto divided, and consciously wrong, . . . becomes unified and consciously right."[10] This simple promise—that, with the help of CR, you could be reborn into unity and righteous conviction—never squared with Sexton's lingering sense of her difference—from other women, of course, but also from her own past selves. At poetry readings, Sexton fathomed this difference with the help of a poem she called "Self in 1958." The title refers to the woman Sexton had been just before she came out as a "secret beatnik" in 1959. In retrospect, she found this "self" awfully hard to pin down. As a matter of fact, when she first drafted the poem back in 1958, it wasn't yet a "self" at all; it was a dramatic monologue with a third-person title, "The Lady Lives in a Doll House."[11] "*I* Live in a Doll House" she came to call it sometime before deciding to include it in a draft of her first book.[12] But, for some reason, she dropped it from *Bedlam* and stuck it in a drawer, where it gathered dust for years. When she rediscovered the poem in 1965 and decided to rewrite it, Sexton made it more confessional ("Self . . ."), yet less immediate than before (". . . in 1958"). As she revised it, she struggled to calibrate her distance from this "self," calling it "Self in 1959," "Self in 1957," and (only after some time and several drafts had passed) "Self in 1958."[13] Meanwhile, she privately confessed, when sending a draft to her friend and fellow writer Tillie Olsen, that "Self Now is true of now as well as then."[14] Neither a persona poem nor a heartfelt confession, this poem was a half-felt foray into an uncertain "self."

As she performed this poem for years, Sexton continued to both avow and disavow the woman it portrayed. "In the next poem," she writes in one scripted preamble, "we have me stopped as the perfect housewife, as the advertised woman in the perfect ticky tacky suburb."[15] History meanwhile did not stop, and neither did Sexton; but no matter how Sexton refashioned her public self, or how feminism redefined women's

Figure Interlude 1.1. A draft of Anne Sexton's "Self in 1958" that, with the help of a shift-lock error, seems to express the poet's frustration as she revised this "self." Anne Sexton Papers, box 7, folder 4, Harry Ransom Center, University of Texas at Austin.

roles across the culture, she felt somehow responsible to this slim remainder of a self in '58—in '65—in '74.

In 1974, Caedmon recorded Sexton performing this poem one last time, capturing this "self" at its most outdated.[16] Still, after a decade and a half, she could neither embrace nor renounce this woman entirely. Sexton begins the performance in an affected voice, a sort of opiated, doll-like drone, but she soon lets her own voice—ragged yet confident— break through this persona. That is, she refuses to immerse herself in the role, and yet she also avoids easy irony toward it. Instead, she breathes back this woman's stilted emotions, sinking often into whispery sentiment. In the poem's final lines, you might even forget which of her selves ('58? '65? '74?) is speaking when she says: "But I would cry / . . . If I could remember how / And if I had the tears." In the end, this blend of affects—intimate proximity to her "selves," but also critical distance from them—was Sexton's signature performance style. Listening to her perform "Self in 1958" this way, I am reminded of Frank Bidart's frustration while trying to edit a poem that Lowell had published two ways: "The two versions refuse to be joined. I think that the poem as a whole is greater in the revised version; but I can't escape the haunting memory of the first."[17] For Sexton as for Lowell such "haunting," though, was already a kind of "joining." Sexton might well have said of her "selves" what Lowell said to Bidart of his poem: "But they both exist."[18]

* * *

Many have, in passing, considered Sexton's relationship to (or influence on) women's performance art, but they tend to limit their claims, as Diane Middlebrook does, to the way "Sexton's performances put her body onstage."[19] Body art, though, has its own genealogy, quite apart from anything Sexton did. The more significant link between Sexton and women performance artists of the 1970s is their wary reliance on personal narrative. Blending confession with artifice, ritual with role-play, they both channeled and checked the spirit of CR. Such ambivalent acts of confession—call them self-consciousness raising—were Sexton's true contribution to women's performance.

In 1974, the same year Sexton recorded her final rendition of "Self in 1958," performance artist Eleanor Antin mounted a piece at the Woman's Building in Los Angeles called *Eleanor of 1954*—or, if you believe the

variant titles of audio recordings in her archive, *Ely 1953*—or else, *Eleanor 1974*.[20] Troubled by the same blend of intimacy and distance from herself that had long preoccupied Sexton, Antin offered to revive her pre-second-wave self through a performance of CR run amok. As she explains in a 1979 interview,

> I sat in a chair and talked, and made confessions about things that had happened twenty years earlier. What I was trying to do was to find out if there was anything *real* left of that self. I tried to shame her out.[21]

The Woman's Building, founded by artists who treated CR as the very wellspring of their art, was the perfect setting for such a performance. Not only would these women catch the allusion; they would notice how Antin was deforming their cherished ritual. Meant to help women banish their pre-feminist selves, CR helped Antin instead bring this old self back to life. Designed to conquer shame, CR, in Antin's hands, became a tool for reviving ugly, old feelings.

But without a (literally) dated text like Sexton's "Self in 1958," Antin had to invent more extravagant ways of fathoming the gap between herself and her self. As Antin explains, "The last four or five years of my life are the Eleanor I recognize"—nothing before.[22] So, she begins *Eleanor of 1954* by telling a story, not from the year in her title, but instead from "about four years ago."[23] It's the story of when she "first felt [her] power" as an artist—or, as she quips, perhaps needling her feminist audience a bit, when she first "became a man."[24] Despite having tried quite hard, Antin had failed to secure gallery representation in New York, but, undeterred, she decided to mount a solo show herself. She rented a room in the Chelsea Hotel and managed a makeshift gallery of her own. But just as this tale seems on the brink of its triumphal conclusion, another voice issues from Antin's mouth. Perky and bright, but laced with poison, this voice warbles, "You're lying again," and then begins to address the audience: "She used to be me. I've been watching her for a long time now—secretly." All of a sudden, a younger Eleanor is present, and she begins to attack our present-day Antin—mocking, for instance, the "hefty kind of walk" she affects, "like a man." Present-day Antin responds by trying to sever all ties with the past, insisting that she "was born that time in the Chelsea," but young Elly has her own master-narrative to push. As she

sees it, Antin's path was set earlier, when she first made a choice "between two dependencies"—that is, when she quit therapy (against her doctor's advice) and moved in with a lover. "Look at her," young Elly squeals with sadistic delight, "she's squirming, she hates that word," *dependencies*.

So far, my account of this performance has relied on an audio recording of *Eleanor of 1954* now housed with Antin's papers at the Getty Research Institute—but when I first took an interest in this piece, I had no idea that a recording like this even existed. Still, I was comfortable writing about *Eleanor of 1954* using the scant evidence that did remain. It hardly escaped me, as I did so, that my attempts to reconstruct this performance doubled Antin's own act of dredging up young Elly. How can we access the ephemeral past, after all, if not by playing with its remains? That was Antin's question—and it was also my own. Consider, then, how mixed my feelings were when Antin's papers opened up to the public in 2012 and among them was this recording. Imagination and desire now gave way, like it or not, to brute fact. With a yank on my leash, the pleasures of play were over, and I was roughly heeled to the evidence at hand. I never realized how quickly I had adjusted, though, until this recording began to show signs of its age. About thirty minutes in, on side B of the cassette, Antin's voice grew muffled at first, then inaudible. Once unaware that such access to this performance was possible at all, I now grew frantic that it was slipping away. "Antin shifted back and forth between her past and present selves, her attitude moving from mockery to analysis to compassion. . . ."[25] This is the memory of Moira Roth, a performance historian who attended the performance that night in 1974. Pushing my headphones on tighter, I remembered Roth's words and focused hard on the waves of white noise coming at me. I strained to hear in the ebbs and flows of static the tones of mockery, the cadence of analysis, and the melody of compassion—but desire, it turns out, is no match for decay, and I soon relinquished the last of my hope.

I did my due diligence, though, listening onward through minute after minute of this noise; and, as I did, I remembered another audience member whose impressions of this performance had later been published: Eleanor's husband, David Antin, a poet, critic, and performance artist in his own right. At some point in the performance, Eleanor's younger self "disappeared," he recalled, and then the present-day Elea-

nor "conceded that [she] had been unfair to her."[26] What, I wondered, did that sound like? Before long, my thirty minutes of white noise were up, and, with suitably dampened expectations, I put on the third and final recording—side A of a second cassette. To my surprise, there was something there—not just something, but precisely the moment David Antin had been describing. After a few last statements by young Elly, the present-day artist finds herself alone again with her audience, and she decides to tell them one last story—a hard tale of Elly's sexual humiliation. "He looked at her, and he pointed to the floor and he, he—he pointed to the floor and he—he made her—." She suddenly stops and addresses her vanished doppelganger directly: "You win. I can't tell it. Your shame is my shame, I can't tell it. I'm ashamed. I'm sorry." And yet she struggles through the rest of the story, ending with a sad laugh (or is it a sob?)—then, with a mixture of loathing and affection, sighing the words, "Stupid nut; stupid, stupid nut." United by shame, these two women were still so far apart—though perhaps they'd drawn closer through this performance.

Looking back on it, Antin never knew quite how to feel about *Eleanor of 1954*. While she confirmed, for instance, that this last story she told was true, she also confessed that it caused her no shame to retell it. If she said otherwise in the performance, this was "bullshit" she spouted for the sake of "a theatrical situation—a melodramatic marriage with my old self."[27] But if Antin sounds angry here, her anger might stem from her thwarted desire: "I really did want . . . to confront honestly—without the theatrical, melodramatic bullshit—Eleanor of 1954."[28] This desire grew stronger each time anyone else tried to imply the same thing: that this performance was nothing but "theatrical . . . bullshit." Discussing the piece in a 1979 interview, Antin begins, "I improvised the whole thing"—and when the interviewer tries to clarify, "Then it was made up—fabricated," she protests:

No. The confessions were real. . . . It was an improvisation. A performance. But the assumption was that underneath my present performing self there was another, the *real*, me.[29]

Whatever the preposition may be (underneath, through, between, or beyond), women artists of this era were striving to do the same thing:

to find "another, the *real*, me" through their art. They were attempting, as Antin puts it, to "discover and invent" themselves—with those verbs held in parallel.[30] For her part, Antin thought of her art as akin to psychoanalysis. A performance like *Eleanor of 1954* was part of her "own psychological machine" of discovery and invention, a "system which is mine, not given to me, say, by . . . Freud or Jung."[31] Like Jung and Freud, Antin used metaphor, misdirection—and, yes, even "bullshit"—in her search for deeper truths.

But her husband David didn't see it that way. In a startling turn of events, he butts into the interview to contest Eleanor's own account of her performance. "No. Sorry. That isn't what happened," he interrupts, after she first describes the piece, and she gradually demurs, allowing him to speak at length on what *he* believed she had intended to do.[32] When he is done, she offers a few more observations, and the interviewer moves on to other topics, but he insists on circling back: "If I may say so, that's a hilarious oversimplification of what you did." The interviewer allows the comment, but then tactfully ignores it: "To get back to [Eleanor's other work] . . . ," she deflects.[33]

* * *

At stake in David and Eleanor's disagreement over *Eleanor of 1954* is precisely the sort of blended affect that Sexton pioneered. David wants to emphasize the tricksiness of Eleanor's performance, whereas Eleanor wants to find the sincerity within the artifice, the confession within the "bullshit." When David speaks of her "conced[ing that she] had been unfair" to this younger self she conjured up, Eleanor exclaims, "Then I was defending someone. There *was* someone before."[34] If Eleanor wanted to "discover and invent" herself, David set himself above such goals, scoffing at the (majority-female) crowd: "The audience was weeping, except for the few of us who were, you know, in odd relationships to the truth. You had the audience freaked out with compassion and sympathy," he crows, implying that such investments were exposed, not evoked, by Eleanor's performance. "One of the most interesting aspects of the thing," he concludes, correcting her "hilarious oversimplification" of her own performance, "was how hard it was to determine who was telling the truth: this one, or that one?"[35] Such questions, designed not to clarify an actual choice, but to elicit a skeptical frisson in the face of

any choice, belie the complexity of Eleanor Antin's work. Far from forc-
ing us to choose between "this one, or that one," the performances of
Anne Sexton, of Eleanor Antin—indeed, of a whole strain of women's
performance—explore the territory underneath, through, between, or
beyond the self, where "another, the *real* me" might lurk. They reject the
easiness of identity without denying the desire to discover (*and* invent)
an identity for themselves.

The sort of easy skepticism David Antin celebrates was, in fact, part
of "the problem" in the first place. As one of Betty Friedan's informants
attests: "There's no problem you can even put a name to. But I'm desper-
ate. I begin to feel I have no personality."[36] This instability, for her, is an
existential problem—not, as for David Antin, a philosophical accomplish-
ment. Peggy Phelan, in a survey of "art and feminism," has suggested that
the rise of second-wave feminism might be considered a kind of trauma.

> All these women waking up and realizing together that they had been
> sleeping for years, if not centuries, might best be addressed as an experi-
> ence of collective trauma. It rarely is, however.[37]

The deconstructive critique of identity (and later feminist theories built
upon it) offer to cure this sort of trauma through homeopathy. Proving
the radical instability of *all* identity, they offer to normalize this trauma
and extend it across the world. This is not, however, the medicine that
Eleanor Antin is prescribing. Although David was allowed to parade
across the battlefield of that interview uncontested, Eleanor seems to
have won the war. In a recent essay, David Antin confesses to having
once believed in "the idea of the exhaustion, experiential and aesthetic,
of representation in all its forms," and particularly in "the uselessness
of narrative."[38] This belief in "exhaustion" surely inspired his search
for cynical tricksiness in *Eleanor of 1954*, but in this latter-day essay, he
espouses a theory of narrative that might easily describe Eleanor's own
understanding of that performance:

> [B]ridge building across change . . . is the central human function of
> narrative. . . . Every change creates a fracture between successive subject
> states that narrative attempts and fails to heal. The self is formed over
> these cracks.[39]

. . . as, in fact, it *was* that night in 1974 at the Woman's Building in Los Angeles. The confessional selves of Eleanor Antin, understood as prompting acts of recuperation or repair, offer neither an essentialist vision of her one, true self, nor mere satire on the idea of identity. Instead, they present identity as a kind of *work*—life-work—continuing steadily over time.

In doing so, Antin's selves resemble the "disidentities" José Muñoz discovers in queer artists of color. These artists, Muñoz argues, refuse "the fiction of identity . . . accessed with relative ease by most majoritarian subjects," but they do not, in the process, cast aside identity or identity politics. Instead, they offer "a version of self that is crafted through something other than rote representational practices, produced through an actual disidentification with such practices."[40] Exposing the consciousness-raising monologue as a kind of "shamanism," Antin "disidentifies" with this popular ritual and rejects its promise of a clean break with the past, but she does so not in order to mock CR's project of feminist self-making, but in order to better represent the self.[41] Performing herself through and against the confessional ritual of CR, Antin suggests that a struggle with identity is, in fact, the defining experience of women under second-wave feminism. This self-conscious struggle, as it manifests across women's performance of the 1970s, is the subject of Chapter 2.

2

Self-Consciousness Raising

The Style of Self-Performance in the 1970s

> Mr. Oscar Wilde, considered by some the great expert on
> this subject, said that, in matters of importance, it was not
> sincerity that mattered but style. To the true stylist they are
> the same thing.
> —Quentin Crisp, *How to Have a Life-Style* (1979)[1]

May 1973, San Francisco—It's a beautiful day. Birds chirping: you know
the sort. A woman has set up a treadmill outside the Art Institute, and
she hikes its endless incline. Given her strenuous task, she's wearing a
rather odd outfit: a stiff, gauzy gown, as if she's ready to head off to the
senior prom. On her feet, though, you can see incongruous moccasins,
and above those, every once in a while, a trouser leg. Aha! *This* is an
outfit more befitting a woman artist in America's most liberated city.
(See, those women across the way are sporting the proper attire: long
pants, sturdy shoes, clothing all in darker hues.) It's getting hot for late
spring—check out the shirtless man who's watching all this from the
hood of his car—but an uphill climb and this unseasonable heat aren't
the only things wearing this woman down. Layers of clothing and rows
of onlookers aren't the only things hemming her in. A flood lamp blazes
up into her face, a tape player sags from her shoulders (playing the bird-
song you thought you heard), and a metallic device cinches her cheeks
back into a smile. Her teeth, exposed by this device, are spotted blue
with some sort of plaque-seeking dye. *It looks like someone is due for a
cleaning.* Hey, it's all right if you're embarrassed. It's only normal to feel
her pain—the pinch in her cheeks, the heat on her face, and the slow,
lactic burn building up in her legs.

This much you can see at a glance, but it takes longer to discern what
this woman is saying exactly. She speaks into a microphone, which,

Figure 2.1. Linda Montano, *The Story of My Life* (1973). Photograph by Mitchell Payne. Linda Montano Papers, box 23, folder 17, Fales Library and Special Collections, New York University Libraries.

besides amplifying her voice, also adds reverb, muddying the sound of her words. But all the *I*'s and *my*'s give her away: this is a life story, a confession, and its meandering shape suggests that she's speaking extempore—all to be expected if this is, as you're starting to suspect, an "art performance." You circle around to the other side and whisper a question to that woman standing closest to the artist. She's been here since the performance began, and so she can tell you that it started with the tale of the artist's own birth—and, since then, she has just kept inching along through the story of her life. You can't afford to stick around, but sometime later you hear the performance wound up lasting about three hours in all. That's how long it took to bring the story up to the present day, and, as soon as that happened, she stepped off the machine and was done.

The woman's name is Linda Montano, a performance artist, and this is an ordeal of her own devising. In it, she pits her own desire to confess against so many constraints as to be either pitiful or absurd. But these constraints were, in fact, designed to fail. In spite of them, she would

succeed in telling us her tale, and in the process she would achieve greater access to herself—even, perhaps, to something beyond herself. Writing eight years later, Montano gave the piece a title, *The Story of My Life*, and explained her reasons for performing it:

> I wanted to get into myself so deeply that I would be able to get out of myself and knew that it was just a matter of time before that would happen. Actually, the piece produced physical euphoria and as a result I couldn't stop walking once the piece was over because my legs had been programmed to move in one way and couldn't stop. My body had a mind of its own.[2]

Montano's description carries hints of Eastern spiritualism, but also Western sadomasochism—the violent power that, according to Michel Foucault, lies at the heart of every confession in the West.[3] Montano wanted "to get out of [her]self," and whether she did so by wearing herself down or fighting back, one thing was clear: she was not only telling the story of her life, she was also putting that story to use. Perhaps this is why Montano never wrote a script for this performance, nor ever had a transcript or recording made. As she accessed and altered herself through narrative, it was the telling that mattered, never the tale.

Of all the contexts we could bring to bear on this piece, one would surely have sprung to the minds of her audience: consciousness raising (CR), that feminist rite where women share their life stories with one another, hoping they will add up to something more. By 1973, CR was everywhere in America, but especially on the West Coast and particularly in the art world. Many considered CR essential to the practice of feminist art—especially feminist *performance* art. As Moira Roth observes, "Whether or not a performer had belonged to a consciousness-raising group (and many had), performance art constituted a perfect medium for the translation of this information into art."[4] Roth never explains why, but the reasons are easy to deduce. Not only did CR coax women into sharing their life stories, turning them all into confessional performers; its proponents also evangelized for an essentially theatrical vision of the world. Drawing on existing feminist rhetoric—e.g., that *woman* was a "role" and femininity a "masquerade"—women in CR were encouraged to understand our sexist world as nothing but bad, stale theater. "We

believe there's something wrong with those roles we're supposed to spend our lives acting out," say the authors of one CR pamphlet.[5] In CR, women learned to "drop their . . . masks," move beyond tired roles, and cast off oppressive scripts.[6] No wonder, then, that performance art proved the "perfect medium" for women inspired by CR. If the goal was to explore (and expand) women's "roles," then how better to do so than by performing? And if their aim was to rebel against a sexist sort of theater—what most people knew as plain old life—then how better to revolt than by dropping your mask in public, as you'd first learned to do in CR?

And yet *The Story of My Life*, though it obviously cites CR, feels ill-aligned with its methods and aims. Montano's speech isn't intimate and direct, but ceremonial—more like liturgy than chat. And though she speaks of wanting "to get into myself so deeply that I would be able to get out of myself," she's not exactly getting out and *into activism*. She seems far more intent on altering her personal consciousness than on raising anyone else's political awareness. Just like Eleanor Antin in *Eleanor of 1954*, Montano is citing CR only to abuse it. Both artists reroute CR's narrative content through bizarre new rituals of their own invention, and in the process they expose CR's own ritual nature and implore us not to embrace this new religion blindly. They're not sneering at second-wave feminism—nor are they writing off CR altogether. They just want us to feel a bit more self-conscious about consciousness raising. They want the practice of feminist CR to be as "conscious" as its content and conclusions were supposed to be.

Many commentators and critics dismiss feminist performance of the 1970s as simplistic or sentimental—a mere pidgin translation of CR into art. If this is true, then Antin and Montano are the exceptions—lonely voices crying out in vain defiance of their time. Either that or they were ten years ahead of their time, because in the 1980s—the story goes—naïve confessionalism gave way to an ironic, critical style. Perhaps Antin and Montano were just untimely ironists, women ready to start the '80s, if only the '70s would let them. I don't buy it. We simply like to tell this kind of story: *they thought like we do, only sooner*. Take, for example, Jeanie Forte who, writing in 1988 about women's performance art of the 1970s, praises its "deconstructive nature" (*avant la lettre*) and marvels at how these women managed to anticipate where performance art (and, more to the point, performance theory) would later go:

Women performance artists show an intrinsic understanding of culture and signification apparently reached solely through their own feminist consciousness-raising and political acumen.[7]

But what would happen if, instead of celebrating select artists as somehow ahead of their time, we were to treat them as women *of* their time? Delaying the rush to later theories (*our* theories), we would have to plumb this art for its own indwelling theories. On closer inspection, the truth of this art is much stranger than our critical fictions would suggest. Sincerity and irony, confession and parody, commitment and camp coexisted in this art, appearing together in the same galleries, in the careers of single artists, and even sometimes within one performance.

Such an account of '70s performance will do more than set this one small corner of the record straight. It will also sharpen our understanding of performance art generally, which has too long been blunted by this reductive binarism. As Peggy Phelan points out, the general public has two images (and only two) of the performance artist. Either she is full of "angst and fire" or she is all "smirk and smile."[8] She is, in other words, either crudely committed or smartly aloof, but never both or in between. I say "she" because, of all the art afflicted with this binary, women's art has suffered most—and West Coast feminist art the most of all. As Helena Reckitt explains, there is an

> especially crude version of American feminist art history which suggests that all the conceptual (read "smart") work was made on the East coast, and all the intuitive and activist (read "non-intellectual") work on the West coast.[9]

Women like Antin and Montano are proof to the contrary. With performance careers that ranged from straight-up confession to exaggerated roleplay, such artists confound our desire (evident in critical histories of feminist performance—and of performance more generally) to segregate confession from roleplay, personal involvement from political detachment, the efficacy of ritual from the subversions of critique. But art can of course be *both*—conceptual and activist, smart and intuitive, critical and sincere, smirking and full of fire. In the 1970s, Antin and Montano took part in a contemporary trend: to seek the truth of the world by first

examining themselves. But they never assumed that all masks could be dropped. Instead, they wore masks of their own devising. Rather than pretend to have achieved a sincerity that needed no style, they sought the style their sincerity needed.

The Personal and the Political

If Montano and Antin were taking jabs at CR and its culture of confession, perhaps these jabs were well deserved. Second-wave feminists saw CR as a place for confession without abjection: a democratized site for the common speech act. But, at the same time, this feminist rite has been justly criticized for enabling classist, racist, and heterosexist thinking. Leaping straight from "the personal" to "the political," coming by way of confession to a quick understanding of women's "commonality," these mostly white, middle-class women ran the risk of discovering a white, middle-class (and yet somehow "universal") womanhood. Kathie Sarachild, a "major architect of consciousness-raising," later admitted as much to historian Alice Echols: "the assumption behind consciousness-raising was 'that most women were like ourselves—not different.'"[10] The true measure of feminist art, then, is not its irony or sincerity, but its capacity to deal with difference.

Judy Chicago and Miriam Schapiro, leading feminist artists and educators, are common targets for this line of critique. Exhibit A in any charge brought against them is the 1973 essay they co-wrote, "Female Imagery." In it, they ask,

> What does it feel like to be a woman? To be formed around a central core and have a secret place which can be entered and which is also a passageway from which life emerges? What kind of imagery does this state of feeling engender?[11]

If this sounds like a high-concept version of a CR discussion prompt, it's no accident. Chicago founded the Feminist Art Program (FAP) at Fresno State, then co-ran it at CalArts with Schapiro, and together they pioneered the use of CR in the classroom and studio. They used it to nurture young women, to build a sense of community, and to

generate subject matter for art. Faith Wilding, first a student, then a teaching assistant in the early days of the FAP, recalls,

> By fortuitous accident, it seemed, we had stumbled on a way of working: using consciousness-raising to elicit content, we then worked in any medium or mixture of media—including performance, roleplaying, conceptual- and text-based art, and other nontraditional tools—to reveal our hidden histories.[12]

In light of later critiques, one phrase sticks out in this passage—and one specific word within that phrase—"*our* hidden histories." Within that first-person plural pronoun lurk all the dangers of false universalism, of the "us" in the room turning into "us all." But as I've read and reread this passage, my unease has come to center on another, less conspicuous phrase: the one about using CR "to elicit content" for art, with no regard to CR's form.

A passion for the content of CR was hardly the only thing drawing women to this practice. Dorothy Tennov, in a pamphlet called "Open Rapping," claims that CR is "a tactic beautiful in itself rather than an ugly means to a worthy goal."[13] If women found CR beautiful, if they took pleasure in its workings, this was mostly a matter of form. I don't mean form in the abstract, architectural sense, but rather the kind that you experience—the thing you feel forming, over the course of minutes or months. "[W]e would jump from topic to topic as new ideas flew from one to another, fragmenting the political from the personal," Ronnie Lichtman explains.[14] "The animation, the excitement of developing a point, the back-and-forth questioning and corroboration that goes on is literally mind-expanding," Letty Cottin Pogrebin enthuses.[15] "Not only do we respond with recognition to someone's account," writes Pam Allen, "but we add from our own histories as well, building a collage of similar experiences from all the women present."[16] This sort of narrative collage—not a static image, but a practice of fragmentation and reordering—can comprehend all sorts of differences among women. Problems arise only when we move from this process to its product. According to Lynn O'Connor, CR participants inevitably discover "that there is a common thread running through each story; that in fact they

have all been telling the same story with minor variations."[17] They should then, says Lee Walker, "combine all their views into a composite, consistent picture" that will form the basis of their politics.[18] They should, in other words, replace a "mind-expanding" form with a limiting and reductive sort of content. "The personal is political"—this slogan needn't imply a reduction of the personal *to* the political, but this is apparently what O'Connor and Walker are after. They want to turn the feminist movement's rallying cry into some sort of alchemical formula: personal stories are transmuted into politics and, if it works, then we are left with no trace of the personal, of social circumstance, of unforeseen difference.

When Wilding speaks of using CR "to elicit content" for her art, I fear she is describing this sort of alchemy—abandoning the tensile form of CR for its static, composite by-product. Wilding's most famous performance of this period, the monologue *Waiting* (1972), first performed as part of the ground-breaking *Womanhouse* installation, is pretty much entirely content. Each line of its poem-like text begins with the same word, then names an iconic moment in Woman's life. For example:

> Waiting to get married
> Waiting for my wedding day
> Waiting for my wedding night
> Waiting for sex
> Waiting for him to make the first move
> Waiting for him to excite me
> Waiting for him to give me pleasure
> Waiting for him to give me an orgasm [etc.][19]

As she progresses through the events of one life in order, Wilding covers an impressive range of subject matter—mother-daughter relationships, "feminine" dress, breasts, menstruation, dating, love, shaving, marriage, sex, orgasm, pregnancy, labor, breastfeeding, childrearing, aging, illness, and death—but she does so in sentence fragments that literally lack a subject: from "Waiting for someone to change my diaper" to "Waiting for the struggle to end." According to Arlene Raven, *Waiting* "exemplifies the consciousness-raising effort of the women's movement of the time—breaking silence by speaking, and thus revealing women's

bitterness as a chorus of single voices."[20] Yet there is nothing about these lines to suggest any appeal to "single voices" at all. If they had once been audible in all their difference, involved not only in "corroboration" but also in "back-and-forth questioning," they are now seamlessly combined, fitting into the arc of a single life story—a composite, consistent picture. In fact, nothing about Wilding's performance suggests any "voices" at all. Her words imply all sorts of feelings—not just the "bitterness" Raven hears ("Waiting for my husband to die"), but also shame ("Waiting to stop being clumsy"), ennui ("Waiting for excitement"), regret ("Waiting for life to begin again"), and despair ("Waiting for my body to break down"). Despite this wide range of feelings, though, Wilding goes out of her way to show none of these in performance: instead, she "rocks slowly in her chair and speaks in a low monotone from beginning to end."[21] Is this a quasi-realist portrait of a woman stripped of her individuality—or even her sanity—by a sexist culture? (Echoes of Betty Friedan's informants in *The Feminine Mystique*.) A video of Wilding's performance suggests something else: she intones her lines like a speaking doll, then, at the end, slows to a stop like a toy winding down.[22] (Echoes of Sexton's "Self in 1958.") Or has Wilding simply turned herself into a vessel or medium for the transcendent plight of Woman, the universal bearer of "*our* hidden histories"? If so—and I have trouble thinking otherwise—then the implied subject of all those sentence fragments isn't "I," but the perennially problematic "we"—CR's content taken raw, without even a grain of salt.

That isn't to say that CR-based art (or politics) can't succeed through "strategic essentialism."[23] Political action felt urgent, no doubt, so who can blame them for proceeding on the basis of a few crude generalizations? Other art out of the FAP shows how such work can be done without precluding all difference. The same year that *Waiting* premiered, other women of the FAP mounted a performance piece called *Ablutions*. This performance, obviously inspired by the confessional mode of CR, deserves the protections of that label *strategically essentialist*—most of all because it leaves room for the "single voices" of women who speak both of their agreement and their difference. Judy Chicago and Suzanne Lacy had long been gathering the testimonials of rape survivors as part of an oral history project, and in *Ablutions* they used many of these tapes (along with some abstract body art) to inform their audience and stir them to action. Moira Roth has recorded her own memory of the piece:

The performance took place in an area strewn with egg shells, piles of rope and fresh meat. A tape of women describing their experiences of being raped played, while a naked woman was slowly and methodically bound with white gauze from her feet upward to her head. At the same time, a clothed woman nailed beef kidneys into the rear wall of the space, thus defining the perimeter of the performance area, while two nude women bathed themselves in a center stage series of tubs containing first eggs, then blood, and finally clay. Finally, two women bound the performance set and other performers into immobility with string and rope. As they left the space, the tape repeated, "and I felt so helpless all I could do was just lie there. . . ."[24]

The symbolism of eggs (fertility), blood (violence, but also menstruation), and clay (death, but also the empowering Earth Goddess depicted in so much 1970s feminist art) may threaten to push this piece in the direction of Chicago and Schapiro's universal language of "Female Imagery."[25] But this same imagery, when presented alongside the "single voices" of real women, seems less coercive somehow, less reductive—and thus more in keeping with CR's "mind-expanding" power. The body art of *Ablutions* is an act of empathy toward these women and their experiences of sexual trauma—fresh meat and beef kidneys offered in exchange for the "blood-dripping gobbets of experience" that these women had bravely shared with Chicago and Lacy.[26] The personal and the political, the raw and the cooked are held together here in exquisite tension. Rather than trying to offer a "composite, consistent picture," the creators of *Ablutions* insist on "fragmenting the political from the personal."

Feminist Theory and Confessional Drag

But just because you *could* have collectivity without (false) universalism doesn't mean that, in practice, it was common. And so the pendulum swung. Critics and theorists of the 1980s agreed on a new model for feminist theory and art—one that was, they thought, confession's antithesis: drag. Anyone casually familiar with feminist thought will think immediately of Judith Butler's influential *Gender Trouble*. In that book, Butler offers drag as an outsized illustration of what she calls gender

"performativity," and she uses both drag and "performativity" to argue against "expressivist" models of identity. These aspects of *Gender Trouble* are not, though, sui generis. They simply consolidate what was, by then, the party line in feminist thought—especially in the field of theater and performance studies. For a full decade, critics and theorists had been clamoring to trade old theories of "femininity as masquerade" (i.e., the theatricalist ideology of CR) for a new understanding of "femininity as drag." The earliest issues of *Women & Performance*, for instance, contain inklings of this now-common idea. In 1983, in the lead essay of that journal's first issue, Martha Roth argues that, given the patriarchal legacy that continues to shape Western theater, *all* women onstage are at risk of becoming "female impersonator[s]" (then, a common synonym for "drag queens").[27] Jill Dolan, writing for the same journal two years later, turns this argument around: if women do embrace drag as a model for performance, they may "debunk the myth that woman even exists."[28] (Take that, Judy Chicago!) Meanwhile, under the editorship of Sue-Ellen Case and Timothy Murray, *Theatre Journal* published a slew of articles strengthening this feminist claim on drag—among the very last of which, by the way, was the first bit of *Gender Trouble* ever published.[29] Drag was obviously attractive to '80s feminists as a campy counterweight to sincere '70s feminism—a finger in the eye of all those gender essentialists who had used CR to bolster their claims. But it was also appealing because, even within gay politics, drag could be seen as an alternative to confession. Just like second-wave feminism, the gay liberation movement of the 1970s also relied on a confessional rite of passage into politics: coming out.[30] So, down with confession—feminist or queer—and up with drag!

This simple contrast between drag and confession has an odd way of polarizing everything it touches. We are left with two choices: the dumb sincerity of confession or the pure, critical irony of drag—or, to recall Phelan's words in a new context, "angst and fire" or "smirk and smile," but nothing else or in between. These theorists may have thought they were lionizing drag, but in fact they were appropriating its power. They thought they had replaced "masquerade" with "drag" in their thinking, but they had actually turned drag into mere masquerade—a pure parody of binary notions of gender, stripped of its power to express a range of queer identities. Cynthia Morrill, writing in 1991,

bemoans what by that point looked like a thorough "acquiescence to the model of 'camp-as-masquerade'" even within queer theory:

> defining Camp as a type of ironic gender play through notions about mimicry and masquerade, and aligning its performance with a political critique of phallocentric ideology, often displaces the specificity of the queer subject. . . .[31]

Morrill must have been thinking of *Gender Trouble*, published only a year before her essay. Drag, according to that book, "fully subverts the distinction between inner and outer space and effectively mocks both the expressive model of gender and the notion of a true gender identity."[32] To mock rigid conceptions of gender is one thing; to dismiss all "gender *identity*," quite another. When Butler claims that "the very notion of 'the person' is called into question," by such departures from "coherent" gender, she ignores the lived reality of queer subjects who sought desperately to be acknowledged as "persons" even while living outside normative, binary notions of gender—people who built and expressed strong identities in defiance of society's judgment upon their "coherence."[33] Surely, she knew that queer subjects like these were getting caught in the crossfire of her argument, but she must have viewed them as collateral damage—unfortunate yet inevitable casualties in the war to deconstruct binary notions of gender.[34] After all, for Butler (and for so many like-minded thinkers at the time) "deconstruct" was an awfully strange sort of verb: terminally intransitive, with either everything or nothing as its object. So, what's a theorist to do?

There is, however, another vision of drag (and of deconstruction, too)—one that, even while undermining normative gender, keeps queer identities out of the blast zone. Drag performers may, for instance, mock gender binaries in order to permit freer gender expression—a first step toward finding a "true gender identity" they can call their own. This vision of drag is certainly alive and well today—for instance, in the performances of Taylor Mac. Not only does Mac use the self-conscious distance of drag to tackle difficult, confessional material; drag also allows Mac to express a "true gender identity" beyond rigid conceptions of what that might entail. The person with the fright wig, the sequined lips, and the gender-queer wardrobe is, Mac insists, "who I really am."[35] I

heard this comment during a talkback after a performance of judy's drag revue, *The Be(a)st of Taylor Mac*. (Lowercase "judy" is Mac's preferred gender pronoun: "And I will say, when people use it, it really makes me happy!")[36] So, there judy sat answering questions in a hoodie and jeans, bald head bare, face wiped clean of any makeup—the very picture of backstage realness—and yet none of this, Mac was saying, was as real or as true as the identity judy had just performed. Drag, for Mac, isn't a path out of confession; it is, in fact, the royal road to self-expression.

Camp sincerity like this isn't new; it also existed in the 1970s and before. Take, for instance, Quentin Crisp—queer memoirist, performer, and self-dubbed "mail-order guru"—who spent his life advocating, practicing, and performing "style." Born in England in 1908, Crisp unsettled his contemporaries with his frankly effeminate manner, strutting down the streets of 1920s London in full makeup, nail polish, and a sweeping scarlet hairdo. His 1968 memoir *The Naked Civil Servant* made him famous in England, and when the BBC made a biopic of Crisp with that same title, it was a surprise hit in America. Seizing his chance, Crisp rented an Off-Broadway theater and became, at seventy years old, the unlikeliest debutant of the 1978 theatrical season. Crisp's one-man show *An Evening with Quentin Crisp* ran off and on for nearly five years, playing in theaters, comedy clubs, and other New York venues while touring occasionally to other North American cities. The show consisted of two hour-long acts separated by an intermission: in the first he lectured on personal style, drawing heavily on his own life for examples, and in the second he took questions from the audience—many about himself and his private life, to judge from a live recording made in 1979.

Although this may sound like the profile of a high-camp subversive, Crisp was remarkable instead for his camp sincerity. He might well have embodied what Susan Sontag, in "Notes on Camp" (1964), calls *instant character*: "a state of continual incandescence—a person being one, very intense thing."[37] And yet, while Sontag conflates style with artifice, Crisp often claimed (contrary to Oscar Wilde, whose epigrams adorn Sontag's essay) that style can and should be sincere—that, in fact, it *allows* true sincerity to exist. Whereas Sontag sees camp as the "the farthest extension, in sensibility, of the metaphor of life as theater,"[38] Crisp proudly relates the following anecdote to his New York audience (which I transcribe from the 1979 LP):

When the manager of the theater where I was playing in London was asked why I was occupying a stage without an Equity card [i.e., without being a member of the actors' union], he replied, "Mr. Crisp is not acting; he's very sincere."[39]

Style, for Crisp, is not an assumed identity, but a perfected self—not an acquired language, but "an idiom arising spontaneously from the personality," then "deliberately maintained."[40] In fact, responding to one audience member who compares his philosophy to that of Oscar Wilde, Crisp objects: "Style isn't a lot of dandyism. It isn't a lot of flourishes encrusted upon your public image. It's a way of stripping yourself of everything *except* your true self."[41] Counterintuitively, style is a species of existential nakedness. While acknowledging that the self is socially constructed, Crisp believed we could participate in its construction. We must simply swim "with the tide, but faster."[42] In his no-nonsense way, Crisp envisions a world of style without guile, and his performances—on the streets and the stages of New York—showed how camp might clear the way for new kinds of sincere expression.

Drag performers, in fact, have often dwelt in these borderlands, though not always with Crisp's glibness and ease. Indeed, if we return to Judith Butler's own source on the subject, Esther Newton's *Mother Camp*, we discover a complex range of stances toward drag in gay communities of the late 1960s: from men who wear their drag lightly to those we'd now want to call genderqueer or transgender. If this range ever narrowed, it was because of concessions made to drag's oppressors. Consider this observation from Newton:

> The limiting condition on drag in public places is its illegality. Thus, on Halloween, drag is legal as a masquerade, and in predominantly homosexual communities . . . the police are not always stringent.[43]

Drag became a masquerade, then—or, *merely* a masquerade—under compulsion from the law. Only in "homosexual communities," where these laws were laxly enforced, could one skirt, so to speak, this imperative to masquerade. All this was clearest to those professional drag queens who performed at both gay bars and straight clubs, as one of Newton's informants did. He explains:

. . . so many of the kids take themselves so seriously. A straight audience won't stand for that. . . . You have to do drag always with tongue in cheek. My act is all comedy; there's nothing serious in it. I poke fun at myself, to let the audience know I'm not serious. . . . [Y]ou must *break* this mask of femininity. If you don't, people say, "Ahhh, that *fruit!*"[44]

With pure irony, *he* would disown what, a few blocks over and a day later, *she*'d happily avow. From lark to liberation in the wink of an eye.

I hardly mean to imply, though, that the late 1960s was a golden age of liberatory queerness. *Mother Camp* is full of the invective that "stage impersonators" would hurl at "street impersonators"—that is, at people who insisted on wearing drag out onto the streets of the (straight, cis) world. As many of Newton's informants complain, these queens are "'giving us a bad name' or 'projecting the wrong image' to the heterosexual world."[45] *Mother Camp* is also full of older queens trashing the "transy" drag and "pussy" clothes of their younger counterparts; they look "too much like a real woman," one performer explains, "It's not showy enough."[46] Clearly, this was a world in transition. But in preserving this sense of possibility and conflict, we open a space between ironic drag and sincere trans womanhood—a space where sincerity and irony can coexist.

This possibility might not even occur to someone whose sense of drag was shaped by '80s and '90s feminist theory—or whose notion of camp begins and ends with Sontag. To such a person, you either accept identity's intransitive deconstruction or you believe in a simplistic "core self" who chooses gender like a shopper grabbing a dress off the rack. Esther Newton and Quentin Crisp (what a couple!) point us instead toward what I like to call "the Core self"—the vision of camp identity proposed by Philip Core, author of *Camp: The Lie That Tells the Truth*. At least since Christopher Isherwood's novel *The World in the Evening* (1954), the idea of camp has been inextricable from acts of list-making, which experts use to initiate others into camp's esoteric knowledge. In the following scene from Isherwood's novel, one character has just begun introducing the idea of "camp" to another, when he stops and asks,

"Do you see what I'm getting at?"
"I'm not sure. Give me some instances. What about Mozart?"
"Mozart's definitely a camp. Beethoven, on the other hand, isn't."

"Is Flaubert?"

"God, no!"

"And neither is Rembrandt?"

"No. Definitely not."

"But El Greco is?"

"Certainly."

"And so is Dostoevsky?"

"Of course he is! In fact, he's the founder of the whole school of modern Psycho-Camp which was later developed by Freud."[47]

Sontag's "Notes on Camp" continues this tradition, not only in its form (a numbered list of aphorisms), but in its content, which is peppered with catalogues of what is and isn't camp. As all this careful list-making implies, camp cannot be represented directly; it must be *triangulated* through an intuitive, collaborative process. Philip Core continues this tradition by beginning his own work with a long list of aphorisms. I select four of them here:

> CAMP is a biography written by the subject as if it were about another person.
> CAMP is a disguise that fails.
> . . .
> CAMP is an ephemeral fundamental.
> CAMP is cross-dressing in a Freudian slip.[48]

The Core self, like camp itself, is not something to be represented, but rather glimpsed, spotted, spied through the gaps—in this case, the many gaps between being and appearance. The Core self is a fundamental truth that reveals itself only in ephemeral ways. It is the self people reveal when they seem (but only seem) to hide or deflect attention. It is the Freudian slip that you glimpse for one second, peeking out from underneath a queen's gown.

Take Two: *The Story of My Life*

In this light, Montano's *The Story of My Life* begins to look like a signature instance of camp sincerity—even of drag, though drag of a rather

unusual sort. Geraldine Harris coined the phrase "double drag" to describe feminist acts of masquerade: women *play men* playing women, dressing themselves in sexist clichés, if only to show how badly they fit.[49] The gown Montano wears for *The Story of My Life*—high femme, all ruched satin and layered chiffon—seems well suited to an act of "double drag," but the rest of her outfit says otherwise. Hanging out at every hem is the masculinized wardrobe of a liberated West Coast woman: T-shirt, trousers, and moccasins. So, a woman plays a man playing a woman playing a man playing a woman—the two polarities of gender start to alternate so quickly, the whole system short-circuits. Only then, with binary gender on the fritz, can Montano begin to confess. Drag clears the way for confession. Irony carves out a space for sincerity.

This last sentence describes not only Montano's approach to gender, but also her approach to her work's mediation. Like a suit of triple drag (quadruple drag?)—anyway, drag *en abîme*—Montano's media are layered on thick. In *The Story of My Life*, there's a microphone and an amplifier distorting her voice, a tape player piping in birdsong, and that dental device—arguably the treadmill, too—impeding the flow of her intimate speech. Montano loved burying her acts of confession this deep, letting them almost get lost amid the noise. But, just as her multi-layered drag did not mock gender identity, but allowed her to proceed unchecked by gender binaries, so these mediating layers do not impugn her confessions, but rather ensure them a truer expression. If she adopted a conventional style of sincerity (say, the intimate voice of feminist CR), her confessions would run the risk of coming too easy—being too glibly performed and too readily received. Worse yet, this chosen style—presumed transparent—might, in fact, occlude the story she's trying to tell.

Montano later gave this treatment, first applied to CR, to hypnosis: a practice that promises not just sincere expression, but unmediated access to the self. The title of her piece *Talking About Sex While Under Hypnosis* (1975) is pretty straightforward: she hired a hypnotist to put her into a trance and then ask her a series of probing questions about her attitudes toward sex—a standard subject for both psychotherapy and CR.[50] She entered this trance, though, not in front of an audience, but instead alone in front of a camera. What her audience saw was only a video installation—more intimate than a performance thanks to its close-up view, yet more distant thanks to its lo-fi texture and its small-screen

presentation. Watching this video, Montano's audience would *feel* their uncertain distance from her confessions. And, if the video alone didn't achieve this effect, Montano ensured that its placement in the gallery would. She presided in person over the gallery where this video played, but she did so in costume, playing a role. She also covered the walls of the gallery with "twelve photographs of myself as different people," surrounding her true confessions with an array of disguises. But just as we were never meant to accept hypnotized speech as pure fact, none of these roles or costumes was pure fiction. Roaming the gallery, Montano appeared "dressed as [her] sister" and the "different people" she played in the photographs were, in fact, a range of possible selves. As she explains, the photographs showed her dressed in "things from my closet which changed my personality when I wore them." Such personal experimentation, a step or two shy of roleplay, was known at the time as "transformation." Not yet reaching for outlandish extremes, artists were instead making forays around the edges of their selves. Wearing "a disguise that fails," "cross-dressing in a Freudian slip," these artists embraced a sort of camp sincerity. Like Montano, they mocked too-easy access to confessional truths, but led their audience the long, hard way back around to confession.

Fearing, perhaps, that she had done too little in *Talking About Sex . . .* to undermine hypnosis, Montano returned to this premise later that same year in a performance she called *Hypnosis, Dream, Sleep* (1975). Again, she was hypnotized, but now she appeared in a gallery where her audience could witness the results firsthand. If this sounds like a chance for them to access the raw truth that her other hypnotic performance withheld, then Montano made doubly sure it wouldn't wind up that way. She had the hypnotist plant a suggestion that would make her confessions seem doubly, triply strange: "I was hypnotized to be able to dream and sleep in the museum for three hours," she explains, "and then to sing the dream [I had] into [a] microphone."[51] Whether or not you believe that a hypnotist can successfully plant such an elaborate suggestion— and you have to wonder whether her audience did—the point is clear: hypnosis, too, has a style and form. It, too, is a practice that mediates the truth. Debunking the notion of a true, unstyled self, Montano is free to find herself, like Quentin Crisp, in style.

Documenting Camp Sincerity

Montano wasn't alone in this approach: blending camp sincerity with a certain zeal for mediation. Around the same time, Eleanor Antin was doing drag (e.g., playing the "King of Solana Beach") as well as masquerade (e.g., playing a prima ballerina) as part of a complex, multimedia performance practice she called—with defiant sincerity—autobiographical. Antin even experimented with drag in real life, but like Montano's it was always drag *en abîme*. In a project she called *4 Transactions* (1972), she pledged to attend an encounter group with other artists, but to do so with a secret agenda. She drew up contracts that required her to follow certain rules, then signed these contracts and had them notarized. In one of these "transactions," a piece called *Encounter #2*, Antin vows:

> At the February 27th meeting I shall come in drag. I will wear a green velvet maxi-dress, Spanish boots, and a brown suede gaucho hat from Saks 5th Ave. It will be the first dress I have worn in over 2 years.

In what sense is this "drag"? Given that she ends with the fact that this "will be the first dress I have worn in over 2 years," perhaps she considers the dress alone to be a kind of drag. Other women might call this a masquerade—the "double drag" of performing a disavowed femininity—but the rest of her outfit doesn't fit with this reading. "Spanish boots" and a "gaucho hat" are hardly the stuff of misogynist fantasy, but neither are they unironically macho. These were literally the clothes of a drag king: part of the outfit Antin wore whenever she played the King of Solana Beach. Antin's gender-queer performance is only complete, though, when a government bureaucrat—the poor straight man to Antin's act—must perforce assign her a gender, typing "She" into a blank space on the standardized notary form. That bureaucrat—you can't make this stuff up—actually signs his name James M. Camp.

Antin's use of Mr. Camp, notary public and unwitting performance art archivist, leads me to wonder: is there something inherently campy about performance documentation? There is certainly something queer, says José Muñoz in his essay "Ephemera as Evidence." "Central to performance scholarship," Muñoz asserts, "is a queer impulse that

ENCOUNTER #2

At the February 27th meeting I shall come in drag. I will wear
a green velvet maxi-dress, Spanish boots, and a brown suede
gaucho hat from Saks 5th Ave. It will be the first dress I have
worn in over 2 years. I will not let anyone know it is my
birthday.

Eleanor Antin

STATE OF CALIFORNIA
COUNTY OF San Diego
On Feb. 26, 1972
said State, personally appeared Eleanor Antin

known to me to be the person whose name is
subscribed to the within instrument and acknowledged to me
that She executed the same.
WITNESS my hand and official seal.
Signature James M. Camp
James M. Camp
Name (Typed or Printed)

OFFICIAL SEAL
James M. Camp
NOTARY PUBLIC CALIFORNIA
PRINCIPAL OFFICE IN
SAN DIEGO COUNTY
My Commission Expires Nov. 7, 1975

Figure 2.2. Eleanor Antin, *Four Transactions: Encounter #2* (1972). Courtesy of Ronald Felman Fine Arts, New York.

intends to discuss an object whose ontology, in its ability to 'count' as proper 'proof,' is profoundly queer."[52] Antin's notarized contract, though, is something more than queer in the sense that Muñoz means. This document plays the game too well—and yet too archly, winking at the crowd behind the referee's back. It brings the full force of the law to bear

on Antin's little life-performance—yet it also makes the law look like a deadpan comedian. In other words, the law may think it has lent its imprimatur to Antin's art, but it has actually just accepted a role (and a campy one) in her performance. "CAMP," says Philip Core, in another of his aphorisms, "is a form of historicism viewed histrionically."[53] No phrase could describe this document better—or, for that matter, the whole ethos that gave rise to it: histrionic historicism.

Life is performance, performance is life—and documentation is the hinge that joins the two together. This was the consensus view in the West Coast performance art scene that gave rise to Antin's and Montano's work. Even while extolling the immediacy of performance, West Coast artists clamored to mediate it, too: they hired photographers and videographers to capture their work, wrote up narrative recaps for the journal *High Performance*, saved and sold key props or remainders, and even reperformed their work when they got the chance. As William Kleb notes in his 1977 survey of the San Francisco scene, "one senses less general discomfort with the presence (and commercial value) of the residual object—whether photo, video tape or written text."[54] More than feeling "less general discomfort," these artists took a campy pleasure in such documentation. In two strikingly similar projects, Bonnie Sherk and Linda Montano photographed the unromantic labor that actually supported their art careers, then displayed those results as evidence of yet one more "performance." From 1972 to 1973, Sherk documented her work as a short order cook and "assigned titles to the work such as *Cleaning the Griddle*."[55] In a similar spirit, Montano displayed a series of photographs called *Odd Jobs* (1973): that is, before-and-after shots of work she had done as a handywoman. There was certainly an ironic overtone to these acts of documentation: just as it risked making them look like profiteers, it also proved how unprofitable their art truly was. But there was also a dead-seriousness to both of these projects. For Sherk, documenting her work as a short-order cook helped her detach from her service role, enabling her to stay critical of the work that sustained her. Montano also found personal comfort in the performance frame ("I liked what I was doing when I called it art," she says), but, like Sherk's, her work also had a critical edge.[56] Montano, in fact, has spent much of her life turning undervalued work into valuable labor by documenting it as performance art. In *Home Nursing* (1973), she went

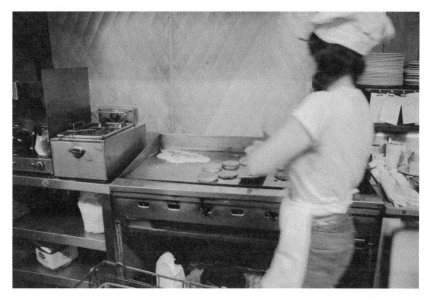

Figure 2.3. Bonnie Sherk, from *Short Order Cook* (1973–74). Courtesy of the artist.

about caring for sick friends, as she might well have done otherwise, but she did so in a nurse's uniform—and in the name of art. So, on the one hand, Sherk and Montano (like Antin in *4 Transactions*) were citing familiar critiques of performance documentation; on the other hand, they were earnestly celebrating the power of documentation to install performance where before there was only life, self-consciousness where before there was only consciousness.

Nowadays, artists and theorists take for granted a very different ethos of performance and documentation. Believing in the near-moral force of their art's ephemerality, which they imbue with the power to put performance beyond the market (or beyond the patriarchy, or, indeed, beyond any oppressive superstructure you care to name), performance artists treat documentation, at best, as a necessary evil—at worst, as the root of all evil. In 2010, during a retrospective of Marina Abramović's performance career at the Museum of Modern Art (MoMA), this ideology was exposed in spectacular fashion. The retrospective, which propelled Abramović into media stardom, offered piles of documentation and presented dozens of young artists reperforming selections from a few decades' worth of her work. When MoMA gathered performance

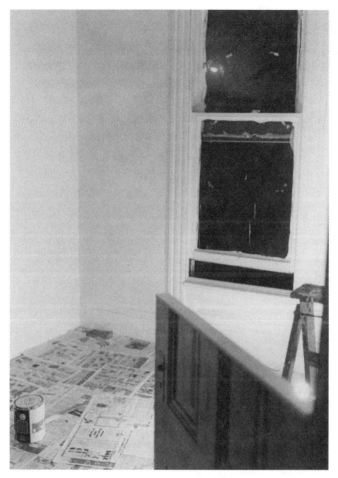

Figure 2.4. Linda Montano, from *Odd Jobs* (1973). Linda Montano Papers, box 23, folder 17, Fales Library and Special Collections, New York University Libraries.

artists for a workshop to discuss how their performances might also one day be preserved and exhibited, the conversation devolved into a shouting match. When Abramović, for instance, expressed an interest in Tino Sehgal's strategy of selling performance rights to his pieces, the room erupted: "'When I began in the late '60s, I didn't think about selling my work,' one artist yelled. 'It just wasn't something you thought about.'" When Abramović declared, "Reperformance is the new concept, the new idea! . . . Otherwise it will be dead as an art form," another grande dame

of performance art, Joan Jonas "grabbed a mike. 'Well, maybe for you,' she said heatedly. 'But not for me.'"[57] This was not the sound of reasonable people disagreeing; it was the sound of rival ideologies clashing. The trouble was that Abramović and Sehgal had no coherent ideology to support their approach to documentation and reperformance—or nothing beyond *Why not?* and *But what of my legacy?* Meanwhile, the others had the full force of performance theory to back them up. Peggy Phelan has put this argument best:

> Performance's only life is in the present. Performance cannot be saved, recorded, documented, or otherwise participate in the circulation of representations *of* representations: once it does so, it becomes something other than performance. To the degree that performance attempts to enter the economy of reproduction it betrays and lessens the promise of its own ontology.[58]

Fair enough, but for artists like Antin, Sherk, and Montano (if not Sehgal and Abramović) performance's "ontology" scarcely matters. Instead, they apply a *rhetoric* of performance to the world and an *epistemology* of performance to their lives. Documentation is crucial to both projects. It allows them to view "historicism . . . histrionically"—both by helping them experience their own lives as performance, and by forcing the documents themselves to perform.[59] When they do, the result is a camp sincerity of performance documentation.

These artists, though they would reject Phelan's '90s-era purism, do agree with her on one crucial point: that, in an age when the self is understood as performative, modes of performance encode models of identity. Each time Phelan makes her strongest claims about the ontology of performance, she goes next to the question of (women's) subjectivity. So, the passage cited above is followed directly by the sentence: "Performance's being, like the ontology of subjectivity proposed here, becomes itself through disappearance." Or, in the case of another oft-quoted version of this claim later in the book:

> Defined by its ephemeral nature, performance art cannot be documented (when it is, it turns into that document—a photograph, a stage design, a video tape—and ceases to be performance art). In this sense, perfor-

mance art is the least marked of all the texts I consider here. In the work of Angelika Festa, a so-called "ordeal artist," *staging disappearance becomes a signature expression of women's subjectivity within phallocentric representation.*[60]

Performance's "ephemeral nature" and inevitable "disappearance" make it the perfect medium, Phelan suggests, for subjects who believe that the structure of representation itself denies them legitimacy. To alter this understanding of performance—e.g., by trading in straight-faced purism for the camp sincerity of Antin, Montano, and Sherk—is also to alter the sense of self expressed in performance. Not quite made present, but also not disappearing just yet, and certainly not an immediate thing: this self is *hypermediate*, visible only at times (and in parts) as it flashes across a complex media array.

Eleanor Antin's Autobiographical Machine

No performance artist of the 1970s was more invested in such complex media schemes than Eleanor Antin. Over her career, she has been an actress, poet, painter, conceptual artist, photographer, videographer, filmmaker, novelist, memoirist, and more. More to the point, she has never been just one of these things—not even while crafting a single work of art. Since 1973, performance has been central to her practice (she has "always [done] several performances as part of [her] exhibitions"), but her exhibitions typically involve several other art forms, too.[61] And although she always claimed to be making autobiographical art (as so many women were), it was never straightforwardly so. (*Eleanor of 1954* was the closest she ever came.) Understandably, critics can hardly even agree what Antin *is*. According to a representative smattering of scholarship and arts journalism, she is a "theatrical" "conceptual" "post-conceptual" "body artist" specializing in "autobiographical" "auto-fictionist" "art performances."[62] With critical outputs this garbled, it's clear she has succeeded in crossing a few wires in our critical mainframe.

The work that so confused these critics was Antin's prolonged experimentation with "autobiographical" roleplay. Starting in 1972, she invented four personae—the King, the Ballerina, the Nurse, and the Black Movie Star—each of whom she presented both in live performance and

in a variety of mediated forms.[63] For a decade or more, these characters morphed and grew. So, the King became a latter-day Charles I, became the King of Solana Beach, became a crusader against land-development corporations in Southern California. The Ballerina likewise began as a general type, yet wound up a faux-historical figure: Eleanora Antinova, the prima ballerina of Diaghilev's Ballets Russes. And the Nurse, who began as a pathetic figure of feminine abjection, an overgrown girl playing with dolls, later became Eleanor Nightingale, Crimean War hero and august founder of the nursing profession. Even more protean than the personae themselves were the media in which Antin explored them. She performed them in scripted and improvised modes—often in theaters or galleries, but sometimes on the street. She ghostwrote their memoirs (*Recollections of My Life with Diaghilev, The King's Meditations*) and filled them with characteristic drawings "by" the personae: Antinova's hurried ink sketches and the exiled King's delicate drawings shaded with chalk. She photographed herself in their guise, both in the studio and in public. She filmed herself in genre-movies (e.g., the Chaplinesque *The Ballerina and the Bum*) and home videos (e.g., *The Adventures of a Nurse.*) And in one particularly elaborate instance, she produced dozens of faux-Victorian photographs documenting Eleanor Nightingale's wartime achievements, with soldiers and civilians played in period costume by a Who's Who of the Southern California art scene. "[A]ll artworks are conceptual machines," Antin has said, whose "style . . . forces the viewer to play [the artist's] game."[64] Here, the game is biographical thinking. Whatever combination of media was involved, the goal was the same: to conjure these people into existence not just as characters in a performance, but as authors, as artists, as historical actors, and as media personalities.

For as long as she'd been making mature art, Antin had been building such biographical media machines. Take, for instance, the *Blood of the Poet Box* (1968), the earliest work included in Antin's 1999 retrospective at the Los Angeles County Museum of Art. In this piece, made years before she avowed an interest in making "autobiographical" art, she was already playing with ideas of confession. The title alludes to Cocteau's *Le Sang d'un poète*, which he called a "confessional" film, but it also refers to the long tradition of treating blood as a symbol for an artist's acts of self-revelation.[65] *Blood of the Poet Box* may seem, at first, like a

mere spoof on this tradition. After all, this box doesn't give us any spurts of subjectivity—just a whole lot of actual, dried-up blood. From 1965 to 1968, Antin collected blood samples from a hundred poets, broadly defined: from Allen Ginsberg, John Ashbery, and Jackson Mac Low to John Cage, Yvonne Rainer, and Carolee Schneemann. She then preserved these samples on slides and filed them away in the box that lends the piece its name. One documentary still-life of the project emphasizes the mundane reality of collecting all this blood. With pseudo-scientific zeal and a flourish of housewifery, Antin displays the alcohol she used to sterilize everything, the "Sewing Susan" brand needles she used to prick each poet's finger, and the bandages she offered once the deed was done. Even the noteworthy specimens she singles out for this photograph— Allen Ginsberg's, Ed Sanders's, Dave Rasey's, and David Antin's—are nothing but faint, brown smudges, it turns out. In their rude materiality, they resemble neither Cocteau's "white blood of [poets'] souls, that flows and leaves traces" in art, nor, say, Milton's "life-blood of a master spirit, embalmed and treasured up on purpose to a life beyond life."[66] They are just so many pin-pricks' worth of bodily fluid gathered at parties, in galleries, and at poetry readings—more an imprint of the art biz in New York City in the '60s than an impression of anyone's soul. Yet, together, these slides do tell a story—not, perhaps, the one viewers were expecting to hear. Like a hundred diary entries or a hundred snapshots, these slides offer a *précis* of three years in Antin's life—three years' worth of parties, poetry readings, and gallery openings; three years of casual networking and professional schmoozing; and three years of being that nut who always turned up to a party with needles and slides somewhere in her bag. Without spilling a single drop of her own life-blood, Antin has written her life story: each row of slides (and each pair of numbered entries on the facing "page") another line in her autobiography. Her confessional medium? Other people's blood.

When Antin turned more deliberately to herself as her subject, she continued to use serial formats, presumably because serial art affords so many rich, narratable gaps. So, for a piece called *Carving*, she took photographs of herself every day for over a month while going on a diet. *Carving* has gotten an outsized amount of attention from critics, mostly because it conforms so nicely to our views of '70s activist art. According to this standard view, *Carving* is a critique of how society

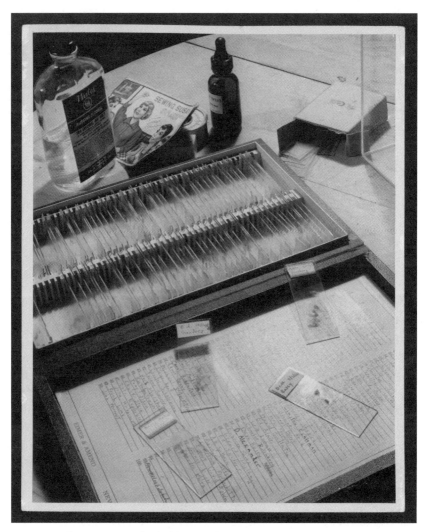

Figure 2.5. Eleanor Antin, *Blood of the Poet* (1965–68). Photograph by Peter Moore ©
Barbara Moore/Licensed by VAGA, New York. Eleanor Antin Papers, box 37, folder 1,
Getty Research Institute, Los Angeles.

disciplines the female body.[67] In this sense, *Carving* is a naked masquer-
ade where Antin slowly dons the hour-glass figure society demands. But
this reading of *Carving*, while obviously true, tells only part of the story.
It is also a work of serial autobiography. In fact, whenever Antin had
the chance, she displayed *Carving* not alone—nor among other works

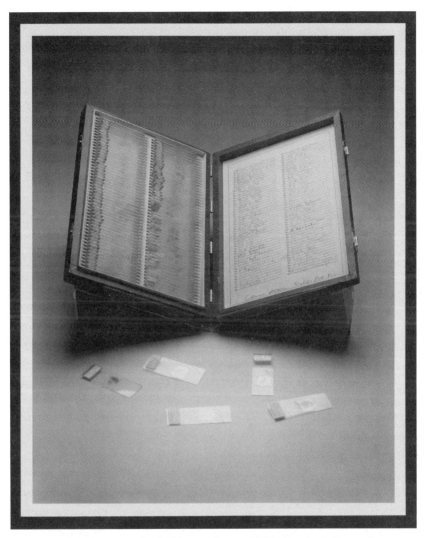

Figure 2.6. Eleanor Antin, *Blood of the Poet* (1965–68). Eleanor Antin Papers, box 37, folder 1, Getty Research Institute, Los Angeles.

of activist art—but among fragments of her own autobiography. Most often, she juxtaposed *Carving* with *Eight Temptations*, a series of campy portraits showing Antin working hard to resist forbidden foods—a humorous take on her actual experience trying to stick to the diet *Carving* required. And for at least one 1973 exhibition in Portland, Oregon, she also included the campy contracts of *Four Transactions* and another bit

of tongue-in-cheek life-documentation called *Domestic Peace*.[68] This latter work concerns a trip she took in 1971 to visit her mother and "discharge familial obligations" in New York. The only problem with the visit, Antin explains, was that "[her] mother . . . [was] not at all interested in [Antin's] actual life but rather in what she considers an appropriate life." Treating the trip as an experiment in social appeasement and provocation, Antin collected a series of stories to tell her mother. Some "contained slightly abrasive elements" and were therefore "for use only on 'good' days," while others "would act as gambits leading to natural and friendly conversation."[69] Antin then transcribed these stories onto graph paper, told them, and mapped the moods that resulted (hers and her mother's) with pseudo-scientific precision. Despite its obviously ironic tone, *Domestic Peace* prompts earnest biographical thinking in its viewers, giving them (between the lines) a confessional portrait of Antin as a discontented daughter. The camp of *Eight Temptations*, the pseudo-legalism of *Four Transactions*, and the faux-scientific rigor of *Domestic Peace* all give us insight into Antin's life, even as they mock the forms this insight takes. Set among these pieces, even the "angst and

Figure 2.7. Eleanor Antin, *Carving: A Traditional Sculpture* (1972), installation view. Courtesy of Ronald Felman Fine Arts, New York.

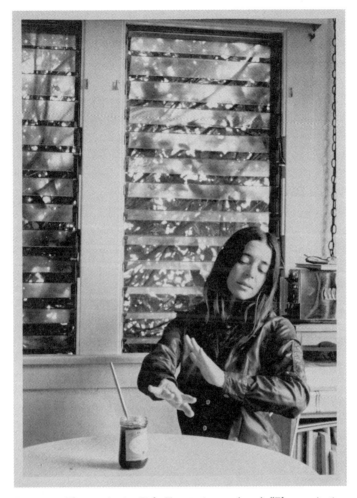

Figure 2.8. Eleanor Antin, *Eight Temptations #3* (1972). "Eleanor Antin shunning jelly." Courtesy of Ronald Felman Fine Arts, New York.

fire" of *Carving* begins to "smirk and smile" behind the curator's back—and even its outwardly neutral, objective photography becomes a kind of diary, too. The audience is encouraged, in other words, not just to appreciate *Carving*'s critique, but also to seek out the narrative between the pictures—a memoir of one month in the artist's life.

When Antin turned from such acts of campy life-documentation to a decade of exploring her personae, this may have seemed like a move

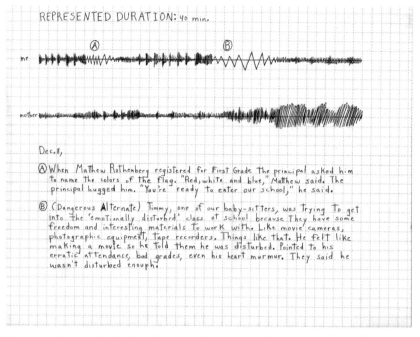

REPRESENTED DURATION: 40 min.

Ⓐ Ⓑ

me

mother

Dec. 8,

Ⓐ When Matthew Rothenberg registered for First Grade the principal asked him to name the colors of the flag. "Red, white and blue," Matthew said. The principal hugged him. "You're ready to enter our school," he said.

Ⓑ (Dangerous Alternate) Timmy, one of our baby-sitters, was trying to get into the 'emotionally disturbed' class at school because they have some freedom and interesting materials to work with. Like movie cameras, photographic equipment, tape recorders. Things like that. He felt like making a movie so he told them he was disturbed. Pointed to his erratic attendance, bad grades, even his heart murmur. They said he wasn't disturbed enough.

Figure 2.9. Eleanor Antin, from *Domestic Peace* (1971–72). Courtesy of Ronald Felman Fine Arts, New York.

away from autobiography, but in fact the opposite was true. To this point, she had focused on getting her public to engage in acts of biographical thinking. Now, she would focus on prompting new modes of autobiographical thinking in herself. As Antin explained to one interviewer:

> For years I had been haunted by the idea that I had no self. Or rather, that I had an endless supply of selves—an embarrassing state not experienced as prodigality but as absence.[70]

It was in response to this feeling (the same feeling, by the way, that had haunted many of Betty Friedan's informants) that Antin began to create her own "psychological machine" consisting of four iconic personae.[71] (Before long, they were reduced to three: the movie star, in fact, appeared only a handful of times.) Antin built this "machine" with spare parts she salvaged from psychoanalysis and realist acting (which, after all, are kissing cousins). In the psychoanalytic sense, these roles were

Jungian archetypes—heightened, mythic expressions of a few core possibilities in Antin's psyche. Or, as in Freudian analysis, they were other people—fragmented out of her own personality through acts of art and mediation—with whom she could play out the transferential drama of the Freudian talking cure. As she explains in a 1974 essay, "Dialogue with a Medium,"

> The psychoanalytic method of mythological exploration is a conversational one, a dialogue in which 2 people over a period of time share a history which they can then hold each other responsible for. . . . Since my dialogue is with myself, my method is to use video, still photography, painting, drawings, writing, performing as mediums between me and myself so we can talk to each other. It is a shamanist theatre which remains out there as proof of itself after the séance is over.[72]

This mediated "dialogue" usually culminated in a live performance where, as in *Eleanor of 1954*, she would often literally converse with herself. For the 1975 exhibition *2 Transformations*, for instance, she spoke first as the Ballerina, then criticized the Ballerina in her own voice, then spoke as the King to correct this critique.[73] After her "dialogue with a medium" was done, in other words, Eleanor herself became the medium, channeling multiple selves as in a séance.

Given how surreal these dramas sound, it might surprise you to learn that Antin drew on realist acting theory as she performed them. In her youth, when she still thought she might become an actress in the mainstream theater, she had studied with Tamara Daykarhonova, an early student of Stanislavsky and one of his most prominent disciples in America. To the well-tuned ear, this Stanislavskian influence is audible whenever Antin describes her persona work.

> . . . I soon saw that my *self*—if I had one!—wasn't waiting out there like America waiting for Columbus, for me to come along and identify it. I had to set up some inventive "as-ifs."[74]

For the Stanislavskian actor, such "as-ifs" are always the first way of entering into an unfamiliar role. "If," says Stanislavsky, "acts as a lever to lift us out of the world of actuality into the realm of the imagination."[75]

But this realm is never unmoored from the actor's own reality—in fact, it sends her deeper into herself. As Stanislavsky puts it, "The circumstances predic[a]ted on *if* are taken from sources near to your own feelings, and they have a powerful influence on the inner life of an actor."[76] Any gap levered open by *if*, in other words, is soon filled with the actor's own feelings and experience. Antin's persona-work has long been misunderstood by critics who fail to hear these Stanislavskian undertones. Jayne Wark, for instance, sees the rift opened by *if*, but mistakes its purpose entirely. "A gap has always remained between herself and her personae that signified her subjectivity not as being but as the agency of being," Wark observes, arguing that Antin's work therefore "foreground[s] imposture."[77] Stanislavsky's *if*, though, is an honest conjunction—meant, in fact, to root out such "imposture." "By using the word *if* I frankly recognized the fact that I was offering you only a supposition," explains Stanislavsky's avatar, Tortsov, and into the gap opened up by this honest *if*, personal truths (not willful fictions) are bound to rush in.[78] *Who am I if I am King?* This is the sort of question Antin is asking. Performance—for her, as for Stanislavsky—is a laboratory, not a factory, of the self.

Trans Formations

The language of agency and imposture may sound empowering in the voice of a feminist critic like Wark, but it loses some of this power once it's repeated point-for-point in chauvinistic attacks. Writing in 1979 for *Arts Magazine*, John R. Clarke compares Antin to the hucksters of the "human potential movement," especially Werner Erhard, creator and guru of the Erhard Seminars Training (*est*), which was sweeping America at the time. According to Erhard, we must all prepare ourselves for the moment of "transformation" when we *choose* who we want to be. "Rather than trying to find our true selves—struggling to figure out 'who we are'—in transformation, we bring forth the possibility of creating ourselves, so that life is a creative expression of our stand," Erhard says.[79] (Or, to use Wark's words, "subjectivity" is not "being but . . . the agency of being.") "The magic of transformation is in your head," Clarke writes, ventriloquizing Antin, "you are, you are, you're *it*! Poof!"[80] *Poof*, indeed: because it quickly becomes clear that Clarke's snarling tone comes, in

part, from gender panic. After all, his essay centers on an unusual pair of performers, Eleanor Antin and Quentin Crisp, and what these two figures share is the defiant queerness of their acts. Antin "chooses" to be a man from time to time, and Crisp "chooses" to defy masculine norms both on the street and on the stage. They are, in Clarke's view, nothing but *est*-style self-actualizers, but, today, we see this language of choice for what it is. Far from espousing Erhard's gospel of "transformation," Antin and Crisp are preaching a new gospel of trans-formation—the queer idea that a self is something formed across the bright lines of conventional, binary gender. "The time comes for everybody," says Crisp, "when he has to do deliberately what he used to do by mistake," but the only "mistake" he and Antin ever made was to find themselves outside the current gender regime.[81]

In her work as the King, Antin escaped this regime by never trying to hide her apparent sex. While walking the streets as the King of Solana Beach, she wore a beard and male clothing, but never tried to bind her breasts or otherwise hide the outward signs of biological sex. In a 1975 interview, she recalls,

> The king went for a walk in Solana Beach about a month ago. I was wearing a cape and a bush hat, which looked like a cavalier's hat, and my beard, and there were my breasts hanging out through a frilly blouse. I wondered if I would have a heavy reaction from people who could see I was a woman walking around with a beard. I had a beautiful reaction. . . . I just said, "I'm a king visiting Solana Beach," and the surfers said, "Far out," and that was it.[82]

In other words, she deliberately failed to pass, daring anyone to object—and she delighted in those moments when, against all the odds, they did not. Feminist critics have attacked drag *queens* for precisely this habit: the performer pretends to identify as female, but remains transparently male underneath. Dropping his voice, removing his wig, the drag queen makes a bid for male authority at the expense of the mere "act" of womanhood. In the scant scholarship on drag kings, it's conventionally held that this move is unavailable to male impersonators. "Both female and male impersonation foreground the male voice and, either way, women are erased," writes Kate Davy, for instance.[83] But this argument relies on

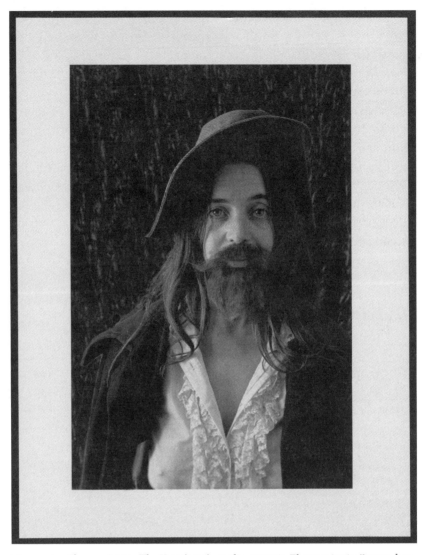

Figure 2.10. Eleanor Antin, *The King* (1972), studio portrait. Eleanor Antin Papers, box 39, folder 5, Getty Research Institute, Los Angeles.

a binary logic of gender that drag (and its aesthetic, camp) are supposed to disrupt. Drag artists can, and Antin does, genuinely affiliate with precisely the gender that they perform.

Rather than understand Antin's King according to traditional theories of drag, then, we should place her in what Laurence Senelick calls

the "alternative drag" tradition.[84] Paul Best, Antin's contemporary on the California performance art scene, exemplifies this "alternative" mode. In a 1980 piece called *Transformation*, Best takes on two roles: Priscilla the disco drag queen (who prefers male pronouns) and Daphne Belle, a transvestite "obsessed with the old South" (female pronouns).[85] Best presented these characters not as "truly" men or "really" women, but as drag queens and transvestites only. And underneath or behind both of these roles, he emphasized the blunt reality of a person named "Paul Best." At the beginning of the performance, again between characters, and one last time at the end, Best provided the raw data of identity assigned to him by various institutions. Best describes this ritual interlude in a write-up of the performance for the journal *High Performance*—here, in its final iteration:

> I sit down and begin reading the ID information again, this time saying, "My name *IS* Paul Best; my Student ID number *IS* U06357280; my Social Security number *IS* [XXX-XX-XXXX]"; etc. emphasizing the reality of the numbers. I repeat the information four more times. I get up and leave the space. The lights go out.[86]

This might seem like the perfect example of what feminists fear—i.e., that drag's only aim is to claim the male privilege of containing (female) multitudes—except that this performance was part of Best's longstanding project of blurring such strict gender categorizations. Starting in 1975, Best performed in the streets, like Eleanor Antin, as a genderfluid person named Octavia. "Octavia is androgynous," Best explains, "but sometimes is more she than he and vice versa."[87] In fact, Octavia's gender seems to morph based on circumstance, sliding halfheartedly toward the conventional gender of certain activities or locations. So, Best titles a 1978 performance *Octavia Goes Shopping in Her New Hair Color* (the underscoring is mine), but the next year, when *Octavia Goes Out for a Beer* (1979) Octavia "is more he."[88] Rather than hardening conventional gender binaries, Best's Octavia works hard to soften them up. So, too, with Antin's gender-fluid persona work. Notice, in fact, how this happens at the level of grammar: in the story of the King I quoted above, a third-person tale simply slides into a first-person voice that has both "my beard" and "my breasts." And, as Antin walks the streets of Solana

Figure 2.11. Eleanor Antin, *My Kingdom Is the Right Size* (1974) from *The King of Solana Beach*. Photograph by Phil Steinmetz. Eleanor Antin Papers, box 39, folder 10, Getty Research Institute, Los Angeles.

Beach in this "I" she raises consciousness (and self-consciousness) about normative gender. Just take a look at this picture of the encounter Antin mentions between the King and some local surfers. In the presence of the King, these long-haired surfers begin to look queer themselves, even as they all share a manly Budweiser. Antin's Stanislavskian *if* can work its magic on just about anyone she encounters.

Taken whole, Antin's persona work is—in another sense, too—an act of self-consciousness raising: she has managed to work the transformative magic of CR on herself. Eschewing the voice of simple identity, she mimics CR, which, in its most liberating form, also eschewed this voice. Antin's selves are held together not in a "composite, consistent picture," as some proselytizers of CR insisted all women must be, but in a fluid yet coherently patterned mosaic. Vivian Gornick, writing in the *New York Times Magazine*, has this to say about CR's power:

Thus, looking at one's history and experience in consciousness-raising sessions is rather like shaking a kaleidoscope and watching all the same pieces rearrange themselves into an altogether *other* picture, one that suddenly makes the color and shape of each piece appear startlingly new and alive, and full of unexpected meaning.[89]

Antin likewise finds herself "startlingly new and alive" as her selves slide across different media and social contexts over the years. Eleanor Antin, denizen of Solana Beach, California, **is** the King of Solana Beach **is** Eleanor Nightingale **is** Eleanora Antinova **is**—and here's the long and the short of it—Eleanor Antin, *in propria persona.*

Confession in the West

In this chapter's subtitle, I promised an account of "self-performance in the 1970s," but as you've probably noticed by now, my actual scope was, in truth, a bit narrower than that: feminist art performance in California, especially *Southern* California in the 1970s. Many groups besides feminists were experimenting with confessional politics at the time—and many artists beyond California were trying their hands at confessional performance—but this vibrant community of Californian women did more than anyone to merge the two. Their task was made easier by the fact that California was ground zero for both second-wave feminism *and* women's performance art. Or, as Eleanor Antin put it in 1976 (a bit more polemically than I'd dare today), "women practically invented performance in Southern California," and, "The only kind of politics Southern California *has* is feminism."[90] The rise and spread of a new confessional culture there seems, in retrospect, inevitable.

Perhaps confessionalism simply *was* Californian in the 1970s, just as it was Bostonian in the 1960s. Echoing Robert Lowell's claim that, around Boston at the turn of the '60s, poetry *tout court* achieved a "breakthrough back into life," Antin claims that, around Los Angeles at the turn of the '70s, women "renewed art's freedom to be human and explore human realities. Women have brought art back to the world, where it belongs."[91] Some did so by basing their art on CR, giving voice to the "angst and fire" of feminist awakening. Others expressed their new political awareness with the "smirk and smile" of satire or masquerade.

But an important subset of women across California, the ones I call self-consciousness raisers, achieved a new style of both politics and art. It was activist *and* critical, sincere *and* campy, immediate *and* tangled in media. This *was* the style of self-performance in the '70s—and it would shape confessional performance into the '80s as "performance art" left the gallery and took to the stage.

One woman bridged these two decades and two worlds: Laurie Anderson. Before her songs climbed the pop charts, before she packed mainstream theaters, before she even was a theater artist at all (if she ever was), Anderson was a performance artist of exactly the sort I've featured in this chapter. In fact, Anderson and Antin were professional twins, with all the natural resemblance—and willed difference—twinship entails. In 1973, their names nestled together in the catalogue for Lucy Lippard's *c. 7500*, an exhibition of women's conceptual art.[92] Then, as their work took a synchronized turn toward autobiography, Anderson and Antin began to appear side by side in one exhibition of life-work after another.[93] In fact, Anderson's first truly confessional performance (*As:If*, 1974) debuted in a series at the Artists Space that also featured some of Antin's earliest work as the King and Ballerina. Speaking in 1976, Antin recognized the similarities, praising Anderson's work in words she might also apply to her own: ". . . it was theatrical and it had narrative stories and it used media and live performance. It was beautiful."[94] But this praise was, in fact, only prelude to a critique. "At the same time," Antin continues, "it was a totally canned, formal performance. It was formal in the sense that it was programmed." "No improvisation?" her interviewer asks. "No, none at all . . . that's total N.Y."[95] Antin herself had turned to improvisation (and autobiography) only when she left New York for California. (Ditto Linda Montano. Free-flowing confession? I guess that's total CA.) Confessional artists, it turns out, are always making this trip from East to West—from "formal" art-work to spontaneous life-work. The confessional poets, you'll remember from Chapter 1, identified as "secret beatniks" at a time when that phrase meant, in part, *secret Californians*. And Robert Lowell quite literally found his confessional style while touring California, learning to leaven his formal, Bostonian poetry with a bit of California-style improv. There must have been something in the Californian air.

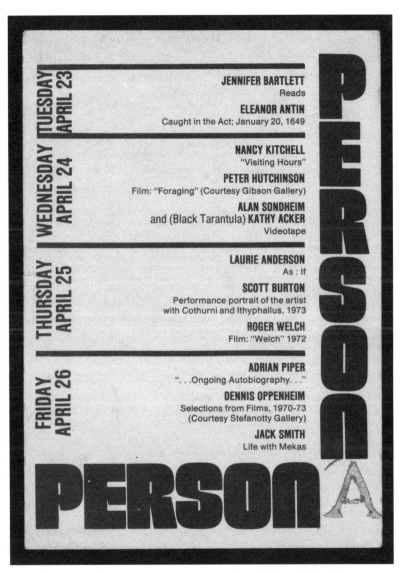

Figure 2.12. Postcard advertising the 1974 group show "Person(a)" at the Artists Space in New York. Eleanor Antin Papers, box 25, folder 5, Getty Research Institute, Los Angeles.

Spalding Gray, an icon of theatrical confession in the 1980s and the main subject of my next case study, may lack Laurie Anderson's direct ties to the feminist performance art scene of the 1970s, but he did make this exact same trip from East to West—from formal, abstract, auto-performance to a simple, spontaneous mode of confession. In the fall of 1977, Gray was ablaze with ideas for solo performance, all of them indebted to New York–style performance art.[96] By mid-1978, however, he had tired of solo performance—had tired, in fact, of the whole New York scene. In an entry dated June 8, 1978, he writes in his journal: "Liz and I go see Joan Jonas do her solo and I see a sort of dispair [sic] in solo work. I realize I've come to a point where I don't want to do that anymore. I'm clear on that."[97] Gray's solo career, in other words, was almost over before it began. Six weeks later, though, having "come to some understanding about another way of working," he was planning what would become his first confessional monologue.[98] What had changed? Just a week or two after despairing entirely, Gray headed west to Santa Cruz, where he taught and studied for the rest of the summer. There, in the land of life-work, he shed old notions of performance and began to think deeply about "life as theatre" and "the art of living."[99] Pretty soon, he was ditching those old "canned, formal" solos and embracing "another way of working"—a way that, in fact, he would pursue for the rest of his life. From autobiography to confession, "programmed" to improvised, despair to "another way of working"—the distance has always been roughly the same: almost three thousand miles, from East to West.

Interlude

Queer Talk, 1979–2010

In a 2010 performance at St. Ann's Warehouse in Brooklyn of his play *A Life in Three Acts*, British drag legend Bette Bourne showed how subtly mediated the simplest confession can be. The tone of the piece, a memoir of Bourne's life in gay activism and art, was familiar: reminiscence, spontaneous and tenderly felt. Tales from his youth, stories of his days in a "drag commune," pearls of wisdom from the founding of Britain's Gay Liberation Front, and fond memories of the early days in his drag ensemble Bloolips—all blended together in an evening of chat. Charles Isherwood, reviewing the event for the *New York Times*, captured the spirit of the show when he observed, "It has the rambling, informal feeling of a languid stroll through an English garden."[1] The result, for spectators, was a strange kind of absorption—familiar in life, but rare in the theater—where words alone warp our sense of time's passage, where a narrated past fills the present, and where the riverrun rhythm of conversation draws together all the fragments of a person's life. This was a raw display of memory-made-public, of layered realities building up into a complicated present.

The first sign of its complexity was reflected right away in the show's peculiar premise. The piece began as a series of recorded conversations between Bourne and Mark Ravenhill, a younger gay British playwright. Once these tapes were transcribed, Ravenhill edited the text into a play-length span of continuous chat. So, the piece is not a monologue per se, but a dialogue, with Ravenhill reprising his role as Bourne's interlocutor. As the performance begins, Ravenhill quickly explains all of this, then he and Bourne re-create the conversation just as it (never quite) happened. They sit in plain chairs, reading from scripts propped up on music stands in front of them. For our benefit, photos they had perused during the original conversation are projected onto

a screen behind them, and an audio recording they listened to (of a young Bourne roundly orating his lines in a production of Marlowe's *Edward II*) plays over the theater's sound system. Ravenhill speaks his lines straightforwardly from the script, never feigning fresh interest in Bourne's response. Instead, he squints out at the audience as they listen, occasionally mugging behind Bourne's back, as if to say, "Can you believe it?" Bourne, on the other hand, sometimes reads from the edited transcript verbatim, sometimes recites his lines from memory, and sometimes (it seems) goes off script altogether, inspired to share a fresh anecdote tonight. Both performance styles emphasize the immediacy of this performance, even as they show it to be triply, even quadruply mediated. Ravenhill's intense, even unsettling, interest in us—his silent conversation with us, even—makes it perfectly clear that he and Bourne are doing a well-worn routine, but at the same time it gives us the impression that, because we're there, this performance just might be unique. Bourne, likewise, never hides that his words have been recorded, transcribed, edited, reconstituted, and re-created—yet he leaves himself open to the impulse of the moment.

Figure Interlude 2.1. Bette Bourne and Mark Ravenhill perform *A Life in Three Acts* at the 2009 Edinburgh Fringe Festival. Photograph by robbie jack. Corbis Entertainment Collection, Getty Images.

Bourne surely learned this technique from Quentin Crisp. Before bringing *A Life in Three Acts* to St. Ann's, Bourne was best known state-side for his Obie-winning performance as Crisp in *Resident Alien*, a monologue based on Crisp's own solo performances. These original per-formances may have seemed more minimalist than Bourne's—no slide-show, visible script, or sound cues, just a steady flow of chat on a set that resembled someone's living room—but they, too, relied on layer after layer of mediation. Crisp may have developed his monologues through loose improvisation, in which "the rehearsal, you might say, was the night before's performance," but it eventually acquired a script. As Crisp recalled in a 1999 interview,

> It was [his first US producer] Mr. Elkins's idea. We recorded one of the shows and the script was typed up from that show. I memorized the script from that recorded show, and that is the show that I now perform, word for word.[2]

So, when (in Chapter 2) I quoted from the live album *An Evening with Quentin Crisp* (1979), it may have seemed like I was quoting fresh talk, but in fact I was quoting a *recording* of Crisp's *recitation* of a *transcript* of a *recording* of a *performance* of a *revision* of a *memory* of a *memory* . . . of once, long ago, chatting freely in front of an audience. Though Crisp never exposed this deep history behind his words quite so baldly as Bourne and Ravenhill do, it still doesn't make sense to call his work immediate. It was rife with remediation.

There's an unstated moral to minimalist confession: plain talk and pure presence mean you're getting the unvarnished truth. Confessional monologue, a spare theatrical form, is usually thought to be sincere in-sofar as it's simple. So, if my focus on the complex mediations of Bourne's performance (and Crisp's) makes you uneasy, this might be why. But, in fact, you're in good company. I suspect most spectators didn't notice—or dwell much on—these mediations. (Charles Isherwood surely didn't.) This only goes to show how desensitized we've become to the complex media strategies behind our simplest talk. Where do such conventions come from, and what hidden complexity have they planted at the heart of confessional performance—at the core of the confessional self?

In the thirty-plus years between Crisp's first performances in Manhattan and Bourne's stint at St. Ann's Warehouse in Brooklyn, this genre—an evening of chat about oneself—came to dominate and pervade the American theater. Several scholarly and popular histories (e.g., Jordan Young's *Acting Solo* and John Gentile's *Cast of One*), multiple anthologies (e.g., Jo Bonney's *Extreme Exposure* and Mark Russell's *Out of Character*), and countless how-to books (e.g., Glenn Alterman's *Creating Your Own Monologue* and Louis Catron's *The Power of One*) have treated this genre as just the latest in a long tradition of solo performance—recitals, monologues, and "monopolylogues" (one actor playing many characters)—stretching back to the eighteenth century or further. What's more, they imply that the recent boom in confessional monologue is just part of a general rise in solo performance. After all, during this same period (i.e., the 1970s to the present) solo dance, cabaret, standup comedy, and clowning performances also took the stage in traditional theaters—as did monologues where actors play, not themselves, but someone else or many others. They unite a wide range of performance practices, in other words, on the strength of a single feature—and a feature that, for me, can't explain much on its own: the formal minimalism of one person alone onstage.

Beyond this basic formal minimalism, the confessional monologue, like much performance art before it, displays a radical *representational minimalism*: performers "play" only themselves in this kind of show. No other form of solo performance shares this quirk, though in virtuoso acts (e.g., solo dance) we may remain agnostic on this question. According to Stephen Bottoms "autobiographical monologue" (as he calls it) "seems predicated on the attempt to present the performer's 'self,' as directly as possible."[3] These monologuists do so, he argues, through a series of minimalizing moves: they "minimiz[e] any sense that [they are] playing a role, or presenting an 'act'" and they "minimize the distance between actor and audience" by speaking to their audience more directly than theatrical conventions typically allow.[4] But we must not mistake these minimalisms for immediate access. Few monologuists, after all, would indulge in this fantasy themselves.

Like Crisp before and Bourne after them, the artists who mainstreamed confessional monologue in the 1980s were playing complex media games, though they rarely made a big deal about it. In particular, they

tended to have a strange relationship to written-out texts, be they scripts or autobiographical books. In place of a script, they typically followed the method modeled by Crisp and Bourne: the moldable stuff of improvised speech is co-opted by an author (Ravenhill, in Bourne's case; Elkins, in Crisp's; but sometimes a closeted, authorly facet of the performer him- or herself) and then is hardened into a text, which the performer must soften and bring to life onstage. Amid this loop of remediations, talk tangles with writing, the actor vies with the author, and the performer fills the stage up with language—liquid, frozen, and thawed. Crowding the stage with papers, they also fill our ears with talk—recorded, recited, and fresh. They dwell—like the confessional poets before them—in the no-man's-land between writing and performance. This ambiguous state of affairs is the subject of Chapter 3.

3

Just Talk

Writing, Media, and Confessional Monologue in the 1980s

I really felt like I talked to the audience and that felt good—
kind of like a preacher, poet, comedian all mixed together.
—Spalding Gray, journal, June 2, 1979[1]

That thing you do, writing talking, whatever it is you do in
the theater.
—Spalding Gray, *Swimming to Cambodia*[2]

When Spalding Gray traveled to Washington, D.C., in 1985 for a retrospective of his monologues, local theater writers didn't know *what* to make of him. A feature piece on Gray published by the *Washington Post* begins, "Spalding Gray talks. You could even say he talks for a living. Since he does it on a stage," the reporter grumbles, "it's called performance art."[3] The *Post*'s theater critic begins his review in a similar vein: "I don't know whether Spalding Gray's 'Swimming to Cambodia, Part I' qualifies technically as theater or just lively talk. Maybe," the critic suggests, "we should call it lively talk in a theater and leave it at that."[4] Both articles appeared under the same, strange headline—one that managed to sound aggrandizing and slight at the same time: "Spalding Gray, Talkmaster."

After Gray's suicide in 2004, his widow Kathy Russo teamed up with director Lucy Sexton to mount another Spalding Gray retrospective, although one of a very different sort: a play-length collage of excerpts from his eighteen monologues, his one novel, and his many, many private journals—all of which was meant to be performed by a cast of five. This play's title *Spalding Gray: Stories Left to Tell* puts an emphasis on talk, on story*telling*, but Russo insisted that what the show really proved, more than anything, was that Spalding Gray was a *writer*. At every stop on the

show's press junket, she repeated the same story: that *Stories Left to Tell* was inspired by that ritual of literary authorship, the bookstore reading. A few months after Gray's death, the story goes, the Theatre Communications Group republished his most famous monologue, *Swimming to Cambodia*, and (to promote the new edition) they got an all-star cast to read excerpts at Barnes & Noble's flagship store in Lower Manhattan. Watching this reading unfold, Russo had a "light-bulb moment." She suddenly realized "that Spalding was a brilliant writer." So, in *Stories Left to Tell*, "His words, *not* his performance, were now taking center stage."[5] This is, I suppose, a natural reaction to the death of a charismatic performer like Gray. Despair over his absence was giving way to a search for his presence, however ghostly, in the texts he left behind. But it also perpetuates a distinction between performing and writing that it was Gray's basic project—and that of his theatrical contemporaries—to subvert.

Actors, Authors, and Other Authorities

Over the past half-century or so, the American theater has seen radical changes to its structures of authority. These transformations began in avant-garde theater of the 1960s—especially in politically committed theater ensembles, who had reasons both artistic and ideological for wanting to distribute theatrical power a bit more equally. Working without (or against) traditional scripts—that is, without an author dictating what would happen onstage—these groups devised texts together, created collective rituals, and generally tried to free the theater from domination. But just like the antiauthoritarian movements that inspired them, these groups struggled to keep an equilibrium. Ousting the author, they soon elevated guru-directors instead, investing them with all the power of an auteur. And so, to this day, the names of these groups are inseparable from the names of their impresarios: Judith Malina, Julian Beck and the Living Theatre, Joe Chaikin and the Open Theatre, Richard Schechner and the Performance Group, Luis Valdéz and El Teatro Campesino, and so on. As Schechner admitted in a 1981 essay, "We [directors] spoke on behalf of the performers . . . but what we were really doing was carving out a domain for ourselves: overthrowing the writers."[6] Meanwhile, actors found new outlets for exploring their

own theatrical authority. Convinced, like Schechner (or, in Spalding Gray's case, *by* Schechner), that a script was only a trellis for the weedy growth of performance—and further convinced that the director's job was to nurture and prune this growth, and little more—American theaters (both avant-garde and mainstream) now sought actors who, in the words of a new cliché, would "make strong choices" in performance. As Schechner laments, "My generation effectively destroyed the idea that the playwright is the only, or main, originator of the theatrical event; the generation after me did the same for the director."[7]

Schechner is thinking not only of how power slowly accrued to actors in rehearsal and performance, but also, no doubt, of a coincident trend: actors dropping out and going solo. And why wouldn't they? Going solo grants them full theatrical authority. As Gray put it, "I don't think I want to imagine being someone else anymore." Instead, he wants to show the audience "me the performer-author-authority-authorized vision."[8] Actor, author, and auteur, after all, are three derivations of a single word. Gray was simply unearthing their tangled roots and grafting these three roles back into one. Spurred on by Gray's example (and by that of his art-world equivalent Laurie Anderson), more and more gallery-based performance artists took to the stage, and theater actors began to nurse their solo shows like so many journalists mulling over their novels or Angelenos brooding over their screenplays. The dream of creating something whole, of finally making a steady buck, of having the say-so over anything they did—in short, the dream of autonomy: aesthetic, financial, and professional—suddenly seemed within reach. What had once seemed artificial, a sign of the actor's subordination— the audition monologue aimed two inches above the head of a rather bored-looking casting director—now looked like a golden ticket out of it all: the performance art monologue, spoken directly and passionately to adoring crowds.

Spalding Gray—speaking his own words and working largely alone to shape them into an evening of theater—knew he was claiming three modes of theatrical authority at once. "I wanted to control the whole thing," Gray recalls in a 1993 interview, "to be director, author, performer"—and others followed Gray's lead.[9] For instance, the paragraph "About the Author" in Gray's first published collection of monologues calls him a "writer, actor, and performer"—with those last two

terms saved from redundancy, I guess, by the presumption that "performers," unlike actors, are auteurs.[10] Whatever form the triple epithet took—"actor, writer, and performance artist," "writer, monologuist, and actor," "storyteller, performer, and actor"—it described a sort of theatrical Trinity, three aspects of a single aspiration: *authoring* words, *acting* them out, and then shaping them up with all the skills of an *auteur*.

Gray didn't always embrace this blended role with such ease or nonchalance. At the start, he often felt he had to choose one role, and the thought of choosing left him an anxious mess. One day, he'd write in his journal, "The idea [is] clear to me that I don't have to be a writer OR an actor. I could be a lot of things like Artaud."[11] But the very next day he'd slip backward: ". . . now the self-doubt creeps in[:] does writing take away from the NEED to ACT. . . ?"[12] The next week, he'd decide he didn't care. Acting be damned! "I lay under a changing sky and had FANTASIES OF BECOMING A POET."[13] And so on for months. As his solo art developed, though, Gray's worries seemed to mellow. He even began to describe his monologues *as* poetry, a neat solution to the crisis he'd undergone. "I'm after a poetry of mind and body," he explained, and, at his best, this was precisely what he achieved: "I got into some real states of found poetry—improvised poetry," he reported, giddy with excitement.[14] But everything changed in November 1979, when Gray won a $10,000 NEA grant for creative writing—or, as he called it, "a grant for writing before I am even a writer."[15] So, even as his solo career launched, he spent the bulk of his time writing, reading, and reading *about* poetry—especially the poetry of Robert Lowell. Even as he toured first America, then Europe with his monologues, he began to feel a "very strong identification and projection on Robert Lowell."[16] He read Lowell's poems in the bathtub, he quoted from them in his diary, and he forced his friends to listen to LPs of Lowell's readings.[17] Pretty soon, this "identification" had wormed its way deep into Gray's psyche, coloring his most private choices. "I don't want a wife now," he scrawled in his diary one night, "I don't care how many Robert Lowell had . . . !"[18] Or, months later, "I keep my distance [from life] with fantasies of dying like Robert Lowell at 60 all of a sudden on the way in from Kennedy [Airport]."[19] His first monologue *Sex and Death to the Age 14* might as well have been called *My Sex and Death as Robert Lowell*. But, in time, Gray

wove these writerly dreams into performance—first by tacking poetry readings onto the beginning or end of his monologue performances, then by embracing the "found poetry" of "mind and body" he found in the monologues themselves. Soon, his "identity as writer" and his "performer's identity" were like two derivations of one primordial thing: the *actor-author-authority-authorized vision*.

Whether or not theater critics were aware of all this turmoil behind the scenes, they picked up on Gray's mix of literary and theatrical effects. From the earliest days of his solo career, years before Gray had actually published his monologues, he was known far and wide as an "actor-author."[20] The interplay, not the conflict, of these roles was presumed. Gray's "impromptu memoir-as-monologue could certainly appear between hard-covers," Mel Gussow gushed in the pages of the *New York Times*, but they "take on added comic dimension in performance," which makes this strange literary-theatrical hybrid worth our while.[21] Even the article in the *Washington Post* that trumpeted Gray as a "talkmaster" notes the quasi-literary feel of his talk. Gray "calls what he does a Talking Novel," the critic reports before affirming that this was audibly true in performance: "he speaks in paragraphs."[22] A colleague at the *Post* put it more colorfully: Gray "hurls himself pell-mell into his personal view of history using tripping cadences that recall the Beat poets and colossal run-on sentences that might make Faulkner's hand hurt." "When it works," the critic concludes, ". . . Gray makes his life his classroom and novel and theater"—all three side by side, as if (of course!) they belonged together.[23]

This list of parallel nouns—*classroom and novel and theater*—beautifully evokes a deeper truth about confessional monologue. Despite its *formal* minimalism (one performer alone on an all-but-bare stage), and despite its *representational* minimalism (one person speaking directly to the audience *in propria persona*), there can never be in Gray's (or indeed any) confessional monologue the sort of *media* minimalism you assume when you say that Gray's work is *just talk* or *actually writing*. Herbert Blau puts it best: "There is nothing more illusory in performance than the illusion of the unmediated."[24] That's because performance is always multimedia (or, better yet, *inter*media)—swinging from the archive to the repertoire and back, caught in tangled loops of

its own remediation. Performance isn't a medium at all; instead, it's what media do.

Gray's loop between writing and talking, the subject of this chapter, is not unusual in confessional art. From the start, it was defined by the tension between autobiography (something written, as the name suggests) and confession (an act performed). If confessional poets of the 1950s and '60s grappled with the thought that they were also performers of their poems, confessional actors of the 1980s came to the opposite realization. They found themselves writing—or, performing the role of Author. The poet Frank Bidart, Robert Lowell's protégé and literary executor, has a lovely way of describing such collisions (or collusions) between writing and performance. Thinking of Robert Frost's desire for the "speaking tone of voice" to be "somehow entangled in the words and fastened to the page," Bidart claims that his own poems speak in "voices [that] hover about a half-inch above the page."[25] Confessional performance sparks across this half-inch synapse—between a page and a voice, between a text and a person, between literature and performance. Jim Leverett, in his afterword to *Swimming to Cambodia*—the very monologue Kathy Russo, in a flash, heard *as writing*—unwittingly echoes Bidart. He sees the same synapse firing, but in the other direction: "What in [Gray's] monologues always seemed to be writing, hovering just above the table from which he performs, is now written."[26] This chapter explores that gap, on either side of which hover Bidart's talk and Gray's writing—Bidart's writing and Gray's talk.

The Stage Presence of Paper: Performing Writing

No honeycomb is built without a bee
adding circle to circle, cell to cell,
the wax and honey of a mausoleum—
this round dome proves its maker is alive,
the corpse of the insect lives embalmed in honey,
prays that its perishable work live long
enough for the sweet-tooth bear to desecrate—
this open book . . . my open coffin.
—Robert Lowell, "Reading Myself"[27]

In "Reading Myself," Robert Lowell can offer only the most slippery (and uncanny) of metaphors for his poems—not that old chestnut about poets living on through their poems, nor the one about poets sloughing their genius off in dead texts, but something else, something peculiar and self-contradictory. His poems, Lowell imagines, are a beehive, built up "cell [by] cell" around him. Together they form a "mausoleum" for their maker, but (oddly) this mausoleum "prove[s him] alive." Well, not alive: a "corpse." And yet alive: he endures—not just "embalmed," but conscious enough to go on "pray[ing]" for the hive itself, which alone is a "perishable" thing. In the end, Lowell prays not that his work might endure, but only that it "live long enough"—long enough, that is, to be destroyed. Promising life and death—death and life—with dizzying speed, this poem captures a certain paradox about texts: they are either livelier than life itself, or else (we can't seem to decide) as dead as fingernail clippings.

"Reading Myself" gained special meaning when Lowell performed it at one of his very last major readings, which Caedmon captured on tape in late 1976, but only released on vinyl in 1978, soon after Lowell had died. In his opening banter that night, Lowell noted that, for the very first time, he was reading not from typescript pages or from a stack of books, but from a single, hefty volume: his newly released *Selected Poems* (1976). This was exactly the sort of thing he had imagined in "Reading Myself": a massive, tessellated thing that the poet had built up, "adding circle to circle, cell to cell." "This open book . . ."—imagine him reading this line while visibly holding his life's work in his hands, its pages still crisp, unbent, and unmarked—"my open coffin." Within a year, he'd be dead.

The set for *Stories Left to Tell*, Gray's theatrical eulogy, seems to literalize Lowell's poem, turning a life's work into a beehive of writings (Figure 3.1). Stacks of marbled composition notebooks fill the stage, not just dressing the set, but also serving as furniture. Meanwhile, looming over the stage is a backdrop built circle by circle, cell by cell from the pages of Gray's private notebooks. Made from roughly 150 distinct facsimiles—far more than necessary if the only goal was to avoid obvious repetition—this backdrop betrays a more fervent aspiration: not just to memorialize Gray but to conjure his presence onstage. Set designer David Korins, speaking to me, emphasized the vicarious sense of touch these notebooks afforded the audience. After all, these were just the sort

Figure 3.1. *Spalding Gray: Stories Left to Tell*, as produced at the Minetta Lane Theater in 2007. Courtesy of David Korins.

of thing Gray always carried around "in his pocket, or his bag," and now they were cradling the bodies of his surrogates onstage.[28] With the help of lighting designer Ben Stanton, Korins's backdrop did more—bringing the notebooks almost to life. Sometimes, lit harshly from the side, these pages showed how well-handled, how creased and crumpled they were. At other times, lit warmly in layers, they grew translucent, taking on the weight and texture of human skin. And like Lowell's beehive-poems, these pages seemed so "perishable." Lit flatly from the front, they formed the shape of a monumental book, but one that was tattered and illegible. Lit more subtly, they began to look not like a book, but like a theater falling to ruin. Two layers were visible in these moments—a torn backdrop and a crumbling proscenium. All the while, the pages were held in place by fishing-line that wrinkled and warped each piece of paper. They looked, Korins observed a bit queasily, "like they had been dredged from the water"—as Gray's own body had been in early 2004.[29] This stage was book and theater, word and body, dead and alive. *This open book . . . my open coffin.*

Jim Leverett thought Gray's art was haunted by writing that "hover[ed]" over the table between him and his audience; in *Stories Left to Tell*, we see the opposite: Gray's writing fills the stage, but it is haunted

Figure 3.2. Video of Spalding Gray performing *Morning, Noon, and Night* is projected onto the set of *Spalding Gray: Stories Left to Tell*, as produced at the Minetta Lane Theater in 2007. Courtesy of David Korins.

by the ghost of Gray's body. If the audience didn't feel this while Gray's surrogates were performing, they surely felt it once these actors had left the stage. In the play's final moments—as the lights dimmed and the actors began to filter out—a video projection brightened the screen of Gray's writing: footage of Gray performing his last fully realized monologue, *Morning, Noon, and Night* (1999). The video starts with a familiar image: Gray seated behind his trademark table and microphone. But it goes on to show one of the few moments in his long career when he actually stood up from behind that desk—a moment that might have been lost (even to imagination) if this archival video had never been made. (No stage directions appear in the published text of *Morning, Noon, and Night*.) Flying across the stage, Gray demonstrates a dance party that broke out among his family one day. And perhaps the most physical moment of his sit-down career, desiccated to a thin, dim image, is projected onto the worm-eaten pages of his writing.

No matter how well the show's design conveyed a sense of the tension between texts and bodies, authorship and acting, the show's publicity materials convinced viewers they were seeing something else. Press releases (and the articles based on them) dutifully repeated Russo's

emphasis on Spalding the Writer: "a five-person ensemble performs the wit and wisdom that is found in the words of Spalding Gray," one press release declared, and here you see how the desire to let "words . . . take center stage" can warp the very fabric of a sentence.[30] How much simpler would it be to say that the play stages "the wit and wisdom of Spalding Gray," or that "a five-person ensemble performs the words of Spalding Gray"? But only this long-winded version can express the team's mission to champion the "writer" *instead of* the performer, the "words" personified instead of the person and his words. This happened quite literally in the show's playbill. Each actor was identified by a theme from Gray's work, which they were personally charged with embodying—Kathleen Chalfant as "Love," Hazelle Goodman as "Adventure," Frank Wood as "Family," a rotating guest celebrity as "Career," and Ain Gordon as "Journals" (i.e., Gray's most private reflections). At the head of this allegorized cast, Gray is credited as "Words"—not actor or author, but Words performing.

Swayed by rhetoric like this, most critics treated *Stories Left to Tell* as a familiar sort of play: author-dominated, text-driven, and honor-bound to do justice to the Words. Anthony Nelson, reviewing the play for *NYTheatre*, praised this production as "generally clear and supportive of the text."[31] Robert Simonson, writing for *Time Out New York*, lauded the cast in similar terms for "letting Gray's wonderful words do the work."[32] And even those who disliked the production based their judgment on this premise. Dan Bacalzo of *Theatermania*, for instance, complained that the show "feels strangely overproduced, which lessens the impact of Gray's words."[33] Such reverence for the authority of words—and such denigration of any production that doesn't meekly defer to them—is common enough in lay understandings of the theater, but given Gray's career-long struggle against this way of thinking, it's awfully strange to encounter it here.

The bad fit between Gray and this aesthetic ideology of "the text" became obvious when, inspired by this production, journalists started to get not just the spirit, but the facts of Gray's practice wrong. Mark Singer, writing a preview piece about *Stories Left to Tell* for the *New Yorker*, begins by noting that Gray "possessed such an immediate, arresting presence . . . that it was possible to forget that his meandering delivery depended upon words he had committed to the page with obsessive

precision."[34] This is simply untrue. Although Gray's private journals and working notebooks do contain anecdotes or phrases that crop up in his monologues, the monologues themselves were never scripted—only ever transcribed. Working in front of an audience, Gray drafted his monologues afresh in each performance; and his revisions were based not on transcripts he read, but on audio recordings of recent performances. As with Quentin Crisp, so too with Gray: "the rehearsal, you might say, was the night before's performance."[35] Gray's "immediate arresting presence," then, was not separate from his writing, not a distraction from the "words he committed to the page." It was inextricable from them.

Thankfully, the staging of *Stories Left to Tell* captured this paradox in ways that exceeded the public statements—perhaps even the private intentions—of its creators. For instance, although Sexton and Russo clearly intended Ain Gordon (Journals) as an avatar for Gray's most private writings, they managed to present him in a way that belied both their privacy and their status as mere writing. In that same *New Yorker* write-up, Gordon, an artist best known for his work as a playwright, explains the rationale behind casting him in this role:

> I don't consider myself an actor. I'm a writer. I write plays . . . I haven't appeared in anyone else's work since college. When we began this project, they said, "We'd like you to read the journal entries." I thought that was good. I'm his offstage self—a writer playing a writer.[36]

The creative team presents Gordon not as Gray's "offstage self," however, but in his most iconic onstage look: seated at a plain desk with a microphone and open notebook in front of him. The writer simply *is* the performer, and vice versa.

And, despite the fact that Gordon visibly reads from the page—rather than speaking more or less spontaneously, as Gray tended to do—his performance best captures Gray's own confessional energy. The other performers, after all, are delivering familiar tales—the greatest hits, the stories you might have heard secondhand even if you never saw Gray perform them. Gordon's material, however, is charged with all the urgency of fresh revelation—not least when he reads (to audible gasps from the audience, the night I attended) Gray's final and hitherto unaired journal entry: a suicide note addressed to Russo. "I don't want an

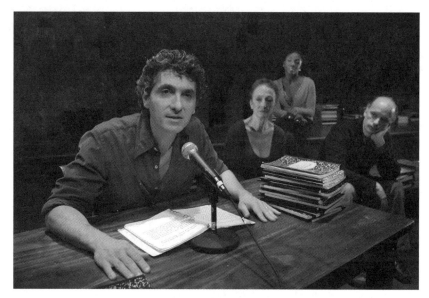

Figure 3.3. Ain Gordon and the cast of *Spalding Gray: Stories Left to Tell*, as produced at the Minetta Lane Theater in 2007. Photograph by Sara Krulwich. Courtesy of the *New York Times* and Redux Pictures.

audience," he writes, "I don't want anyone to see me slip into the water."[37] Reading this passage, Gordon gives Gray the audience he finally did not want. As an act of exposure it's riveting, if unsettling. And it's the consummate extension of Gray's practice—conflating the most private kind of authorship with public performance. After all, Gray's presence onstage was always haunted by writing—and one critic, at least, seemed to remember this fact. Gray's "writing," the *New York Times*'s Ben Brantley exclaims in a proper tone of surprise, "turns out to have a cohesive theatrical life of its own." There is something ghostly, though, in seeing the words without Gray's performance: "by the end," Brantley shivers, "I was hearing its author's voice as if he were sitting beside me."[38]

Such uncanniness, the result of seeing "writing" take on a sudden theatrical life, is not only available in postmortem productions of Gray's work. (His own notion of his monologues as "talking novels" might suggest as much.) Francine Prose, in her introduction to Gray's posthumously published monologue *Life Interrupted*, begins with a consciously overblown comparison of Gray to a novelist—except with one crucial caveat:

Years ago, I heard a novelist say that his most cherished fantasy was to sit at a small wooden desk in the middle of Yankee Stadium. On the desk he would have his typewriter. . . . He'd write a sentence; the crowd would watch. Another sentence, and he could sense the fans moving toward the edge of their seats. And then at last he would write a particularly brilliant and beautiful sentence, and the stadium would erupt in a mad frenzy of applause, cheers, and whistles. . . . [I]t's often occurred to me that what he imagined was an exaggerated but essentially accurate description of Spalding's working method. Spalding wrote at a small wooden desk in front of an audience; the only thing missing was the typewriter.[39]

A writer without writing, Gray let his words fall toward his audience, a page hanging off the back of an invisible typewriter. Ultimately, though, this is only a metaphor. We must not begin to believe in invisible typewriters! If we do, we won't just overvalue the "writing" of such monologues; we will also, in fixating on this phantom, fail to see what is happening in front of our eyes. We'll stare right past all those technologies of inscription and mediation that actually *did* fill Gray's small wooden desk as he performed. (Look more closely at Figure 3.2.) For all the alleged minimalism of confessional monologue, Gray's cluttered desk shows us something else: an utterly maximalist approach to media. If a self *is* captured in confessional monologue, it is held down tight by this cross-media knot—caught in the strange loop from inscription to performance and back. Rooted neither in talk nor in writing alone, it grows up through the cracks between the two. It thrives in the "interpolated distance" that occasions (and then haunts) any act of mediation.[40]

Spalding Gray, finally, did not "tak[e] center stage" at the expense of "his words"—the false history Russo posits only to subvert. He shared the limelight. Invited to speak at Gray's memorial service, A. M. Homes—a writer of novels (the merely written kind)—attested to this fact, describing the joy audiences took in watching Gray share the stage with his writings. Recalling those same Washington, D.C., performances that earned Gray the dubious title of "Talkmaster," Homes fixates instead on Gray's notebooks—the ones from which he never quite read.

I watched the notebooks, wondering what was in them. Was every line written out point by point? Or was it filled with a general outline,

concepts, or perhaps they were blank, just a prop? I could never bring myself to ask, or peek.[41]

The uncertainty seems to have mesmerized Homes. In fact, these notebooks contained—well, no. Let that wait. Gray's confessions raised questions like these on purpose, but not in hopes of eliciting any quick, easy answers. A delicious delay is exactly—for now—what we need and deserve.

This ambiguity may seem to distinguish Gray's performances from the certainties of the poetry reading, where authors tend to read set texts from authorized copies—and yet Gray turned to poetry readings for ideas on how to disrupt assumptions like these. In one interview, for instance, he tells of an early stab at solo, confessional performance: on a cross-country trip in 1978, he stumbled upon a Beat-style "open-air poetry reading" in Boulder, Colorado, and decided, on a whim, to "get up on that platform and do a poem." As he remembers it, "I spoke as fast as I could remember all the details from the time I left NYC on the Greyhound bus . . . I just told that story real fast and then I ran."[42] But in addition to patterning his work on such obviously "raw" modes of improvised poetry performance, Gray was fascinated with the medium-rare spontaneity of Robert Lowell. Gray would have met Lowell in 1968 when making his Off-Broadway debut in a production of Lowell's play *Endecott and the Red Cross*, but it was that final, live Caedmon recording of Lowell's reading that left the greatest mark on Gray. As Gray once explained, citing this particular LP:

> I leaned toward Robert Lowell who used poetry as a diary. I heard Robert Lowell on record read, say at the YMHA, and when he would introduce the poem, the introduction was as interesting as the poem. . . .[43]

By 1976, when this reading was recorded, Lowell had grown confident in his role as a confessional performer. He not only delivered long, anecdotal introductions to the poems; he also peppered his readings with fresh talk. During some of the poems he reads on this album, he hardly seems able to get through three lines of verse without wanting to digress: on the private meaning a word holds for him, on his history with a person he mentions in the poem, on a relevant detail he somehow never

thought to include. He even stops sometimes to comment on how the audience responds.[44] The result is a blend of writing and talk every bit as unstable as the performances of Gray (or Quentin Crisp, for that matter, or Bette Bourne). And given the consciously speech-like style Lowell adopts from time to time in his poems, it can be tough to know just where the poem's chat drops off and the poet's picks up. Even a printed version of the poem wouldn't help, since Lowell obsessively revised even after his poems had long been published. Gray took inspiration from Lowell, then, not only as a fellow New Englander who, like Gray, "used poetry as a diary," but also as a performer playing with and against the authority of confessional texts.

This origin myth for Gray's monologues—i.e., that they were based on Gray's sense of how a reading might go rogue—contrasts starkly with another just-so story. According to this oft-cited account, Gray's monologues were born in a moment of pure theatrical presence, where confession suddenly welled up from underneath all the artifice of theater. Here's this story as Gray told it in 1999:

> Richard [Schechner] said, "I want you . . . to drop your character. Drop all this character you've built up . . . and just stand there." . . . I remember . . . feeling this onion of the character peeling away, peel after peel. . . . It began to occur to me, What if I didn't rebuild my character? If I continued to stand here, looking at the audience. What might I say?[45]

This is a pretty appealing origin story, agreeing as it does with our sense that such monologues must be minimalist, stripped of character, script, and all mediation. What's more, both Gray's champions and his detractors find their deepest beliefs confirmed in this version of the story. Those who want to affirm Gray as someone who shattered dramatic conventions and shook the theater down to its very foundations cite the story (see Schechner's introduction to William Demastes's book *Spalding Gray's America*), but so do those who want to criticize Gray for espousing a naïve, essentialist view of the self (as Peggy Phelan does in her witty and scathing article, "Spalding Gray's *Swimming to Cambodia*: The Article").[46] Both camps, in doing so, miss the point: they ignore a certain dead-serious play, a camp sincerity, at the heart of Gray's practice— perhaps at the heart of all confessionalism. This practice demands not

only spontaneous, direct expression ("What might I say?"), but also acts of mediation and revision—not just naked sincerity, but also the distance and irony that many layers of media can provide.

"Performance Art": Media and Minimalism

If Gray's presence is hard to disentangle from his words, his acting from his authorship, this is something he always made palpable in performance. From the start of his solo career to the end, Gray filled the stage with language in all its many states, from liquid to solid. This should not be surprising since he first learned to stage his autobiography while working with the Wooster Group—an experimental group he co-founded and whose name is now synonymous with "multimedia theater." Gray developed his first three autobiographical works (ensemble pieces known collectively as the Rhode Island Trilogy) with the Group, and, as he did, the layers of media just kept accumulating. The first

Figure 3.4. Ron Vawter, Spalding Gray, and Joan Jonas in the Wooster Group's *Nayatt School* (1978). Photograph by Bob Van Dantzig.

piece, called *Rumstick Road*, documented the suicide of Gray's mother using family letters, photographic slides, and (controversially) audio-tapes of interviews that Gray conducted with his relatives and with his mother's psychiatrist. The next piece, called *Nayatt School*, dealt with Gray's response to this suicide—and it went even further in this direction, putting onstage what the group's chronicler David Savran calls "an explosion of texts, performers, images, props and media."[47] From a long, thin table that cut across the stage, three record players spouted music "ranging from disco music to the Berlioz *Requiem*."[48] Meanwhile, behind the table in a sound-proof room, actors performed an old-time radio horror sketch, which reached the audience through the theater's sound system. And, up front, Gray read from T. S. Eliot's *The Cocktail Party*, commented on the private significance it held for him, and played snippets from an audio recording of its most famous midcentury production.

As the years went by, the Wooster Group went further and further in this direction, incorporating an ever-growing variety of audiovisual media into their performances. Gray, instead, went solo. As David Sterritt, a performance critic for the *Christian Science Monitor* and one of the earliest and most prolific commentators on Gray's work, observed in 1980:

> Gray's work has been flying in two different directions lately. On one hand, he appears in huge multimedia meditations. . . . On the other hand, returning to radical simplicity, he presents entertaining "monologues" devoid of all theatrical trappings, including a prepared script.[49]

Sterritt was hardly alone in seeing these as "two different directions," opposed and incompatible. According to many, this was a moment of truth: Gray stood at a crossroads between multimedia ensemble work and minimalist solo performance, and he chose the latter. For these critics, Gray's secession from the Wooster Group not only made his theatrical commitments clear; it also clarified a new understanding of the autobiographical self. Stephen Bottoms, for instance, observes:

> [The Rhode Island Trilogy's] collage approach seemed to invite audiences to view "selfhood" as a kind of patchwork of scraps and memories. . . .

When he moved to develop solos, however, Gray rejected such layering, and instead pursued a seeming artlessness in presentation.[50]

But in passages like these from Sterritt and Bottoms, their desire for a neat story leads them to overstate the case. The contrasts they base these stories on, after all, aren't so clear-cut as they may sound: "multimedia meditations" can be radically simple, after all, and layered selves can be performed in an artless manner.

If "multimedia" implied "maximalist" for many critics of the time, it wasn't just because they saw a clear fork in Gray's career path; it was also because they were tacitly comparing Gray's choices to those of his nearest contemporary, Laurie Anderson. Emerging not from the theater world, as Gray did, but from the conceptual and performance art communities, Anderson won fame with an epic, semi-autobiographical piece called *United States*, which she developed alongside Gray's earliest solo work (i.e., from 1979 to 1983). Unlike Gray's minimalist work—with no script, plot, or costume, minimal design, and something just shy of character—Anderson's work was wildly maximalist, a meticulously scored, multimedia extravaganza. Ornamented with baroque encrustations of technology—from back-projected video and fog machines to jury-rigged synthesizers and vocoders that Anderson, a great tinkerer, designed herself—*United States* resembled nothing so much as a souped-up rock 'n' roll concert. Such work, one critic observed in 1983, was "a healthy reaction to the *reductio ad absurdum* of modernism and its last, 'minimalist,' gasp."[51]

Wowed by Anderson, and by her ties to the gallery art world where "art performance" had first taken hold, journalists based their definition of "performance art" on her peculiar style of techno-maximalism. "Many kinds of 'performance art,'" writes John Rockwell, "are in reality embryonic operas, mixed-media experiments that may soon blossom into full-scale pieces of musical theater."[52] As amusing as it might be to imagine Linda Montano's rituals or Eleanor Antin's persona performances "blossom[ing] into . . . musical theater," this remark only shows how successful Anderson was in *redefining* "performance art" as it entered the popular lexicon. It is only in contrast to Anderson, then, that Gray—later considered a definitive "performance artist" himself—was at first denied this label. Mel Gussow, for instance, began his review of one of the first

performances of *Swimming to Cambodia* (1984) by musing, "Were it not for the absolute simplicity of the presentation, one might be tempted to say that Spalding Gray has invented a performance art form."[53]

* * *

Contrary to the view that Gray's monologues marked a reaction *against* the Wooster Group and its multimedia aesthetic—or else against the multimedia "performance art" of Laurie Anderson—Gray insisted that he was pursuing the exact same aesthetic by different means. For starters, it's widely acknowledged that Gray's first stab at "radical simplicity" happened *within* one of the Wooster Group's "multimedia meditations." In the first scene of *Nayatt School*, Gray addressed the audience directly, discussing his own experience of performing in a production of *The Cocktail Party*, analyzing the text of this play, and illustrating his analysis with snippets from an audio recording of a famous production. And, in spite of the critical consensus that Gray rejected the Wooster Group methods when he embarked on his solo career, Gray and LeCompte (the group's director) seemed to agree that he was simply adapting these methods in new, minimalist ways. Note this exchange from a 1986 interview:

> SPALDING GRAY: . . . the monologues never would have come into being had not the Group been my first supportive audience, at the table, in *Nayatt*. And then it was a matter of shrinking the table down to a desk.
>
> ELIZABETH LECOMPTE: As I am expanding it.[54]

Shrinking the table of *Nayatt School* down to a desk, Gray retained all of its multimedia play.

In his monologues, Gray is constantly holding, wielding, reading, interpreting, and showing off scraps of writing and sound. They are traces he has left in the world, or else remnants of what the world has left with him. For example, in *Nobody Wanted to Sit Behind a Desk* (1980), he tells the story of a cross-country trip, the one that brought him, in fact, to the venue where the monologue premiered—and he proves what he is saying by bringing everything from a South Dakotan place mat to a Santa Cruz newspaper onstage.[55] In *47 Beds* (1981), also a kind of travelogue,

Gray brings a recent issue of *Playboy* onstage in order to display a certain series of cigarette ads that had haunted and mocked him on his recent travels across Europe. (The ads showed men—far manlier than he—roughing it alone in ways he failed to do on that trip.)[56] And in *Travels Through New England* (1984), a monologue about touring his act through that region, Gray quotes ads from village bulletin boards, reads out local newspaper coverage of his tour, recalls graffiti from the men's rooms at the Rhode Island School of Design, and discusses at great length a questionnaire for aspiring writers he found while picking through the bales behind a paper mill.[57] In short, with every passing year, he would admit more (not less) foreign text into his talk.

But it's his use of audio recordings that betrays Gray's deepest debt to the Wooster Group and their methods. For instance, Gray builds an entire section of *Booze, Cars, and College Girls* (1979) around the "recordings of road races" he and his childhood buddies loved to play—in particular, one album where "you could hear [road-race] drivers talk when they pulled in for repairs."[58] In this passage from one of his earliest monologues, Gray is using one of the Wooster Group's chief working methods in those days—what company members had taken to calling "record [album] interpretations."[59] In these "interpretations," members of the Group would build a scene (or an entire performance) around some artifact of recorded sound. So, *Rumstick Road* grew up around the taped interviews about Gray's mother, *Nayatt School* grew around recordings of *The Cocktail Party* and Arch Oboler's radio horror skits, etc. In each case, the cast took a guilty pleasure in these recordings even as they offered a critical perspective on them. This is what Gray continued to do in his monologues.

Complementing all these scraps of text and sound, Gray also brought ephemeral writings of his own onstage—cocktail-napkin scribbles and bedside scrawlings—making sure to distinguish such documents from the fluid, fresh talk all around them. At the beginning of *47 Beds*, for instance, Gray removes two sheets of paper from his notebook and, in a monotone voice, reads an account of a dream he's recently had. He even pauses midsentence to turn the page, as if to make doubly sure we know he's reading.[60] Later in the same monologue, recalling the manner in which tourists swapped autobiographical stories with him, he even

pulls out a copy of one of these stories, which (we're meant to believe) he wrote down at the time. In short, as Gray's solo career developed, his monologues didn't grow more immediate; in fact, he loaded his shrunken table with more (and more various) piles of media.

This accumulation of media—recorded sound; transcribed stories, graffiti, and dreams; published text, found images, etc.—is a familiar trope of 1980s performance, and indeed of all postmodern art. Few artists, at the time, were trying to capture their culture by telling its story directly; instead, they gathered its detritus, especially its mass-produced junk, and tried to conjure the truth from that mess. With this context in mind, the Coca-Cola and Schaefer Beer cans flanking Gray's record player in *Booze, Cars, and College Girls* look like his attempt to become a Warhol painting in the flesh. Noël Carroll, writing in 1986 about the overlapping terms "art performance" (more gallery-bound) and "performance art" (more theatrical), describes them as sharing with one another "a kind of extended show-and-tell as artists rummage through the junkyard of cultural images and artifacts of . . . our Post-Everything predicament."[61] This is precisely what Spalding Gray's monologues shared

Figure 3.5. Spalding Gray in *Booze, Cars, and College Girls* (1979). Photograph by Nancy Campbell.

with the work of the Wooster Group, Laurie Anderson, and so many others. Though their style may have differed quite radically on the surface, their cultural logic was the same underneath.

Indeed, the Wooster Group's first piece without Gray—*L.S.D. (. . . Just the High Points . . .)*—looks remarkably similar to the solo work Gray was doing at the time. Exploring a memoryscape of the 1950s, just as Gray's earliest monologues were doing, *L.S.D.* began with the ensemble onstage listening to interviews about Timothy Leary and his early work with psychotropic drugs at Harvard. They then interjected brief readings from a pile of countercultural books from that period. Neither these readings nor the interviews *describe* history exactly, nor do they cause a *reenactment* to break out; instead, they conjure it up. "It's a little bit like a divining rod," Ron Vawter explains, "or passing your hands over a Ouija board's heat. It's staying light on your toes over a lot of materials and finding what's possible between them."[62] And what the cast found "between them," it turns out, was often a kind of confession, though they mostly refrained from actually confessing. As one member of the en-

Figure 3.6. The "expanding" table in the Wooster Group's *L.S.D. (. . . Just the High Points . . .)* (1984). Photograph by Paula Court.

semble later recalled, "*L.S.D.* is so much an encapsulization of the days of my twenties. . . . I remember being so happy when my father was in Boston to see it. I thought . . . this is a true moment of autobiographical exchange with him. I can really give him a section of my life. . . ."[63] Autobiography was, in this sense, a kind of intimate formalism—a lingering trace of the "Ouija board's heat." And many critics said the same of Gray's monologues, in spite of the fact that he offered so many outright confessions: "[T]he real autobiography in his monologues wasn't what he said so much as the way he connected what he was saying."[64] The scraps and snippets he brought onstage reminded his audience to hear his monologues that way: as the words of a man ranging "over a lot of materials and finding what's possible between them."

The Flatness of Paper: Publishing Performance

If this was clear in each performance of Gray's monologues, it was quickly papered over, so to speak, in print. For instance, the dream I describe as Gray's opening gambit in *47 Beds* does not appear in the printed text at all. This results in a more "literary" opening, I suppose: instead of starting, as he usually did in his early monologues, with a blunt autobiographical fact, Gray seems to begin *in medias res*, saying, "I awoke a little anxious to find. . . ."[65] This hardly changes the literal meaning of *47 Beds*, but it proves a poor guide to his confessional practice—and to its representational logic. The way his monologues were flattened onto the page may account, in fact, for the scholarly consensus that Gray's work—and, by extension, confessional monologue as a genre—is minimalist, and therefore *im*mediate.

Simply transcribing these photo, audio, and print objects—or else eliding their presence altogether—threatens to downgrade a complex act into a simple recital, a labored performance into an unruffled text. The experience, for instance, of listening to *The Sounds of the Annual International Sports Car Grand Prix of Watkins Glen, N.Y.* during *Booze, Cars, and College Girls,* has very little to do with the experience of reading its words transcribed onto the page, which is all its published text has to offer us.[66] On the page, it may seem as if Gray is simply channeling his boyish admiration for these manly mechanics and the mysterious argot they share. In performance, though, Gray's bemused tone and his choice

of a particularly absurd bit of patter from that album turn this moment into something else: a sly critique of anxious, competitive masculinity. Actually listening to the recording along with Gray, you can't ignore just how stilted these men sound in front of the microphone and how irrelevant the mere facts of the technical inspection they're conducting ("a toe rim on the rear wheel" "there *is* no alignment on the rear wheels" "a bent axle or something of that nature" "a bent bell housing") ultimately are. What matters are their attempts to perform, for each other and for that microphone, the sort of technical prowess that might prove they *belong* in the macho world of racing. All this talk of what's "bent," in other words, reveals nothing so much as their desperate desire to be counted as "straight." The text transcribed obscures this point.

Elisions like these are only exacerbated by the truly bizarre form in which Gray's monologues have been printed. When Random House published six of Gray's earliest monologues under the title *Sex and Death to the Age 14*, they decided to apply the print conventions not of drama but of prose memoir. This is easy to do with monologues, of course, which usually have no need for speech tags, stage directions, or anything that would erode the solid rectangle of text. But Random House did much more than just make each page look as neat as a page of prose. For instance, in the publication of an anthology of theatrical scripts, it is customary to preface each play with a page of production history—crediting the play's original writers, designers, and producers and providing the date and location of any developmental or premiere productions. Random House excludes this information entirely, though, making the monologues look like chapters in a single, long prose autobiography.

The outside of the book conveys an even weirder message. The back cover categorizes the book as a work of "fiction," implying not only that its contents aren't true, but that this material was born in prose. And if we turn to the front cover, we see Gray awash in white—white shirt, white table, white wall—an overwrought denial of the spot-lit isolation that darkens every photo of Gray actually performing. Meanwhile, the featured blurb from the *New York Times* does little to clarify matters, as it mashes up theatrical and literary ways of describing Gray: "A sit-down monologuist with the soul of a stand-up comedian . . . a contemporary Gulliver." So eager was Random House to project Gray the Writer and

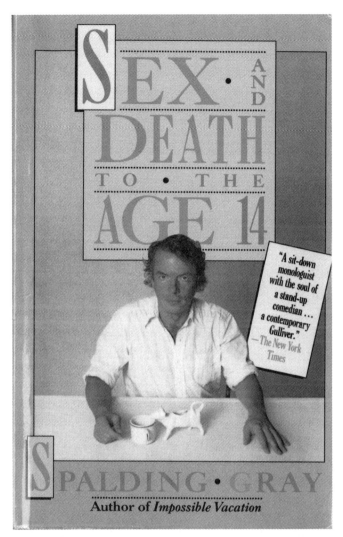

Figure 3.7. Front cover of Spalding Gray's *Sex and Death to the Age 14* (Vintage, 1986), featuring a photograph by Nancy Campbell.

evade Gray the Performer, they even went so far as to credit him (on later printings) not as "the acclaimed monologuist" or "creator of *Swimming to Cambodia*, now a Major Motion Picture"—i.e., not on the actual basis of his national and international fame—but as the "Author of *Impossible Vacation*," a quasi-autobiographical novel that Gray published to mixed reviews and limited sales in 1992.

Even without all these paratexts to persuade us, the monologues themselves, transcribed and flattened to the page, deny their own media complexity. Some documentary intrusions (such as the dream at the start of *47 Beds*) are omitted entirely, while others are sanded down until they're flush with the rest of Gray's words. The tourist's tale in *47 Beds*, for instance, loses its code-switching tag, "The only one I wrote down was . . . ," and we lose any sign that much of the text is piped in from record players and tape decks or read from little scraps of paper, not spoken in the uniform voice of Spalding Gray, gregarious storyteller. Any sense that the self performed might emerge from shuffling papers and "finding what's possible between them"—any lingering trace of "the Ouija board's heat"—disappears into the cool, placid myth of the Prose Author. And so a "minimal" and "immediate" Gray is projected backward from the printed page.

Imagine, for a moment, that Robert Lowell's readings were published in the same manner as Spalding Gray's monologues. Below, I transcribe one track from Caedmon's *Robert Lowell: A Reading* in the Random

Figure 3.8. Robert Lowell's reading of his "Memories of West Street and Lepke" from *Robert Lowell: A Reading* (LP; Caedmon, 1978)—reimagined as a Gray-style monologue.

House *Sex and Death* mode. Try to pick out the poem. Which asides are spoken ad lib and which ones were written down in the poem from the start? Where exactly do the line breaks occur? What is talk and what is writing? You may get most of it right, but I bet you'll make a few "mistakes." Now, ask yourself: *Does it really matter?* And besides, the poem Lowell read that night may still differ from the text he published seventeen years earlier in *Life Studies*. Perhaps Lowell has made deliberate revisions over the years, but it's also possible that he's "mak[ing] little changes just impromptu" as he reads, just as he did when this poem was still fresh.[67] If this task of picking through patter to arrive at the poem feels familiar, or even easy, that's because we think we know what a poem *really* is: a stable thing. Secure in that knowledge, we fancy we can *see through* this text (or *hear through* the reading) to arrive at the poem. Meanwhile, we ignore that it, too, was destined for performance, and for a kind of multimedia play that we'll never put down in squat blocks of text. We should never accept, in the more obviously unstable case of Gray's performances, what fails to account for even the far simpler scene of the formal poetry reading.

Dancing with the Dictionary, or, The Outlines of a Self Performed

We would be mistaken to think, along with Random House, that all writings aspire in their souls to be a novel—or that any book can stay static for long. Texts, as literary scholars know well—as actors, perhaps, know better—are always inviting us to dance. The important question is: what are the steps, and who gets to lead? In her essay "Dances with Things," Robin Bernstein develops a performance-inflected approach to material culture that can help us to answer questions like these. In that essay, she reads a wide range of historical objects (from photo arcades to racist alphabet books) as "scriptive things"—that is, things that, "like a play script, broadly structure a performance while simultaneously . . . unleashing original, live variations. . . ."[68] Although Bernstein is speaking figuratively, here, the American theater over the past half century has literalized her claim. From documentary drama and reader's theater to our increasingly bookish avant-garde, American artists have made theater out of books, letters, transcripts, and other printed ephemera—treating

them not as prior scripts, but as present and scriptive things that visibly license and constrain performance.[69] This is one way of understanding all that paper Gray puts onstage: in lieu of a script, he surrounds himself with scriptive things. And from the moment Gray went solo, one sort of scriptive thing lorded over his confessions: I mean the dictionary or lexicon.

In his earliest theatrical solo, Spalding Gray wasn't alone on stage. In fact, he wasn't even seated center stage. He sat stage right, far away from his trademark table and chair, which sat somewhere stage left. There, an assistant was seated—her eyes fixed on the pages of a dictionary. The premise of the piece, called *India and After* and first performed in 1979, was this: Gray would tell stories from the last few years of his life (starting with his tour of India in the Performance Group's production of *Mother Courage*), but he would do so under only the strictest conditions. First, his assistant would read a random word (and its definition), then she would announce a unit of time, from fifteen seconds to seven minutes. In that time, Gray would have to tell a story related, however tenuously, to the word or its definition. When the time was up, a bell would ring and the process would repeat. Civilian, hurdy-gurdy, setting, friend, time-clock, drown, Stalingrad—and so on for over an hour. After the bell had rung one final time, his assistant would reread, in order, a full list of the seed words that night—usually around forty of them—and the piece would end.

Few scholarly analyses of *India and After* exist, but all of them crystallize around a reading of this final moment: the ritual incantation of that night's scriptive lexicon. Both the Wooster Group historian David Savran and the Gray biographer William Demastes interpret this moment (and, retroactively, the whole piece) as a vanishing act, where the dictionary *disappears*—as all Gray's media seem to do—to be replaced by the stories he tells. As the words are read aloud, both critics claim to hear them as "cues" to the "narrative fragments" Gray had attached to them.[70] Perhaps these two critics have powers of memory that I lack, but as I watched the same recording of *India and After* they did—made during a 1982 retrospective of Gray's monologues—I experienced no such revelation.[71] Only three or four of the forty-eight words from that performance brought any particular story back to mind, and the rest marched coldly past me. Given that many of Gray's narrative fragments

relate only loosely to the seed words the dictionary provides, and given how many seed words Gray blazed through in every performance of *India and After*, I've got to imagine most spectators would share my own experience of that ending. After all, such feats of memory, and the watchings and rewatchings that make them possible, are the privilege not of theatrical spectators, who must grasp at the threads of narrative blowing past, but of scholars in the archive, who can patiently weave and reweave their understanding of a work. I was left, then, and I suspect most would be, with an overwhelming feeling not of the dictionary's disappearance or transparency, but of its presence and obduracy.

Because these critics read the piece as a vanishing act, where narrative invades and displaces the dictionary like new skin growing over a graft, they view the dictionary merely as a randomizing device—important not in itself, but only as the source of arbitrary formal constraints. In particular, they understand its senseless commands as a stand-in for one aspect of *India and After*'s story—namely, the manic-depressive episode that crippled Gray during much of the period he recalls in this piece. As David Savran observes, "[Gray] communicates the severity of [this] crisis less through the content of the stories than through their fragmentation."[72] And indeed, Gray claimed that he turned to the dictionary only when he despaired that his tale was too droningly linear to capture "the way my mind was working at the time."[73] But "fragmentation" hardly suffices to describe this state of mind—or the particular structure Gray devised to express it.

First, if we accept Gray's claim that the dictionary helps him capture "the way [his] mind was working at the time," we do not therefore need to accept, as Savran does, that the dictionary simply *represents* Gray's mental illness. This is just a fresh example of an old temptation: to recuperate form as content—in this case, to see fragmented stories as a figure for a fragmented psyche. But this is not how form works—least of all in the performing arts. Form is not just the architecture of art, to be taken in whole, then translated into meaning. We experience the form of performance as flow—feeling its force whenever an obstacle threatens to bend or disrupt it. To understand what role the dictionary plays in *India and After*, we should pay attention not to the structure it provides, but to the habits of thought and action it occasions. That is, we should see it

as a scriptive thing—something whose meaning happens only when we treat it as a scene partner.

Observed for its pressure upon performance, the dictionary of *India and After* doesn't simply fragment some normal mental order; it injects a foreign premise into an otherwise sensical thought process. In other words, it doesn't simply *represent* some sort of fractured mental state. It *occasions* a struggle for coherence onstage; it gets rid of the need to refer elsewhere for this struggle. The effect, in practice, is not a feeling of fragmentation, but a sense of near-coherence, frustrated (but just barely) at every turn. In the performance that Savran and Demastes are discussing, this sweet coherence is so close you can taste it. Gray elegantly interweaves five larger narratives—each one told piecemeal (and out of order) throughout the night—and yet he brings each one to a gentle conclusion at the end of the agreed-upon time.[74] So, *India and After* doesn't show us incoherence, as Savran and Demastes both argue it does; instead, the piece *enacts* a struggle for coherence each time it is performed. And as Gray seeks out coherence within tight constraints, he learns how to be a kind of lexico-hacker, looking for the "exploit": the word, phrase, or stray connotation that opens up a loophole out of the dictionary's frozen idiom and back into his own fluid performance of himself.

And yet it seems wrong to treat the dictionary as nothing more than a frozen monument. In the conflict Gray enacts between *langue* and *parole*, the dictionary is an arbiter, not a partisan. When Samuel Johnson, writing in the preface to his 1755 *Dictionary of the English Language*, explains that "our speech is copious without order, and energetick without rules," he is exulting in the strain this puts on dictionaries. "May [that] lexicographer be derided," he exclaims, "who . . . shall imagine that his dictionary can embalm his language, and secure it from corruption and decay."[75] Dr. Johnson was not creating a hermetically sealed system; he was managing the feedback between a language and the world. Lexicographers after Johnson have developed a whole set of strategies for monitoring this feedback loop—a cybernetics of the language system. These are mostly rhetorical strategies; conventions of description and definition that, in their very conventionality, aspire to escape our notice. But we simply can't avoid noticing them when we start to play with, around, and against the dictionary. In the nineteenth-

century parlor game Dictionary, for instance, known nowadays as the branded board game *Balderdash*, players compete to offer fake yet credible definitions of an obscure word, which are then read alongside the one from the dictionary. The best player is the one who can steal and repurpose the voice of dictionary definition—one, that is, who can ventriloquize the dictionary and perform its peculiar brand of authority. By revealing the character and style of this authority, Balderdashers call our attention to the cybernetic nature of dictionaries—their reliance on circles—hopefully virtuous, but potentially vicious—between their words and the world out there.

In *India and After*, Gray isn't mimicking the voice of dictionary definition, but the form of the dictionary leaves its mark, and that form, it seems to me, is fundamentally digital. There is, after all, a good reason that dictionaries (along with encyclopedias and telephone directories) have been so smoothly incorporated into the digital age—and why they (like computers and databases) are said to have users, not readers. With their hypertextual exuberance, they were always digital things. We thumbed through page after page, ran our fingers down a column of headwords, riffled through the thick page block in search of something. This play of digits, the material practice of treating a book as a random-access database, defines our experience of the dictionary. In *India and After*, on that table stage left, we can see, when we turn away from Gray, the cybernetics of this digital dictionary in action.

And this is why Gray would come to rely upon the dictionary: his theory of the self was, in fact, equally cybernetic. Gray has cited as "his Bible" *Psychotherapy East and West*, a book by Alan Watts, an early theorist of cybernetics who acquired a cult following in the sixties by using these theories to unite psychoanalysis with Americanized Buddhism and other pop-psychologies of the self.[76] Most poignantly, Gray remembers reading Watts to his mother as her mental health declined—one last attempt to fix her fried psychic circuitry. But Watts's theories were not only a comfort to a young and anxious Gray; they were also appealing to Gray the polished performer. Improvising his monologues each night, abandoning them when they got too rigid (at which point, and not before, he had them published), Gray knew too well the constant blurring of the life narrated and the one lived, the narrative sculpted and the performance unleashed. Armed with the cybernetic theories of

Alan Watts, Gray could accept this confusion as inevitable—not cause for existential hand-wringing, but the natural result of trying to mediate the self. "It cannot be stressed too strongly," Watts writes, "that liberation does not involve the loss or destruction of such conventional concepts as the ego; it means seeing through them—in the same way that we can use the idea of the equator without confusing it with a physical mark on the surface of the earth."[77] This is Buddhist *maya* ("the illusoriness of life") reinterpreted as a way to frame and understand your life—as arbitrary (and as useful) as structuring your narrative around whatever the dictionary throws your way.

Gray stuck with this cybernetic sense of the self and kept sharing the stage with scriptive things all his life—kept performing, in fact, with a lexicon at hand. (Finally, an answer to A. M. Homes's lingering question: what *was* in those notebooks Gray brought onstage?) In his first true solo pieces (the ones discussed above) Gray didn't cast off his dance partner, the dictionary, nor did he shrug off its constraints. As he notes in the preface to his first published monologues, "I sat behind that desk with a little notebook containing an outline of all I could remember," or, as he clarifies later, "an outline [of] key words."[78] In other words, though he now wrote his own rules and kept his own time, he was still working from a list like the one his assistant kept in *India and After*: an otherwise inscrutable list of words that drew these stories out of him, allowing the "outlines" of a self to emerge.

This tension between confession and constraint comes to a head in Gray's 1981 monologue *47 Beds*. Just as the titles of his previous monologues had set out clear memory tasks (*Sex and Death to the Age 14*; *Booze, Cars, and College Girls*; *A Personal History of the American Theater*), *47 Beds* implies a schematic task: to tot up his travels over the previous six months by counting the beds in which he had slept. At the beginning of the monologue, he recalls that recently he "awoke a little anxious" and "instead of counting sheep, which I thought might put me back to sleep and I didn't want to do that, I started counting beds and realized that I'd slept in about 47 since the first of March."[79] He seems to be setting up a perfect "travelogue" structure, moving in a list from bed to bed—tempting us, perhaps, to think that his notebook contains that very list. Instead, it's his many digressions from this imaginary list that define this monologue. As Mel Gussow grumbles in a review of the

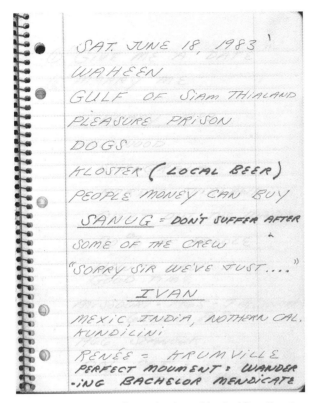

Figure 3.9. First page of a notebook used by Spalding Gray in performances of *Swimming to Cambodia*. Courtesy of the Harry Ransom Center, University of Texas at Austin.

piece for the *New York Times*, "Perhaps it was not 47 [beds]. It is easy to lose count. . . ."[80] In *India and After*, it is the generative clash between the dictionary game and confessional storytelling that produces the true meaning of the event. *Sex and Death* likewise plays on the mismatch between the simplicity of "an outline of all I could remember" and the complex structures of memory and storytelling. So, too, with *47 Beds*, which posits a neat outline only to show it getting bent out of shape. The force behind all this warping and bending—the thing submerged in the flow and troubling the waters—is what Gray is really trying to capture onstage. If we, like Gussow, feel ourselves losing track and catching up, then we are feeling its presence—a vaguer "outline," an unseen force: the self itself.

Beginning with *47 Beds*, Gray's search for this vaguer "outline" of the self—neither a strict schema nor an artless confession, but whatever emerges in the tension between the two—becomes a conscious theme of his monologues. Telling of his time in an Indian ashram, for instance, Gray dwells on the mandala—an intricate circular design used in both Buddhist and Hindu spiritual practice—as a figure for his own confessional art. Carl Jung—whose work Gray knew well, both in theory and as a patient of a Jungian therapist—was obsessed with mandalas, which he saw as holding both diagnostic and therapeutic power. For Jung, this obsession resulted in a private ritual every bit as repetitive as Gray's very public monologue making: beginning in the 1910s, Jung "sketched every morning in a notebook a small circular drawing, a mandala."[81] "My mandalas were cryptograms," he wrote. "In them I saw the self—that is, my whole being—actively at work."[82] These patterns, he claimed, "represent very bold attempts to see and put together apparently irreconcilable opposites and bridge over apparently hopeless splits."[83] Mandalas must have looked, to Gray, like a perfect model of his method—especially since Jung himself insisted that the mandala need not stay on the page, but can be "drawn, painted, modeled, *or danced.*"[84] Hoping to "bridge over" the "apparently hopeless splits" within himself, Gray added to Jung's catalogue the "mandala performed." Describing how his early attempts to meditate at the ashram resulted only in "hallucinations of black-and-white pornographic films on the wall," Gray has a revelation:

> I realized this was probably how the monks create their mandalas. It's all psychic projection from sitting so long in a cave: They finally project their psychic pattern on the wall and they just color it in like paint-by-number pictures. They probably start with pornographic movies and throw that away like lower chakra footage left on the cutting room floor.[85]

When Gray does finally manage to clear away all of this "lower chakra footage," he has an epiphany, and one that puns on the contents of that notebook in front of him:

> I was sitting there meditating, and everything all of sudden just emptied out. I was only an outline. . . . I was just this breathing outline with the room floating through me.[86]

As soon as this sensation has passed, he sets himself the task of "trying to figure out how to get back to that outline."[87] This, in brief, is a pretty good description of his confessional career. Setting up roadblocks to easy confession, he found something else—the vaguer "outline" of (what he hoped was) a truer confession.

The unstable relationship between writing, reading, and performance—which defines literary readings and bookish theater alike—is, I believe, a central feature of all autobiography. After all, this genre has a special relationship to performance—not simply because it draws upon embodied rituals of testimony, confession, and self-narration, but because, in its representational logic, it resembles drama more nearly than it does prose forms like the novel. As one scholar of life-writing has noted in an essay that argues for life-writing's "dramatic lineage," "in drama and life writing [unlike in the novel] . . . what is being imitated can never be fully expropriated or superseded by the copy."[88] This is probably why so many of autobiography's literal and imagined performances involve the author neither reading nor writing a life story, but wielding it instead. Memoirists on their talk show interviews, monologuists on their tours, confessional poets on the reading junket; they are originals who present us with a copy or trace, and dare us to compare—just as Jean-Jacques Rousseau, in the introduction to his *Confessions*, imagines he will do one day, waving that book in front of God and all mankind come Judgment Day.[89] The confessional self somehow sparks in that synapse between media—between the scriptive book and the playful body—between autobiography and confession.

Just (a) Talk

. . . Spalding Gray could be that popular, eccentric, sometimes outrageous college professor whose lectures were always packed.
—Joe Brown, "Spalding Gray, Talkmaster," *Washington Post*[90]

If, in person, many confessional monologues seem so transparent—so much more fluid and natural than I've made them sound by obsessing over their anxious relationship to writing and the written—perhaps this is because, as sociologist Erving Goffman argues in his last book *Forms*

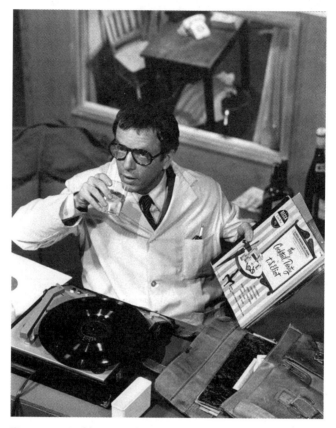

Figure 3.10. Spalding Gray lecturing on *The Cocktail Party* in the Wooster Group's *Nayatt School* (1978). Photograph by Clem Fiori.

of Talk, "deeply incorporated into the nature of talk are the fundamental requirements of theatricality."[91] Just as realist playwrights work hard to create speech-like interactions on the stage, so talk is also full of complex illusions—elisions of writing and rhetorical convention. Indeed, the idea that talk *ever* flows in fresh streams is, for Goffman, a collective fiction. (I was tempted to call it an enabling fiction, but part of Goffman's point in *Forms of Talk*—and mine here—is that we won't be disabled at all if we refuse to believe this myth.) If this is true of "talk" in general, it is doubly true of *the talk*—i.e., the academic lecture—a form that confessional monologuists (including Gray) often imitate.

Goffman dedicates an entire chapter of *Forms of Talk* to the genre of the academic lecture, not just because it's a form he knows well, but because it captures better than any other genre the "differences between talk and the printed word."[92] As simple as it may seem, the lecture combines a dizzying array of rhetorical stances and textual modes into its ritual performance of mental presence—its spectacular enactment of the stage-life of the mind. Lecturers can read or talk. They can vacillate between the two. They can verbally annotate, then spin off into stints of fresh talk. What's more, they can do so using the same multimedia apparatus (growing less subtle in the age of PowerPoint, Keynote, and Prezi) that fills the stages of monologuists like Gray. Just as the goal, in Gray's case, is to conjure a self, so the goal of "the talk"—especially in moments of off-the-cuff revision or elaboration—is to make hearers believe that "they have preferential access to the mind of the author," "that live listening provides the kind of contact that reading doesn't."[93] This is more than a return of the academic repressed—more than the admission that, as Goffman tactfully reminds us, "lecturers come equipped with bodies."[94] It is an article of faith in a world, academia, where we are known to each other mostly on paper, as author-functions in the print-public sphere. The talk requires that its author become a "mediator between text and audience," and so "expos[e] himself" to them.[95] Along the way, lecturer and audience "join in affirming that organized talking can reflect, express, delineate, portray—if not come to grips with—the real world, and that finally there is a real, structured, somewhat unitary world out there to comprehend."[96] A real world and, within it, something solid to get right—for the confessional talker, a perdurable self.

What the talk contributes to the article, book, or blog post, confessional performance affords autobiographical writing. When Gray clutters the stage with textual ephemera, he enacts his sense that mere writing will always prove insufficient, just as academic lecturers always perform the insufficiency of text to convey the full life of the mind. And just like Goffman's lecturer, the confessional performer offers text, but with a difference—steps onstage filled with conviction that "the textual self . . . is not the only one he wants to be known by."[97]

Interlude

Broadcast Intimacy; or Confession Goes on Tour

Public discourse says not only: "Let a public exist," but: "Let
it have this character, speak this way, see the world in this
way." It then goes out in search of confirmation that such a
public exists. . . .
—Michael Warner, "Publics and Counterpublics"[1]

Let a public exist . . .

A public is always a notional thing: the result of someone's rhetori-
cal conjuring. "It exists," Michael Warner says, "*by virtue of being
addressed.*"[2] Even so, a public is never the same thing as the people lit-
erally being addressed. Instead, it's always a bit open, indefinite—except
perhaps, Warner says, in the theater:

> A public can also be a second thing: a concrete audience, a crowd wit-
> nessing itself in visible space, as with a theatrical public. . . . A performer
> onstage knows where her public is, how big it is, where its boundaries are,
> and what the time of its common existence is.[3]

Warner is no scholar of performance, and so he's hardly trying to pro-
nounce once and for all on the nature of theatrical publics—and it's a
good thing, too, because he's almost certainly wrong. Few performers
confuse their audience for their public, least of all confessional perform-
ers. Anne Sexton, for instance, always began her readings with the exact
same poem ("Her Kind") and introduced it this way:

> I always say "I'll read you this poem, and then you'll know what kind of
> poet I am, just what kind of a woman I am. And then if anyone wishes
> to leave, they may do so." The first time I made this statement and read

the poem—and this was at Harvard—the wife of the head of the English Department rose solemnly from her front row seat and walked out.[4]

Repeating this tale, Sexton draws a magic circle around her venue, branding anyone who stays as potentially one of "her kind." I say *potentially* because Sexton never really believed that her audience had much to do with her public. As a matter of fact, she often doubted whether her audience at a reading would contain even one of "her kind." But even in her 1973 essay "The Freak Show," where she openly despairs of ever finding her public at readings, she ends on a hopeful note. In a postscript to the essay, she shares a letter she received from a woman who attended the awful reading that led Sexton to write this essay. Having heard from this woman and deemed her one of "her kind," Sexton concludes: "Who knows? Some day I may go forth on some jet to some college and look for that one person again and read my goddamned heart out."[5] And she soon did exactly that.

It's no surprise that Sexton found the balm to her wounds in a letter from a fan; she was obsessed with letters. She wrote them in reams, kept them by the cartload, and generally considered them the world's most privileged form discourse. Writing to a fan she knew only by mail, Sexton explained how the form had created a minor public for the two of them: "I'm afraid you'll take 'us' as a kind of standard and go out looking for it," she said, warning, "There aren't many of us! And even 'us' wouldn't exist if it weren't for paper and stamps and the U.S. mail."[6] Just imagine Sexton's relief, then, when "The Freak Show," her essay against readings, brought stacks of letters pouring in from her fans, all of them shouting in chorus, *But, but, but—I am your kind! Please come and read your goddamned heart out to* me! And imagine her joy when she read, in one of these letters, a fan saying, "There are poets who reach the heart, the marrow, the mind with the immediacy of unexpected mail. You are foremost [among them]."[7] Since her early poem "Some Foreign Letters," she had sought to blur the line between poems and letters—and in real life, too, this had become a favorite image of hers, especially when explaining to fans why she could no longer respond to their letters. "I hope you understand that my poems are really letters to you and say it all," she tenderly told one fan.[8] "[T]here just isn't time in my life to answer [your letter], except for the very factual feeling I have that my poems

are an answer," she told another, perhaps a bit disingenuously.[9] Finally, she carbon-copied a letter of this sort (explaining, "I have always felt my poems were a letter to someone and you seem like that someone"), and filed it away for future use, calling it: "Form #4: Letters to Mad Poets I Want to Get Rid Of."[10] Whether in earnest or out of sudden exasperation, Sexton stuck with this idea: that her poems should act like letters, and that letters, after all, were pretty hard to "live up to" in person. What she was trying to describe, I think, was the feeling of mediated intimacy she found in writing confessional poems—and found so hard to perform in person at a reading. If she put herself out there, would anyone care—or would they just gobble her up with a wolfish grin? She had stumbled onto the problem of what I'll call broadcast intimacy.

Let it have this character . . .

Spalding Gray never had much trouble getting into the mood of broadcast intimacy, and so he could use his performances to explore the nature of this feeling. That's not to say he had faith, any more than Sexton did, that his audience would be the same as his public—but he was curious to see what sort of public he could raise. From the beginning to the end of his solo career—and as often as possible in between—Spalding Gray did something more than sit behind his table, safely buffered from the audience. He also turned up the lights and turned the tables in a piece he came to call *Interviewing the Audience*. He describes the basic format of the piece this way in a 2002 interview:

> I hang out with the audience in the lobby. I come up to anyone and say, "Look, if I call your name tonight would you be willing to talk about any topic that comes up?" And if the person says yes, I'll take down the name and ask a few questions. . . . Then they come up onstage with me. . . . And if a person goes with the questions it turns into a wonderful dialogue. We begin to hear a story about what it is to live in the world. It's a sharing. The theatre becomes a community.[11]

What moved this monologuist to make room for dialogue? "I get tired of talking about myself," he explains at one point in Steven Soderbergh's 2012 documentary *And Everything Is Going Fine*, "so the conversations

with the audience are a way of talking to other people . . . and hopefully empathizing with other people."[12] But, as Theresa Smalec has pointed out in her essay on that film, Soderbergh cuts from that comment to an uncomfortable moment in one performance of Gray's *Interviewing the Audience*—one that, according to Smalec, gives the lie to Gray's stated desire to empathize with others. In this clip, he's interviewing a middle-aged woman when he decides to raise the touchy topic of suicide. Touchy topics weren't a problem. As a matter of fact, they were Gray's specialty, but this one was especially fraught for him. Gray's life and monologues were both haunted by his mother's suicide, which he considered—sometimes with fear, sometimes resigned to his fate—a pattern for his own demise. So when Gray asked this woman, "Did you ever try to kill yourself?" he may have expected the answer he got ("No . . . life's so short that it's the least you can do to hang in"), but he probably didn't imagine that she would back up her opinion (to him, distasteful) with some experience of her own. As Theresa Smalec observes, "His face grows troubled—even dumbstruck—when," after telling the story of her ex-husband's suicide, the woman "dismisses killing oneself as an easy way out." She isn't just some platitudinous square that Gray, our traumatized hipster, can easily dismiss—but neither does her viewpoint square easily with his own, and Smalec sees him getting annoyed at this predicament. He had invited his audience onstage, but there were only supposed to be two outcomes: either he'd expose them as shallow squares, or he'd be able to affirm them as one of "his kind." This, anyway, is Michael Peterson's reading of the piece, which he calls "a ritual thrashing" of the audience. In fact, according to him, *Interviewing* only poses as a dialogue; it's actually a monologue in disguise, promoting Gray's ideas and eliciting *his* stories while only seeming to invite the audience and their perspectives onstage.[13] I'll agree with Smalec and Peterson this far: the language of empathy seems wrong—insufficient, at least, to describe what Gray is up to.

. . . speak this way . . .

Such pretense of open dialogue, where others' voices are only honored when they contribute to some kind of choral monologue, reminds me

of nothing so much as feminist consciousness raising—at least as it was codified by the National Organization for Women (NOW). That organization's 1975 *Guidelines* recommend that CR should happen under the guidance of a NOW-approved leader, and they even provide "topic outlines" for this leader to follow. These outlines literally *begin* with the "political points to recognize" in each session, giving the lie to the notion that feminist politics will respond to *these* women's experience.[14] This was not, as advertised, an act of personal exploration; it was, in fact, an act of political pedagogy. Gray's *Interviewing the Audience*, I suggest, was pedagogical in precisely this way. Michael Peterson seems to intuit as much, comparing the audience vibe at one performance of *Interviewing* to the mood Brecht encouraged with his teaching plays, or *Lehrstücke*. Though Peterson never credits Gray with having any pedagogical motive himself, he obviously did: "Interviewing the audience," Gray wrote in his journals, "is my SOCRATIC piece," and perhaps this can explain Peterson's discomfort.[15] Socrates, too, was a teacher who staged dialogues that (at least as Plato wrote them) can look awfully monologic, and this disturbs many modern-day readers of Plato. Nowadays, we take for granted that good teaching will always preserve the student's mental and moral integrity. Socrates's students, by contrast, look like yes-men—or worse, like "Gosh, I never saw it that way, but now that you mention it . . ."-men. Even his strongest scene partners have a tendency to become mere prostheses to his will, nothing but cogs in his perpetual reason machine. But Socrates's scene partners rarely object, which suggests a third possibility: not that Socrates's interlocutors are rubes (any more than they're empowered liberal subjects), but that they've sought out an opportunity to lose their will in the name of philosophy. In *The Symposium*, a drunken Alcibiades gives this frank assessment of Socrates as a teacher: he is "a bully," but his words "even at second-hand, and however imperfectly repeated, amaze and possess the souls of every man, woman, and child who comes within hearing of them."[16] The whole point of a Socratic dialogue, for those who enjoy taking part in them, is to be *possessed*, to get lost in "the madness and Bacchic frenzy of philosophy."[17] Losing yourself, you are inducted into esoteric thinking. Stripped of identity, you embark on a new way of life: the love of wisdom, or *philosophia*. Whenever Gray performed *Interviewing*

the Audience, a way of life and a mode of thinking likewise hung in the balance—but it was offered only to those who possessed themselves of Gray's own way of thinking, speaking, seeing the world.

. . . *see the world in this way* . . .

Gray sometimes called *Interviewing* "a combination of town meeting, gestalt therapy session, and talk show," but most audiences latched onto the "talk show frame."[18] As Joseph Chaikin observes in *The Presence of the Actor*, the talk show host is a special sort of performer:

> Johnny Carson doesn't appear to be acting while he hosts a talk show on TV, but he is. He is performing himself, and in so doing he *recommends* a way to perform. As you attend his party, you are at once being trained for eligibility. . . . At this party you also learn to perform yourself and to stylize yourself.[19]

Cast aside the idea that *Interviewing the Audience* aims to stage an empathic dialogue, and it's clear that Gray tries to *possess* his audience in order to *train them for eligibility*. This is, in other words, primarily a rite of initiation. Gray always began these interviews with the exact same question ("How'd you get here today?"), and though this may seem like a throwaway question, it's not.[20] Gray's own monologues are often answers to this question, in their strange, evening-length, meandering way. This is especially true of the monologue he was performing when he first decided to start *Interviewing the Audience*. So, that question isn't just an icebreaker; it's the first step toward inviting each person into Gray's own confessional practice. It's phase one of a lesson on how to turn your life into narrative the way he does. This becomes painfully clear whenever *Interviewing* fails—as it often did—to win converts to the cause. In his 1984 monologue *Travels through New England*, Gray describes touring that region for two months, performing only *Interviewing the Audience*. As long as he stuck to the cities (or to keep-it-weird enclaves like Provincetown, MA, and Burlington, VT), he did fine, but as soon as he strayed into the country he immediately ran into trouble. Either the audience revolted, as they did in Shirley, Massachusetts, or, as in Irving, Massachusetts, they answered his questions with mumbled platitudes.[21]

Meanwhile, only the foreigners, the misfits, and a few whispering allies caught his interest—or admitted to him that he'd caught theirs. This was by design. Like Anne Sexton drawing the magic circle around "her kind" at each poetry reading, Gray never expected to find more than a few in each place—and so the tour went on.

It then goes out in search of confirmation . . .

Isn't it strange that confession, such an intimate and vulnerable mode of performance, should rely on touring as its primary business model— every night a new audience, every week a new town? Doesn't it bring the old theatrical sense of a "one night stand" a bit close to its cruder, latter-day meaning? But maybe I've got this the wrong way around: perhaps the prospect of sending confessions like these on tour is just so lucrative—*no sets! one costume! few lights! and only one "talent" to pay!*—that the business decision is made *in spite of* the act's unusual intimacy. And yet, there's something in the way these performers talk about their touring that suggests a deeper reason, too. If it's so hard to find members of your public in each audience, of course you have to go out on the road—and each time you find another cache of your kind, you effectively connect them to all the others. You elevate them from their local scene and help them join a wider public. To judge from her fan mail, this was an effect Sexton often had in small college towns, where she gave the bulk of her readings. No wonder that the next generation of solo performers in the mold of Spalding Gray would be "wandering queer performer[s]," as one of them (Tim Miller) has called himself, bringing the light of liberated queerness to dark corners of the nation.[22] Reflecting on "the homo-friendly theaters, alternative art spaces, sleazy drag bars, or independent coffeehouses" he'd encountered on the road, Miller exclaims—with his signature blend of sarcasm and sincerity—"I know this is what George W.'s daddy was really talking about with that 'thousand points of light' nonsense a few years back."[23] Long before supportive chat rooms, anonymous modes of social media, and endless playlists of "It Gets Better" videos, queer performers networked the nation by taking their acts of confession on tour.

* * *

No single text can create a public. Nor can a single voice, a
single genre, or even a single medium.
—Michael Warner, "Publics and Counterpublics"[24]

I should be careful not to imply that what I'm talking about here is *Sexton's* public alone—or Gray's, or Miller's, or anyone else's. They are each tapping into a much larger public—one that has grown steadily since the mid-twentieth century, and that now has come awfully close to simply being *the* public. I mean the mass of people who make (and receive) confessions easily and often. *To be public* at all has come to mean, more and more, *to live confessionally.* Celebrities straddle the line between public and private—and, in turn, those who straddle that line stand a chance of becoming celebrities. Joseph Roach calls this style of spectacular living "public intimacy" and traces its roots back to eighteenth-century England.[25] Now, this kind of broadcast intimacy is simply what it *means* to be celebrated at all in America: "the illusion of intimacy, the sense of being an exalted confrère . . . is part of celebrity status in the age of mass-media," Chris Rojek observes.[26]

If any genre captures the collision of publicity and intimacy "in the age of mass media," it's reality TV. Since the early 1990s TV producers have made a star (for a short time) of any person willing to live this way. "It is flagrant and intimate," says Fred Inglis, and "its characters practice the analysis of their feelings . . . not exactly in public but in colossally visible intimacy."[27] This genre and its modes of broadcast intimacy are the subject of Chapter 4.

4

Broadcast Yourself

The Confessional Performance of Reality TV

Perhaps the most confessional thing about reality TV is that we aren't allowed to *say* that we watch it—we must *confess*. Take a look, for instance, at *The Reality TV Handbook*, co-authored by John Saade (at the time, ABC's head of reality programming). It begins, "Just admit it. You love to watch reality shows."[1] But, wait: haven't we admitted this much already? We bought his book, after all—and we can't pretend we were confused. This book was hardly coy about its contents: it's "An Insider's Guide," its front cover declares in all caps, on how to "Ace a Casting Interview . . . and Capitalize on Your 15 Minutes of Fame." In other words, it's clearly marketed to people who don't just love reality TV, don't just watch it, but want to *appear on* such programs themselves. No, it's not that we've failed to confess our "love." We must simply learn to do it again and again. We must flush with shame (or is it defiant pride?) as we obey Saade's command to *admit it*. We must feel the same pain (or is it really titillation?) with each page we turn, each chapter we devour. We must accept what we are—Saade's little masochists—and accept what this is, after all: our guilty pleasure.

Well, I confess it—*mea maxima culpa*—and, while I'm at it, I'll confess something more: I see in reality TV a culmination of the story I've been telling in this book. It may seem worlds away from Robert Lowell's poetry readings or Eleanor Antin's performance art, but it is heir to their tradition of confessional performance and has mainstreamed this tradition's most basic assumptions: that the self is not only "performative," but something literally to be performed; that it can never be captured, only conjured in live performance with the help of dead media; and that roleplay—especially the "inverted Method acting" of people playing themselves—can reveal as much as it obscures.[2] As a media practice fueled by confession, as a common topic in contemporary

discussions of "performance," and as a provocation to theories of the self's "performativity"—reality TV must be (Lord, forgive me!) my final case study in confession.

Critical Contexts: Reality TV and American Confession

In his 1974 book *Television: Technology and Cultural Form*, Raymond Williams makes a rather surprising claim: that television has secured the importance of *drama* in a way that millennia of theater failed to do.

> Many though not all societies have a long history of dramatic performance. . . . But there has never been a time, until the last fifty years, when a majority of any population had regular and constant access to drama, and used this access. . . . [D]rama as an experience is now an intrinsic part of everyday life.[3]

What television did for drama, reality TV has done for performance, that everyday *doing* of identity and culture. Please remember that "performance," for me—as for so many scholars in the field of performance studies—is a scrupulously neutral term. It can describe the most fantastical acts of fakery, but also the most mundane enactments of the real.

TV scholars don't tend to use the word this way. In an influential 2002 essay called "Performing the Real," John Corner uses "performance" as a mere synonym for bad theatricality, the showy or cynical putting-on of a role. For good measure, he even treats "performative" as if it's merely the adjectival form of "performance."[4] "This self-display," Corner writes of reality TV conduct, "is no longer . . . an attempt to feign natural behavior," but instead "a performative opportunity in its own right."[5] Like some sort of anxious Platonist, Corner can only see performance (theater, really) as something *doubly* removed from the real—not only an attempt to "feign" reality, but in fact a baseless invention at reality's expense. Even those scholars who don't share Corner's Platonism tend to share his anxiety, and (like him) they hang it all on one word: "performance." In a typical catalogue of horrors, June Deery writes:

> This programming [reality TV] allows us to think about a cluster of contemporary concerns, including the requirement that we all perform—

because of surveillance, because of the marketization of everyday life, because of the demand for individual impression management.[6]

. . . in short, because of all that's wicked and oppressive. The surveillance state, neoliberal economics, coercive social pressures—these, for Deery as for most of her peers, are the only conceivable reasons we might "perform." In fact, even those scholars who celebrate the "performance" of reality TV love only its power to falsify life. Beverley Skeggs and Helen Wood, for instance, celebrate reality TV as an "inadvertently radical" genre that "breaks down the (unconscious) performative into a full-blown conscious performance."[7] Like an act of feminist masquerade, this "conscious performance" has one job: to call bullshit on performativity. Only one scholar of reality TV, unmoved by this antitheatrical panic, has consistently used the word "performance" in the neutral sense I intend whenever I use it. In her 2012 overview of the genre, Misha Kavka writes, "Just as artifice is not opposed to actuality . . . so performance is not opposed to authenticity." After all, she goes on, "authenticity operates on a sliding scale *within*, rather than opposed to, the framework of performance."[8] Those other scholars can have the word *theatricality*—even, if they're careful, *performativity*—but we need *performance* unspoiled. Only with its help can we make sense of the behaviors that make up this genre: from contrived action to spontaneous behavior, from exaggerated feelings to repressed responses—and from interviews filmed to activities surveilled.

This last pairing is key: reality TV is defined by how it intercuts fly-on-the-wall footage with direct-to-camera monologues by the cast. TV scholars have spent most of their time and energy dissecting the fly-on-the-wall footage—or, as they tend to call it, "surveillance" footage. Nick Couldry, for instance, has argued that reality TV promotes "the idea that surveillance is a natural mode through which to observe the social world," and Mark Andrejevic, in his influential book *Reality TV: The Work of Being Watched*, takes this argument even further: "Perpetual surveillance," according to the rhetoric of reality TV, "doesn't compel conformity; rather, it reveals authentic individuality."[9] Meanwhile, the other ingredient in reality TV (direct-to-camera monologue) is often ignored, or else argued away. In "Performing the Real," for instance, John Corner defines reality TV as I just have: a genre that relies on the "interplay

between observed action" and "to-camera participant testimony."[10] But then he barely ever mentions this "testimony" again, except to name it as the one "privileged moment" when performance isn't happening.[11] Likewise, Laurie Ouellette and Susan Murray, in their introduction to a leading essay collection in the field, acknowledge the "confessional ethos" of reality TV; then, one sentence later, they list the genre's key "textual characteristics" and confessional monologue doesn't make the cut.[12] This is doubly surprising since Ouellette and Murray are basing this catalogue of key features on their reading of MTV's *The Real World*, which, Leigh Edwards points out, actually "perfected [the] confessional mode of direct address (widely copied by other series)."[13] When TV scholars don't gloss over this "confessional . . . direct address" entirely, they often try to conflate it with the observational "surveillance" footage that, for them, defines the genre—as if being addressed eye-to-(camera-to-) eye were the same as peering on, an unacknowledged voyeur. So, for instance, Rachel Dubrofsky remarks that "one of the central activities surveilled in [reality] shows is a participant confessing."[14] And Andrejevic argues that, in *The Real World*'s signature direct-to-camera monologues, we "are positioned as the invisible viewer, directly spying on the cast members."[15] By this logic, I have been "spying" on talk show hosts, news anchors, sports commentators, and politicians my whole adult life. *Somebody, stop me!*

In the rare moments when scholars of reality TV do take the genre's monologues seriously, they tend to treat them as something strange or out of place. Minna Aslama and Mervi Pantti, in an essay on reality TV's "monologue mania," declare it a "literary way of talk" and seem unaware of any but the most old-fashioned precedents for it:

> Traditionally, in drama as well as prose, single-person speech situations have served to reveal the inner life, secret thoughts and feelings of the characters. Interestingly, reality shows have reintroduced this out-of-date talk situation into the context of television.[16]

Jon Dovey, author of *Freakshow: First Person Media and Factual Television*, reaches just as far back for his own "out-of-date" comparison. These monologues, he says, are "the visual equivalent of an actor

working downstage in soliloquy to the audience"—a sight common in early modern theater, but rarely used since the eighteenth century.[17] Of course, there *were* up-to-date models for such "talk"—namely, everything I've featured in this book! From poetry readings and standup comedy to performance art and theatrical confession, eye-to-eye "talk" in a confessional mode had, in fact, been one of America's favorite genres of performance. What's more, in the years leading up to reality TV's rise, the American airwaves were, as a matter of fact, chock-full of confessions, though rarely delivered directly to the camera. As Mimi White and Jane Shattuc both argue, daytime talk shows of the 1980s drew on models from psychotherapy and political activism (e.g., feminist consciousness raising) to elicit all sorts of confessions from the "ordinary" people they featured on-air. So, in the American context at least, there was nothing the least bit strange or "out-of-date" about this mania for confession.

This American context, though, is often ignored or downplayed by scholars of reality TV—perhaps because most of the earliest accounts of reality TV were (and, to this day, an outsized number of them are) written in the UK. The sheer, overwhelming Britishness of this scholarly field can, in fact, explain the biases I've pointed out so far. The focus on surveillance, for example, makes sense as soon as you realize that, in the UK, the reality craze was kicked off by *Big Brother* (a pointed title), which debuted just as the UK was earning its dubious distinction: most surveilled nation in the West. Likewise, the focus on bad sorts of "performance" was driven by local, British concerns. In the UK, reality shows (including *Big Brother*) first aired on public-service channels whose executives, to the dismay and outrage of many, were counting these programs toward their state-mandated quota of "factual programming." Denying the *factuality* of these programs was therefore an obvious tactic and an urgent task.[18] At first a mere weapon of convenience in this fight for the survival of documentary, news, and educational programming, this antitheatrical prejudice soon infected the broader conversation about reality TV—including the conversations featured in reality programs themselves. As Nick Couldry notes, "A particular focus" of *Big Brother*'s third season in the UK "was the housemates' mutual accusations of performing to the cameras and the anxious denials

that resulted."[19] See? Discussions of reality TV can only benefit from being placed in their local, national context—as recent work on "global" reality programming has proven time and again.[20]

In this chapter, then, I aim to tell a story about *American* reality TV, with a special focus on the first season of MTV's *The Real World* (1992). I choose *The Real World* not only because it launched the genre in America, setting the pattern for many programs to come, but also because it gives fits to any scholar who attempts to treat British and American reality TV together. Misha Kavka, for instance, tries to divide the genre's Anglo-American history into three clear "generations," but she stumbles as soon as she reaches *The Real World*. Chronologically, it belongs among "first-generation" programs, some of which—especially British "docusoaps"—it resembles quite a bit.[21] (*The Real World* was literally created by a producing duo who specialized in documentary [Jonathan Murray] and soap opera [Mary-Ellis Bunim].) Nonetheless, Kavka winds up labeling *The Real World* "a second-generation programme well before its time."[22] Why? Because in British and Commonwealth contexts (Kavka herself is based in New Zealand) the crucial distinction is between what June Deery calls "edited reality in the observational mode" (e.g., docusoaps) and shows that take place within "contrived settings" (e.g., the sealed house of *Big Brother*)—or, as John Corner puts it, between shows set in "world space" and those set in "television space."[23] *The Real World*, though, is simply both—real and contrived, world and studio, performance and theater. That, in the end, might be the most American thing about it.

* * *

The first season of *The Real World* brought seven young strangers together to share an apartment and pursue their careers in New York City—all of which they did under the watchful gaze of multiple camera crews. The resulting material was then packaged into thirteen twenty-two-minute episodes, each of which blends this kind of actuality footage with direct-to-camera monologues in a jagged collage. Sometimes these episodes explore particular themes (e.g., out-of-town parents visiting the cast in Season 1, Episode 10), but they mostly just follow the slow, serial narrative of these seven cast mates' lives, with a special focus on their changing relationships with one another.

Like many of the reality shows that have flooded the American market ever since, *The Real World* created an artificial microcosm for its subjects to inhabit—in this case, a luxury loft in SoHo. No wonder the press (egged on by the show's producers) compared the program over and over to Biosphere 2: an experimental, man-made ecosystem that had just gone up when *The Real World* started shooting.[24] The difference, of course, is that MTV was concerned with *social* ecology. As Kevin, a member of the first season's cast, described *The Real World* and its mission: "[T]his is like an experiment of whether young people in this country can work together and make this a better society."[25] The idea of blending drama with social experimentation never lay far below the surface of *The Real World*—least of all in its fourth season when, in a fit of reflexivity, they cast a playwright, an anthropologist, and a graduate student "taking time off from his PhD in experimental psychology at Oxford."[26] This world is "real" in the way that any experiment is real: natural behavior unfolds under unnatural conditions, with those conditions always in danger of causing what they claim to simply show us.[27]

Unlike Biosphere 2, unlike *Big Brother*, and unlike most "contest TV" (the term I prefer when describing later, competition-driven formats like *Survivor* or *American Idol*), *The Real World*'s microcosm was, by definition, porous to the world beyond its walls. Its subjects went out often into the *real* real world—sometimes with reality-warping camera crews in tow—and they brought back to the loft some of the people, things, and ideas they encountered out there. The aim was to subject these young people to sudden cross-cultural contact, then track the (hopefully positive) changes it wrought on each of them. In this sense, *The Real World* was deeply indebted to the mainstream politics of multiculturalism in the 1990s. And since that era's multiculturalism was based in identity politics, with its love of personal, testimonial stories, it's only fitting that the cast's transformation was revealed most of all in their direct-to-camera monologues.

It can be difficult, twenty-five years on, to remember a time when reality TV had—or felt the need to profess—a social purpose, but *The Real World* did at the start. Media scholars and cultural critics have justly tallied the program's failings, then and now: the way it removes "identity" from its context, the way its casting tends to tokenize racial, sexual, and

regional minorities, and the way it can therefore short-circuit social thinking before it rises to the level of politics.[28] At the same time, other critics have justly celebrated *The Real World* for the platform it offers (or, once offered) marginalized people—people who, back then, would've been hard-pressed to get on TV any other way. Take, for instance, Pedro Zamora, a gay, Cuban-American man living with AIDS, who appeared on (and celebrated his wedding on-air during) the third season of *The Real World* in 1994.[29] (This was the age of "Don't Ask, Don't Tell"—but Pedro never waited to be asked.) And while it's true that the show has always privileged the personal over the political and the local over the systemic, it never drew, at first, a bright line between the two. The cast of Season 1 is shown having bald (if not always incisive) discussions about race and American imperialism; they bring camera crews along to campaign rallies during the Democratic presidential primary; and several go all the way to Washington, D.C., again with cameras in tow, to join pro-choice demonstrations as the Supreme Court prepares to hear *Planned Parenthood v. Casey*. In short, it wasn't (or, wasn't yet) a show about who was canoodling with whom in the hot tub.

But *The Real World*'s social mission eroded over time—and, as it did, the producers sealed off their microcosmic setting from the outside world. These changes are painfully easy to see if you just watch several seasons' worth of *Real World* title sequences back to back.[30] The standard voiceover, established in Season 1, is: "This is the true story of seven strangers picked to live in a loft and have their lives taped—to find out what happens when people stop being polite and start being real." But this text slowly changed to reflect the program's tighter and tighter control of the cast's onscreen lives, as well as its growing neglect of the *real* real world. Season 5 adds that the cast will "start a business" together, Season 6 interjects that they will "volunteer some time," Season 7 notes that the cast will "live on a pier" and "work together" (a common feature from this point on), and Seasons 8, 9, and 10 see the participants living in "paradise" (i.e., a beach house), in "a mansion," and in "a casino"— three spaces that specialize in helping people forget the outside world. Meanwhile, the images under this voiceover slowly shift focus. Whereas the Season 1 title sequence features mundane scenes of home-life at the loft or shots of cast members practicing their art, later seasons show

participants just posing for the camera while wearing fewer clothes with every passing year. By Season 17, the title itself is literally tanned into the back of a topless, faceless woman.

And yet regardless of the show's shifting content and despite the tightening choke-collar of its managed environment, *The Real World* has, throughout the years, been utterly consistent in its narrative form and visual aesthetic. This house style—flashy editing that takes a jumble of fly-on-the-wall footage and threads it neatly along an ongoing confessional narrative—has shaped not only *The Real World* and its spinoffs, but also unrelated programs across American television. Studying this house style at all is, in some circles, a radical act. Jeremy Butler, author of *Television Style* (2010), defends television against scholars (in film studies, he suggests) who presume that it has no style. "[A]ll television texts contain style," he declares, but some have it least of all—say, reality TV.[31] While defending soap opera against charges that it lacks any style worth the name, Butler treats reality TV (in fact, *The Real World* in particular) as the *true* measure of "zero-degree" style.[32] Like other critics before him, Butler is thinking only of reality TV's fly-on-the-wall footage, which may indeed be our era's "zero-degree" of visual style. And yet this is not the only—let alone the definitive—feature of this genre's style. If any feature deserves that pride of place, it would have to be direct confessional address. The primacy of confession within the genre is hardly natural or inevitable; it was (and is) laboriously achieved. From casting and filming to postproduction and marketing, producers work hard to keep confession a central feature of this genre.

In studying the centrality of confession to reality TV, I draw on methods from performance historiography. These monologues may look like solo acts, but of course they're actually ensemble performances. Although we see one performer alone onscreen, others are also performing just out of the frame—and these performances are reflected in what we see. Trying after the fact to study these scene partners, we face a problem like the one the Supreme Court faced in *Miranda v. Arizona*. Reality TV's confession booths, like the back rooms of police stations in 1960s America, are "incommunicado" spaces, black boxes from which only confessions emerge—single-voiced and solo-authored, it seems. Just as Chief Justice Warren relied on interrogation manuals and on his own

experience as a prosecutor to fill in the "gap in our knowledge," I rely on journalistic accounts, participant interviews, audition instructions, and collectible fan-books for the glimpses they afford us into *The Real World*'s confession booth. Such documents, taken in aggregate, reveal the repertoire behind the archive of confessions we see onscreen.

Just as valuable, though, are two works of art that try to adapt *The Real World* into another medium: the 1994 film *Reality Bites* (dir. Ben Stiller) and the 2000 memoir *A Heartbreaking Work of Staggering Genius* by Dave Eggers. Confessionalism, I've argued, is a movement—always on the move between media. So, we see its signature affects and gestures, its logic and ideology, its rhythms and style when other artworks set it in motion. *Reality Bites* tells the story of an aspiring documentarian whose footage of her friends is co-opted by a music/lifestyle channel for an experiment in "real programming." As you might guess from this synopsis, the film's allusions to *The Real World* are hardly subtle. In fact, the movie's main character bears an uncanny resemblance to one particular member of *The Real World*'s first cast, whom Ben Stiller knew personally.[33] *A Heartbreaking Work . . .* , meanwhile, not only reflects on how to write autobiography in the age of reality TV; it also has at its center (literal and conceptual) the true story of Eggers's callback audition for *The Real World*'s third season. Both works offer a critique of reality TV—but they also, in their attempts to translate *The Real World* and its ethos into other media, help us see it more clearly.

What such sources wind up helping me see is a paradox at the heart of reality TV: its many confessions are both theatrical posturing *and* authentic behavior, labored performance *and* effortless being, styled rhetoric *and* artless talk. This list of contradictions should look familiar; I have found them in all kinds of confessional performance. By placing *The Real World* in this tradition—a tradition that, as I'll show, the program consciously cites—I hope to carry us beyond merely paranoid readings of the genre. Reality itself, in the age of reality TV, is a block of marble from which we carve our confessions. Programs like *The Real World* simply teach us how to hold the hammer and chisel—and show us where to strike.

Origins: Reality TV and/as Confession

I just don't understand why things can't just go back to
normal after the half-hour . . . like the *Brady Bunch* or
something.
—Lelaina Pierce (Winona Ryder) in *Reality Bites* (1994)

In early 1973, PBS aired what everyone agreed was an unprecedented
series: *An American Family* told the story of the Louds of Santa Barbara,
who agreed to have their lives filmed for a year (seven months, it turned
out) then released in twelve weekly installments. The Louds' many chil-
dren and their California lifestyle made them the real-life counterparts
to ABC's *The Brady Bunch* (1969–74), but both the content and the
structure of *An American Family* set them worlds apart from Mike and
Carol Brady. *The Brady Bunch*, a sitcom, tells the story of a widower
and a single mother (divorce is implied, but goes unmentioned) who
are trying to blend their two families into one. *An American Family*, by
contrast, shows a real marriage heading toward divorce. For viewers of
the program, this end was always in sight: before returning to the start
of the seven-month shoot, the series begins at the end, in the aftermath.
So, whereas *The Brady Bunch* moved in comforting cycles of crisis and
resolution, each episode leading us back to family unity, *An American
Family* edged onward in serial slow-motion, each installment bringing
us closer to an ugly separation.[34]

Pretty soon, public intellectuals were extolling this program as the
future of television. Raymond Williams, who happened to be teaching
in California at the time, saw firsthand the effects of *An American Fam-
ily*'s "rethinking and reworking of the conventional distinction between
'reality' and 'fiction.'" He witnessed "Californian families [becoming]
deeply involved with this unusual presentation or exposure of . . . their
neighbours," and he proclaimed that a new genre had just been born,
which "may prove to be one of the most significant innovations in our
contemporary culture."[35] Writing about the series for *TV Guide*, Mar-
garet Mead played the role of the prophet with even more gusto: "It is,
I believe, as new and as significant as the invention of drama or the
novel—a new way in which people can learn to look at life, by seeing
the real life of others interpreted by the camera."[36] According to Mead,

An American Family wouldn't just alter TV; it might actually change the world. Life would become camera-fodder—the *theatrum mundi*, a television studio—until people learned "a new way . . . to look at life." Neither Mead nor Williams would live to see their audacious predictions come true, but many critics now credit *An American Family* with the invention of reality TV—and many producers (including the team behind *The Real World*) freely acknowledge their debt to this trailblazing series.

If *An American Family* did teach viewers "a new way . . . to look at life," it was, in part, to look at life as though it were a confession. The Louds, to be clear, spent no time in the sort of "confession booth" that *The Real World* would popularize. Instead, this program used fly-on-the-wall footage, tying it together when needed with a bit of voice-of-God narration. Still, the show felt confessional somehow to the public. Critics often say the same thing about reality TV today. In the words of Rachel Dubrofsky, "All that is surveilled by the cameras can be used to confess the self, and all that is selected during the editing and production process can be used to represent a confessed self."[37] We watch people on reality TV, in other words, the way psychoanalyst Theodor Reik must have watched his neurotic patients: ready to hear every word, see every gesture as a symptom brought to the surface by their "compulsion to confess." Surely, *An American Family* primed its viewers to watch this way. Because the first thing we see is how the story will end, we're bound to watch for the symptoms of the coming catastrophe. But there was also something else going on—something milder than Dubrofsky's surveillance state anxieties or Reik's diagnostic gaze. The show aired in confessional times, as Mead reminds us when she compares *An American Family* to several popular rituals of the early 1970s: "It is, of course, related to all the current encounter adventures—to group therapy, to the meetings in which one person speaks of his or her own troubles so that others may learn that they are not alone." This was 1973, after all: the year when consciousness raising (CR) got so popular it almost escaped the feminist movement's grasp—or, as Claudia Dreifus puts it, the year of CR's "Madison Avenue-ization."[38] *An American Family*, Mead concludes, "is related to a strange new willingness to share one's inner life, to perform on a stage before other concerned eyes."[39] And while Mead may find this "perform[ance] on a stage" a bit "strange," she never imagines

(as most commentators on reality TV do) that such performances are necessarily offered in bad faith.

But, of course, the Louds aren't "shar[ing their] inner life"—they're only letting the camera see their outward behavior. So, why does Mead mistake surface for depth—outward behavior for inward feeling? What makes her think she sees these people's "inner lives" through their actions? The answer is the same for *An American Family* as it is for so many confessional performances: not because it *really* lets us see inside them, but because it's *more* revealing than words alone would be. Mead again:

> In the past the imaginative person could reconstruct a scene from another's words, as when your brother or lover, back from Vietnam, told you what it was like that lonely night 10,000 miles away from home. With *An American Family*, it is not your imagination but the immediate, the actual, what it is really like, that is there.[40]

This sense of an encounter with "the immediate, the actual, what it is really like" is only a feeling that we get—and, let's be honest, a mistaken one—but it grows stronger whenever the show takes us by surprise, and even stronger when it manages to catch a performer unawares. In these moments, we feel we are getting—if not depth or authenticity, exactly—at least something deeper and more authentic than what autobiography would give us. "This is an age of autobiographies," Mead observes, ". . . But each person who writes an autobiography is reporting on a known life, a life already lived. He or she can select just those incidents which, remembered, make a point. In *An American Family* nobody knew what was going to happen." The specter of a pat, autobiographical text makes this footage—full of irrelevancies and inadvertencies—feel, by contrast, revealing. Mead believes this program teaches people a "new way . . . to look at life," and now it's clear just what that "new way" would be: a way of *seeing* mundane behavior, and yet *hearing* revealing speech—the raw tales of consciousness raising, the traumatized whisperings of a veteran's late-night confessions. Each image worth a thousand intimate words.[41]

Setting the pattern for reality TV to come, *The Real World* looked back to *An American Family*, both mimicking its features and extending its effects. First, they created a format that could be judged (favorably, they hoped) against a fictional counterpart, *Beverly Hills, 90210*. Follow-

ing the success of that program on Fox, Mary-Ellis Bunim and Jonathan Murray were "retained by MTV to develop a soap focused on 18- to 25-year-olds," but they soon worried "that few writers possessed enough insight into the young generation to pull off such a show."[42] So, inspired by *An American Family*, Bunim and Murray decided that, rather than commission a writer to create young characters, they would just have young people play themselves. Not only would these people come cheap; they would serve as living proof of what writing could never achieve. According to a *New York Times* TV critic, it worked: the show's "seven principal players," he affirms, "are far too independent to be stuffed into a tidy little soap opera."[43] Their independence was tangible—first, because the story of their lives resisted a familiar form ("There are no writers here who can manipulate incidents with the flip of a word processor"), but also because these people resembled their fictional counterparts just enough to keep the flattering comparison in our minds.[44] Just as the Louds resembled the Bradys, even while smashing the cultural and dramaturgical norms of *The Brady Bunch*, the cast members of *The Real World* resembled the students of West Beverly Hills High School, even as they gave the lie to *90210* and its soap opera plots. If conventional TV plotting and characterization were forms of intolerable containment, then we were meant to feel these people (the Louds, the *Real World* cast) busting out—achieving what Robert Lowell called "a breakthrough back into life."

But even as they busted containment, defying the norms of contemporary TV, the cast members of *The Real World* were busy building a new sort of narrative cage—not a dramatic plot exactly, but a confessional story. Every week during the filming of *The Real World*, the cast "had to undergo grueling on-camera interviews . . . about their motivations and feelings."[45] Starting with the second season, they could also go at any time to a separate space called the "confessional," "a small, soundproof room" where the camera was unmanned and "the subject was up to them."[46] These self-guided confessions, though, were often blended in postproduction with the old sort of interview, so that, together, they formed one side of the show's basic binary: confession performed, as opposed to action surveilled. Most TV scholars have settled for comparing these confessions to first-person narration in prose (a "literary way of talk") or to "an actor working downstage in soliloquy." This implies

that the confession's main purpose is to "deepen the plots thrown up by interaction."[47] In practice, the opposite is true: interaction deepens confession. That is, editors don't just use these interviews to stitch the story together; these interviews *are* the story. This is what Leigh Edwards means when she claims that "*The Real World* pulls viewers in by playing on a desire to fetishize narrative, to reify the process of imagining one's life as a story."[48] The creation and maintenance of narrative is the central concern of reality programs like *The Real World*.

To show what I mean, here's a transcript of slightly more than a minute from Episode 3 of *The Real World*'s debut season. In it, you can see the show's producers and editors reflecting on *The Real World*'s relationship to 1970s-style performance art, which was obsessed (as I argue in Chapter 2) with turning life into art by merely documenting it. But, for now, I offer it only as a representative chunk of reality TV narrative—an example of how cast members' monologues are used to make a story out of a jumble of footage. As you read this transcript, pay attention to its way of balancing monologue and dialogue, narrative and action.

Box 4.1. A Shot-by-Shot Transcription: 81 seconds from Season 1, Episode 3 of *The Real World*
("confession booth" speech in bold text)

1. *(5 seconds)* Camera follows Becky into a crowd *(after 3 seconds, Norman begins in voiceover)*: **"I brought Julie, Becky to . . ."**
2. *(4 seconds)* Cut to Norman walking along a row of paintings, as he continues: **". . . the art opening because a friend of mine, uh, who I respect a lot, William Rand . . ."**
3. *(7 seconds)* Cut to Norman and William talking, as Norman continues: **". . . was having a piece in this group show."** (William says into Norman's ear, "He's a shameless self-promoter") **"Y'know, it's part of, like, my world. It's part of . . ."**
4. *(3 seconds)* Norman continues, no longer in voiceover, but shown now in front of one of his paintings back at the loft: **"how, y'know, artists get to know each other."**
5. *(4 seconds)* Cut to Julie chatting with an artist, as Norman continues: **"They get to, like, talk with each other."** Zoom out to show William talking with someone else beside Julie. **"It's an open, free dialogue, and everyone brings to themselves . . ."**

6. *(5 seconds)* Cut to close-up on an old photograph, seen through circular aperture; zoom out to reveal a wooden barrier bearing the message "Ouverte au Public" and (above and below the opening) "PEEP" and "KNEEL." All the while, Norman continues, "**. . . their own personal, little creative—world.**" *(Norman's monologue ends)*

7. *(11 seconds)* Cut to enormous stacks of square paper, which Norman is perusing. Artist speaks to Norman: "Everything I do is art, and every individual does individual art. And, um, I document everything. This *[gesturing out of the frame]* is early documentation of me actually masturbating in 1979."

8. *(9 seconds)* Cut to Julie and Becky talking to Norman's friend, William. William is saying "[inaudible] sort of demented, frog-looking—He's at a bar with my wife right now; otherwise he'd be here." Julie begins in voiceover, "**Oh, those artists were so phony . . .**"

9. *(4 seconds)* Julie continues, now shown back in the loft: "**They weren't even looking at the art. They were running around—it was just a social event.**"

10. *(4 seconds)* Cut back to conversation with William, with Julie now left out of the frame. William says, "Maybe we should do that when you kids come over—turn flowers into food."

11. *(2 seconds)* Counter-shot of Julie, responding, with heavy sarcasm: "We'll have to do that, then."

12. *(6 x 1 second; 2 seconds; 4 seconds)* Quickly edited montage of various art. Over the last shot, Becky begins, in voiceover: "**We went to dinner . . .**"

13. *(4 seconds)* Cut to Becky emerging from the gallery. She continues in voiceover: "**. . . after the art opening and, uh, Norman and I just started getting more and more . . .**"

14. *(7 seconds)* Cut to all three of them leaving: "**. . . tired. And we both decided that we couldn't go to Andre's—to go to see Andre's show 'cause it was out on Staten Island—that we were exhausted.**"

One thing is immediately clear: the action here is following the monologue's lead. Rather than momentary eruptions from the plot, these monologues *are* the plot, insofar as one exists. Personal narrative doesn't puncture the dramatic frame; it fills that frame entirely. The subjects' voices overflow any barrier between confessional and dramatic space, appearing out of nowhere (see #1, #8, #12), and leading only occasionally

(and briefly) to images of these people actually speaking to the camera (see #4, #9). Before long, these voices have flowed back into and over the footage of events narrated (see #5, #6).[49] Like reporters narrating a TV news package, they and their voices retain priority even as these images flash by. Sometimes the editing seems to follow these monologues' lead with almost laughable literality, as when Norman's mention of his artist-friend William calls up footage of the two of them talking together—calls it up, as a matter of fact, in the very instant Norman mentions William's name (see #2, #3). At other times, the video deepens or helps us make sense of the monologue, as when Julie's accusation that artists are phony calls up footage of one middle-aged artist suggesting that he and she get together sometime and "turn flowers into food." The bald come-on, which Julie never mentions, clearly displeases her as much as the corny line and its smarmy tone. "Phony," this editing instructs us, also means "lewd"—making this scene part of the show's ongoing interest in Julie's sexuality. (Julie is both the youngest member of the cast and the one from the most conservative background.) In moments like these, the video footage comes to seem like a mere illustration of the personal narrative, dredged up from a deep archive of options because it substantiates or supplements the words of these monologues—quite the opposite of how asides or soliloquies work. Personal narrative, here, is the primary reality; filmed action, the revealing supplement.

This editing-logic, the aesthetic surround of the "confession booth"—later a literal place on set, but always a good metaphor for how the show arranges narrative space—has spread from *The Real World* to every form of reality TV imaginable, from talent-search shows (e.g., *American Idol*) and reality game shows (e.g., *Survivor*) to makeover shows (e.g., *What Not to Wear*) and docusoaps (e.g., *The Osbournes*). The effect of this style, as dance historian Kate Elswit argues in her essay on Fox's *So You Think You Can Dance*, is to reimagine actuality footage (in this case, dance performances) as somehow "saying" things—becoming, in short, a mere "supplement" to confession.[50] What *So You Think You Can Dance* does to dance, *The Real World* does to the world: it conjures things, people, social relations—*the great globe itself*—only to dissolve them in a steady stream of first-person speech. Just as in *An American Family*—or, anyway, in Margaret Mead's strange account of it—so too (but more literally) in *The Real World*: televisual images become nothing but

words-by-proxy. Offering a retort to the poststructuralist mantra that "everything's a text," reality TV responds: No, everything's a *confession*.

Postproduction: Editors in Love

And yet how could *An American Family* be an autobiography? How could *The Real World* truly be ruled by its cast's confessions? As Jon Dovey observes, "What may look in documentary like autobiographical self-speaking is almost always biographical direct speech."[51] The Louds and the *Real World* roommates might be producing raw confessions on set, but reality TV is a postproduction art. Unlike confessional monologues in the theater (see Chapter 3), which tend to assure us that actor and auteur are one and the same, reality TV separates performance from production, the confession from its composition. In other words, the "confessional" narratives of *The Real World* are created through acts of editing over which the cast has no control—hence the charge often leveled at reality TV producers: that they have edited their subjects unfairly. This complaint is as old as the genre itself: Bill Loud, for instance, loudly protested that *An American Family* "was edited with a purpose: that of dramatising any row or difficulty"—presumably in order to make his ejection from the house and from the family seem inevitable.[52] Other members of the Loud family quickly followed suit, defending themselves against a judgmental public by blaming everything on the distortions of editing.[53]

If the mere fact of editing could raise hackles in 1973, it would only raise more in 1992. Raymond Williams could aptly describe *An American Family* as a "slow and disjointed" program with "no obvious editing," but the opposite was true of *The Real World*, which startled viewers with its in-your-face editing style.[54] John Podhoretz has referred to *The Real World* as "a television show that is edited like a music video," and he is right in more ways than he probably knows.[55] The editing team behind *The Real World* did indeed work hard to make the show's visual style mesh with the rest of MTV's lineup, filled as it was with jumpy, jittery music videos. Not only that: they accomplished this style using cutting-edge technology seldom used on full-length programs back then—a nonlinear, computer-based editing system that could contain

(and then randomly access) hours of video footage at once. Versions of these systems had been used in the world of big-budget films for some time, but in the late eighties these systems got cheaper and more common. Due to technical constraints, though, these new systems were still mostly used to edit short-form videos like news packages, commercials, and, yes, music videos.[56] So, whereas the editors of *An American Family* spent over a year turning three hundred hours of film into 12 one-hour installments—each one full of long, lingering shots that made the editor's task much simpler—*The Real World*'s team was able to trim nine hundred hours of video into 13 twenty-two-minute episodes (a seven- or eightfold increase in the ratio of raw footage to final cut) in a matter of months—all while executing a wild, quick-cut style that often required dozens of edits per minute.[57] Pretty soon, critics recognized this frenzied editing as the signature feature of *The Real World*'s style ("the familiar MTV gloss of breathless pacing and quick edits") and predicted how transportable it would be: "Find some telegenic young people, turn on the cameras and let the editors go to work."[58] And so reality TV as we know it was born.

If editing of any kind raised red flags back in 1973, editing like this surely warranted deep suspicion. No wonder, then, that *The Real World*'s editorial director Oskar Dektyar made such a fuss over how he *felt* while he was editing: "We observe situations," he explains in one 1995 insider's guide to the show, and then, "we sit and absorb with our hearts. What are the specifics and the essence of these people"—and then, correcting himself—*no*, "of this *family*?"[59] Director George Verschoor, the man who actually conducted most of *The Real World*'s confessional interviews, claimed to rely on an equally intimate sense of his subjects. In a statement published in the same insider's guide, he recalls coaxing the cast members to open up, saying,

> Please tell me everything about your life, the good, the bad, and the ugly, whatever you can tell me. I need the complete picture in order to paint an accurate portrait of your life.[60]

For these portraitists, Dektyar and Verschoor, what's at stake is not their artistry (or so they say) but their *character*.

Indeed, many of reality TV's firmest proponents stress an alliance or bond of trust between editor and subject. Jon Dovey, for instance, extols as the most powerful and ethical form of confessional television the BBC's *Video Nation* (1993–2011), in which documentary subjects film themselves, then co-edit this video-diary with the help of specialists at the BBC.[61] Similarly, Christopher Pullen, writing about Pedro Zamora's on-air AIDS activism, emphasizes how eager Jonathan Murray, *The Real World*'s gay producer, was to form "an alliance between producer and performer."[62] This theme can be traced all the way back to Margaret Mead's first ecstatic vision of the genre in 1973. Unable to find a suitable name, she concludes, "Whatever the name turns out to be, it will have to include the essential ingredient of trust. The production staff and the family placed their future in each other's hands. They came together in a joint undertaking. . . ."[63] I wonder, though: did Bill Loud's sense of betrayal ever cause her to question these sunny views?

The 1994 film *Reality Bites* offers an origin myth for reality TV, and it posits exactly this sort of editorial betrayal as the genre's original sin.[64] The film concerns a young documentarian, Lelaina Pierce (Winona Ryder), whose footage of her friends is picked up by an MTV-like network, then ruined by that network's faceless editors who deal it death by a thousand cuts. Lelaina's own documentary project is presented, within the film, as a fundamentally raw (and therefore honest) source. The film begins with all the comforting signs of a home video—a blue screen, the rattle of a VHS cartridge, and then the white lettering, "VCR PLAY." We then see Lelaina in a cap and gown giving a speech, inveighing against the Vietnam generation for the way it slipped back into greed and materialism. Grainy images of the speech and of the graduation ceremony then give way to shaky, handheld shots of friends celebrating on a rooftop later that day. When this sequence fades to white, we slowly realize that it's the crisp, woven white of a fancy tablecloth. The scene into which we've cross-faded—a stilted conversation between Lelaina, her divorced parents, and their new spouses—is shot in theatrical uplight with an obsessively sharp focus—the very opposite of the footage we've just been watching. But perhaps the most striking difference is how painfully precise the dialogue becomes. Thus, the terms of the film are set: scriptedness, repression, old age, and greed belong to film, while

improvisation, expression, youth, and countercultural freedom all fall on the side of video. Indeed, the sense of authenticity that surrounds Lelaina's video comes not only from its visible grain or its shaky camera work, but also from the free-flowing, "unscripted"—and, yes, often quite confessional—expression it draws from her subjects.

Such a raw feed, the movie suggests, begs to be handled tenderly. When Stiller shows us Lelaina in the editing studio, he represents the process as something tantamount to therapy. Lelaina works *through* her feelings by working *on* this footage. For example, when we first see Lelaina in the editing room, she's piecing together a sequence about her friend Troy (Ethan Hawke), while also puzzling through her own complex feelings toward him. Following a scene in which Lelaina and her roommates fight over whether or not to let Troy move in, we cut to a sequence from Lelaina's documentary that introduces Troy, then treats the act of filming itself as a conduit for their sexual tension. (Troy taunts Lelaina, "You like to watch don't you, you like to watch," before grabbing the camera and turning it back on her.) When we emerge from this footage again, we now see Lelaina watching its final shot: Troy sauntering down an alley toward the camera. She sits, mesmerized, nodding

Figure 4.1. Lelaina Pierce (Winona Ryder) editing Troy (Ethan Hawke) in *Reality Bites* (Universal Pictures, 1994).

sharply as if to affirm each moment's perfection. A smoldering cigarette droops from her hand—its long ash a sign of her total absorption in the scene. She pauses the video, stares at the monitor for a while, lingering on a full-frame image of Troy—and it seems like she might do so forever, except that her boss barges in, demanding that she pay attention to her day-job. Lelaina begs him to watch the video we've just seen, but he refuses—and his callous disregard for her work only deepens our sense of Lelaina's emotional involvement in it.

The next time we see Lelaina editing, she's doing so in the well-appointed offices of In Your Face, an MTV-like channel. Her now-boyfriend Michael (Ben Stiller), a vice president at the channel, has successfully pitched her work to the network, but no matter the change of venue, Lelaina's approach remains the same. As if to prove it, we see the same scene of editing, except focused now on her friend and roommate Sammy (Steve Zahn). She watches long takes of Sammy spilling his guts to the camera after a rocky attempt to come out to his mother. "I can't really start my life without being honest about who I am," Sammy rasps. Again, the long ash of her cigarette droops as she stares, watery-eyed, at the screen.

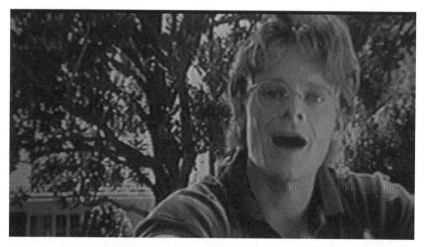

Figure 4.2. Sammy (Steve Zahn) confesses after coming out to his family in *Reality Bites* (Universal Pictures, 1994).

Figure 4.3. Lelaina Pierce (Winona Ryder) edits Sammy (Steve Zahn) in *Reality Bites* (Universal Pictures, 1994).

Two scenes later, we arrive at In Your Face headquarters for the preview screening of Lelaina's new show. Michael assures Lelaina—"We had our best guys working on it, and, y'know—just put some titles on and shaped it a little bit"—before introducing the piece to the assembled crowd as the beginning of "a new phase here at the channel: *real programming*." The screening, though, is a catastrophe—and not because the crowd is displeased. (They aren't, and this might only make things worse.) But, almost from the start, Lelaina feels betrayed by what she sees onscreen. When opening credits roll—a twitchy, effects-heavy sequence that's a perfect send-up of the *Real World* title sequence—Lelaina smiles nervously and says (not really asking a question) "What's this?" What follows—a hodge-podge of scenes and themed segments—paints her friends as broken, overgrown children. In one final blow, the editors have set Lelaina's graduation speech to the strains of the Talking Heads. *We're on the road to nowhere* And just like that, Lelaina's love for the project and for Michael vanishes. His sin was not that he permitted editing—nor even that he permitted *so much* editing—but, rather, that he permitted *loveless* editing. And that can never be forgiven.

Contracts: The Performance of Reality

This ideal of emotionally intimate editing—posited both by *Reality Bites* and by *The Real World*'s staff—has an unintended side-effect. It treats reality TV participants as nothing more than passive subjects: either objects of the editor's love or victims of their betrayal, but never coauthors of their own confessions. All this talk of love and betrayal only simplifies the true power-dynamic between producer and performer.

Yes, participants in reality TV are, in a very real sense, at the mercy of their producers—a reality we mystify at our peril. This is true not only because producers wield ultimate control over the show's edited narrative, but also because, with the help of reality TV, networks have radically redefined the terms of a television performer's labor. It's no secret that networks see reality TV as a way to fill the airwaves while skirting labor policies, and this was a major reason for the genre's explosive growth. A 1995 *New York Times* piece titled "MTV's Low-Cost Way of Business" summarizes this business model bluntly: "Get nobodies for virtually nothing, and today's bottom line salivates."[65] Doing away with traditional scriptwriters and replacing actors with "nobodies," reality TV producers not only circumvent the industry's unions—the Writers Guild of America (WGA), the Screen Actors Guild (SAG), and the American Federation of Television and Radio Artists (AFTRA)—they also ensure themselves a virtually limitless pool of performers. As one anonymous television executive told the *New York Times* in 2001, "These people are not represented by any unions—they have very little power, and there are literally thousands of people behind them waiting for their 15 minutes."[66] *Perform*, producers can afford to say, *or else*.

Meanwhile, they exploit an ambiguity in how we think (legally and culturally) about self-performance. Is "performance" a fiction, even when performers are playing themselves? If it *is* a fiction, whose fiction is it exactly? And what happens to "fictions" who go on living their lives? Having gotten her hands on one participant's contract for *Survivor*, Debora Halbert knows how one production team would respond—and the answer isn't pretty. When people agree to appear on *Survivor*, they cede to CBS all stake in their own personalities. "I hereby grant and release to Producer, in perpetuity and throughout the universe, the exclusive right . . . to depict, portray and represent me and my life," con-

testants affirm when they sign this contract.[67] As Halbert observes, "The *Survivor* cast has not only granted CBS the rights to what took place on the television show, but the rights to their entire life story as well. . . . CBS owns their public identities and the rights to disclose their private identities."[68] This includes, alarmingly, the right to "portray me and my Life Story either accurately or with such liberties and modifications as Producer determines necessary."[69] Given this emphasis on the "liberties" a producer might take, it's no surprise that this contract is based on case law about fictional characters, not about real, famous people. Characters can, in theory, be owned outright by their authors, but celebrities own their public personae by dint of the labor it took to construct them. This property right is "alienable," Halbert points out, both by contract (e.g., an endorsement deal) and by transfer (e.g., deeding control of these rights to your heirs)—but it always preserves the idea of a person who labored to create this persona. The contract signed by *Survivor* contestants, by contrast, presumes that CBS has taken these "nobodies" and all-but-literally made them who they are. This legal fiction—that a person *is* a fiction, and one owned by CBS—allows the network to claim full rights to that person's life story, even as more chapters are written—a nightmarish literalization of the idea that our selves are constructed by powers beyond our control.

The Real World, though never as far-reaching in its legal claims, also relies on effacing the laboring person behind the persona shown onscreen. They just work the same angle from a different direction. Whereas *Survivor*'s contracts presume that the show is a fiction, *The Real World*'s make the opposite claim: that this show is pure, unadorned reality. MTV isn't doing the labor of self-making—but then again, they say, *nobody* is. The cast is just *being* while cameras capture it all.

As I learned at an open casting call for *The Real World*'s twenty-sixth season, producers rely on the legal fiction that, whatever the cast is doing, it isn't performance. And auditioners fall in line. When I asked them, in my capacity as a journalist, what it took to get cast on *The Real World*, they responded with phrases they surely picked up from the show: "Just be yourself," they said, "who you *really* are." When I asked them why they were personally well-suited to the show, they replied: "Because I'm pretty much who I am." Soon after tossing such tautologies around with me, these auditioners would certify them as legally true.

Attached to the application form was a waiver, a version of the "guest release" form the crew hands to anyone who stumbles into the gaze of a *Real World* camera. By signing, auditioners acknowledge and agree that *The Real World* may present them in "disparaging, defamatory, embarrassing or . . . otherwise unfavorable" ways, and, furthermore, that what they are doing on the show is passively *being themselves*. One clause reads,

> I also hereby warrant and represent EITHER: (i) that I am not a member of any collective bargaining organization, including without limitation, the Screen Actors Guild (SAG) and/or the American Federation of Television and Radio Artists (AFTRA); OR (ii) if I am a member of a performing arts union or guild, I agree that my appearance in the Program *is not a performance and is not employment* and is not subject to any union or guild collective bargaining agreement. . . .

Essentially, reality TV participants must affirm that they are not performers, or, if they are, that they are not performing for *The Real World*'s cameras. Combined with the show's insistence that people should simply *be themselves*, this agreement does more than just define the terms of their employment (i.e., that they are not laboring, and therefore waive labor protections), it also affirms that there is no technique or style peculiar to what reality TV participants do (i.e., play themselves).[70]

As the contracts of *Survivor* and *The Real World* each suggest, reality TV relies on the legal and ideological fiction of the form's utter simplicity. Either the participant's persona is a pliable fiction in the hands of CBS, or it's just raw material for MTV to capture and display. But whether or not they call it performance, the casting directors for *The Real World* do select for a particular skill set. A document posted on the website of Bunim-Murray Productions, instructing people on how to apply by video, mainly answers logistical questions: how close should I be to the camera? how should I light myself? etc. The last bullet point is the only one concerning the contents of this tape—and it suggests what kind of performance they really want. "Sit down and tell us a story," they advise, "The majority of your casting tape should look like this. Be creative, have fun, get crazy and most of all, keep it 'real!'"[71] Auditioners, then, are trying out not for the show in general, but for the confession

booth in particular—i.e., for the most stylistically peculiar feature of the show. When I interviewed *Real World* casting director Shannon Mc-Carty during the casting call I attended, she restated this expectation: participants must not only be open and willing to confess, "they need to be good storytellers. In this age of texting and tweeting and Facebook, we're looking for those people who can still give us a beginning, a middle, and an end."[72] When I pressed for further details—after all, surely there are more than enough people who meet this basic requirement—McCarty responded by contrasting *The Real World* with competition-based reality shows like *Survivor*. *The Real World*'s interviews, she said, are unique for "not being immediate, in-the-moment interviews." This meant, she went on, that cast members needed to know how to revive the immediacy of past feelings. They needed, in short, to be Method actors of the self. So basic a requirement may not count, in everyone's eyes, as artistry, but it's surely a kind of performance. And that's before we've even started to ponder the demand that auditioners "keep it 'real.'" What unspoken style, what art of artlessness do those little scare quotes imply?

With this question in mind, let's consider the one admission of art I was able to wrest out of auditioners that day. I pushed one young hopeful to imagine his coming audition: "Okay, so, you're going into that room and you've got to tell a story into the camera. How exactly do you plan on doing that?" He paused a moment, then carefully replied, "I guess I'm just going to pretend like I'm looking at someone else, eye to eye. . . ."

The Intimate Lens

Imagine yourself on the scene. You are sitting, confessing. No, you are sitting, looking into a camera, confessing. No, you are sitting, responding to questions from a director, while looking into a camera lens, confessing. To whom are you confessing? To your "viewers," of course. Now say it again, but this time "in complete sentences, and when possible, in the present tense."[73] This is what *The Real World* requires of its cast: that they revive the near past with verbal precision and emotional accuracy; that they foster a sense of immediacy amid layer after layer of mediation; that they banish all the clutter of this complex scene (camera and crew, a prodding producer, a notional audience out there) and speak

directly and intimately to no one in particular. If you want to succeed at all this, you must learn to "keep it 'real'" in rather surreal situations.

Master these techniques—and once you have, "You" will have earned your status as *Time*'s 2006 Person of the Year. YouTube, the main force behind *Time*'s choosing "You," has done a lot to naturalize this unnatural form of talk. In fact, it has fostered whole communities of vloggers (video-bloggers) who learn to stare right into cameras and bare their souls. Lev Grossman, in his contribution to "Your" issue of *Time*, complains, "This isn't what YouTube was designed for—to be the public video diary of a generation of teens and twentysomethings."[74] But that's not exactly true. Nowadays we may know it as an omnibus of online video, but YouTube started its life as a clearinghouse for intimate talk—though mostly monologues of the "I like long walks on the beach" variety. Yes, that's right: YouTube started as a concept for a dating site, "a video version of HOTorNOT.com."[75] And insofar as it stuck to that premise—retaining, for instance, certain social-networking features—people could use YouTube to find one another, not only for romance or sex, but for all sorts of intimacy. "Broadcast Yourself," YouTube's slogan commands, and this has always been a confessional pun. On the one hand, it touts all the tools this site offers to DIY video distributors—that is, the way it helps you "Broadcast [all by] Yourself." But, more importantly, it presumes from the start that such videos will be somehow self-revealing—that they will help you, in other words, "Broadcast Your Self."

Cast your mind back, though, to a time before built-in cameras were an expected feature of computers and phones, before Skype and FaceTime video calls grew mundane, and you'll realize that, at first, this was a problem to solve. How would reality TV cast members learn to broadcast themselves? How would they come to feel intimate with the lens? How would producers, directors, and crew help them do it? These are questions that have scarcely been asked in scholarship on reality TV, probably because scholars—especially those in the British tradition, who take *Big Brother*'s unmanned "surveillance" cameras as the norm—tend to presume that the camera's gaze is, by definition, blank and cold—its point of view unattributable. But even the teenagers I met at auditions for *The Real World* knew better than that. They knew the lens would stare back at them like the dumb, dilated pupil that it is, but they also

knew that they'd have "to pretend like [they were] looking at someone else, eye to eye."

Every documentary genre has to "construct" its own "naturalisms of behavior and speech," but some documentarians go about this by rejiggering the whole filmmaking apparatus.[76] Take Errol Morris, for example: an Academy Award–winning filmmaker who weaves his films out of the monologues of others. When Morris wanted to draw a new sort of "naturalism" out of his subjects, he set about it in a rather unnatural way. Morris asked, "What if the camera and myself could become *one* and the same?"—and he meant it more literally than you'd think.[77] He found his answer in a jury-rigged device he came to call (with a wink and a nudge) the Interrotron. Despite its frightening name, this is basically a tool for personalizing the camera—helping people "pretend like [they are] looking at someone else eye to eye." Using a two-way mirror as a transparent screen (i.e., the same trick that makes a teleprompter work), Morris streams a live image of his face directly over the camera lens as he films his interviewees. Meanwhile, an identical setup superimposes the interviewee's face over another lens, to which Morris addresses his questions. They're in separate spaces, each looking at a camera, and yet they're also looking directly into each other's eyes. For quick proof of the Interrotron's power, just watch the trailer for Morris's 2003 film *The Fog of War*.[78] In this deeply confessional film, Morris gets Robert McNamara (former US Secretary of Defense) to reflect on—and, ultimately, to repent for—the role he played in masterminding the Vietnam War. The film's trailer alone is enough: it heralds Morris's success (filmic and moral) by showing the difference between past interviews of McNamara and the ones Morris conducted for this film. The trailer begins with grainy black-and-white footage of the young, unrepentant McNamara being asked, "What about the contention that your attitude is sometimes arrogant—that you never admit you were wrong? Have you ever been wrong, sir?" We don't need to hear the answer, not only because we see the smirk on young McNamara's face, but also because this interview—shot at a sharp angle, with McNamara addressing an interviewer out of the frame—has no chance of catching him out. When we cut to Morris's own high-definition, full-color interview, we still don't need to hear a word. The older McNamara simply looks—not just *at*, but

deeply *into* the lens. This look alone—its soulful aspect, yes, but also its blunt gaze—is as good as a confession. When the trailer ends with Mc-Namara looking deep into the camera and saying, "We were wrong," this admission feels like the natural result of how Morris has forced him to look us square in the eye. "No more *faux* first person," Morris declares in an interview about this film and the Interrotron, "This was the *true* first person"—or, at least, a new naturalism of speech and gaze.[79] This bald sort of intimacy was achieved with the help of even greater mediation—but mediation made theatrical. "It is a moment of drama . . . , a moment with *dramatic* value," Morris says of the moment when he captures true eye contact on film—and he means it both ways: it's "dramatic" in the untheatrical sense of being vivid and revealing, but also "dramatic" in a more theatrical sense.[80] It's a strange bit of acting, in which a man plays a camera and a camera plays a man.

As far as I know, no reality TV director has ever adopted Morris's gadget or anything like it, but let the high-tech Interrotron symbolize all of the low-tech work that goes on in any direct-to-camera interview. Absent a whiz-bang solution like Morris's, the filmed confession becomes a Turing test—but in reverse. Instead of facing a machine that's trying to convince us that it's human, we work hard to convince ourselves that it's no mere machine—that it's something other than what it plainly is. If we pass this test easily, perhaps it's because we are performing an instinctual act of *transference*, in the classical Freudian sense of that word. Like neurotics who fall in love (or in loathing) with their therapists, we transfer onto the camera feelings it never earned—onto the lens, a kind love whose true object lies elsewhere. And "whether it be hostile or affectionate," this transference "aids in opening the locked compartments of the psychic life."[81] It makes the psychic life, previously a subject for distant reflection, vividly present in the moment of confession. In this transferential drama between camera and confessant, not only do we revive past emotions and experiences; we also reduce a complex situation—involving a camera and its operator, a demanding director and a prodding producer, and (somewhere out there) a notional audience—to a scene of direct and intimate speech. When it works, our performance for the lens mirrors our viewer's own romance with the screen—and through this circuit of lens and screen the emotional current of confession will flow.

Recalling his own initiation into the *Real World* interview, Dave Eggers highlights (and sends up) this drama of transference. In a central chapter of his memoir *A Heartbreaking Work of Staggering Genius*, Eggers recalls his second-round audition with the casting director of *The Real World*'s third season—the same season that would make Pedro Zamora famous. At first, Eggers presumes that the show requires roleplay from him. In the waiting room, his mind races as he tries to figure out how he might fit into the MTV mold:

> While waiting and chatting [with the MTV assistants], I realize that, duh, I'm already auditioning. I begin to think harder about my words, making them more memorable, wanting to be fun, cutting edge, soulful and Midwestern. I notice my legs; they're crossed. But how to cross my legs? The guy-guy way or the women's-older man's way? If I do the latter, will they think I'm gay? Will that help?[82]

At the very height of Eggers's self-consciousness, though, the casting director arrives and in an instant becomes, like a therapist under transference, everything and everyone to him.

> She looks down at me. She is my mother, my girlfriend, my wife. It is Laura, the producer/casting person who called. She has an Ali MacGraw look about her—her skin lightly tanned, her eyes dark, with straight, milk-chocolate hair, soft on her shoulders, a velvet curtain touching a velvet stage.[83]

She's not only a screen for his projections; she's a "stage" where he can act out his fantasies—both of romance and confession. "I am ready to give myself to her," he says, meaning both things at once, "She will listen and when she listens, she will know."[84] And though he sinks once again into neurosis—*should he check his hair in the mirror? No,* "she'd think I was vain," *but* "maybe she wants someone vain. I could be the Vain Person."—it only takes her one question and a comment to cut through all the noise. "Where did you grow up?" "A little suburb of Chicago, Lake Forest." "I know Lake Forest." And, all of a sudden he feels "a format change coming, one where quotation marks fall away and a simple interview turns into something else, something *entirely so much more.*"[85]

Of course—and Eggers knows this—it's a mystification to say that people slip into *The Real World*'s confessional rhetoric like neurotics slipping into the grip of transference. I mean, the cast of Season 1 didn't just look into the camera for the first time, say one thing, and mean their mother. *(Oops!)* Instead, across three months of auditions and "six or seven interviews" apiece, these people were selected for (and trained into) this rhetoric—these new "naturalisms of behavior and speech."[86] But, seeing as *The Real World*'s producers have an interest—both economic and attitudinal—in pretending that no skill or imagination is involved, it's no wonder they paint the show's debut cast as *idiots savants* of broadcast intimacy. In their introduction to one fan book, Mary-Ellis Bunim and Jonathan Murray describe one cast member as if he simply mistook the camera for his viewers.

> We wanted it to appear as though Julie or Eric or Kevin were talking directly to you, the viewer at home. For a while, Eric actually thought he was. He'd begin his interviews often by saying, "So you guys probably want to know what happened this week. . . ."[87]

They laugh him off as naïve, but maybe he knows what he's doing: performing his public into existence by getting intimate with that lens. When scholars of reality TV do reflect on where cast members' confessional skills initially came from, they always offer the same answer: daytime talk shows. Reality programs are "a form of location talk show," says John Corner.[88] They require "styles . . . of address" familiar from "talk-show guests," says Richard Kilborn.[89] But such arguments never rely on actually proving the connection. No one is studying reality stars' daytime TV viewing habits. Instead, they rely on the implicit claim that this "talk show" rhetoric was in the air. There were more direct sources, though—especially in the case of *The Real World*'s debut cast. Kevin Powell, one member of that cast, puts his finger on the source when he observes, "We were really a slice of what's going on in our generation, *except we're all artistic*."[90] This could hardly have been an accident: Andre the musician, Becky the actor-singer-songwriter, Eric the model (soon turned TV personality), Heather the rapper, Julie the dancer, Kevin the poet, and Norman the painter.[91] Gwendolynne Reid, writing about *The Real World*'s first season, claims that these "artistic

endeavors become a backdrop" for the show, "but they [i.e., the cast] do not reflect as much on their arts," but that simply isn't true.[92] Cast members practice their art onscreen. They attend each other's recording sessions, gigs, classes, and exhibitions. They speak about it all the time—and, what's more, they think of their art in thoroughly confessional terms. It helps them "express" something hidden, they say, and their highest term of praise for each other is that the art they're making is "honest." Only people like these—people brought up in art, and in a confessional mind-set about what art *is*—could be trusted, as Eric put it, to "[solve] *The Real World*" for other casts to come.[93]

For all their protestations to the contrary, the *Real World* producers are obviously aware of what they've done. Beyond casting these people in the first place, beyond citing such precedents as 1970s-style performance art (see Box 4.1), they also work overtime to blur the line between confessional art and the "confession booth" interview. Having no dedicated space for their confessions (à la Season 2's "confession booth"), the debut cast often confesses at the scene of their art-making: Kevin at his typewriter, Norman in front of his paintings, Heather in a recording studio, and Eric in front of a wall full of headshots that echo the shot that has captured him there, ready to chat with "you, the viewer at home." In one extraordinary sequence, they even substitute a poetry reading where, otherwise, they would use interview footage. It's a fraught sequence (Episode 11). Race riots are raging in Los Angeles (though, to their shame, the editors have removed any reference to this context) when a fight breaks out between Kevin (our race-conscious, New Jerseyite poet) and Julie (our bristling, white Southerner). In a flurry of contradictory interviews, the show tries to explain exactly what happened, but for a while Kevin's point of view has gone missing. Then, all of a sudden, we're transported to the Nuyorican Poets Café, where Kevin is giving a reading. He introduces a poem: "This is called 'Mental Terrorism,' and I think all of us in here are going through that [bleep]." Then, he starts reading. It's not an obviously confessional poem, but Kevin's intro and the editors' choices have taught us how to hear it that way. "Can I cry in living color?" Kevin asks. Shown in a tight shot that echoes the look of a *Real World* interview, this reading sublimates the confession-booth monologue into poetry. There, in the Nuyorican Poets Café, New York's home for slam poetry—today's torch-bearer for confessional poetry and,

Figure 4.4. Eric Nies confesses in front of a wall full of headshots in Season 1 of *The Real World* (MTV, 1992–present).

generally speaking, for the vitality of poetry performance—*The Real World* makes its own confession: that it has knowingly sunk its roots deep in the traditions of American confessional performance.

No doubt this hits close to home for Dave Eggers, who quotes both Anne Sexton and Robert Lowell in his preface to *A Heartbreaking Work*. He loves *The Real World* and loathes it. He desperately wants to be cast, and he wants, just as desperately, to have nothing to do with this show. You can hear him playing out this ambivalence in the audition, at least as he presents it. He mocks the interview format, but then equates it with what he's doing in this book. Not only has he given pride of place to this *Real World* scene—over fifty pages of prime real estate at the heart of this book—but the story he pitches to MTV's casting director is the exact same story he's been pitching to us. "So, I can be the average white suburban person . . . whose tragic recent past touches everyone's heart, whose struggles become universal and inspiring."[94] (You might call it, say, *A Heartbreaking Work of Staggering Genius*.) "Have I broken your

Figure 4.5. Kevin Powell performs his poetry at the Nuyorican Poets Café in Season 1 of *The Real World* (MTV, 1992–present).

heart?" he asks plaintively, "Was my story sad enough? . . . I know how this works. I give you these things, and you give me a platform."[95] (Hear these words aimed over the casting director's head and addressed to the acquisitions editors at Vintage.) Meanwhile, the "velvet curtain" of the casting director's hair—a passing detail, you might think—becomes his memoir's own brand, gracing the cover of every copy of this book: a red, theatrical curtain pulled back to show a dusky sky. In a moment of self-consciousness, Eggers even broaches this topic with the casting director directly. He loves *The Real World*: "I mean, we're in the same business, really, though we take vastly different approaches." He loathes *The Real World*: ". . . but you guys, your show claims to do more but then has a strange ability to flatten all the depth and nuance from these people."[96] Or, as he puts it a bit later, tasting the sour grapes of *The Real World*'s rejection: "It's a stupid show, a show that's almost unbearable to watch, everyone on it made hideous, silly and simple, two-dimensional."[97] But the attentive reader will notice that he has already lobbed these very same

critiques at himself and his memoir. Life-writing like this, he cries in frustration, can capture only "one, two dimensions of twenty" on its (literally) two-dimensional pages. "So you're reduced to complaining about it," he has his little brother chide him. "Or worse, doing little tricks, out of frustration." "Right, right," Eggers concedes—confesses.[98]

By the end of the interview, Eggers has pulled one of his very favorite "tricks," perhaps the signature trick of this book. By this point, we've realized that this long dialogue we've been reading isn't "really a transcript of [his] interview" at all, but he promises that somewhere a truer, fuller version may in fact survive.[99] "You know, the great thing is that this format makes sense, in a way, because an interview where I opened all this up to a stranger with a video camera actually did take place— MTV could conceivably still have the tape. . . ."[100]

The Sense of an Archive

Within the recesses of a large pre-war masonry building in Hollywood sit thousands of tapes and transcripts from the first five seasons of *The Real World*. One box is labeled "Julie—Alabama," another "David/Tami Fight," still another, "Neil's Tongue." Each one of these labels represents all that was recorded on that subject. But as each *Real World* episode is only a half hour, there remains much that the audience hasn't seen or heard.

—Introduction to *The Real World Diaries*[101]

With this Borgesian image, Mary-Ellis Bunim and Jonathan Murray lure *The Real World*'s fans into the archive. Somewhere, they promise, there are towering shelves—row after row—containing all there is to know about the show's first five seasons. (This includes, I smile to think, Dave Eggers's audition tape, which "MTV could conceivably still have.") Of course, this warehouse isn't open for public perusal, Bunim and Murray demur, but here, culled from the depths of its holdings, are just a few more things for our dearest fans. Every *Real World* fan book does something like this. *The Real Real World* promises stuff from "Off-camera / Behind-the-scenes / Beyond the censors," and crows, "if you thought their lives were open books, you haven't cracked this one!"[102]

The Real World: The Ultimate Insider's Guide teases us with the prospect of "new photos, confessions, revelations, and tensions."[103] This is a common enough tactic for fostering fandom. Movie stars perform this striptease every time they share a few more details about their lives, and Apple performs it whenever they let another tech-spec leak during the run-up to a product launch. But, in the case of *The Real World*, this gesture is doing something more: enacting the very essence of this program's aesthetic. Programs like this "work by managing an economy, a textual heap, of possible narrative-discursive chunks," says James Friedman.[104] Each episode exudes a sense of having been sculpted from a vast, suppressed archive of all available footage.

As the marketing for *Real World* fan books suggests, this sense of an archive is obvious, even to the viewers who are most absorbed in the show itself—and yet, our conversations about reality TV often proceed on the assumption that viewers have missed this point. As Mark Andrejevic observes, we seem to posit "a mysterious group of dupes who believe that reality television really is *real* (in some unspecified but clearly fallacious way)"—and he finds our motivations for saying so suspect.[105] Are we questioning reality TV, or are we, in fact, trying to shore up our own naïve perspective on reality itself? Reality TV, Andrejevic argues, "serves as a kind of negative proof of the unspecified reality of which it falls short." This is "one of [our] strategies for the panic-stricken production of the real."[106] What if, instead of positing a public of "dupes," we pay attention to the public that *The Real World* actually presumes—or the one it constructs through its editing and self-promotion?

The Real World Diaries are representative. They come in the guise of an illicit scrapbook, positively crammed with an excess of revealing stuff. The soft cover is embossed so as to look like a deluxe hard-cover diary, complete with a trompe l'oeil strap and lock. Inside, the pages are filled with every kind of text—scraps of notebook and graph paper stained with coffee-cup rings and covered in scrawling handwritten narratives; computer windows and hard-copy typescripts full of text; type-tape labels, dog-eared pages, Post-it notes, and more—not to mention all the photographs stapled, taped, and paper-clipped onto these scraps. The source materials for this stuff are the "confessionals and weekly interviews" that went unaired in the program itself, and the point of sharing them now, the book's editors explain, is to "add a depth and

perspective that is not possible to achieve in a mere twenty-two minutes per episode."[107] And yet even this book—chock-full, jam-packed—is meant to leave us pining for what still isn't here. These piles of image and text are, in fact, printed on a glossy, two-dimensional page. We cannot, though it may look like we can, pick each scrap up to see what else lies underneath—and even what we *can* see is rudely cropped, having spilled beyond the edges of each full-bleed page. *The Real World*'s archive is unmanageable.

This word, *unmanageable*, is an Eggers favorite for describing his own hodgepodge scrapbook of a memoir. Beyond narrative prose, *A Heartbreaking Work* also contains diagrams, musical notation, certificates, drawings, poetry, transcripts, and all sorts of found text. Its preface, meanwhile, leads the reader further afield, conjuring a vast array of (possibly fictional) materials. It begins by alluding to all the profiles, interviews, and talk-show appearances that (he hopes) will surround the memoir's release ("For all the author's bluster elsewhere . . ."), and it ends with a comprehensive list of key "omissions" from the book, which he then goes on to quote in their entirety.[108] It's like he knows how to set an edge, but not how to stop wishing it weren't there. Once again, Eggers knows that this trick is something he shares with reality TV. Among the seven whole pages of "omitted" passages, five pages' worth supposedly came out of the *Real World* audition scene. When he ends by listing epigraphs he asked to have "removed" (including quotations from Anne Sexton and Robert Lowell), we hear his own frustration coming from the lips of Lowell: "Why not just write what happened?"[109] Ha! As if this were ever "just" possible. That exasperating word—for Eggers as for Lowell (as for *The Real World*)—marks the point where art ends and life begins. Through this miniscule fissure—*just!*—pours a sudden breakthrough back into life.

If Eggers did loathe *The Real World*, in the end, it wasn't because it captured only "one, two dimensions of twenty"—that, after all, was a charge he leveled also at life-writing—it was the ease with which the show, settling for the two, pretended the twenty never existed in the first place. Or, you might say—given Eggers's fixation on typecasting—it was the ease with which the seven took the place of the 250 million—i.e., the way a handpicked cast was meant to stand in for America. Certainly, when *The Real World* told the story of racial tensions in that Season 1

loft, leaving out the fact of antiracist uprisings nationwide, they sacrificed dimension for the sake of sheer ease. And yet, in this very moment, they also ran up against the limits of their own Borgesian archive. Because no camera was there to witness the angry exchange between Julie and Kevin that kicked off this fight, all *The Real World* can show us is a dizzying mixture of confessions and conversations about what happened. Bereft of fly-on-the-wall footage, *The Real World* found they couldn't produce—if indeed, they wanted to do so in the first place—a single, complete, monologic narrative. All they could give us, in the end, was the unsteady collision of seven atomized perspectives.

With the rise and spread of reality TV in the early twenty-first century, both technology and technique have developed to the point where master narratives look increasingly possible—even easy to create. In a 2011 speech at Brown University, Jill Zarin, one of the cast members of *The Real Housewives of New York City* (Bravo, 2008–present), explained how producers' power had grown, even during her first three years on the show. "In the old days [i.e., before the 2008 premiere] . . . I decided," she explained, "to pay my own way and see how they put the show together."[110] What she discovered was a roomful of headphone-clad typists staring at a roomful of television screens, transcribing every word spoken by her and her fellow "housewives"—each group interaction and each direct-to-camera monologue. "Here they are," she shuddered, remembering her thoughts at the time, "they're living in my head." All of this, she explained, went into a searchable and taggable database, so that when the producers wanted to call up a certain scene or memorable comment—or even wanted to fish for material—they could do so in a flash. And, over the next three years, that bevy of typists— already a massive advantage over what *The Real World* staff had at their disposal—would give way to voice-recognition software, which, Zarin insisted, could instantly turn intimate footage into a narrative database. (This was surely an exaggeration.) Together with the negligible cost of digital "film," such technology promises a theoretically limitless archive along with the promise of editorial ease—all the power and mystique of *The Real World*'s Borgesian warehouse shrunk down to the size of a computer server. Behold: the realist art machine.

* * *

Realist art, no matter the genre, paints a picture of the world—but, like it or not, our eyes always drift to the frame. Art, after all, has edges, while the world has none. Art must end, even as the world goes on and on. The harder we try to capture the world, the more we realize that art is simply something different. This is the realist's paradox. Naturalists don't gloss over this impasse; they embrace it, never aspiring to paint a picture of the world. In the famous words of naturalist playwright Jean Jullien, they offer us *une tranche de vie*—a slice of life. Naturalists like Jullien would freely admit that their way of slicing up life is arbitrary, but they dismember the world in the hope that their public will re-member it. They grab the scalpel so we will reach for needle and thread. Realists, by contrast, are delicate souls: they try, if they can, never to wound anyone. Faced with the paradox of art's edges, they reach not for the scalpel, but for smoke and mirrors. They set the limits they must, in other words, but then try their very best to help us ignore them entirely. Either that, or they pick limits so far and so gentle that they seem only natural—every bit as true (and only as false) as the horizon. Henry James puts it best: "Really, universally, relations stop nowhere, and the exquisite problem of the artist is eternally but to draw, by a geometry of his own, the circle within which they shall happily appear to do so."[111] This circle *is* the world in the realist's hands.

One element of realist art, however, always threatens either to wound or be wounded by the artwork: its characters. As Alex Woloch points out in *The One vs. the Many*, his study of "character-systems" in the realist novel, "*all* characters are potentially overdelimited within the fictional world—and might disrupt the narrative if we pay them the attention they deserve."[112] And so the characters struggle to stake their claims on "narrative space," and authors are left to decide which "potentially full human beings" to "subordinat[e]."[113] Novelists, at least, can make such decisions with confidence. They control all this straining at the limits of narrative. Reality TV producers, though, don't quite have this prerogative. No doubt, they may *try* to exercise it, but a full human being lurks behind each character, threatening to upset any order they might impose. And so, as Su Holmes observes, "the mediated self" of reality TV becomes "a site of contest," a site whose "meanings are struggled over between participants, producers, and viewers."[114]

Inhabiting a supposedly first-person medium, but thrown at the mercy of total third-person editorial control, the subjects of reality TV have done the only thing they can. Mastering new rhetorics of intimacy, they take to Facebook, Twitter, and the ever-expanding universe of social media. (Jill Zarin confessed that she hired a social media team to help her do precisely this.) Connecting directly to viewers through Facebook or tweeting along with new episodes, she tried to envelop the televisual world in a universe of social media performance. Now, as always, the confessional performer is a master of media—captivated by many, but captured by none.

Coda

Confession in the Age of Aggregation

Famous people glow, it's often said, and it's a glow that comes from the number of times we have seen the images of their faces, now superimposed on the living flesh before us—not a radiation of divinity but the feverish effect of repeated impacts of a face upon our eyes.
—Leo Braudy, *The Frenzy of Renown*[1]

I am particularly fascinated by the individual need to assert a presence online, when in fact the very condition of this presence is a kind of individual erasure. In my mind, an image on Instagram, Facebook, Flickr . . . may have the look of subjectivity, but seen with all the rest, points directly to a question of what subjectivity means when everyone is basically taking the same picture.
—Penelope Umbrico, contemporary artist[2]

In the future, we may be famous our whole lives—if only in attenuated ways. A quieter strain of celebrity is now catching: not the rare case of charisma, not an acute pang of prominence, but a chronic, low-level condition. Call it "micro-celebrity" or, if it's got you feeling anxious, call it "the soft end of the surveillance continuum."[3] Whatever you call it, you can probably get it: a bit of that "glow" Leo Braudy describes. I've seen it at weddings, reunions, conferences—really, anywhere that distant acquaintances converge. Someone I don't know very well (or haven't seen for many years) walks by and a spotlight picks them out. Not everyone sees it, but I do—and, upon reflection, I know why. When this person first appeared, I didn't just see them; I also saw hundreds

of images, feelings, and stories "superimposed on [their] living flesh." I found I knew what they ate for dinner last night—knew the pain they'd been going through lately—knew exactly what sort of cat GIFs they tend to prefer. I had experienced, in other words, "the feverish effect of repeated impacts of [their] face" (not to mention their souls laid bare) "upon [my] eyes." If this isn't fame exactly it's something similar: fame's workings made mundane, as if the star's signature stance—what Joseph Roach calls "public intimacy"—came first, long before the actual stardom got around to anointing it.[4]

For the purveyors of social networks and microblogging platforms, this is a surefire sign of social progress. Now, everyone has the power (nay, the right!) to transcend their own privacy and become fully public—if only for an audience of a few dozen people. No one has preached this gospel of self-revelation quite like Lee and Sachi LeFever, creators of the animated video "Twitter in Plain English," which, for years, greeted all first-time visitors to Twitter. With all the placid good cheer of the born-again, Lee LeFever explains the idea behind the platform:

> *So, what are you doing?* It's one of the first questions we often ask friends and family. Even if the answer is just *mowing the lawn* or *cooking dinner*, it's interesting to us. It makes us feel connected and a part of each other's lives.
>
> Unfortunately, most of our day-to-day lives are hidden from people that care. Of course, we have e-mail and blogs and phones to keep us connected, but you wouldn't send an e-mail to a friend to tell them you're having coffee. Your friend doesn't *need* to know that.
>
> But what about people that *want* to know about the little things that happen in your life? Real life happens between blog posts and e-mails, and now there's a way to share.[5]

"Real life," LeFever posits, is what happens in between our conscious acts of reflection and mediation. But Twitter, he promises, will fill in those gaps, making "real life" finally the same as its avatar online. *But real life happens between tweets*, you might object. No matter: he'd only smile and say, *We're working on that.* Just a few more bugs to fix and we'll reach the promised land: total, effortless self-mediation.

Back in 1968, Andy Warhol promised us "fifteen minutes of fame." Our basic ration hasn't grown, but social media have taught us how to spend it frugally, divvying it up for distribution to small, scattered audiences. We parcel it out across 140-character tweets, six-second Vines, and ten-second Snaps. We spread it thin across updates and blog posts. We upload it and stream it; we filter and promote it. And in the end, there's too much for one viewer to consume—for one scholar of confession to fathom. Enter, art. Enter, the algorithm.

* * *

Picture a spider at the center of its web. It senses any disturbance along each silken thread, but watch closely and you'll notice that it ignores every tremor but one. It knows the telltale twitch of its wriggling prey and, feeling that, crawls right over to feed. The spidering bot (or Web crawler) earned its name by doing this on the worldwide Web. Attuned to one kind of information, this bit of code crawls the Web and returns to its user with a belly full of data. Back in 2005, Sep Kamvar and Jonathan Harris built a spider that thrived on a peculiar diet: it fed on feelings. This bot knew the frisson of someone writing "I feel" on the web. It monitored blogs across the world (written in English) and brought back each instance it could find—gathering, at first, an average of ten thousand per day. Kamvar and Harris then used these data to build a website called *We Feel Fine: An Exploration of Human Emotion, in Six Movements*. Using a variety of data-visualization techniques, this site helped users fathom—or else *feel* they were fathoming—the whole confessional Web at once.[6]

When you first open the site, your screen fills with swarming, color-coded dots, each one a recent feeling expressed online. "Happy positive feelings are bright yellow, sad negative feelings are dark blue, angry feelings are bright red, calm feelings are pale green, and so on," Kamvar and Harris explain, teaching us how to read this swarm like some kind of global mood ring.[7] But if this view feels too distant, you can click on any dot to reveal the sentence it encodes—one textual shard of a person's life. You can even, in the website's next "movement," watch these statements scroll by, "appear[ing] letter by letter, as if being typed by their author" before your very eyes.[8] But the greatest illusion of access will come in the next movement, where these statements are superimposed over images

found nearby in the same blog posts. Often, though not always, this is the author's photograph, a portrait of the "I" in "I feel." But even as we stand on the brink of this breakthrough, we find ourselves discouraged from going any further. You can sometimes follow an embedded link back to the blogs from which these data were initially drawn, but the site's remaining "movements" promote a different perspective: the individual was never the point. In *We Feel Fine*'s final three movements—called "Mobs," "Metrics," and "Mounds"—Kamvar and Harris take us up and away from the ignoble strife of the madding crowd. Instead, they let us parse feelings and sort them by the demographic features of the people who once expressed them—even, for instance, by the weather at their location when they wrote. They let us see them, that is, but only in aggregate—and just like that, the individual floats down the data stream, around a bend, and out of sight.

A decade later, *We Feel Fine* is a museum piece. Quite literally: it was acquired in 2015 by the Museum of Modern Art. But figuratively, too: this project feels trapped in its moment, impossible to revive or reproduce. Back in 2005, anyone armed with a good algorithm might have seen the social web as a manageable thing. MySpace had existed for less than a year, Facebook was available on only a few college campuses, and the first YouTube video had only just been posted online. Today, by contrast, the sheer quantity of online confession boggles the mind, and the many platforms and media through which it's channeled would baffle the bot behind *We Feel Fine*. The idea that we might cut a clear cross section of feelings confessed, received, and displayed online—this seems like the stuff of fantasy now. But, more than that, the sort of scattershot intimacy fueling *We Feel Fine* now seems like a relic of the past—of a time when privacy restrictions and closed networks were not yet the norm, when all expressions of feeling online were broadcast to the world at large.

But one thing about *We Feel Fine* feels prescient—its reluctance to take the plunge from a bird's-eye view to a close-up look at individuals. The more we share our lives online, the less certain we can be that they matter—that *we* matter—except in aggregate. And even then, they may matter most to social network operators, who use our output to guide the right advertisements our way. "In database marketing," David Lyon observes, expressing the general mood right now, "the idea is to lull in-

tended targets into thinking that they count when all it wants is to count them."[9] At our most intimate and personal, we now find ourselves sorted and grouped as the market demands.

* * *

Kamvar and Harris aren't the only artists trying to make sense of this paradox: the way an intimate social Web (geared like never before toward individual users, their expressions, their needs, and the scale of their use) feeds into an impersonal semantic Web (a "machine-understandable Web" that enables untold feats of aggregation).[10] Take, for instance, Penelope Umbrico—a photographer, or, more precisely, an artist whose medium is other people's photography. She has spent the past decade collecting and arranging images that she finds online, whether on photo-sharing websites like Flickr or on e-commerce platforms like Craigslist or eBay. As her work with Flickr reveals, there are forces much deeper than the market that shape our online intimacies—from cultural scripts and photographic conventions to the ever-changing affordances of digital media and Internet platforms—and these forces overwrite individuals, even as these people try to assert their individuality online. Photographs posted on Flickr "may have the look of subjectivity," Umbrico says, but seen in aggregate (a viewpoint that Flickr makes possible) these photographs raise the "question of what subjectivity means when everyone is basically taking the same picture."[11] Umbrico's work, in other words, aims to make people see the social web through the eyes of a search engine.

Take, for instance, Umbrico's most famous series, *Suns from Flickr* (2006–present). For each installation of this piece, she begins by entering the search term "sunset" on Flickr. Then, browsing through some of the millions of search results, she selects hundreds (sometimes, thousands) of these images and sets to work. She crops "just the suns from these pictures and [uploads] them to Kodak, making 4" x 6" machine prints from them."[12] Setting these prints edge-to-edge, she then fills most of a gallery wall with a grid of blazing suns. As simple as this premise may sound, the results are sublime—at first, in the euphoric sense, then (upon reflection) in a crueler way. But most viewers never get beyond the euphoria. One art critic, who spent time observing the crowds around this piece when it appeared in the San Francisco Museum of Modern

Figure C.1. Penelope Umbrico, *Suns from Sunsets from Flickr* (2006–present). Courtesy of the artist.

Art, concluded that it obviously "makes viewers feel good."[13] This response must surely have dismayed Umbrico, who, it seems, has darker designs upon her public than this. She can't blame them for "basking in the warmth" for a while.[14] But she hopes that, sooner or later, this piece will make them feel their sense of self slipping away. After all, the people who post these suns on Flickr are usually trying "to claim individuality or subjectivity with these photographs."[15] But tiled together these images reveal, to the contrary, how un-individual their behavior was from the start. Umbrico notes, "I only use images that follow very closely to a scripted idea of what a 'sunset' image is—they are all practically indistinguishable from each other."[16] Thus, the sunset—for some, the very image of humanist beauty—becomes instead the secret judgment of big data on your soul.

Peeved, perhaps, to have been misunderstood by crowds who simply wanted to bask in the warmth of her suns, Umbrico soon began work on another installation, *Sunset Portraits*, which sharpened the point of her critique. Using the same source material as *Suns from Flickr*, but leaving the photographs uncropped, *Sunset Portraits* shows a few hundred people, each posing in front of a sun-painted sky. They're all trying, Umbrico says, to make "the individual assertion of 'being here,'" but in aggregate their portraits reveal the opposite: "so many assertions [of 'being here'] that are more or less the same."[17] More to the point,

Umbrico selects only portraits where the photographer—equipped with a bad camera or a poor grasp of photographic technique—has accidentally reduced the people to mere silhouettes. (She has since put an end to this series, since most cameras—though not most humans—are now smart enough to compensate for this kind of backlighting.)[18] In short, the same sublime "suns from Flickr" are now literally blacking out people's features, stripping them of the very identity they are trying to assert. How could anything—even a confession—put online today escape this de-subjectifying gaze?

* * *

Natalie Bookchin, a video artist, thinks she has found an answer to this question—has found a way to look at people through the search engine's eyes without going blind to their intimate particularity. Like Umbrico, Bookchin trawls the Internet for vast stores of other people's material—in her case, videos posted on sites like YouTube and Vimeo—and, just like Umbrico, she turns the material she finds into sublime mosaics that can fill whole gallery walls. This superficial resemblance, though, masks a deeper disagreement about the purpose of such art. Umbrico's art is primarily critical, using these mosaics to undermine people's claims to individuality. Bookchin's art, on the other hand, is primarily political, and aims to make out of these individuals a new collective. She is focused, in other words, on finding out what commitments are possible on the far side of critique. Of course, this may mean calling into question people's overblown claims to originality and individuality, but it also requires a measure of sympathy toward the people whose material Bookchin repurposes.

This is true even of Bookchin's most critical (and perhaps most famous) installation, a video-mosaic called *Mass Ornament* (2009). She owes the title to Siegfried Kracauer's famous 1927 essay comparing mass choreography (all the rage, at the time) to Taylorist models of factory work.[19] As Kracauer sums up this argument in a later essay:

> When they [the Tiller Girls, a wildly popular dance troupe] formed an undulating snake, they radiantly illustrated the virtues of the conveyor belt; when they tapped their feet in fast tempo, it sounded like *business, business*; when they kicked their legs with mathematical precision, they

joyously affirmed the progress of rationalization; and when they kept re-
peating the same movement without ever interrupting their routine, one
envisioned an uninterrupted chain of autos gliding from the factories into
the world.[20]

Like Kracauer's essay, Bookchin's video installation concerns the cultural
meaning of dance—and, like his essay, it finds this meaning by way of a
rather unflattering comparison. Bookchin started with a trove of ama-
teur videos culled from YouTube showing people (mostly young women)
dancing alone for their webcams. In *Mass Ornament*, snippets of these
videos appear and disappear in rows, forming a troupe of unwittingly
synchronized dancers. (This virtual chorus line stretches, at one point, to
include as many as twenty-one dancers at once.) Meanwhile, Bookchin
underscores their dancing with the soundtracks of two different 1935
films: the Busby Berkeley movie musical *Gold Diggers of 1935* and Leni
Riefenstahl's Nazi propaganda film *Triumph of the Will*. Her message is
clear: "In seeming displays of personal expression, the YouTube dancers
perform the same movements over and over" like goose-stepping fas-
cists at a rally—except the operative force here is not military discipline,
but the codes of social dance and gender expression.[21]

Bookchin's editing of this material can feel cruel as it exposes the hid-
den choreography in supposedly free expression, but this cruelty be-
longs not to the artist, but instead to the social forces she's revealing
in this piece. As Jaimie Baron observes, "The bodies of these dancers
seem to have been colonized by the same hand—even before Bookchin's
hand entered the picture."[22] Something in Bookchin (or in her medium)
holds her back from simply reveling in these dancers' dehumanization.
They "may be placed in a collective unit at different moments" in this
piece, Bookchin concedes, "but they aren't standardized or abstracted.
The pathos and vulnerability—and the specificity—of their original ex-
pressions with their unpolished, clumsy, yet urgent intimacy, remains
intact."[23] By lining these dancers up side by side, Bookchin also trains
our eyes to see every unscripted flourish, each deviation from the norm.
Each one feels like a glimpse of possibility—of power *in potentia*.

That last quotation—about the "urgent intimacy" of Bookchin's
subjects—captures the difference between *Mass Ornament* and Umbrico's
Sunset works, but now I must confess: she wasn't describing *Mass Orna-*

ment in that passage. She was, in fact, describing the video work that she's done ever since. For the past eight years, Bookchin has worked exclusively with troves of direct-to-camera, confessional monologue— mostly vlogs or video diaries, though also (in her latest project *Long Story Short* [2016]) original interviews shot in roughly the same style. Editing many of these monologues together into the same sort of mosaic she constructed in *Mass Ornament*, Bookchin conducts choral monologues on issues of social concern, ranging from sexual identity to economic precarity. "Once I choose a topic I want to explore," Bookchin explains, "I look for patterns in the way people talk about it: the words they choose, their tone, their attitudes, the narrative arcs they follow."[24] Just as *Mass Ornament* shows what secret forces lie behind the bodies of amateur dancers, this work highlights the rhetorical and emotional patterns that shape the way people talk about their lives. Bookchin's aims, again, are not merely critical; this work has a constructive, political bent. Like a second-wave feminist consciousness raiser, Bookchin hopes that when we see these patterns, we will feel compassion—and then feel moved to action.

These political aims seem clearest in *Laid Off,* one of four video-mosaics that Bookchin included in a 2009 installation called *Testament.*[25] Created less than a year after the 2008 stock market crash—which, in the United States alone, would eventually wipe out nearly nine million jobs—*Laid Off* collects the voices of vloggers who have just been fired and—only now, right in front of our eyes—are beginning to grapple with this fact. It begins (with a musical precision that I can only represent in the following poetic manner):

<div align="center">

so

TODAY

I enter a new phase *really*

sucked

in my life

</div>

This opening passage is representative. *Laid Off* revels in these vloggers' cadenzas of euphemism and false hope—especially those moments in which they try to ventriloquize their oh-so-caring bosses—but it always undercuts this virtuosic bullshit with blunt talk, raw anger, and despair:

Figure C.2. Nathalie Bookchin, still from *Testament: My Meds* (2009/2016). Courtesy of the artist.

"What the fuck . . . Are you firing me?" "They're outsourcing my job." "Now I'm, uh, fighting for my life, basically." By calling our attention to such contrasts, Bookchin exposes the inch-deep delusion (or mile-high privilege) of those who embrace their unemployment as a blessing—a chance to "work on my skills," to "be reckless," to "go for a little vacation," or (worst of all) to "do [more] video blogs." (Or perhaps, to be a bit more generous to her subjects, Bookchin shows an assortment of people who feel the same "pathos and vulnerability," but admit to their precarity to varying degrees.) By helping us hear the rage beneath the hope, the precarity behind the privilege, the critique within each justification of the system, Bookchin hopes to forge a new political will—one that could help us, together, *fight for our lives, basically*. Putting the cold, disinterested gaze of aggregation to use, Bookchin doesn't reproduce its ideology; instead, she offers a searing new vision: these people, once brought together and freed from their frames or cells, might eventually amount to a social movement.

* * *

On November 12, 2015, at one o'clock in the afternoon three students, women of color, staged a sit-in near the entrance to the Robert Frost

Library at Amherst College. It was supposed to last an hour—a quick show of solidarity with antiracist protests going on at Yale and Mizzou—but pretty soon, the conversation turned to students' own experience of racism, especially during their time at Amherst College. An hour stretched into two, three, and four. The news spread and the crowd grew until over a thousand students—"some estimate . . . as many as three-quarters" of the student body—had packed into the library to speak and to listen.[26] The sit-in had spontaneously turned into something else: something its leaders later dubbed an "open discussion" and that the campus newspaper named a public "forum," but that the *New York Times* called "a confessional" where students of color had risen "to talk about feelings of alienation and invisibility."[27]

The stories students told that day had mostly been told before, but behind closed doors to friends, mentors, or therapists. The feelings expressed, if they'd been aired publicly at all, had only been telegraphed in silent side-eye and knowing glances. Now, a microphone and amplifier had appeared, and these feelings were booming out over the heads of a capacity crowd. The room's ethos, according to one leader of the Uprising, was one of "radical compassion," and students' testimony was "full of anger but not aggression."[28] But the prevailing mood—this the *Times* got right—was one of pathos and vulnerability. As one white student said, speaking to a reporter for the Amherst student paper, "I didn't know how deeply that pain cut . . . I knew that as an abstract, racism exists, but to see it on such a personal level, people who were breaking down because they were finally able to explain everything—that was eye-opening."[29] But I should note: this wasn't a spectacle staged for the edification of white students. It was a rite held by, and for the benefit of, students of color. People "were breaking down" at the mic, and these public breakdowns felt—to the students who had them—like a kind of collective breakthrough.

A funny thing: everyone recalls the feeling in the room that day, but few remember more than a couple of the stories people shared. For several hours, we told and heard—not just heard, *listened to*—personal stories being aired in public for the first time, and what remained most of all was a feeling: some mix of private sentiment and public commitment. Let's call it a new consciousness. People had "jump[ed] from topic to topic as new ideas flew from one to another, fragmenting the political

from the personal."[30] It was hard; there were lots of tears, but also plenty of what you might call, in a strange way, exhilaration. "The animation, the excitement of developing a point, the back-and-forth questioning and corroboration" that went on for days—all of this was "literally mind-expanding."[31] All of the quotations I'm citing here, you might recall, are contemporary descriptions of second-wave feminist consciousness raising—testimony from the people who first discovered and refined this political rite of passage.[32] That day, I emerged from my office, where I had been trying to capture this history on the page, and I felt it coming alive for my students, many of whom had never learned it in the first place. Brought up on the glib confessionalism of social media, they rediscovered on their own the power of consciousness raising: "a tactic beautiful in itself rather than an ugly means to a worthy goal."[33] And they learned what many women had discovered before them: that the telling can matter so much more than the tale.

But if you knew the Uprising only from its national news coverage, you'd scarcely even know about the telling. News stories tended to lead with the sit-in, but then sped ahead to a list of "demands" that a few student-activists released. A few of these demands were quickly met, others set aside just as quickly, but the forum's effects lingered on—though unnoticed by most beyond the edges of our campus. Hearing and sharing their stories that day, Amherst students had become more real to one another; but within days (or hours) they had also turned imaginary in the eyes of countless, distant others. We were all swept up into a master narrative, what Hua Hsu brilliantly called "The Year of the Imaginary College Student." This student, an "absurdly thin-skinned," "offense-seeking" millennial, was—that year more than ever—the favored bogeyman of folks all along the American political spectrum. "It's worth asking," Hsu observes, "why the politics of everyday college life . . . have become so important to people spending their lives far from the classroom," and why all of this focus and attention came to center on this one image of who college students might be today. I believe Hsu's explanation: that the imaginary student of 2015 was "a character born of someone else's pessimism," capturing (in negative) our scornful, low estimate of ourselves and of America today—of what kinds of hurt are reasonable to feel and express and what kinds of justice are currently up for discussion.[34] On campus, it was complicated—institutions, campus

cultures, and, most of all, people are complicated. In the media (social and mass), however, things were pretty simple.

It was a rude awakening for many of my students: suddenly to see firsthand how the spirit and texture of life could be stripped away, how a local event could differ radically from its avatar in the national media. It wasn't just that the stories shared that day were deemed too personal and thus kept private. (When has the privacy of individuals ever been a primary concern of the media?) No, the confessional ritual that defined this day on the ground just couldn't travel in the media—and, even if it could, it would never get a chance. Someone had created a short pull-quote of text—an activist listicle of demands—and so the media (social and mass) had all they needed.

* * *

Over the past decade, the Internet has grown more multimedia, immersive, and experientially rich—in theory, more ready to accept and conduct performances, and yet text is still king. If an activist wants to make an experience, rather than a text, go viral—wants a *doing*, rather than a *saying* to circulate—it takes hard work and careful planning. Sometimes this means offering a text, but only in such a way that the text stays inseparable from its context—often literally embedded in an image. This strategy became popular, for instance, during Occupy Wall Street, and activists have copied it ever since. Think of all of those movements—"We are the 99%," Project Unbreakable, etc.—where people share their stories by posting photos of themselves holding a handwritten narrative of their experience.[35] Other activists, though, resist narrative and text altogether, forcing the media to deal with concrete situations instead. This was also a strategy recently popularized by Occupy Wall Street, which resisted (to its detriment, critics say) any call to release a checklist of demands. Instead, they focused on simply camping out in nominally public (but actually private, corporate-owned) space. For nearly a month, they simply lived the contradiction of our increasingly privatized, supposedly "public" sphere.

Living our contradictions in the public eye—this was also the strategy of Emma Sulkowicz who, unlike the people behind Occupy Wall Street, was doing so as a way of consciously engaging with the history of performance art in America. When Columbia University dismissed

her allegations of rape against a fellow student, Sulkowicz went first to the traditional media. She publicly joined a Title IX complaint against Columbia, gave an interview to the *New York Times*, wrote an essay for *Time*, and held a joint press conference with US Senator Kirsten Gillibrand.[36] But she soon gave up talking and writing and did something instead. She found an extra-long, twin-size foam mattress—precisely the sort that appears in every Columbia dorm room—and started carrying it around everywhere she went on campus. This act of protest, which also served as her senior thesis in art, quickly went viral—both on campus and online. Campus activists at Columbia joined her protest, carrying around their own mattresses, on which they spelled out in red tape (pun intended) *Carry That Weight*, the name Sulkowicz had given to her performance.[37] Soon, there were twenty-eight women lugging mattresses around Columbia—the same number who joined the Title IX complaint—and, when they were through, they piled their mattresses outside the university president's home. (When this last action netted them a $471 fine, they paid it with a check written out on a mattress.)[38] Meanwhile, the mattress became a universal emblem of campus movements against sexual assault, appearing in protests from Connecticut to California and from Georgia to Winnipeg.[39] As it spread across Columbia, then the nation, then North America, Sulkowicz's mattress became, more and more, a pure ideological emblem—and its meaning hardened into a statement of politics. Quite literally, it became a surface on which to write words of testimony, solidarity, and support. In one case, a hundred students signed their names on a mattress, agreeing with the statement: "I support survivors of sexual and domestic violence and am helping to #carrythatweight."[40]

We must remember, though, that this began not as a verbal message, not as a statement of politics, but as a confessional performance—or, as one art critic called it, an act of "pure radical vulnerability."[41] Sulkowicz made a spectacle out of crossing from privacy into public space—hauling a piece of her dorm room out onto the quad. She converted an inner struggle into an outward ordeal—and, in so doing, she invited a community to take shape around her. People who never would have known (or responded to) her story were now literally helping her carry that weight. (What else are you supposed to do when you see someone struggling to shoulder a heavy burden?) And her performance, iconic

and replicable, was echoed by distant others—by new communities who added story after story around her act. Personal narrative may still be important to American politics, but Sulkowicz's mattress proved the value of offering that narrative in something other than copy-and-paste-able text. We seem to believe too much, as a nation, in the transparency of texts to their meaning, of words to beliefs, but a woman carrying a mattress—that might actually make you pause. No wonder, then, that when interviewed about *Carry That Weight*, Sulkowicz spoke mostly about the practicalities of carrying a mattress around everywhere, some-times actually refusing to make the confession her mattress was meant to encode and imply. The emotions of a survivor, sad to say, often get less attention and support than a woman lugging a mattress around. So, she forces us to dwell on the concrete scenario of *Carry That Weight*— the startling fact of it and the mundane stories of a life lived with this literal burden—before she lets us the long way around to her confession, her demands, her policy recommendations on sexual assault.

In an essay on political art, Jacques Rancière observes, "Images change our gaze and the landscape of the possible," but only "if they are not anticipated by their meaning and do not anticipate their effects."[42] In the age of aggregation, it grows harder for any image to outstrip its verbal meaning. Users "tag" each image quickly, and technologists are working to automate (or to outsource) such constant acts of verbal de-scription. But performance—understood as a hypermedial practice, as a way of playing with and between media—is what stays disentangled from this semantic web. It's more important than ever to find ways to *do* our meaning, to *act* on our beliefs, to *perform* our politics—and to do so in ways that won't quickly be swallowed up by their own verbal remains. Confessional performers have much to teach us on this subject. They perform the story of their lives over and against the rule of writing. They show us how we might *do* things with the stories of our lives. In the age of aggregation, this is truly the only way to confess.

NOTES

ABBREVIATIONS

APAS Audiotapes and Papers of Anne Sexton, Schlesinger Library, Radcliffe Institute, Harvard University, Cambridge, MA.

ASP-HRC Anne Sexton Papers, Harry Ransom Center, University of Texas at Austin.

EAP-GRI Eleanor Antin Papers, Getty Research Institute, Los Angeles.

LAP Lee Anderson Papers, Beinecke Library, Yale University, New Haven, CT.

SGP-HRC Spalding Gray Papers, Harry Ransom Center, University of Texas at Austin.

PREFACE

1 Rosenthal, "Poetry as Confession," 154.

2 Lowell, *Collected Prose*, 244.

3 Nadel, *Containment Culture*.

4 Gray, *Sex and Death*, xii.

5 The phrase is Goethe's from his autobiography, and serves as the title of psychoanalyst Theodor Reik's own autobiography. For more on Reik and his place in midcentury American thought, see the section of this book's introduction called "What Was Confession?"

6 The example of the Gothic is inspired by the published and unpublished work of Nathalie Wolfram, scholar of Gothic theater.

7 Muñoz, *Disidentifications*, 176.

8 Ibid., 5.

9 Antin, interview by Munro, 429.

10 Bolter and Grusin, *Remediation*, 14.

INTRODUCTION

1 Brooks, *Troubling Confessions*, 111.

2 Foucault, *History of Sexuality*, 59.

3 Sexton, *Anne Sexton: A Self-Portrait*, 68.

4 Lowell, *Collected Prose*, 244.

5 Plath, interview by Orr, 167.

6 Qtd. in Longenbach, *Modern Poetry after Modernism*, 5. The critic in question was poet Jean Garrigue.

7 Lerner, "What Is Confessional Poetry?," 46.

8 Ibid., 66.

9 Ibid., 48.

10 Middlebrook, "What Was Confessional Poetry?," 632.

11 Ibid., 636.

12 Williamson, "Stories about the Self," 51; White, *Lyric Shame*.

13 Rosenthal, "Poetry as Confession," 154.

14 For more of this argument, see Grobe, "Advertisements for Themselves."

15 I take this date from Matthew Daube, who generously lent me his ear and his unpublished work: "Laughter in Revolt."

16 Comparing Rodney Dangerfield to Richard Pryor as representatives of their respective generations, Richard Zoglin explained the difference: "The old comics made jokes about real life. The new comics turned real life into a joke." Zoglin, *Comedy at the Edge*, 5.

17 The phrase comes from Robert Lowell's poem "Memories of West Street and Lepke," in Lowell, *Collected Poems*, 187–88.

18 Collins, "My Grandfather's Tackle Box," 82.

19 Thompson, "What's So Funny?," 75. Joanne Gilbert, writing of her own experience as a standup comic in 1980s New York, goes further than Rivers. The audience, she says, doesn't just want to *know* you; they want to know something hard. They want "angst-driven humor" about "personal pain and anger." Gilbert, "Performing Marginality," 317.

20 Lerner, "What Is Confessional Poetry?," 66.

21 Lasch, *Culture of Narcissism*, 17.

22 Trilling, *Sincerity and Authenticity*, 1.

23 Ibid., 11–12.

24 Ibid., 11.

25 Gornick, "Consciousness," 22.

26 Rosenthal, "Poetry as Confession," 154.

27 Davison, *Fading Smile*, 8.

28 Qtd. in Rosenthal, "Poetry as Confession," 155.

29 Felski, "On Confession," 104.

30 Reik, *Compulsion to Confess*, 180.

31 Ibid., 348.

32 The ads appeared in the *New York Times*, March 22, 1959, and April 16, 1966.

33 Nabokov, *Lolita*, 3–5.

34 *Culombe v. Connecticut* (1961).

35 Ibid.

36 Ibid.

37 Ibid.

38 *Miranda v. Arizona* (1966).

39 *Culombe v. Connecticut* (1961).

40 *Miranda v. Arizona* (1966).

41 *Culombe v. Connecticut* (1961).

42 Baker, *Miranda*, 103.

43 *Miranda v. Arizona* (1966).

44 Inbau, *Lie Detection*, 94.

45 Qtd. in Alder, *Lie Detectors*, 31.

46 Both Snodgrass and Sexton wrote important early poems called "The Operation," in which they reflect on the nature of their self-revealing art. Lowell, meanwhile, is described by M. L. Rosenthal as performing some "kind of ghoulish operation on his father"—and, it's implied, on himself.

47 *Miranda v. Arizona* (1966).

48 I borrow this hardware/software distinction from Ken Alder. See Alder, *Lie Detectors*, 266.

49 Inbau's manual *Criminal Interrogation and Confession* (1962) had previously been known, after all, as *Lie Detection and Criminal Interrogation* (1953), and Warren cites both editions in *Miranda v. Arizona*.

50 Rosenthal, "Poetry as Confession," 155.

51 Lejeune, *On Autobiography*; Kaplan, "Resisting Autobiography," 208; Gilmore, *Autobiographics*, 21.

52 De Man, "Autobiography as De-Facement," 923; Gilmore, *Autobiographics*, 110.

53 *Miranda v. Arizona* (1966).

54 Olney, *Autobiography*, 13.

55 Tambling, *Confession*, 200.

56 Felski, "On Confession," 107.

57 De Man, "Autobiography as De-Facement," 930.

58 Taylor, *Archive and the Repertoire*, 16.

59 Ibid., 28.

60 As a result of such new requirements, editors of nonfiction trade books now routinely "assess the author's mediagenic qualities, that is, how the author will come across on the small screen in a few fleeting minutes." Rabiner and Fortunato, *Thinking Like Your Editor*, 36.

61 For more on this, see Grobe, "Memoir 2.0."

62 McLuhan, *Gutenberg Galaxy*, 6.

63 Olson, *Human Universe*, 5.

64 For an account of this event, see Molesworth and Erickson, *Leap Before You Look*, 299.

65 For discussions of "performance theater," see Bigsby, *Critical Introduction to Twentieth-Century American Drama: Volume 3, Beyond Broadway*; Heuvel, *Performing Drama/Dramatizing Performance*.

66 Kattenbelt, "Intermediality in Theatre and Performance," 23.

67 Guillory, "Genesis of the Media Concept," 343.

68 Bolter and Grusin, *Remediation*, 53.

69 Guillory, "Genesis of the Media Concept," 341.

70 Rousseau, *Confessions*, 3.

71 Lowell, *Collected Prose*, 243–44.

72 Dickey, "Dialogues with Themselves," 50.

73 Lerner, "What Is Confessional Poetry?," 52.

74 Here are two dueling examples. "It would be a mistake to regard Ginsberg as a merely 'confessional' writer like Anne Sexton." Simpson, *Revolution in Taste*, 78. "How valid are any attempts to distinguish productive disclosures from the merely confessional?" Diamond, "Scripted Subjectivity," 35.

75 It's no coincidence that, during this period, American presidents took to calling their major policy initiatives "wars"—as in Lyndon Johnson's War on Poverty (ca. 1964), Richard Nixon's War on Drugs (ca. 1972), and George W. Bush's Cold War–inflected War on Terror (ca. 2001), to name only a few. The Cold War made such actions thinkable as "war."

76 "Breakthrough?"; "Thorpiter or Thupiter?"; "Breakthrough in Molybdenum."

77 "G.G. Proves Itself"; "Gains in Grafts."

78 "Cold War Breakthrough."

79 Nadel, *Containment Culture*, 5.

80 Sexton, *Anne Sexton: A Self-Portrait*, 70–71.

81 Belgrad, *Culture of Spontaneity*, 1.

82 Ibid., 165, 10.

83 Lowell, *Collected Prose*, 243.

84 Hall, "Poetry Reading," 72.

85 Wojahn, "A Kind of Vaudeville," 277.

86 *People v. Bruce*, Trial Transcripts (1962). Many thanks to Maria Damon, who lent me her copy of this transcript.

87 Bruce, *Sick Humor of Lenny Bruce*.

88 Goldman, *Ladies and Gentlemen, Lenny Bruce*, 225.

89 Bruce, *I Am Not a Nut, Elect Me!*

90 Ibid.

91 Limon, *Stand-Up Comedy in Theory*, 4.

92 Magnuson, *Lenny Bruce Performance Film*.

93 Berton, *Voices from the Sixties*, 96.

94 Goldman, *Ladies and Gentlemen, Lenny Bruce*, 49.

95 Ibid., 51.

96 Qtd. in Javadizadeh, "Elizabeth Bishop's Closet Drama," 136.

97 Rosenthal, "Poetry as Confession," 154.

98 Kattenbelt, "Intermediality in Theatre and Performance," 23.

99 Guillory, "Genesis of the Media Concept," 357.

100 Felman, *Scandal of the Speaking Body*, 111.

INTERLUDE: THE UNBEARABLE WHITENESS OF
BEING CONFESSIONAL

1 Bishop and Lowell, *Words in Air*, 247.
2 Ibid., 327.
3 Ibid., 333.
4 Ibid., 132.
5 Garcia, *Autobiography in Black and Brown*, 41.
6 Gates, *"Race," Writing, and Difference*, 11.
7 The Riverbends Channel, *James Baldwin Debates William F. Buckley (1965)*.
8 Nelson, *Pursuing Privacy*, 31.
9 Baldwin, *Price of the Ticket*, 298.
10 Lowell, *Collected Poems*, 191.
11 Nelson, *Pursuing Privacy*, 46, 51.
12 Sexton, *Complete Poems*, 156.
13 Plath, *Collected Poems*, 237.
14 Ibid., 238.
15 Ibid., 238.
16 Bryant, "Confessional Other," 178.
17 Flanzbaum, "Imaginary Jew," 29.
18 Rosenthal, "Poetry as Confession," 154.
19 Bryant, "Confessional Other," 183.
20 Lowell, *Collected Poems*, 121–22.
21 Ibid., 159.
22 Ibid., 169–70.
23 Plath, *Collected Poems*, 223; qtd. in Smith, *Enacting Others*, 97; Vilga, *Acting Now*, 111.
24 Bryant, "Confessional Other."
25 I borrow these terms from Svonkin, "Manishevitz and Sake," 167.
26 Saul, *Becoming Richard Pryor*, xii.
27 Ibid., 216.
28 Ibid., 238–40.
29 Ibid., 252.
30 Blum, *Richard Pryor*.
31 Dell Hymes, "Breakthrough into Performance."
32 Saul, *Becoming Richard Pryor*, 3.

CHAPTER 1. THE BREATH OF A POEM

1 For more on the relationship between confessional poetry and publicity, see Grobe, "Advertisements for Themselves."
2 Phelan, "'Just Want to Say,'" 946.
3 Middlebrook, "What Was Confessional Poetry?," 633.
4 Middleton, *Distant Reading*, 34.

5 Bernstein, "Introduction," 5.

6 Perelman, "Speech Effects," 200; Roubaud, "Prelude," 20.

7 Javadizadeh, "Elizabeth Bishop's Closet Drama," 121.

8 McLuhan, *Gutenberg Galaxy*, 17.

9 Lask, "Poetry on Records," 8.

10 MacArthur, "Monotony."

11 Allison, *Bodies on the Line*.

12 Bernstein, "Introduction," 13.

13 Wheeler, *Voicing American Poetry*, 23. The rest of the body does make a cameo in a late chapter comparing academic-style readings to slam poetry performances.

14 Bernstein, "Introduction," 13.

15 McGurl, *The Program Era*, 255.

16 Box 2, folder labeled "Misc. material re: 'Memoirs' and Yale Series of Recorded Poets," LAP.

17 "Ted Hughes," box 2, folder labeled "Memoirs," LAP.

18 Qtd. in Smith, *Spoken Word*, 65.

19 Muñoz, "Ephemera as Evidence," 10.

20 Olson, *Human Universe*, 61.

21 Hamilton, *Robert Lowell*, 354.

22 Sexton, *Anne Sexton: A Self-Portrait*, 70–71.

23 Ibid.

24 Ibid., 68.

25 Ibid., 71.

26 For a summary of Lowell's feelings on Snodgrass, as poet and student, see Hamilton, *Robert Lowell*, 234. "He [Lowell] seems not to have been writing much" in Iowa, Hamilton observes—and, at this point, Lowell had written only the non-confessional poems of *Life Studies*: e.g., "A Mad Negro Soldier" and "Words for Hart Crane." Ibid., 198.

27 "Robert Lowell," box 2, folder labeled "Memoirs," LAP.

28 Lowell, "National Book Award Acceptance Speech."

29 Lowell, *Robert Lowell Reading His Own Poems*.

30 Lowell, "National Book Award Acceptance Speech."

31 Lowell, *Collected Prose*, 237, 239.

32 Ibid., 244.

33 Ibid., 242–43.

34 Middlebrook, *Anne Sexton*, 142.

35 I offer this as a counterweight to Mutlu Blasing's account of the role the typewriter played in Sexton's practice. Blasing, *Lyric Poetry*, 178–97.

36 Plath, *Unabridged Journals*, 421.

37 Ibid., 508.

38 Ibid., 514–15.

39 Ibid., 285.

40 Ibid.

41 Ibid., 370.
42 Plath, interview by Orr, 170.
43 Alvarez, "Sylvia Plath," 194.
44 Plath, *Unabridged Journals*, 515.
45 Ginsberg, *Letters of Allen Ginsberg*, 134.
46 Roach, "Viva Voce," 110.
47 Wilbury Crockett, Plath's literature teacher for three years running, trained students to read both poetry and their classroom assignments aloud. McCurdy to the Author, July 13, 2010.
48 Armstrong and Brandes, *Oral Interpretation of Literature*, 3.
49 Ibid.
50 Geiger, *Sound, Sense, and Performance of Literature*, 14.
51 Ibid., 6.
52 Ginsberg, *Howl and Other Poems*.
53 Ginsberg, *Collected Poems 1947–1997*, 142.
54 According to Gordon Ball, Ginsberg was literally crying at the microphone in the Fantasy Records studio while reading this poem: "I had been drinking wine and I wept at the truth and untruth of it," he quotes Ginsberg as saying. Ball, *East Hill Farm*, 197. These literal tears, however, only corroborate what the poem had always already encoded.
55 Ginsberg, *Collected Poems 1947–1997*, 141.
56 Ibid., 139.
57 Ibid., 142.
58 Ibid.
59 Ginsberg's meditation practice, mainly Buddhist, surely taught him what he knew about shaping an emotional body by controlling the way it breathed. He later wrote of "a calm breath, a silent breath, a slow breath [that] breathes outward from the nostrils." Ibid., 619. This, not coincidentally, is the breath he achieves in the final line of the "Footnote to Howl."
60 These examples are drawn from "Terminal Days at Beverly Farms," "Waking in the Blue," and "Skunk Hour"—all of which appear in the "Life Studies" section of *Life Studies*. Lowell, *Collected Poems*, 176, 184, 191. The ellipses proliferate in Lowell's next book of original poems, *For the Union Dead*.
61 Lowell, *Collected Prose*, 248.
62 Lowell, *Collected Poems*, 176.
63 Lowell, *Robert Lowell Reads from His Own Work*.
64 Rosenthal, "Poetry as Confession," 154.
65 Lee, *Oral Interpretation*, 5.
66 Ridout, *Stage Fright*, 87.
67 Qtd. in White, *Lyric Shame*, 116.
68 Levertov, "An Approach," 53; Hall, "Poetry Reading," 76; Bernstein, "Introduction," 11; Levertov, "An Approach," 56.
69 Yenser, *Circle to Circle*, 216.

70 Lowell, *Robert Lowell: A Reading*.

71 Lowell, *Collected Poems*, 334.

72 Ibid.

73 I borrow this phrase from Lowell's poem "Memories of West Street and Lepke." Ibid., 186.

74 Nolan Miller to Anne Sexton, March 9, 1959, box 17, folder 4, ASP-HRC.

75 Nelson, *Pursuing Privacy*, 45.

76 Anne Sexton to Gerald Rice, November 13, 1968, box 36, folder 4, ASP-HRC.

77 Anne Sexton, "Statement for Poetry Book Society" (n.d.), box 16, folder 4, ASP-HRC.

78 Anne Sexton to Miss McGhie, December 20, 1968, box 36, folder 4, ASP-HRC.

79 Foucault, *History of Sexuality*, 17.

80 "Embarras, N." Ridout also highlights this buried meaning: Ridout, *Stage Fright*, 81.

81 Austin, *How to Do Things with Words*, 22.

82 Furr, *Recorded Poetry and Poetic Reception*, 61.

83 Smith, "Confessional Poetry," 123.

84 Gill, *Anne Sexton's Confessional Poetics*, 110.

85 Derrida, *Limited Inc*, 9.

86 Goffman, *Presentation of Self*, 72. Phillip Manning, surveying the changes Goffman made before releasing this trade edition, bemoans a shift in Goffman's thinking. Goffman's edits served to "undermine . . . the view that we are all cynical actors performing instrumentally for personal gain." While Manning prefers this worldview, even he must admit Goffman never again believed or espoused it. Manning, *Erving Goffman and Modern Sociology*, 8.

87 Goffman, *Presentation of Self*, 21.

88 Ibid., 254.

89 Lowell, *Collected Prose*, 247.

90 Sexton, *No Evil Star*, 103.

91 Anne Sexton, interview by Richard Stern, *Just Published*, WGBH, January 12, 1967, R 0094, ASP-HRC.

92 Anne Sexton to Alice C. Parter, June 14, 1967, box 36, folder 4, ASP-HRC.

93 Sexton, *Complete Poems*, 485.

94 Perle Epstein and Shelley Neiderbach to Anne Sexton, November 26, 1964, box 33, folder 3, ASP-HRC.

95 Bob Abzug to Anne Sexton, November 7, 1973, box 17, folder 2, ASP-HRC.

96 Dr. Martha Brunner to Anne Sexton, March 8, 1974, box 18, folder 4, ASP-HRC; Anne Sexton to Dr. Martha Brunner, April 1, 1974, box 18, folder 4, ASP-HRC.

97 Anne Sexton to Courtney Haden, July 5, 1973, box 36, folder 4, ASP-HRC.

98 Sexton, "Reactions of an Author in Residence."

99 The terms "environmental theater" and "non-matrixed performance" were popularized in the pages of *TDR* by Richard Schechner and Michael Kirby, respectively.

100 Stanislavsky, *Stanislavsky on the Art of the Stage*, 32. Sexton's own copy can be found among her personal library, held by the Harry Ransom Center, University of Texas at Austin.

101 Anne Sexton to Philip Legler, September 11, 1966, box 22, folder 2, ASP-HRC. See also Anne Sexton, interview by Dr. Martin Orne, February 14, 1961, reel 5, APAS.

102 Anne Sexton, interview by Dr. Martin Orne, April 29, 1961, reel 18, APAS.

103 Sexton, *No Evil Star*, 114.

104 Ibid., 108.

105 Ibid., 17.

106 Sexton, "Untitled Talk on Poetry" (n.d.), box 16, folder 4, ASP-HRC.

107 Stanislavski, *Actor Prepares*, 176.

108 Strasberg and Schechner, "Working with Live Material," 122.

109 Rosenthal, *New Poets*, 67.

110 Anne Sexton to George Starbuck, December 18, 1962, box 28, folder 1, ASP-HRC.

111 Anne Sexton to Philip Legler, September 11, 1966, box 22, folder 2, ASP-HRC.

112 Sexton, *No Evil Star*, 17.

113 Anne Sexton to Carla Hartke, March 24, 1966, box 36, folder 4, ASP-HRC.

114 Sexton, *No Evil Star*, 33.

115 Stanislavsky, *Stanislavsky on the Art of the Stage*, 16.

116 Ibid., 35.

117 Stanislavski, *Actor Prepares*, 182.

118 Ibid., 191.

119 Ibid., 185.

120 Strasberg and Schechner, "Working with Live Material," 133.

121 Sexton, *Complete Poems*, 6–7.

122 Sexton, *Anne Sexton Reading Her Poems with Comment at the Fassett Recording Studio*; Sexton, *AS Reading Her Poetry*.

123 Sexton, *Anne Sexton Reads Her Poetry*.

124 Stanislavski, *Actor Prepares*, 295.

125 Sexton, *Complete Poems*, 9–11.

126 Sexton, *No Evil Star*, 16.

127 Middlebrook, *Anne Sexton*, 205.

128 Sexton, *Complete Poems*, 49–51.

129 Ibid., 133–35.

130 Ibid., 135–36.

131 Ibid., 42–46.

132 Culler, *Pursuit of Signs*, 135.

133 Sexton, *Complete Poems*, 35–42.

134 Gill, "Textual Confessions," 74.

135 Sexton, *Poetry of Anne Sexton*.

136 Jorie Hunken to Anne Sexton, 1974, box 34, folder 5, ASP-HRC.

137 Olson, *Human Universe*, 75.

138 Gray, interview by Schechner, 163; Gray, interview by Georgakas.

INTERLUDE: FEMINIST CONFESSIONS, 1959–1974

1 John Holmes to Anne Sexton, February 8, 1959, box 20, folder 6, ASP-HRC.
2 Anne Sexton to Wendy Owen, February 25, 1974, box 36, folder 4, ASP-HRC.
3 Friedan, *Feminine Mystique*, 62–63.
4 "Guide to Consciousness-Raising," 22.
5 Allen, *Free Space*; O'Connor, "Defining Reality," 7.
6 National Task Force on Consciousness Raising, Perl, and Abarbanell, *Guidelines*, 3.
7 Ibid., 4.
8 Willson, "Majority Report."
9 National Task Force on Consciousness Raising, Perl, and Abarbanell, *Guidelines*, 41.
10 Newton and Walton, "Personal Is Political," 113, 115.
11 For these earliest drafts, see box 9, folder 3; box 10, folder 1; and box 41, folder 1, ASP-HRC.
12 See the early full draft of *To Bedlam . . .* , where it appears under this title as that book's second poem: box 41, folder 3, ASP-HRC. For other drafts from this phase, see box 5, folder 4; box 7, folder 4; box 10, folder 1; and box 41, folders 1 and 4.
13 This round of drafts can be found in box 7, folder 4, ASP-HRC.
14 Anne Sexton to Tillie Olsen, October 2, 1965, box 24, folder 1, ASP-HRC.
15 See box 16, folder 5, ASP-HRC, which holds lecture materials for a course Sexton taught about her own poetry at Colgate University.
16 Sexton, *Anne Sexton Reads Her Poetry.*
17 Lowell, *Collected Poems*, xii.
18 Ibid.
19 Middlebrook, "What Was Confessional Poetry?," 644.
20 See box 54, items C1 and R1, EAP-GRI.
21 Antin, interview by Munro, 428.
22 Transcribed from an audio recording of a talkback about the performance: "Eleanor, 1954" (cassette), box 54, C2, EAP-GRI.
23 Ibid.
24 First quotation: ibid.; second quotation transcribed from an audio recording of the performance itself: "Ely, 1953" (2 cassettes), box 54, C1, EAP-GRI. All remaining quotations from the piece are transcribed from this latter recording.
25 Roth, "Toward a History of California Performance: Part Two," 122.
26 Antin, interview by Munro, 429.
27 "Eleanor, 1954" (cassette), box 54, C2, EAP-GRI.
28 Ibid.
29 Antin, interview by Munro, 428.
30 Ibid., 429.
31 Ibid.; Antin, "Re: Your 'Selves.'"
32 Antin, interview by Munro, 428.
33 Ibid., 429–30.
34 Ibid., 429.

35 Ibid.

36 Friedan, *Feminine Mystique*, 65.

37 Phelan, "Survey," 33.

38 Antin, *Radical Coherency*, 258.

39 Ibid., 262.

40 Muñoz, *Disidentifications*, 5, 170.

41 Antin, interview by Munro, 429.

CHAPTER 2. SELF-CONSCIOUSNESS RAISING

1 Crisp, *How to Have a Life-Style*, 8.

2 Montano, *Art in Everyday Life*, n.p.

3 "Since the Middle Ages, torture has accompanied [confession] like a shadow, and supported it when it could go no further: the dark twins." Foucault, *History of Sexuality*, 59.

4 Roth, "Amazing Decade," 18.

5 Piercy and Freeman, "Getting Together" (transcribed by Lynn Freeland from a pamphlet issued ca. 1972 by Cape Cod Women's Liberation).

6 "Consciousness Raising in Group Nine," n.p.

7 Forte, "Women's Performance Art," 253.

8 Phelan, "Reciting the Citation of Others," 14.

9 Reckitt, "Preface," 12.

10 Echols, *Daring to Be Bad*, 10.

11 Chicago and Schapiro, "Female Imagery," 40.

12 Wilding, "Feminist Art Programs," 34.

13 Tennov, "Open Rapping," 3.

14 Lichtman, "Sisterhood and the Small Group," n.p.

15 Pogrebin, "Rap Groups," 81.

16 Allen, *Free Space*, 18.

17 O'Connor, "Defining Reality," 3.

18 Walker, *Quick Rundown*, n.p.

19 Wilding, "Waiting," 215.

20 Raven, "Womanhouse," 58.

21 Ibid.

22 Demetrakas, Chicago, and Schapiro, *Womanhouse*.

23 I borrow the term from Gayatri Spivak, who famously worried about how to square the dilatory power of deconstruction with an urgent need for political action: "Since one cannot not be an essentialist, why not look at the ways in which one is essentialist, carve out a representative essentialist position, and then do politics according to the old rules whilst remembering the dangers in this?" Spivak, *Post-Colonial Critic*, 45.

24 Roth, "Amazing Decade," 86.

25 For a survey of this Great Goddess work, see ibid., 22–27. Roth is also eloquent on the unease this work stirred in some feminists of the time: why are we "celebrating

the Great Goddess," they might ask, "while the Equal Rights Amendment is in such jeopardy" (27)?

26 I borrow this phrase from Robert Lowell's description of the "raw" poetry practiced by the Beats. For my discussion of this phrase in its original context, see the section of Chapter 1 called "Secret Beatniks."

27 In this essay, you can see the language of masquerade (e.g., "caricature of femininity" and "masks of male attribution" [5]) giving way in real time to the language of drag. Roth, "Notes toward a Feminist Performance Aesthetic," 8.

28 Dolan, "Gender Impersonation Onstage," 10.

29 The relevant articles from this period in *Theatre Journal*'s history, including Butler's "Performative Acts and Gender Constitution," are collected in Case, *Performing Feminisms*.

30 The Gay Liberation Front, formed a month after the Stonewall Riots (i.e., July 1969), named their official magazine *Come Out!* As a point of comparison, the Redstockings, a New York–based women's liberation group, and one of the strongest early advocates for feminist CR, was founded in February of that same year.

31 Morrill, "Revamping the Gay Sensibility," 111.

32 Butler, *Gender Trouble*, 186.

33 Ibid., 23.

34 Butler has since softened this stance, most notably when reflecting on its implications for the trans community. In an interview with *TransAdvocate*, she explains, "*Gender Trouble* was written about 24 years ago, and at that time I did not think well enough about trans issues. . . . I think I needed to pay more attention to what people feel, how the primary experience of the body is registered, and the quite urgent and legitimate demand to have those aspects of sex recognized and supported. I did not mean to argue that gender is fluid and changeable (mine certainly is not). I only meant to say that we should all have great freedoms to define and pursue our lives without pathologization, de-realization, harassment, threats of violence, violence, and criminalization." Williams, "Gender Performance."

35 Taylor Mac, talkback after performance of *The Be(a)st of Taylor Mac*, Yale Repertory Theatre, New Haven, CT, January 29, 2010.

36 Mac goes on: "I just wanted [a pronoun] that would bring people joy when they said it, instead of frustration. It would bring them a certain discomfort, but a pleasing discomfort. So, that's primarily why I chose it. But also because I perform a lot in some kind of gender confluence, and people would always say 'he' when they talk about me, or they would say 'she,' and neither one of those felt right. So I felt like I needed to help people along, so they could understand what I'm doing outside of any kind of binary system." Mac and Kumar, "Taylor Mac Talks Gender."

37 Sontag, "Notes on Camp," 286. Indeed, Crisp observes that style "will tell [others] instantly who and what you are." Crisp, *How to Have a Life-Style*, 8.

38 Sontag, "Notes on Camp," 280.

39 Crisp, *An Evening with Quentin Crisp*.

40 Crisp, *How to Have a Life-Style*, 8.

41 Crisp, *An Evening with Quentin Crisp*.

42 Ibid.

43 Newton, *Mother Camp*, 35–36.

44 Ibid., 65.

45 Ibid., 104.

46 Ibid., 51.

47 Isherwood, *World in the Evening*, 110.

48 Core, "Camp," 80–81.

49 Harris, *Staging Femininities*, 52.

50 Montano, *Art in Everyday Life*, n.p.

51 Montano and Roth, "Matters of Life and Death," 6, 7.

52 Muñoz, "Ephemera as Evidence," 6.

53 Core, "Camp," 80.

54 Kleb, "Art Performance," 41.

55 Loeffler, "From the Body into Space," 380.

56 Montano, *Art in Everyday Life*, n.p.

57 Kino, "Rebel Form Gains Favor."

58 Phelan, *Unmarked*, 146.

59 I don't mean what Philip Auslander does when he says that performance documentation is "performative." He argues that documentation, beyond "describ[ing] an autonomous performance and stat[ing] that it occurred," actually "produces an event as a performance and, as Frazer Ward suggests, the performer as 'artist.'" Auslander, "Performativity of Performance Documentation," 5. I mean, instead, that the document is made to play a role in the artist's performance, as Antin's notarized contracts do in *4 Transactions*.

60 Phelan, *Unmarked*, 31, emphasis added.

61 Antin, interview by Munro, 427.

62 To list only one citation for each term, in order: Ollman, "Will the Real Eleanor Antin Stand Up? (And Take a Bow)," 1; Wark, "Conceptual Art and Feminism," passim; Antin, "Some Thoughts on Autobiography," 80; Jones, *Body Art/Performing the Subject*, 159; Gaulke, "Performance Art of the Woman's Building," 157; Messerli, "Role of Voice in Nonmodernist Fiction," 301; Kleb, "Art Performance," passim.

63 The Black Movie Star soon disappeared—first into blackface versions of the other three personae, and then, in a cloud of controversy, altogether. For the most thorough study of Antin's experiments in blackface, see Smith, *Enacting Others*, 79–134.

64 Antin, interview by Nemser, 273.

65 Introducing the film at a 1932 screening, Cocteau said, "Can you imagine the work involved in making a film? You arrive at dawn, the hour of the guillotine, and you go from studio to studio until midnight. . . . Sleeping on one's feet means talking without realizing it, confiding things. It means that you say things that you

wouldn't tell anyone. You open up. . . . This is why the film you are about to see is confessional. . . ." Cocteau, "Postscript," 64.

66 Ibid., 66; Milton, "Areopagitica," 930.
67 For a version of this standard reading, see Frueh, "Body through Women's Eyes," 195.
68 Sutinen, "Radical Realists." See box 31, folder 7, EAP-GRI.
69 Eleanor Antin, "Domestic Peace: An Exhibition of Drawings by Eleanor Antin," n.d., box 39, folder 2, EAP-GRI.
70 Antin, interview by Munro, 422.
71 Qtd. in Levin, "Eleanor Antin," 19.
72 Antin, "Dialogue with a Medium," 23.
73 "Eleanor Antin (Stefanotty)."
74 Antin, interview by Munro, 425.
75 Stanislavski, *Actor Prepares*, 46.
76 Ibid., 49.
77 Wark, "Conceptual Art and Feminism," 47.
78 Stanislavski, *Actor Prepares*, 47.
79 Erhard, "Way to Transformation."
80 Clarke, "Life/Art/Life," 135.
81 Crisp, *An Evening with Quentin Crisp.*
82 Antin, interview by Nemser, 288.
83 Davy, "Fe/male Impersonations," 113.
84 Senelick, *Changing Room*, 415.
85 Best, "Transformation," 56.
86 Ibid. The original text contains Best's unredacted Social Security number.
87 Best, "Octavia Goes Out for a Beer," 42; Best, "Octavia Goes Shopping in Her New Hair Color," 51.
88 Ibid.
89 Gornick, "Consciousness," 77.
90 Antin, interview by Rubinfien, 75.
91 Ibid., 76.
92 Lippard, *Six Years*, xi.
93 See, for instance, the 1975 exhibition *Lives: Artists Who Deal with Peoples' Lives (Including Their Own) . . .* , curated by Jeffrey Deitch at the Fine Arts Building in New York. "Lives" (flyer), box 25, folder 3, EAP GRI.
94 Antin, interview by Wilde.
95 As Laurie Anderson's star rose, Antin's friendly opposition to her (and her qualified praise for her performances) turned sour. Henry Sayre, for instance, recalls how Antin started "intentionally parodying Anderson" in certain New York performances. "How about some flashing lights?" she said, getting ready to play a song on a "musical 'machine' consisting of electric caterpillars, spiders, grasshoppers, bells, horns, and so on." "You might get a kick out of it," she cajoles, "I could

distort my voice." No New York audience at that time would miss the clear, caustic reference. Sayre, *Object of Performance*, 157.

96 In late 1977, for instance, he conceived of a piece (never performed) called *Self Portrait*, which would combine the as-is with the as-if—and the immediate performance with hypermediate art. At the center of *Self Portrait* would be "some representation of myself in the moment," but on either side would be mediated fact and fantasy: the facts of his past ("baby slides of me" and a recording of his grandmother's voice) and the fantasy of his future ("a fantasy film of me in a large home with family"). Every week or two, he would record another idea for such a solo. Spalding Gray, "Personal Journals, 1977–78," box 34, folder 4, SGP-HRC.

97 Spalding Gray, "Personal Journals, 1978," box 34, folder 5, SGP-HRC.

98 Ibid. (see entry for July 21, 1978).

99 Ibid. (see entry for July 8, 1978).

INTERLUDE: QUEER TALK, 1979–2010

1 Isherwood, "Of Youth, Frocks and Politics."

2 Qtd. in Alterman, *Creating Your Own Monologue*, 111.

3 Bottoms, "Solo Performance Drama," 521.

4 Ibid., 521–22.

CHAPTER 3. JUST TALK

1 Gray, *Journals of Spalding Gray*, 62.

2 Gray, *Swimming to Cambodia*, 27.

3 Rosenfeld, "Spalding Gray," B1.

4 Richards, "Spalding Gray, Talkmaster," B1.

5 Playbill, ephemera filed under *Spalding Gray: Stories Left to Tell*, Performing Arts Research Collection, New York Public Library for the Performing Arts, New York.

6 Schechner, "Decline and Fall of the (American) Avant-Garde," 11.

7 Ibid., 16.

8 Spalding Gray, Personal Journal (n.d., [1978?]), box 35, folder 1, SGP-HRC.

9 Gray, interview by Georgakas.

10 Gray, *Sex and Death*, n.p.

11 Spalding Gray, Personal Journals 1978–79 (see diary entry for July 28, 1979), box 35, folder 1, SGP-HRC.

12 Ibid. (see entry for July 29, 1979).

13 Ibid. (see entry for August 8, 1979).

14 Ibid. (see entries for October 23, 1979, and October 4, 1979).

15 Ibid. (see entry for November 5, 1979).

16 Spalding Gray, Personal Journals 1980 (see diary entry for March 9, 1980), box 35, folder 4, SGP-HRC.

17 Ibid. (see entries for March 5, February 10, and March 14, 1980).

18 Ibid. (see entry for March 17, 1980).

19 Spalding Gray, Personal Journals 1980 (n.d. [after August 1980]), box 35, folder 3, SGP-HRC.

20 Gussow, "Stage," 4.

21 Gussow, "Theater: 'Sex and Death,'" 15.

22 Rosenfeld, "Spalding Gray," B32–33.

23 Brown, "Spalding Gray, Talkmaster," 36.

24 Blau, *Eye of Prey*, 164.

25 Bidart, interview and classroom discussion.

26 Gray, *Swimming to Cambodia*, 133.

27 Lowell, *Collected Poems*, 591.

28 Korins, interview.

29 Ibid.

30 See ephemera filed under *Spalding Gray: Stories Left to Tell*, Performing Arts Research Collection, New York Public Library for the Performing Arts, New York.

31 Nelson, "Spalding Gray."

32 Simonson, "Spalding Gray," 166.

33 Bacalzo, "Spalding Gray."

34 Singer, "Shades of Gray," 34.

35 Qtd. in Alterman, *Creating Your Own Monologue*, 111.

36 Singer, "Shades of Gray," 35.

37 Gray, Russo, and Sexton, *Spalding Gray*, 66.

38 Brantley, "Master of Monologues," 7.

39 Gray, *Life Interrupted*, 17–18.

40 Guillory, "Genesis of the Media Concept," 357.

41 Gray, *Life Interrupted*, 165.

42 Gray, interview by Schechner, 162.

43 Ibid., 163.

44 See, for example, his reading of the *Life Studies* poem "Memories of West Street and Lepke" on Lowell, *Robert Lowell: A Reading*.

45 Gray, interview by Schechner, 161.

46 Demastes, *Spalding Gray's America*, xiv; Phelan, "Spalding Gray's Swimming to Cambodia," 27–28. Phelan's argument here can be difficult to pin down. Ultimately, she sees both a kind of earnestness and a sort of irony in Gray's work, but they do not mingle for her. To her mind, Gray's earnestness is reduced to naïve desires for "oneness" with everything (28), and his irony is a "blanket irony" that he "affects" simply in order to "minimize [the] risk" of being "boring" (29). "Gray's work," she concludes, "manipulates the spectator into feeling either empathic sympathy or profound impassiveness. These are the only choices" (29). I am suggesting that there may not be a choice to be made, but rather a tension to be sustained.

47 Savran, *Breaking the Rules*, 102.

48 Ibid., 104.

49 Sterritt, "Adventures Way Off Broadway," 18.

50 Bottoms, "Solo Performance Drama," 522.

51 Shewey, "Performing Artistry of Laurie Anderson," 27.

52 Rockwell, "Laurie Anderson Grows as a Performance Artist," 14.

53 Gussow, "Spalding Gray as Storyteller," 3.

54 Savran, *Breaking the Rules*, 108.

55 Gray, *Sex and Death*, 125, 134.

56 Ibid., 93.

57 Ibid., 157, 177, 177–78, 194.

58 Ibid., 58.

59 Savran, *Breaking the Rules*, 162, 176.

60 Gray, *47 Beds*.

61 Carroll, "Performance," 78.

62 Savran, *Breaking the Rules*, 201.

63 Ibid., 197.

64 Klinkenborg, "Appreciations," 26.

65 Gray, *Sex and Death*, 81.

66 Ibid., 58–59. Cf. *Sounds of the Annual International Sports Car Grand Prix of Watkins Glen, N.Y.*

67 Lowell, *Collected Prose*, 243.

68 Bernstein, "Dances with Things," 69.

69 For a fuller account of this phenomenon and of its implications for the history and theory of reading, see Grobe, "On Book."

70 Savran, *Breaking the Rules*, 74. The precise language is Savran's, but see also Demastes, *Spalding Gray's America*: "What winds up happening is that the dictionary meanings of the words take a back seat and are replaced by our own memories of what those words inspired Gray to say" (71).

71 Gray, *India and After (America)*.

72 Savran, *Breaking the Rules*, 72.

73 Ibid., 73.

74 Gray, *India and After (America)*.

75 Johnson, "Johnson, Preface to the Dictionary."

76 Gray, *Sex and Death*, 159.

77 Watts, *Psychotherapy East and West*, 20.

78 Gray, *Sex and Death*, xiii.

79 Ibid., 81.

80 Gussow, "Theater: Spalding Gray's '47 Beds,'" 21.

81 Jung, *Memories, Dreams, Reflections*, 195.

82 Ibid., 196.

83 Jung, *Mandala Symbolism*, 5.

84 Ibid., 3, emphasis added.

85 Gray, *Sex and Death*, 87.

86 Ibid., 88.

87 Ibid.

88 Hinz, "Mimesis," 199.
89 Rousseau, *Confessions*, 3.
90 Brown, "Spalding Gray, Talkmaster," 9.
91 Goffman, *Forms of Talk*, 4.
92 Ibid., 160.
93 Ibid., 175.
94 Ibid., 183.
95 Ibid., 177, 191.
96 Ibid., 194.
97 Ibid., 175.

INTERLUDE: BROADCAST INTIMACY; OR, CONFESSION
GOES ON TOUR
1 Warner, "Publics and Counterpublics," 82.
2 Ibid., 50.
3 Ibid.
4 Anne Sexton, "Lecture Five," in "Lecture materials for Colgate University . . . ," box 16, folder 5, ASP-HRC.
5 Sexton, *No Evil Star*, 38.
6 Sexton, *Anne Sexton: A Self-Portrait*, 159.
7 Bill Dalton to Anne Sexton, July 10, 1973, box 34, folder 4, ASP-HRC.
8 Anne Sexton to Noreen Ayres, December 28, 1972, box 36, folder 4, ASP-HRC.
9 Anne Sexton to William Vassilopoulos, July 8, 1974, box 36, folder 4, ASP-HRC.
10 Anne Sexton, "Form #4: Letters to Mad Poets I Want to Get Rid Of," July 10, 1974, box 33, folder 1, ASP-HRC.
11 Gray, interview by Schechner, 169.
12 Soderbergh, *And Everything Is Going Fine*, qtd. in Smalec, "And Everything Is Going Fine."
13 There is "a pattern [Gray] follows with almost every interviewee . . .—the topic turns out to be him, as he begins to discuss his therapist and the audience member actually asks him a few questions." But Peterson also calls this monologue in a larger sense: "a monologue of theatrical power, a ritual thrashing of the audience's sacrificial representative." Peterson, *Straight White Male*, 61, 65.
14 National Task Force on Consciousness Raising, Perl, and Abarbanell, *Guidelines*, 37ff.
15 Gray, *Journals of Spalding Gray*, 280.
16 Plato, *Six Great Dialogues*, 176.
17 Plato, *The Symposium*, 57.
18 Gray, "Alive Interview," 21. In *Travels through New England*, Gray's monologue about a tour performing *Interviewing the Audience*, his hosts and audiences are constantly referring to him as Spalding Gray "the world-renowned talk-show host." Gray, *Sex and Death*, 169, 171, 175, 178.
19 Chaikin, *Presence of the Actor*, 69.

20 Gray, interview by Schechner, 169. Michael Peterson, describing his own experience seeing *Interviewing* in 1992, corroborates the detail (Peterson, *Straight White Male*, 60). This is no surprise, since *Interviewing* began as a piece called *What Happened on the Way Here*, where Gray would work with Ron Vawter to interview audience members. Smalec, "Scenes of Self-Recruitment," 32.

21 Gray, *Sex and Death*, 171–72, 181.

22 Miller, "Battle of Chattanooga," 91.

23 Ibid., 94–95.

24 Warner, "Publics and Counterpublics," 62.

25 Roach, "Public Intimacy." See also Roach, *It*.

26 Rojek, *Celebrity*, 19.

27 Inglis, *Short History of Celebrity*, 32.

CHAPTER 4. BROADCAST YOURSELF

1 Saade and Borgenicht, *Reality TV Handbook*, 10.

2 The phrase "inverted Method acting" is Spalding Gray's, featured in Soderbergh, *And Everything Is Going Fine*.

3 Williams, *Television*, 55–56.

4 In an "Afterword" later appended to the essay, Corner clarifies: "For me, such 'performance of the real' was questionable, its self-conscious and often mannered display to camera an element of the 'commodity real' within the new framework of 'reality-as-entertainment.'" Corner, "Performing the Real," 61–62.

5 Ibid., 53.

6 Deery, *Reality TV*, 2.

7 Skeggs and Wood, *Reacting to Reality Television*, 222, 220.

8 Kavka, *Reality TV*, 92, 94.

9 Couldry, "Teaching Us to Fake It," 90; Andrejevic, *Reality TV*, 104.

10 Corner, "Performing the Real," 46.

11 Ibid., 53–54.

12 Ouellette and Murray, "Introduction," 4–5.

13 Edwards, *Triumph of Reality TV*, 56.

14 Dubrofsky, "Therapeutics of the Self," 271.

15 Andrejevic, *Reality TV*, 121.

16 Aslama and Pantti, "Talking Alone," 178, 181, 175.

17 Dovey, *Freakshow*, 73. For extensive analysis of the way talk shows channeled therapeutic discourse in the years leading up to reality TV, see White, *Tele-Advising*. For more of the same, plus a special focus on the relationship between daytime talk shows and feminist consciousness raising, see Shattuc, *Talking Cure*, 128ff.

18 This is what Misha Kavka means when she observes, "Documentary, and attendant concerns of authenticity, belong more strongly to the British televisual context." Kavka, *Reality TV*, 50.

19 Couldry, "Teaching Us to Fake It," 87.

20 See, for instance, Kraidy and Sender, *Politics of Reality Television*; Hetsroni, *Reality Television*; Oren and Shahaf, *Global Television Formats*.

21 For Kavka's thoughts on the rise of the (British) docusoap, see Kavka, *Reality TV*, 60ff.

22 Ibid., 83. In a particularly baffling moment, Kavka even claims, "The live-in camera went into hibernation after 1992, not to be reawakened until the arrival of the *Big Brother* juggernaut at the end of the decade." Ibid., 44. The live-in cameras of *The Real World*, in fact, started airing precisely in 1992, the year they supposedly went dormant.

23 Deery, *Reality TV*, 49–50. Corner qtd. in Hill, *Reality TV*, 26.

24 Producers were the first to compare the program to Biosphere 2, and the press repeated the idea. Norman Korpi, a member of *The Real World*'s debut cast, first encountered the production team not as a would-be participant but as a potential landlord. When MTV approached him to inquire about renting a loft he co-owned in Brooklyn, they made the following pitch: "We want to do this Biosphere kind of project, where we put people in a space and then we're going to videotape it and put it on MTV." Johnson and Rommelmann, *Real Real World*, 25. An early article on the program in the *New York Times* either parroted the comparison or arrived at it independently, calling *The Real World* "MTV's version of Biosphere 2" and a "melding of *Beverly Hills, 90210* and Biosphere 2," referring to the contemporary teen soap opera on Fox (1990–2000). Kleinfield, "Barefoot in the Loft," 33.

25 Kleinfield, "Barefoot in the Loft," 42.

26 O'Connor, "MTV's Low-Cost Way of Business," 22; Lyall, "London Living," 25.

27 Anna McCarthy argues that "reality TV" (which she defines capaciously to include early shows like *Candid Camera*) has deep and reciprocal ties to experiments in social science. McCarthy, "'Stanley Milgram, Allen Funt, and Me.'" Jon Dovey, in a similar move, calls reality TV a form of "simulation," akin to "computer simulations" or mathematical models that produce "real knowledge about real things in the real world and [have] real effects upon real lives." Dovey, "It's Only a Game Show," 233.

28 See, for example, Schroeder, "'Sexual Racism' and Reality Television"; Kraszewski, "Country Hicks and Urban Cliques"; Andrejevic and Colby, "Racism and Reality TV."

29 Pullen, *Documenting Gay Men*, 116–38 and passim; Muñoz, *Disidentifications*, 143–60.

30 *Real World Intros*.

31 Butler, *Television Style*, 15.

32 Ibid., 46.

33 The cast member in question, Becky Blasband, comments on the film in one fan book: "When I got to LA, I did extra work on the Ben Stiller show. He was fascinated by *The Real World* and talked a lot about doing a skit where I'd play myself, but we never did. When *Reality Bites* came out, which Ben Stiller wrote [*sic*; in fact, he directed it], Norman [Korpi, a *Real World* cast mate] called me up

and said, 'You're going to be really mad because it's about you. It's you exactly.'"
Johnson and Rommelmann, *Real Real World*, 15.

34 And yet even this much resemblance—the presentation of their lives in weekly
installments—distanced *An American Family* from traditional documentary as
much as from TV drama. As Jeffrey Ruoff explains, "Although serial structure had
been used on American television for many years, it was unusual for documen-
tary at the time." Ruoff, *An American Family*, xxiii.

35 Williams, *Television*, 70–72.

36 Mead, "As Significant as the Invention of Drama or the Novel," 21.

37 Dubrofsky, "Therapeutics of the Self," 272.

38 Dreifus, *Woman's Fate*, 18.

39 Mead, "As Significant as the Invention of Drama or the Novel," 21–22.

40 Ibid., 22.

41 According to Amy Villarejo, *An American Family* may even, in turn, have pro-
voked confessional outpourings from its viewers. The queer performance of Lance
Loud, one of the family's sons, "may have actually inspired the gay movement's
new political rallying cry: come out," she conjectures. Villarejo, *Ethereal Queer*,
24. Of course, the timing is not quite right, since the cry to "come out" predates
An American Family by many years, but Villarejo is hardly the only one to treat
Lance Loud's performance on the program as a pivotal moment in queer visibility.
Erika Suderburg, for instance, argues that "for millions of Americans" Lance
"became 'the first queer.'" Suderburg, "Real/Young/TV Queer," 49.

42 Kleinfield, "Barefoot in the Loft," 33.

43 O'Connor, "'The Real World,' According to MTV," 15.

44 Ibid., 22.

45 Lyall, "London Living," 25.

46 Bunim and Murray, "Introduction," 5.

47 Corner, "Performing the Real," 51.

48 Edwards, *Triumph of Reality TV*, 77.

49 This technique may arise from the need to internally edit these interviews—an
effect much easier to accomplish in voiceover than in synchronous sound and
video, where the cuts would be jarringly visible.

50 "My neck itches," Elswit confesses, "when I hear the uninterrogated maneuver of
using terminology for speech ('talking,' 'saying,' e.g., 'the dance talks about . . .') in
relation to a series of movements that can obviously say very little without verbal
supplement." Elswit, "*So You Think You Can Dance* Does Dance Studies," 139.

51 Dovey, *Freakshow*, 110.

52 Williams, *Television*, 71.

53 Ruoff, *An American Family*, xxv.

54 Williams, *Television*, 72. Ouellette and Murray, for instance, identify "rapid editing
techniques" as one of the four essential features of reality TV, as modeled by *The
Real World*. Ouellette and Murray, "Introduction," 5.

55 Podhoretz, "'Survivor' and the End of Television," 51.

56 Jonathan Murray, a former producer of short TV news documentaries, must have been familiar with the technology already. This would make him rare among TV producers beyond the news. The first edition of Michael Rubin's seminal hand-book on nonlinear editing had been published only in 1991, and the book seems to presume a wide readership of editors who were still unaware of such technology. Rubin, *Nonlinear.*

57 For information on the editing of *An American Family*, see Ruoff, *An American Family*, 40. The *Real World* figures are widely reported, but cited here from a statement by editorial director Oskar Dektyar. Johnson and Rommelmann, *Real Real World*, 149. He claims that episodes are twenty-four minutes long, but in the first season, at least, they run only twenty-two.

58 O'Connor, "A Soap Opera," 11; O'Connor, "'The Real World,' According to MTV," 15.

59 Johnson and Rommelmann, *Real Real World*, 149, emphasis added.

60 Ibid., 147.

61 Dovey, *Freakshow*, 61.

62 Pullen, *Documenting Gay Men*, 10.

63 Mead, "As Significant as the Invention of Drama or the Novel," 23.

64 Stiller, *Reality Bites.*

65 O'Connor, "MTV's Low-Cost Way of Business," 22.

66 Qtd. in Andrejevic, *Reality TV*, 11.

67 Qtd. in Halbert, "Who Owns Your Personality," 45.

68 Ibid.

69 Qtd. in ibid.

70 The efforts of reality TV producers to separate truth and performance from one another—whether by presuming that the performance is a fiction (à la *Survivor*) or by protesting that the truth needn't be performed (à la *The Real World*)—have been bolstered by a scholarly discourse on the genre that also accepts this separation as a given. Annette Hill, for instance, a British scholar doing sociological analyses of television viewers, asks the subjects she interviews to apply what she calls a "truth/performance rating" to various kinds of factual programming, including reality TV—as in, "Is it true, or is it just a performance?" Hill, *Restyling Factual TV*, 28 and passim. Although she acknowledges in her introduction to this book-length study that "[t]here is factual content that is real and at the same time performed. . . . And there is factual content that is . . . performed in such a way it loses its hold on reality," this doesn't stop her from encouraging her subjects to treat truth and performance as polar opposites. Ibid., 18. I proceed on a different assumption: that the truth, insofar as it exists, must of course be performed, and that the aesthetics of this performance can have consequences far beyond the realm of reality TV.

71 "Real World Is Now Accepting Casting Tapes."

72 McCarty, interview.

73 Bunim and Murray, "Introduction," 5.

74 Grossman, "Power to the People," 44.

75 Cloud, "YouTube Gurus," 70.
76 Corner, "Interview as Social Encounter," 40.
77 Morris, "Eye Contact."
78 *The Fog of War—Trailer.*
79 Morris, "Eye Contact."
80 Ibid.
81 Freud, *General Introduction to Psychoanalysis,* 384.
82 Eggers, *Heartbreaking Work,* 183.
83 Ibid.
84 Ibid., 183–84.
85 Ibid., 184.
86 Jonathan Murray qtd. in Kavka, *Reality Television, Affect and Intimacy,* 81.
87 Bunim and Murray, "Introduction," 5.
88 John Corner qtd. in Kilborn, *Staging the Real,* 102.
89 Ibid., 61.
90 Johnson and Rommelmann, *Real Real World,* 23.
91 Two of them even profess an interest in performance art. Becky observes, "Norman and I decided to turn the experience [of being on *The Real World*] into a Warhol event," before confessing, "Part of me wants to be a wacky performance artist, go seriously underground." Ibid., 14–15.
92 Reid, *Rhetoric of Reality Television,* 41.
93 Solomon, *Real World,* 248.
94 Eggers, *Heartbreaking Work,* 205.
95 Ibid., 235.
96 Ibid., 209.
97 Ibid., 239.
98 Ibid., 115.
99 Ibid., 196.
100 Ibid., 200.
101 Bunim and Murray, "Introduction," 4.
102 Johnson and Rommelmann, *Real Real World.*
103 Solomon, *Real World.*
104 Friedman, "Prime-Time Fiction," 275.
105 Andrejevic, "When Everyone Has Their Own Reality Show," 42.
106 Ibid., 43.
107 Bunim and Murray, "Introduction," 5.
108 Eggers, *Heartbreaking Work,* x–xi.
109 Ibid., xvii.
110 Zarin, keynote address.
111 James, *Art of the Novel,* 5.
112 Woloch, *One vs. the Many,* 13.
113 Ibid., 44.
114 Holmes, "'The Viewers Have . . . Taken over the Airwaves?,'" 18.

CODA: CONFESSION IN THE AGE OF AGGREGATION

1 Braudy, *Frenzy of Renown*, 6.
2 Umbrico, "Statements 31."
3 Senft, *Camgirls*, 25ff.; Bauman and Lyon, *Liquid Surveillance*, 54.
4 See Roach, "Public Intimacy." There are, of course, social media stars—people whose celebrity begins on MySpace or YouTube or Twitter—but until they are given the imprimatur of older media (e.g., offered a record deal, a book contract, a TV show) these "stars" are no different from other users—or different in degree rather than in kind. All are engaged in crafting a public personality for themselves, creating a star image for themselves, something "extensive, multimedia, intertextual." Dyer, *Heavenly Bodies*, 3. "Avatars" we call such online surrogates, using the Hindu word for a god's earthly form. If, as Leo Braudy, Joseph Roach, and so many others have said, a celebrity can incite quasi-religious feelings in the public, then our "avatars" have turned us all into minor celebrities—that is, into local gods.
5 LeFever and LeFever, *Twitter in Plain English*.
6 Though the site remains active at www.wefeelfine.org, it is now a mere shadow of its former self. The data gathering behind the site has grown spotty. As of early 2015, no data at all had been collected since mid-2013. As of mid-2016, the interactive portion of the website, powered by JavaScript, no longer meets Java's minimum security requirements, and is therefore unavailable to the casual user. Information on the site, though, can currently be found on Jonathan Harris's website: http://number27.org/wefeelfine. A version of the website also resides in the permanent collection of the Museum of Modern Art in New York.
7 Kamvar and Harris, "Movements."
8 Ibid.
9 Bauman and Lyon, *Liquid Surveillance*, 54.
10 Berners-Lee, *Weaving the Web*, 158.
11 Umbrico, "Statements 31."
12 Umbrico, "Suns from Flickr, Artist's Statement."
13 Albers, "Abundant Images and the Collective Sublime."
14 Ibid.
15 Labey and Bick, "Digital Sublime," 94.
16 Umbrico, *Penelope Umbrico: Photographs*, n.p.
17 Umbrico, "Sunset Portraits, Artist's Statement."
18 Paleari, "Day with Penelope Umbrico," 190.
19 Kracauer, "Mass Ornament."
20 Qtd. in Witte, Correll, and Zipes, "Introduction," 63–64.
21 Kane, "Dancing Machines."
22 Baron, "Subverted Intentions," 36.
23 Stimson, "Out in Public."
24 Ibid.

25 Bookchin, *Laid Off*.

26 Daalder, "Amherst College Students."

27 "Timeline"; Ahn, "Students Hold Sit-In," 1; Hartocollis, "With Diversity Comes Intensity."

28 Daalder, "Amherst College Students."

29 Ahn, "Students Hold Sit-In," 1.

30 Lichtman, "Sisterhood and the Small Group," n.p.

31 Pogrebin, "Rap Groups," 81.

32 See the section of Chapter 2 titled "The Personal and the Political."

33 Tennov, "Open Rapping," 3.

34 Hsu, "Year of the Imaginary College Student."

35 For a collection of OWS memes, see http://wearethe99percent.tumblr.com. For a sample of antirape activist memes, in this case from activists at my own home institution, see http://acvoice.com/2012/10/23/surviving-at-amherst-college.

36 Pérez-Peña and Taylor, "Fight Against Sexual Assaults"; Sulkowicz, "'My Rapist Is Still on Campus.'"

37 Beusman, "Columbia Students Drag Mattresses."

38 Ryan, "Columbia Rape Protesters Pay Fine."

39 Shaw, "12 Photos"; Lee, "CA Cheerleader Protests Rape Case."

40 This particular mattress, created and displayed during rallies at Connecticut College, is pictured here: Shaw, "12 Photos."

41 Saltz, "19 Best Art Shows of 2014."

42 Rancière, *Emancipated Spectator*, 105.

BIBLIOGRAPHY

Ahn, Dan. "Students Hold Sit-In." *Amherst Student*, November 18, 2015.

Albers, Kate Palmer. "Abundant Images and the Collective Sublime." *Circulation | Exchange*, October 1, 2013. Accessed May 14, 2016. circulationexchange.org.

Alder, Ken. *The Lie Detectors: The History of an American Obsession*. Lincoln: University of Nebraska Press, 2009.

Allen, Pam. *Free Space: A Perspective on the Small Group in Women's Liberation*. Albany, CA: Women's Liberation Basement Press, 1970.

Allison, Raphael. *Bodies on the Line: Performance and the Sixties Poetry Reading*. Iowa City: University of Iowa Press, 2014.

Alterman, Glenn. *Creating Your Own Monologue*. New York: Allworth Press, 1999.

Alvarez, A. "Sylvia Plath: A Memoir." In *Ariel Ascending: Writings about Sylvia Plath*, edited by Paul Alexander, 185–213. New York: Harper & Row, 1985.

Andrejevic, Mark. *Reality TV: The Work of Being Watched*. Lanham, MD: Rowman & Littlefield, 2003.

——. "When Everyone Has Their Own Reality Show." In *A Companion to Reality Television*, edited by Laurie Ouellette, 40–56. Malden, MA: Wiley-Blackwell, 2014.

Andrejevic, Mark, and Dean Colby. "Racism and Reality TV: The Case of MTV's Road Rules." In Escoffery, *How Real Is Reality TV?*, 195–211.

Antin, David. *Radical Coherency: Selected Essays on Art and Literature, 1966 to 2005*. Chicago: University of Chicago Press, 2011.

Antin, Eleanor. "Dialogue with a Medium." *Art-Rite*, no. 7 (1974): 23–24.

——. Interview by Cindy Nemser. In Nemser, *Art Talk: Conversations with 12 Women Artists, 1966–2005*, 267–302. New York: Charles Scribner's Sons, 1975.

——. Interview by Denice Wilde, April 22, 1976. Box 24, folder 24. Eleanor Antin Papers, Getty Research Institute, Los Angeles.

——. Interview by Eleanor Munro. In Munro, *Originals: American Women Artists*, 417–30. New York: Simon & Schuster, 1979.

——. Interview by Leo Rubinfien. "Through Western Eyes." *Art in America*, October 1978.

——. "Re: Your 'Selves.'" E-mail to the Author. July 27, 2014.

——. "Some Thoughts on Autobiography." *Sun & Moon*, nos. 6/7 (Winter 1979): 80–82.

Armstrong, Chloe, and Paul D. Brandes. *The Oral Interpretation of Literature*. New York: McGraw-Hill, 1963.

Aslama, Minna, and Mervi Pantti. "Talking Alone: Reality TV, Emotions and Authenticity." *European Journal of Cultural Studies* 9, no. 2 (May 2006): 167–84.

Auslander, Philip. "The Performativity of Performance Documentation." *PAJ: A Journal of Performance and Art* 28, no. 3 (September 1, 2006): 1–10.

Austin, J. L. *How to Do Things with Words*. Cambridge, MA: Harvard University Press, 1962.

Bacalzo, Dan. "Spalding Gray: Stories Left to Tell." *Theatermania*, March 7, 2007. Accessed June 14, 2017. www.theatermania.com.

Baker, Liva. *Miranda: Crime, Law and Politics*. New York: Atheneum, 1983.

Baldwin, James. *The Price of the Ticket: Collected Nonfiction, 1948–1985*. New York: Macmillan, 1985.

Ball, Gordon. *East Hill Farm: Seasons with Allen Ginsberg*. Berkeley, CA: Counterpoint Press, 2011.

Baron, Jaimie. "Subverted Intentions and the Potential for 'Found' Collectivity in Natalie Bookchin's *Mass Ornament*." *Maska* 26, nos. 143–44 (Winter 2011): 303–14.

Bauman, Zygmunt, and David Lyon. *Liquid Surveillance: A Conversation*. Malden, MA: Polity, 2012.

Belgrad, Daniel. *The Culture of Spontaneity: Improvisation and the Arts in Postwar America*. Chicago: University of Chicago Press, 1999.

Berners-Lee, Tim. *Weaving the Web: The Original Design and Ultimate Destiny of the World Wide Web*. San Francisco: HarperBusiness, 2000.

Bernstein, Charles, ed. *Close Listening: Poetry and the Performed Word*. New York: Oxford University Press, 1998.

———. "Introduction." In Bernstein, *Close Listening*, 3–26.

Bernstein, Robin. "Dances with Things: Material Culture and the Performance of Race." *Social Text* 27, no. 4 (December 2009): 67–94.

Berton, Pierre. *Voices from the Sixties: Twenty-Two Views of a Revolutionary Decade*. 1st US ed. Garden City, NY: Doubleday, 1967.

Best, Paul. "Octavia Goes Out for a Beer." *High Performance* 2, no. 3 (September 1979): 42–43.

———. "Octavia Goes Shopping in Her New Hair Color." *High Performance* 2, no. 1 (March 1979): 50–51.

———. "Transformation." *High Performance* 3, no. 2 (Summer 1980): 56.

Beusman, Callie. "Columbia Students Drag Mattresses onto Campus to Support Rape Survivor." *Jezebel*, September 12, 2014. Accessed July 2, 2016. www.jezebel.com.

Bidart, Frank. Interview and classroom discussion. Yale University, New Haven, CT, November 13, 2006.

Bigsby, C. W. E. *A Critical Introduction to Twentieth-Century American Drama: Volume 3, Beyond Broadway*. Cambridge: Cambridge University Press, 1985.

Bishop, Elizabeth, and Robert Lowell. *Words in Air: The Complete Correspondence between Elizabeth Bishop and Robert Lowell*. Edited by Thomas Travisano and Saskia Hamilton. New York: Farrar, Straus and Giroux, 2010.

Blasing, Mutlu Konuk. *Lyric Poetry: The Pain and the Pleasure of Words*. Princeton, NJ: Princeton University Press, 2009.

Blau, Herbert. *The Eye of Prey: Subversions of the Postmodern*. Bloomington: Indiana University Press, 1987.

Blum, Michael. *Richard Pryor: Live & Smokin'*. MPI Home Video, 2001.

Bolter, Jay David, and Richard Grusin. *Remediation: Understanding New Media*. Cambridge, MA: MIT Press, 2000.

Bookchin, Natalie. *Laid Off*. 2009. www.vimeo.com/19364123.

Bottoms, Stephen J. "Solo Performance Drama: Self as Other?" In *Companion to Twentieth-Century American Drama*, edited by David Krasner, 519–34. Malden, MA: Blackwell, 2005.

Brantley, Ben. "A Master of Monologues, Living On in His Words." *New York Times*, March 7, 2007, sec. E.

Braudy, Leo. *The Frenzy of Renown: Fame and Its History*. Oxford: Oxford University Press, 1986.

"Breakthrough?" *Time*, May 22, 1950.

"Breakthrough in Molybdenum." *Time*, January 26, 1959.

Brooks, Peter. *Troubling Confessions: Speaking Guilt in Law and Literature*. Chicago: University of Chicago Press, 2001.

Broude, Norma, and Mary D. Garrard, eds. *The Power of Feminist Art: The American Movement of the 1970s, History and Impact*. New York: Harry N. Abrams, 1994.

Brown, Joe. "Spalding Gray, Talkmaster." *Washington Post*, April 19, 1985, sec. Theater/ Dance.

Bruce, Lenny. *I Am Not a Nut, Elect Me!* LP. Berkeley, CA: Fantasy, 1960.

———. *The Sick Humor of Lenny Bruce*. LP. Berkeley, CA: Fantasy, 1959.

Bryant, Marsha. "The Confessional Other: Identity, Form, and Origins in Confessional Poetry." In *Identity and Form in Contemporary Literature*, edited by Ana María Sánchez-Arce, 177–94. New York: Routledge, 2013.

Bunim, Mary-Ellis, and Jonathan Murray. "Introduction." In *The Real World Diaries*, edited by Amy Keyishian and Sarah Malarkey, 4–5. New York: MTV Books, 1996.

Butler, Jeremy. *Television Style*. New York: Routledge, 2010.

Butler, Judith. *Gender Trouble: Feminism and the Subversion of Identity*. 2nd ed. New York: Routledge, 2006.

Carroll, Noël. "Performance." *Formations* 3, no. 1 (Spring 1986): 63–79.

Case, Sue-Ellen, ed. *Performing Feminisms: Feminist Critical Theory and Theatre*. Baltimore: Johns Hopkins University Press, 1990.

Chaikin, Joseph. *The Presence of the Actor*. New York: Theatre Communications Group, 1993.

Chicago, Judy, and Miriam Schapiro. "Female Imagery." In *The Feminism and Visual Culture Reader*, edited by Amelia Jones, 40–43. New York: Routledge, 2003.

Clarke, John R. "Life/Art/Life, Quentin Crisp and Eleanor Antin: Notes on Performance in the Seventies." *Arts Magazine*, no. 53 (February 1979): 131–35.

Cloud, John. "The YouTube Gurus." *Time*, December 25, 2006.

Cocteau, Jean. "Postscript." In *Two Screenplays*, translated by Carol Martin-Sperry, 61–67. New York: Orion Press, 1968.

"Cold War Breakthrough." *Time*, September 30, 1957.

Collins, Billy. "My Grandfather's Tackle Box." In Sontag and Graham, *After Confession*, 81–86.

"Consciousness Raising in Group Nine—Criticisms and Comments." n.d. Box 33, folder 562, location 14D. Noel Phyllis Birkby Papers, Sophia Smith Collection, Smith College, Northampton, MA.

Core, Philip. "Camp: The Lie That Tells the Truth." In *Camp: Queer Aesthetics and the Performing Subject*, edited by Fabio Cleto, 80–86. Ann Arbor: University of Michigan Press, 1999.

Corner, John. "The Interview as Social Encounter." In *Broadcast Talk*, edited by Paddy Scannell, 31–47. London: SAGE, 1991.

———. "Performing the Real: Documentary Diversions." In Murray and Ouellette, *Reality TV*, 44–64.

Couldry, Nick. "Teaching Us to Fake It: The Ritualized Norms of Television's 'Reality' Games." In Murray and Ouellette, *Reality TV*, 82–99.

Crisp, Quentin. *An Evening with Quentin Crisp*. LP. Port Washington, NY: DRG Records, 1979.

———. *How to Have a Life-Style*. New York: Methuen, 1979.

Culler, Jonathan. *The Pursuit of Signs*. Ithaca, NY: Cornell University Press, 1981.

Culombe v. Connecticut, 367 US 568 (1961).

Daalder, Marc. "Amherst College Students Are Occupying Their Library Right Now over Racial Justice Demands." *In These Times*, November 14, 2015. www.inthesetimes.com.

Daube, Matthew. "Laughter in Revolt: Race, Ethnicity, and Identity in the Construction of Stand-Up Comedy." PhD dissertation, Stanford University, 2010.

Davison, Peter. *The Fading Smile: Poets in Boston, 1955–1960 from Robert Frost to Robert Lowell to Sylvia Plath*. New York: Knopf, 1994.

Davy, Kate. "Fe/male Impersonations: The Discourse of Camp." In Meyer, *Politics and Poetics of Camp*, 111–27.

Deery, June. *Reality TV*. Malden, MA: Polity Press, 2015.

de Man, Paul. "Autobiography as De-Facement." *MLN* 94, no. 5 (December 1979): 919–30.

Demastes, William. *Spalding Gray's America*. New York: Limelight Editions, 2008.

Demetrakas, Johanna, Judy Chicago, and Miriam Schapiro. *Womanhouse*. DVD. New York: Women Make Movies, 2006.

Derrida, Jacques. *Limited Inc.* Edited by Gerald Graff. Translated by Jeffrey Mehlman and Samuel Weber. Evanston, IL: Northwestern University Press, 1988.

Diamond, Suzanne. "Scripted Subjectivity: The Politics of Personal Disclosure." In *Compelling Confessions: The Politics of Personal Disclosure*, ed. Suzanne Diamond, 23–55. Lanham, MD: Fairleigh Dickinson University Press, 2010.

Dickey, James. "Dialogues with Themselves." *New York Times Book Review*, April 28, 1963.

Dolan, Jill. "Gender Impersonation Onstage: Destroying or Maintaining the Mirror of Gender Roles." *Women & Performance: A Journal of Feminist Theory* 2, no. 2 (1985): 5–11.

Dovey, Jon. *Freakshow: First Person Media and Factual Television*. Sterling, VA: Pluto Press, 2000.

———. "It's Only a Game Show: Big Brother and the Theatre of Spontaneity." In *Big Brother International: Formats, Critics and Publics*, edited by Ernest Mathijs and Janet Jones, 232–49. New York: Wallflower Press, 2004.

Dreifus, Claudia. *Woman's Fate: Raps from a Feminist Consciousness-Raising Group*. New York: Bantam Books, 1973.

Dubrofsky, Rachel E. "Therapeutics of the Self: Surveillance in the Service of the Therapeutic." *Television & New Media* 8, no. 4 (November 2007): 263–84.

Dyer, Richard. *Heavenly Bodies: Film Stars and Society*. 2nd ed. New York: Routledge, 2004.

Echols, Alice. *Daring to Be Bad: Radical Feminism in America 1967–1975*. Minneapolis: University of Minnesota Press, 1989.

Edwards, Leigh H. *The Triumph of Reality TV: The Revolution in American Television*. Santa Barbara, CA: Praeger, 2013.

Eggers, Dave. *A Heartbreaking Work of Staggering Genius*. Reprint ed. New York: Vintage, 2001.

"Eleanor Antin (Stefanotty)." *Art News*, March 1975.

Elswit, Kate. "*So You Think You Can Dance* Does Dance Studies." *TDR* 56, no. 1 (February 13, 2012): 133–42.

"Embarras, n." *OED Online*. Accessed April 6, 2016. www.oed.com.

Erhard, Werner. "A Way to Transformation." *WernerErhard.com*. Accessed June 10, 2016. www.wernererhard.com.

Escoffery, David S., ed. *How Real Is Reality TV? Essays on Representation and Truth*. Jefferson, NC: McFarland, 2006.

Felman, Shoshana. *The Scandal of the Speaking Body: Don Juan with J.L. Austin, Or Seduction in Two Languages*. Stanford, CA: Stanford University Press, 1983.

Felski, Rita. "On Confession." In *Beyond Feminist Aesthetics: Feminist Literature and Social Change*, 86–121. Cambridge, MA: Harvard University Press, 1989.

Flanzbaum, Hilene. "The Imaginary Jew and the American Poet." In *The Americanization of the Holocaust*, edited by Hilene Flanzbaum, 18–32. Baltimore: Johns Hopkins University Press, 1999.

The Fog of War—Trailer. YouTube. Accessed July 1, 2016. www.youtube/6pOPbiA_eMw.

Forte, Jeanie. "Women's Performance Art: Feminism and Postmodernism." In Case, *Performing Feminisms*, 251–69.

Foucault, Michel. *The History of Sexuality: An Introduction*. 1977. Reprint, New York: Knopf Doubleday, 2012.

Freud, Sigmund. *A General Introduction to Psychoanalysis*. New York: Boni and Liveright, 1920.

Friedan, Betty. *The Feminine Mystique*. New York: Norton, 2001.

Friedman, James. "Prime-Time Fiction Theorizes the Docu-Real." In *Reality Squared: Televisual Discourse on the Real*, edited by James Friedman, 138–54. New Brunswick, NJ: Rutgers University Press, 2002.

Frueh, Joanna. "The Body through Women's Eyes." In Broude and Garrard, *Power of Feminist Art*, 190–207.

Furr, Derek. *Recorded Poetry and Poetic Reception from Edna Millay to the Circle of Robert Lowell*. New York: Palgrave Macmillan, 2010.

"Gains in Grafts." *Time*, February 17, 1958.

Garcia, Michael Nieto. *Autobiography in Black and Brown: Ethnic Identity in Richard Wright and Richard Rodriguez*. Albuquerque: University of New Mexico Press, 2014.

Gates, Henry Louis, Jr. *"Race," Writing, and Difference*. Chicago: University of Chicago Press, 1992.

Gaulke, Cheri. "Performance Art of the Woman's Building." *High Performance* 3 (1980): 156–63.

Geiger, Don. *The Sound, Sense, and Performance of Literature*. Chicago: Scott, Foresman, 1963.

"G.G. Proves Itself." *Time*, November 3, 1952.

Gilbert, Joanne R. "Performing Marginality: Comedy, Identity, and Cultural Critique." *Text and Performance Quarterly* 17, no. 4 (1997): 317–30.

Gill, Jo. *Anne Sexton's Confessional Poetics*. Gainesville: University Press of Florida, 2007.

———. "Textual Confessions: Narcissism in Anne Sexton's Early Poetry." *Twentieth Century Literature* 50, no. 1 (Spring 2004): 59–87.

Gilmore, Leigh. *Autobiographics: A Feminist Theory of Women's Self-Representation*. Ithaca, NY: Cornell University Press, 1994.

Ginsberg, Allen. *Collected Poems 1947–1997*. New York: Harper, 2007.

———. *Howl and Other Poems*. LP. Berkeley, CA: Fantasy, 1959.

———. *The Letters of Allen Ginsberg*. Edited by Bill Morgan. Boston: Da Capo Press, 2008.

Goffman, Erving. *Forms of Talk*. Philadelphia: University of Pennsylvania Press, 1981.

———. *The Presentation of Self in Everyday Life*. New York: Doubleday Anchor Books, 1959.

Goldman, Albert. *Ladies and Gentlemen, Lenny Bruce!!* New York: Random House, 1974.

Gornick, Vivian. "Consciousness." *New York Times Magazine*, January 10, 1971.

Gray, Spalding. *47 Beds*. 1982. VHS. Theatre on Film and Tape Archive, New York Public Library for the Performing Arts.

———. "Alive Interview: Spalding Gray." *Alive: The New Performance Magazine*, December 1982.

———. *India and After (America)*. 1982. VHS. Theatre on Film and Tape Archive, New York Public Library for the Performing Arts.

———. Interview by Dan Georgakas. "The Art of Autobiography: An Interview with Spalding Gray." *Cineaste* 19, no. 4 (1993): 34–37.

———. Interview by Richard Schechner. "My Art in Life: Interviewing Spalding Gray."
 TDR 46, no. 4 (Winter 2002): 154–74.

———. *The Journals of Spalding Gray*. Edited by Nell Casey. New York: Knopf, 2011.

———. *Life Interrupted: The Unfinished Monologue*. New York: Crown, 2005.

———. *Sex and Death to the Age 14*. New York: Vintage, 1986.

———. *Swimming to Cambodia*. New York: Theatre Communications Group, 2005.

Gray, Spalding, Kathleen Russo, and Lucy Sexton. *Spalding Gray: Stories Left to Tell*.
 Woodstock, IL: Dramatic Publishing, 2008.

Grobe, Christopher. "Advertisements for Themselves: Poetry, Confession, and the Arts
 of Publicity." In *American Literature in Transition, 1950–1960*, edited by Steven Bel-
 letto and Daniel Grausam. Cambridge: Cambridge University Press, forthcoming.

———. "Memoir 2.0; Or, Confession Gone Wild." *Public Books*, March 18, 2013. Ac-
 cessed February 28, 2016. www.publicbooks.org.

———. "On Book: The Performance of Reading." *New Literary History* 47, no. 4 (Au-
 tumn 2016): 567–89.

Grossman, Lev. "Power to the People." *Time*, December 25, 2006.

"A Guide to Consciousness-Raising." *Ms.*, July 1972.

Guillory, John. "Genesis of the Media Concept." *Critical Inquiry* 36, no. 2 (January
 2010): 321–62.

Gussow, Mel. "Spalding Gray as Storyteller." *New York Times*, November 16, 1984, sec. C.

———. "Stage: Spalding Gray's 'Point Judith.'" *New York Times*, December 30, 1980, sec. C.

———. "Theater: 'Sex and Death.'" *New York Times*, October 30, 1982.

———. "Theater: Spalding Gray's '47 Beds.'" *New York Times*, December 12, 1981.

Halbert, Debora. "Who Owns Your Personality: Reality Television and Publicity
 Rights." In *Survivor Lessons: Essays on Communication and Reality Television*,
 edited by Matthew J. Smith and Andrew F. Wood, 37–56. Jefferson, NC: McFar-
 land, 2003.

Hall, Donald. "The Poetry Reading: Public Performance/Private Art." *American Scholar*
 54 (Winter 1985): 63–77.

Hamilton, Ian. *Robert Lowell: A Biography*. New York: Random House, 1982.

Harris, Geraldine. *Staging Femininities*. New York: Manchester University Press, 1999.

Hartocollis, Anemona. "With Diversity Comes Intensity in Amherst Free Speech De-
 bate." *New York Times*, November 28, 2015. www.nytimes.com.

Hetsroni, Amir. *Reality Television: Merging the Global and the Local*. New York: Nova
 Science, 2011.

Heuvel, Michael Vanden. *Performing Drama/Dramatizing Performance: Alternative
 Theater and the Dramatic Text*. Ann Arbor: University of Michigan Press, 1993.

Hill, Annette. *Reality TV*. New York: Routledge, 2015.

———. *Restyling Factual TV: Audiences and News, Documentary and Reality Genres*.
 New York: Routledge, 2007.

Hinz, Evelyn J. "Mimesis: The Dramatic Lineage of Auto/Biography." In *Essays on Life
 Writing: From Genre to Critical Practice*, edited by Marlene Kadar, 195–212. Toronto:
 University of Toronto Press, 1992.

Holmes, Su. "'The Viewers Have . . . Taken over the Airwaves?' Participation, Reality TV and Approaching the Audience-in-the-Text." *Screen* 49, no. 1 (Spring 2008): 13–31.

Hsu, Hua. "The Year of the Imaginary College Student." *New Yorker*, December 31, 2015. www.newyorker.com.

Hymes, Dell. "Breakthrough into Performance." In *Folklore: Performance and Communication*, edited by Dan Benamos and Kenneth S. Goldstein, 11–74. The Hague: Walter de Gruyter, 1975.

Inbau, Fred. *Lie Detection and Criminal Interrogation*. Baltimore: Williams & Wilkins, 1948.

Inglis, Fred. *A Short History of Celebrity*. Princeton, NJ: Princeton University Press, 2010.

Isherwood, Charles. "Of Youth, Frocks and Politics: A Not-So-Ordinary Life." *New York Times*, March 8, 2010, sec. C.

Isherwood, Christopher. *The World in the Evening*. New York: Random House, 1954.

James, Henry. *The Art of the Novel: Critical Prefaces*. Edited by Richard P. Blackmur. New York: Scribner, 1950.

Javadizadeh, Kamran. "Elizabeth Bishop's Closet Drama." *Arizona Quarterly* 67, no. 3 (Autumn 2011): 119–50.

Johnson, Hillary, and Nancy Rommelmann. *The Real Real World*. New York: MTV Books, 1995.

Johnson, Samuel. "Johnson, Preface to the Dictionary." In Johnson, *A Dictionary of the English Language* (1755), edited by Jack Lynch. Accessed May 15, 2016. andromeda.rutgers.edu.

Jones, Amelia. *Body Art/Performing the Subject*. Minneapolis: University of Minnesota Press, 1998.

Jung, C. G. *Mandala Symbolism*. Translated by R. F. C. Hull. Princeton, NJ: Princeton University Press, 1972.

———. *Memories, Dreams, Reflections*. Translated by Clara Winston and Richard Winston. New York: Vintage, 1989.

Kamvar, Sep, and Jonathan Harris. "Movements." *We Feel Fine*. Accessed April 1, 2017. www.wefeelfine.org.

Kane, Carolyn. "Dancing Machines: An Interview with Natalie Bookchin." *Rhizome Blog*, May 27, 2009. Accessed January 20, 2015. www.rhizome.org.

Kaplan, Caren. "Resisting Autobiography: Out-Law Genres and Transnational Feminist Subjects." In *Women, Autobiography, Theory: A Reader*, edited by Sidonie Smith and Julia Watson, 208–16. Madison: University of Wisconsin Press, 1998.

Kattenbelt, Chiel. "Intermediality in Theatre and Performance: Definitions, Perceptions and Medial Relationships." *Culture, Language and Representation*, no. 6 (2008): 19–29.

Kavka, Misha. *Reality Television, Affect and Intimacy: Reality Matters*. New York: Palgrave Macmillan, 2008.

———. *Reality TV*. Edinburgh: Edinburgh University Press, 2012.

Kilborn, Richard. *Staging the Real: Factual TV Programming in the Age of Big Brother*. Manchester: Manchester University Press, 2003.

Kino, Carol. "A Rebel Form Gains Favor. Fights Ensue." *New York Times*, March 14, 2010, sec. Arts.

Kleb, William. "Art Performance: San Francisco." *Performing Arts Journal* 1, no. 3 (Winter 1977): 40–50.

Kleinfield, N. R. "Barefoot in the Loft: A Real New York Story." *New York Times*, March 22, 1992, sec. A.

Klinkenborg, Verlyn. "Appreciations; Spalding Interrupted." *New York Times*, March 10, 2004.

Korins, David. Telephone interview by Christopher Grobe, August 11, 2010.

Kracauer, Siegfried. "The Mass Ornament." Translated by Barbara Correll and Jack Zipes. *New German Critique*, no. 5 (1975): 67–76.

Kraidy, Marwan M., and Katherine Sender, eds. *The Politics of Reality Television: Global Perspectives*. New York: Routledge, 2010.

Kraszewski, Jon. "Country Hicks and Urban Cliques: Mediating Race, Reality, and Liberalism on MTV's *The Real World*." In Murray and Ouellette, *Reality TV*, 205–22.

Labey, Christina, and Elizabeth Bick. "The Digital Sublime: A Dialogue with Penelope Umbrico." *Conveyer*, April 2011.

Lasch, Christopher. *The Culture of Narcissism: American Life in an Age of Diminishing Expectations*. 1979. Rev. ed., New York: Norton, 1991.

Lask, Thomas. "Poetry on Records: Poet's Works on Disks." *New York Times*, June 24, 1956, sec. Arts & Leisure.

Lee, Charlotte I. *Oral Interpretation*. Boston: Houghton Mifflin, 1965.

Lee, Vic. "CA Cheerleader Protests Rape Case by Carrying Mattress." *ABC7 Los Angeles*, October 31, 2014. www.abc7.com.

LeFever, Lee, and Sachi LeFever. "Twitter in Plain English." *Common Craft*, 2008. www.commoncraft.com.

Lejeune, Philippe. *On Autobiography*. Edited by Paul John Eakin. Translated by Katherine Leary. Minneapolis: University of Minnesota Press, 1989.

Lerner, Laurence. "What Is Confessional Poetry?" *Critical Quarterly* 29, no. 2 (Summer 1987): 46–66.

Levertov, Denise. "An Approach to Public Poetry Listenings." In *Light Up the Cave*, 46–56. New York: New Directions, 1982.

Levin, Kim. "Eleanor Antin." *Arts Magazine*, no. 51 (March 1977): 19.

Lichtman, Ronnie. "Sisterhood and the Small Group." n.d. Box 88, folder 9, location 63F. Joan E. Biren Papers, Sophia Smith Collection, Smith College, Northampton, MA.

Limon, John. *Stand-Up Comedy in Theory, or, Abjection in America*. Durham, NC: Duke University Press, 2000.

Lippard, Lucy. *Six Years: The Dematerialization of the Art Object from 1966 to 1972*. New York: Praeger, 1973.

Loeffler, Carl. "From the Body into Space: Post-Notes on Performance Art in Northern California." In *Performance Anthology: A Source Book for a Decade of California*

Performance Art, edited by Carl Loeffler, 369–89. San Francisco: Contemporary Arts Press, 1980.

Longenbach, James. *Modern Poetry after Modernism*. New York: Oxford University Press, 1997.

Lowell, Robert. *Collected Poems*. Edited by Frank Bidart and David Gewanter. New York: Farrar, Straus and Giroux, 2007.

———. *Collected Prose*. Edited by Robert Giroux. New York: Farrar, Straus and Giroux, 1990.

———. "National Book Award Acceptance Speech." National Book Foundation, March 27, 2010. www.nationalbook.org.

———. *Robert Lowell: A Reading*. LP. New York: Caedmon, 1978.

———. *Robert Lowell Reading His Own Poems*. n.d. PL 32–33. Library of Congress, Recorded Sound Reference Center.

———. *Robert Lowell Reads from His Own Work*. LP. New Haven, CT: Yale Series of Recorded Poets, 1959.

Lyall, Sarah. "London Living, Under a Camera's Icy Gaze." *New York Times*, July 2, 1995, sec. H.

Mac, Taylor, and Naveen Kumar. "Taylor Mac Talks Gender, Acting, and Ground-breaking New Play, 'Hir.'" *Towleroad*, November 12, 2015. www.towleroad.com.

MacArthur, Marit J. "Monotony, the Churches of Poetry Reading, and Sound Studies." *PMLA* 131, no. 1 (January 2016): 38–63.

Magnuson, John. *The Lenny Bruce Performance Film*. DVD. Port Washington, NY: Koch Vision, 2005.

Manning, Philip. *Erving Goffman and Modern Sociology*. Stanford, CA: Stanford University Press, 1992.

McCarthy, Anna. "'Stanley Milgram, Allen Funt, and Me': Postwar Social Science and the 'First Wave' of Reality TV." In Murray and Ouellette, *Reality TV*, 23–43.

McCarty, Shannon. Interview by Christopher Grobe, March 23, 2011.

McCurdy, Philip. Letter to the Author, July 13, 2010.

McGurl, Mark. *The Program Era: Postwar Fiction and the Rise of Creative Writing*. Cambridge, MA: Harvard University Press, 2011.

McLuhan, Marshall. *The Gutenberg Galaxy*. Toronto: University of Toronto Press, 2011.

Mead, Margaret. "As Significant as the Invention of Drama or the Novel." *TV Guide*, January 6, 1973.

Messerli, Douglas. "The Role of Voice in Nonmodernist Fiction." *Contemporary Literature* 25, no. 3 (1984): 281–304.

Meyer, Moe, ed. *The Politics and Poetics of Camp*. New York: Routledge, 1994.

Middlebrook, Diane. *Anne Sexton: A Biography*. New York: Vintage, 1992.

———. "What Was Confessional Poetry?" In *The Columbia History of American Poetry*, edited by Jay Parini and Brett C. Miller, 632–49. New York: Columbia University Press, 1993.

Middleton, Peter. *Distant Reading: Performance, Readership, and Consumption in Contemporary Poetry*. Tuscaloosa: University of Alabama Press, 2005.

Miller, Tim. "The Battle of Chattanooga." In *Cast Out: Queer Lives in Theater*, edited by Robin Bernstein, 91–102. Ann Arbor: University of Michigan Press, 2006.

Milton, John. "Areopagitica." In *The Complete Poetry and Essential Prose of John Milton*, edited by William Kerrigan, John Rumrich, and Stephen M. Fallon, 923–66. New York: Random House, 2007.

Miranda v. Arizona, 384 US 436 (1966).

Molesworth, Helen, and Ruth Erickson. *Leap Before You Look: Black Mountain College, 1933–1957*. New Haven, CT: Yale University Press, 2015.

Montano, Linda. *Art in Everyday Life*. Los Angeles: Astro Artz, 1981.

Montano, Linda, and Moira Roth. "Matters of Life and Death." *High Performance* 1, no. 4 (December 1978): 2–7.

Morrill, Cynthia. "Revamping the Gay Sensibility: Queer Camp and Dyke Noir." In Meyer, *Politics and Poetics of Camp*, 94–110.

Morris, Errol. "Eye Contact." *ErrolMorris.com*, 2004. Accessed July 1, 2016. www.errolmorris.com.

Muñoz, José Esteban. *Disidentifications: Queers of Color and the Performance of Politics*. Minneapolis: University of Minnesota Press, 1999.

———. "Ephemera as Evidence: Introductory Notes to Queer Acts." *Women & Performance: A Journal of Feminist Theory* 8, no. 2 (1996): 5–16.

Murray, Susan, and Laurie Ouellette, eds. *Reality TV: Remaking Television Culture*. 2nd ed. New York: New York University Press, 2009.

Nabokov, Vladimir. *Lolita*. 1955. Reprint, New York: Vintage, 1989.

Nadel, Alan. *Containment Culture: American Narratives, Postmodernism, and the Atomic Age*. Durham, NC: Duke University Press, 1995.

National Task Force on Consciousness Raising, Harriet Perl, and Gay Abarbanell. *Guidelines to Feminist Consciousness Raising*. Los Angeles, 1979.

Nelson, Anthony C. E. "Spalding Gray: Stories Left to Tell." *NYTheatre*, March 4, 2007. www.nytheatre.com.

Nelson, Deborah. *Pursuing Privacy in Cold War America*. New York: Columbia University Press, 2002.

Newton, Esther. *Mother Camp: Female Impersonators in America*. Chicago: University of Chicago Press, 1972.

Newton, Esther, and Shirley Walton. "The Personal Is Political: Consciousness Raising and Personal Change in the Women's Liberation Movement (1971)." In Esther Newton, *Margaret Mead Made Me Gay: Personal Essays, Public Ideas*, 113–41. Durham, NC: Duke University Press, 2000.

O'Connor, John. "MTV's Low-Cost Way of Business." *New York Times*, July 18, 1995, sec. C.

———. "'The Real World,' According to MTV." *New York Times*, July 9, 1992, sec. C.

———. "A Soap Opera Based on Reality Moves to L.A." *New York Times*, July 1, 1993, sec. C.

O'Connor, Lynn. "Defining Reality." In *The Small Group: Three Articles*, 2–7. Berkeley, CA: Women's Liberation Basement Press, n.d.

Ollman, Leah. "Will the Real Eleanor Antin Stand Up? (And Take a Bow)." *Los Angeles Times*, May 26, 1999, sec. F.

Olney, James. *Autobiography: Essays Theoretical and Critical*. Princeton, NJ: Princeton University Press, 2014.

Olson, Charles. *Human Universe and Other Essays*. Edited by Donald Allen. New York: Grove Press, 1967.

Oren, Tasha, and Sharon Shahaf, eds. *Global Television Formats: Understanding Television across Borders*. New York: Routledge, 2013.

Ouellette, Laurie, and Susan Murray. "Introduction." In Murray and Ouellette, *Reality TV*, 1–20.

Paleari, Paola. "A Day with Penelope Umbrico." *Yet*, August 21, 2014.

People v. Bruce. Trial Transcripts, San Francisco City Municipal Court: Dept. No. 11: County of San Francisco, March 5–8, 1962.

Perelman, Bob. "Speech Effects: The Talk as a Genre." In Bernstein, *Close Listening*, 200–216.

Pérez-Peña, Richard, and Kate Taylor. "Fight Against Sexual Assaults Holds Colleges to Account." *New York Times*, May 3, 2014. www.nytimes.com.

Peterson, Michael. *Straight White Male: Performance Art Monologues*. Jackson: University Press of Mississippi, 2010.

Phelan, Peggy. "'Just Want to Say': Performance and Literature, Jackson and Poirier." *PMLA* 125, no. 4 (October 2010): 942–47.

———. "Reciting the Citation of Others; or, A Second Introduction." In *Acting Out: Feminist Performances*, edited by Lynda Hart and Peggy Phelan, 13–34. Ann Arbor: University of Michigan Press, 1993.

———. "Spalding Gray's *Swimming to Cambodia*: The Article." *Critical Texts* 5, no. 1 (1988): 27–30.

———. "Survey." In Phelan and Reckitt, *Art and Feminism*, 14–49.

———. *Unmarked: The Politics of Performance*. New York: Routledge, 1993.

Phelan, Peggy, and Helena Reckitt, eds. *Art and Feminism*. London: Phaidon, 2001.

Piercy, Marge, and Jane Freeman. "Getting Together: How to Start a Consciousness-Raising Group." Accessed May 10, 2016. http://userpages.umbc.edu.

Plath, Sylvia. *Collected Poems*. Edited by Ted Hughes. London: Faber & Faber, 1981.

———. Interview by Peter Orr. In Orr, *The Poet Speaks: Interviews with Contemporary Poets*, 167–72. London: Routledge, 1966.

———. *The Unabridged Journals of Sylvia Plath*. Edited by Karen V. Kukil. New York: Anchor, 2000.

Plato. *Six Great Dialogues: Apology, Crito, Phaedo, Phaedrus, Symposium, The Republic*. Translated by Benjamin Jowett. Mineola, NY: Dover, 2007.

———. *The Symposium*. Edited by Christopher Gill. New York: Penguin, 1999.

Podhoretz, John. "'Survivor' and the End of Television." *Commentary*, November 2000, 50–52.

Pogrebin, Letty Cottin. "Rap Groups: The Feminist Connection." *Ms. Magazine*, July 1972.

Pullen, Christopher. *Documenting Gay Men: Identity and Performance in Reality Television and Documentary Film*. Jefferson, NC: McFarland, 2007.

Rabiner, Susan, and Alfred Fortunato. *Thinking Like Your Editor: How to Write Great Serious Nonfiction and Get It Published*. New York: Norton, 2010.

Rancière, Jacques. *The Emancipated Spectator*. Translated by Gregory Elliott. New York: Verso, 2009.

Raven, Arlene. "Womanhouse." In Broude and Garrard, *Power of Feminist Art*, 48–65.

The Real World Intros. Accessed June 24, 2016. http://youtu.be/xIni27L3q_k.

"Real World Is Now Accepting Casting Tapes." Bunim-Murray Productions, n.d. www.bunim-murray.com.

Reckitt, Helena. "Preface." In Phelan and Reckitt, *Art and Feminism*, 10–13.

Reid, Gwendolynne. *The Rhetoric of Reality Television: A Narrative Analysis of the Structure of Illusion*. Saarbrucken: Verlag Dr. Muller, 2007.

Reik, Theodor. *The Compulsion to Confess: On the Psychoanalysis of Crime and Punishment*. New York: Farrar, Straus & Cudahy, 1959.

Richards, David. "Spalding Gray, Talkmaster: On Stage, More Than Monologues." *Washington Post*, April 17, 1985.

Ridout, Nicholas. *Stage Fright, Animals, and Other Theatrical Problems*. Cambridge: Cambridge University Press, 2006.

The Riverbends Channel. *James Baldwin Debates William F. Buckley (1965)*. YouTube. Accessed March 9, 2016. http://youtube/oFeoS41xe7w.

Roach, Joseph. *It*. Ann Arbor: University of Michigan Press, 2007.

———. "Public Intimacy: The Prior History of 'It.'" In *Theatre and Celebrity in Britain, 1660–2000*, edited by Mary Luckhurst and Jane Moody, 15–30. New York: Palgrave Macmillan, 2005.

———. "Viva Voce." *Yale Review* 99, no. 4 (October 2011): 108–18.

Rockwell, John. "Laurie Anderson Grows as a Performance Artist." *New York Times*, October 27, 1980, sec. C.

Rojek, Chris. *Celebrity*. London: Reaktion Books, 2001.

Rosenfeld, Megan. "Spalding Gray, Talkmaster: In Person, a Lifetime in Words." *Washington Post*, April 17, 1985.

Rosenthal, M. L. *The New Poets: American & British Poetry since World War II*. New York: Oxford University Press, 1960.

———. "Poetry as Confession." *Nation*, September 19, 1959.

Roth, Martha. "Notes toward a Feminist Performance Aesthetic." *Women & Performance: A Journal of Feminist Theory* 1, no. 1 (Spring/Summer 1983): 5–14.

Roth, Moira. "The Amazing Decade." In *The Amazing Decade: Women and Performance Art in America 1970–1980*, edited by Moira Roth, 14–41. Los Angeles: Astro Artz, 1983.

———. "Toward a History of California Performance: Part Two." *Arts*, no. 52 (June 1978): 114–23.

Roubaud, Jacques. "Prelude: Poetry and Orality." In *The Sound of Poetry/The Poetry of Sound*, edited by Marjorie Perloff and Craig Dworkin, translated by Jean-Jacques Poucel, 18–28. Chicago: University of Chicago Press, 2009.

Rousseau, Jean-Jacques. *Confessions*. Edited by Patrick Coleman. Translated by Angela Scholar. New York: Oxford University Press, 2000.

Rubin, Michael. *Nonlinear: A Guide to Electronic Film and Video Editing*. Gainesville, FL: Triad, 1991.

Ruoff, Jeffrey. *An American Family: A Televised Life*. Minneapolis: University of Minnesota Press, 2002.

Ryan, Erin Gloria. "Columbia Rape Protesters Pay Fine with Giant Check Written on Mattress." *Jezebel*, December 15, 2014. Accessed July 2, 2016. www.jezebel.com.

Saade, John, and Joe Borgenicht. *The Reality TV Handbook: An Insider's Guide*. Philadelphia: Quirk Books, 2004.

Saltz, Jerry. "The 19 Best Art Shows of 2014." *Vulture*, December 10, 2014. www.vulture.com.

Saul, Scott. *Becoming Richard Pryor*. New York: Harper, 2014.

Savran, David. *Breaking the Rules: The Wooster Group*. New York: Theatre Communications Group, 1986.

Sayre, Henry M. *The Object of Performance: The American Avant-Garde since 1970*. Chicago: University of Chicago Press, 1989.

Schechner, Richard. "The Decline and Fall of the (American) Avant-Garde [Part 2]." *Performing Arts Journal* 5, no. 3 (1981): 9–19.

Schroeder, Elizabeth R. "'Sexual Racism' and Reality Television: Privileging the White Male Prerogative on MTV's 'The Real World: Philadelphia.'" In Escoffery, *How Real Is Reality TV?*, 180–94.

Senelick, Laurence. *The Changing Room: Sex, Drag and Theatre*. New York: Routledge, 2000.

Senft, Theresa M. *Camgirls: Celebrity and Community in the Age of Social Networks*. New York: Peter Lang, 2008.

Sexton, Anne. *Anne Sexton Reading Her Poems with Comment at the Fassett Recording Studio*. Boston, 1960. Archive of Recorded Poetry and Literature, Library of Congress.

———. *Anne Sexton Reads Her Poetry*. LP. New York: Caedmon, 1974.

———. *Anne Sexton: A Self-Portrait in Letters*. Boston: Houghton Mifflin Harcourt, 2004.

———. *AS Reading Her Poetry*. University of Houston, 1973. R 0082. Anne Sexton Papers, Harry Ransom Center, University of Texas at Austin.

———. *The Complete Poems*. Edited by Maxine Kumin. Boston: Mariner Books, 1999.

———. *No Evil Star: Selected Essays, Interviews, and Prose*. Edited by Steven E. Colburn. Ann Arbor: University of Michigan Press, 1985.

———. *The Poetry of Anne Sexton*. Cassette. Audio Forum, 1964.

———. "Reactions of an Author in Residence in a Little Town Called Boston." *Charles Playbook*, May 1964. Anne Sexton Personal Library, Harry Ransom Center, University of Texas at Austin.

Shattuc, Jane M. *The Talking Cure: TV Talk Shows and Women*. New York: Routledge, 1997.

Shaw, Maureen. "12 Photos Show How the 'Mattress Girl' Campus Protest Has Become a National Movement." *Mic.com*, October 30, 2014. www.mic.com.

Shewey, Don. "The Performing Artistry of Laurie Anderson." *New York Times Magazine*, February 6, 1983.

Simonson, Robert. "Spalding Gray: Stories Left to Tell." *Time Out New York*, March 15, 2007.

Simpson, Louis. *A Revolution in Taste: Studies of Dylan Thomas, Allen Ginsberg, Sylvia Plath, and Robert Lowell*. New York: Macmillan, 1978.

Singer, Mark. "Shades of Gray." *New Yorker*, March 5, 2007.

Skeggs, Beverley, and Helen Wood. *Reacting to Reality Television: Performance, Audience and Value*. New York: Routledge, 2012.

Smalec, Theresa. "And Everything Is Going Fine: Soderbergh on Spalding Gray." *The Fanzine*, May 21, 2010. www.thefanzine.com.

———. "Scenes of Self-Recruitment: Ron Vawter's Entry into the Performance Group." *Theatre Journal* 61, no. 1 (2009): 23–41.

Smith, Cherise. *Enacting Others: Politics of Identity in Eleanor Antin, Nikki S. Lee, Adrian Piper, and Anna Deavere Smith*. Durham, NC: Duke University Press, 2011.

Smith, Ernest. "Confessional Poetry." In *American Poets and Poetry: From the Colonial Era to the Present*, edited by Jeffrey Gray, Mary McAleer Balkun, and James McCorkle, 1:120–25. Santa Barbara, CA: ABC-CLIO, 2015.

Smith, Jacob. *Spoken Word: Postwar American Phonograph Cultures*. Berkeley: University of California Press, 2011.

Soderbergh, Steven. *And Everything Is Going Fine*. Irvington, NY: Criterion Collection, 2012.

Solomon, James. *The Real World: The Ultimate Insider's Guide*. New York: MTV Books, 1997.

Sontag, Kate, and David Graham, eds. *After Confession: Poetry as Autobiography*. Saint Paul, MN: Graywolf Press, 2001.

Sontag, Susan. "Notes on Camp." In *Against Interpretation and Other Essays*, 275–92. New York: Picador, 1966.

Sounds of the Annual International Sports Car Grand Prix of Watkins Glen, N.Y. LP. Washington, DC: Folkways Records, 1956.

Spivak, Gayatri Chakravorty. *The Post-Colonial Critic: Interviews, Strategies, Dialogues*. Edited by Sarah Harasym. New York: Routledge, 2014.

Stanislavski, Constantin. *An Actor Prepares*. New York: Routledge, 1989.

Stanislavsky, Konstantin. *Stanislavsky on the Art of the Stage*. Translated by David Magarshack. New York: Hill & Wang, 1963.

Sterritt, David. "Adventures Way Off Broadway." *Christian Science Monitor*, September 23, 1980.

Stiller, Ben. *Reality Bites*. Universal Pictures, 1994.

Stimson, Blake. "Out in Public: Natalie Bookchin in Conversation with Blake Stimson." *Rhizome Blog*, March 9, 2011. www.rhizome.org.

Strasberg, Lee, and Richard Schechner. "Working with Live Material." *Tulane Drama Review* 9, no. 1 (October 1964): 117–35.

Suderburg, Erika. "Real/Young/TV Queer." In *Between the Sheets, in the Streets: Queer, Lesbian, Gay Documentary*, edited by Chris Holmlund and Cynthia Fuchs, 46–70. Minneapolis: University of Minnesota Press, 1997.

Sulkowicz, Emma. "'My Rapist Is Still on Campus.'" *Time*, May 15, 2014. www.time.com.

Sutinen, Paul. "Radical Realists & a Conceptual Artist." *Portland Scribe*, June 2, 1973.

Svonkin, Craig. "Manishevitz and Sake, the Kaddish and Sutras: Allen Ginsberg's Spiritual Self-Othering." *College Literature* 37, no. 4 (Fall 2010): 166–93.

Tambling, Jeremy. *Confession: Sexuality, Sin, the Subject*. Manchester: Manchester University Press, 1990.

Taylor, Diana. *The Archive and the Repertoire: Performing Cultural Memory in the Americas*. Durham, NC: Duke University Press, 2003.

Tennov, Dorothy. "Open Rapping." Pittsburgh, PA: KNOW, Inc., n.d.

Thompson, Thomas. "What's So Funny?" *Life*, January 8, 1971.

"Thorpiter or Thupiter?" *Time*, August 26, 1957.

"Timeline." *Amherst Uprising*. Accessed June 30, 2016. http://amherstuprising.com.

Trilling, Lionel. *Sincerity and Authenticity*. Cambridge, MA: Harvard University Press, 2009.

Umbrico, Penelope. *Penelope Umbrico: Photographs*. New York: Aperture, 2011.

———. "Statements 31: Penelope Umbrico." Mark Moore Gallery, 2014. www.issuu.com/markmooregallery.

———. "Suns from Flickr, Artist's Statement." *PenelopeUmbrico.net*. Accessed May 15, 2016. www.penelopeumbrico.net.

———. "Sunset Portraits, Artist's Statement." *PenelopeUmbrico.net*. Accessed May 15, 2016. www.penelopeumbrico.net.

Vilga, Edward. *Acting Now: Conversations on Craft and Career*. New Brunswick, NJ: Rutgers University Press, 1997.

Villarejo, Amy. *Ethereal Queer: Television, Historicity, Desire*. Durham, NC: Duke University Press, 2014.

Walker, Lee. *A Quick Rundown on Feminist Consciousness-Raising Groups*. Pittsburgh, PA: KNOW, Inc., n.d.

Wark, Jayne. "Conceptual Art and Feminism: Martha Rosler, Adrian Piper, Eleanor Antin, and Martha Wilson." *Woman's Art Journal* 22, no. 1 (Spring/Summer 2001): 44–50.

Warner, Michael. "Publics and Counterpublics." *Public Culture* 14, no. 1 (2002): 49–90.

Watts, Alan. *Psychotherapy East and West*. New York: Pantheon Books, 1961.

Wheeler, Lesley. *Voicing American Poetry: Sound and Performance from the 1920s to the Present*. 2nd ed. Ithaca, NY: Cornell University Press, 2008.

White, Gillian C. *Lyric Shame: The "Lyric" Subject of Contemporary American Poetry*. Cambridge, MA: Harvard University Press, 2014.

White, Mimi. *Tele-Advising: Therapeutic Discourse in American Television*. Chapel Hill: University of North Carolina Press, 1992.

Wilding, Faith. "The Feminist Art Programs at Fresno and CalArts, 1970–75." In Broude and Garrard, *Power of Feminist Art*, 32–47.

———. "Waiting." In *Through the Flower: My Struggles as a Woman Artist*, by Judy Chicago, 213–17. Garden City, NY: Doubleday, 1975.

Williams, Cristan. "Gender Performance: The TransAdvocate Interviews Judith Butler." *TransAdvocate*, May 1, 2014. www.transadvocate.com.

Williams, Raymond. *Television: Technology and Cultural Form*. 3rd ed. New York: Routledge, 2003.

Williamson, Alan. "Stories about the Self." In Sontag and Graham, *After Confession*, 51–70.

Willson, Norma. "Majority Report: The New Women's Poetry." *English Journal* 64, no. 3 (1975): 26–28.

Witte, Karsten, Barbara Correll, and Jack Zipes. "Introduction to Siegfried Kracauer's 'The Mass Ornament.'" *New German Critique*, no. 5 (1975): 59–66.

Wojahn, David. "'A Kind of Vaudeville': Appraising the Age of the Poetry Reading." *New England Review and Bread Loaf Quarterly* 8, no. 2 (December 1, 1985): 265–82.

Woloch, Alex. *The One vs. the Many*. Princeton, NJ: Princeton University Press, 2003.

Yenser, Stephen. *Circle to Circle: The Poetry of Robert Lowell*. Berkeley: University of California Press, 1975.

Zarin, Jill. Keynote address to the "We Are Who We Watch: Reality TV, Citizenship, Celebrity" conference, Brown University, Providence, RI, April 22, 2011.

Zoglin, Richard. *Comedy at the Edge: How Stand-Up in the 1970s Changed America*. New York: Bloomsbury USA, 2008.

INDEX

White, Mimi, 191
white flight, 40
whiteness, 12, 15; on college campuses, 239; confessional poetry and, 37–43; gender and, 98; on television, 219–20
Wilde, Oscar, 93, 105–6
Wilding, Faith, 99; *Waiting*, 100–101
Williams, Raymond: on *An American Family*, 197–98, 204; *Television*, 188
Wojahn, David, 30
Wolfram, Nathalie, 245n6
Woloch, Alex, 226; *The One vs. the Many*, 226
Womanhouse, 100
Woman's Building (Los Angeles), 86–87, 92
Women & Performance, 103
Wood, Frank, 150
Wood, Helen, 189

Wooster Group, 168; *L.S.D. (. . . Just the High Points)*, 162; *Nayatt School*, 156, 156–57, 159–60, *176*
Wordsworth, William, 3
World War II, 13, 27
Writers Guild of America (WGA), 210

Yale Series of Recorded Poets (YSRP), 50
Yale University, 239
Yenser, Stephen, 63
YMHA Poetry Center, 79, 154
Young, Jordan: *Acting Solo*, 138
YouTube, 214, 232, 235–36, 268n4

Zahn, Steve, 208–9, *209*
Zamora, Pedro (*Real World* cast member), 194, 206, 217
Zarin, Jill, 225, 227
Zoglin, Richard, 246n15

ABOUT THE AUTHOR

Christopher Grobe is Assistant Professor of English at Amherst College. His scholarly essays have appeared in *PMLA*, *Theater*, *Theatre Survey*, and *NLH*, as well as in several edited collections. He has also written essays and reviews for *Public Books* and the *Los Angeles Review of Books*. For more information, go to www.cgrobe.com.